THE SOCIAL LIFE
OF INKSTONES

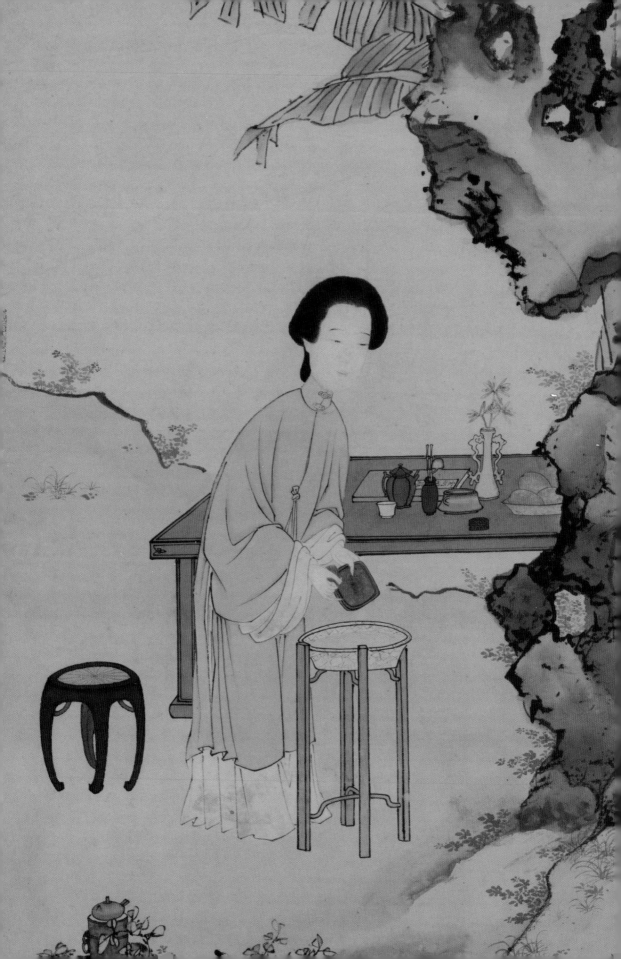

THE
Social Life
OF Inkstones

ARTISANS AND SCHOLARS
IN EARLY QING CHINA

Dorothy Ko

A William Sangki and Nanhee Min Hahn Book

UNIVERSITY OF WASHINGTON PRESS
Seattle and London

The Social Life of Inkstones was supported by a generous grant from the William Sangki and Nanhee Min Hahn Fund for Books on East Asia.

MM Publication of this book has been aided by a grant from the Millard Meiss Publication Fund of the College Art Association.

Publication of this book also was made possible by grants from the Chiang Ching-kuo Foundation for International Scholarly Exchange and Barnard College, Columbia University.

A Study of the Weatherhead East Asian Institute of Columbia University
The Studies of the Weatherhead East Asian Institute were inaugurated in 1962 to bring to a wider public the results of significant new research on modern and contemporary East Asia.

© 2017 by the University of Washington Press
Printed and bound in the United States of America
Design by Thomas Eykemans
Composed in Minion Pro, typeface designed by
 Robert Slimbach
21 20 19 18 17 5 4 3 2 1

UNIVERSITY OF WASHINGTON PRESS
www.washington.edu/uwpress

FRONTISPIECE: Lan Ying and Xu Tai, *Washing the Inkstone*, detail, 338 x 45 cm. Tianjin Museum.

INDEX: Susan Stone

LIBRARY OF CONGRESS CATALOGING-IN-PUBLICATION DATA
Names: Ko, Dorothy, 1957– author.
Title: The social life of inkstones : artisans and
 scholars in early Qing China / Dorothy Ko.
Description: Seattle : University of Washington
 Press, 2016. | Series: A Study of the
 Weatherhead East Asian Institute Columbia
 University | Includes bibliographical
 references and index.
Identifiers: LCCN 2016020379 | ISBN
 9780295999180 (hardcover : alk. paper)
Subjects: LCSH: Ink-stones—China—History—
 Ming-Qing dynasties, 1368–1912. | Ink-
 stones—Social aspects—China.
Classification: LCC NK6035.2.C6 K6 2016 | DDC
 745.6/19951—dc23
LC record available at https://lccn.loc.
 gov/2016020379

If you think your teacher has done right
by you, don't give it back, pass it on!

—Harold L. Kahn

To my teachers and students

CONTENTS

ACKNOWLEDGMENTS

Although I practiced writing with a brush as a child, I did not know the first thing about inkstones until I became interested in Gu Erniang. Many people have taken the time and effort to initiate me into the world of inkstone making and connoisseurship. In Zhaoqing, Guangdong, I had the good fortune of learning the subtleties of Duan stone carving and authentication from Liu Yanliang Laoshi, National Arts and Craft Master Li Keng, and his female disciple Guan Honghui. In Wuyuan, Hu Zhongtai Laoshi showed me the magnificence of She inkstones although I did not incorporate them in this book. In Tianjin, Cai Hongru Laoshi opened my eyes to the fine art of connoisseurship; her grace and humor made the lessons always a pleasure. In Beijing, during my last research trip in 2012, I met the remarkable inkstone carver, scholar, and collector Wu Ligu, whose research resonated with mine. Our views mesh so perfectly that my only regret is that I did not meet him and his wife, Liang Qing, earlier.

Custodians of treasures in museums and private collections have been most helpful in accommodating my viewing requests and in their own pioneering research. My heartfelt gratitude goes to Ms. Chi Jo-hsin, Ms. Tsai Mei-fen, Ms. Liu Pao-hsiu, and Ms. Chen Hui-hsia at the National Palace Museum in Taipei; Ms. Zhao Lihong and Ms. Wu Chunyan at the Palace Museum in Beijing; and Mr. Zang Tianjie at the Tianjin Museum. Without them I would not have been able to write this book. My friends Xu Yiyi, Guo Fuxiang, and Huang Haiyan, masterful scholars all in the field of craft and material culture, helped made these research trips in China possible and enjoyable. Together with Mei Mei Rado, they have also been instrumental in helping to secure the rights to reproduce images from various institutions in China.

As I grow older, ironically I find myself looking more to the future. At some point during the writing of this book, my mentors and senior colleagues retired and my main interlocutors shifted to those who came after me. My students at Rutgers and Barnard have been most inspiring as I cast about for a conceptual framework bringing gender to bear on material culture. At Columbia, students in my Visual and Material Cultures seminar have contributed in ways big and small. In particular, the research of Man Xu on funerary goods, BuYun Chen on textiles, Shing-ting Lin on

medical instruments, Kaijun Chen and Meha Priyadarshini on porcelain, Kyoungjin Bae on furniture, and Yijun Wang on metalwork have been exemplary. They are more colleagues than students.

My friend Jonathan Hay has taught me to look closely and to think deeply; his constructive reading of the manuscript, not to mention lectures and conversations through the years, have meant a great deal. The pioneering research, wise counsel, and good company of Francesca Bray, Dagmar Schäfer, Jacob Eyferth, Mareile Flitsch, and Pamela Smith have urged me on when I felt lost. Qianshen Bai has been helpful with his expert knowledge of calligraphy and steles. Among other friends I must mention Charlotte Furth, Angela Leung, Judith Zeitlin, Susan Naquin, Sophie Volpp, Lydia Liu, Rebecca Karl, Lai Hui-min, and the Senior Feminist Reading Group at Columbia, whose generosity and brilliance have made research a pleasurable collaboration. JaHyun Kim Haboush, Terry Milhaupt, and John Perreault, who would have dropped everything to celebrate with me, sadly did not live to see this book completed.

My husband Marvin Trachtenberg, who held my hand through these ten years, deserves special mention even as he is naturally included in the list of teachers and students to whom I dedicate this book.

The John Simon Guggenheim Memorial Foundation, American Council of Learned Societies, and the Weatherhead East Asian Institute at Columbia have provided generous research fellowships. The Institute for Advanced Study in Princeton, the Max Planck Institute for the History of Science in Berlin, and the Needham Research Institute in Cambridge, England, offered reprieve from teaching and a congenial environment when I most needed it. The Millard Meiss Publication Fund of the College Art Association, the Office of the Provost of Barnard College, and the Chiang Ching-kuo Foundation provided crucial subvention toward the cost of publication. Dr. Chengzhi Wang, the Chinese Studies librarian at the C. V. Starr East Asian Library at Columbia, is unfailingly helpful in procuring rare books from China. Meticulous and efficient, Lorri Hagman and her colleagues at the University of Washington Press are wonderful to work with, as is Jennifer Shontz of Red Shoe Design. It is a pleasure to offer my gratitude to these institutions and the good people who run them.

Random acts of kindness from strangers whose names I failed to record resulted in major finds: the kindly Zhaoqing storekeeper who took me on her motorcycle to the ferry landing on the opposite banks of Old Pit; the construction foreman on the site of Huang Ren's house who let me photograph his set of architectural drawings. Lastly, my Pilates teacher, Megan Frummer, reminds me that writing is a physical exertion that can break one's back. She has driven home the lesson that in separating those who work with their brains from those who work with their brawn, Mencius has unleashed uncounted damage onto the world. May we all have teachers like her.

CONVENTIONS

NAMES Following East Asian convention, people are referred to by family (or last) name first. Educated Chinese men and women have multiple personal names: the formal name (*ming*); courtesy name (*zi*); self-assigned artistic or literary names (*hao*). To avoid confusion, I choose one to refer to a person throughout the book.

AGES People's ages are given by East Asian reckoning, whereby a person is one year old at birth.

TITLES In the interest of standardization, the translation of all official titles follows that of Hucker, *A Dictionary of Official Titles in Imperial China*.

CANTONESE Cantonese words are rendered in the Jyutping romanization system.

DATES All dates (e.g., the fifth day of the fifth month) are in the lunar calendar. All years by dynastic reign and the stem-branch sixty-year cycle have been converted to the Gregorian calendar. For example, the nineteenth year of the Kangxi reign, *gengshen*, is given as 1680.

CHINESE DYNASTIES AND PERIODS

Xia dynasty, 2070–1600 BCE

Shang dynasty, 1600–ca. 1045 BCE

Zhou dynasty, ca. 1045–256 BCE
 Spring and Autumn period,
 770–476 BCE
 Warring States period, 476–221 BCE

Qin dynasty, 221–206 BCE

Former (Western) Han dynasty,
 206 BCE–8 CE

Later (Eastern) Han dynasty, 25–220 CE

Three Kingdoms, 220–280

Six Dynasties
 Western Jin, 265–317
 Eastern Jin, 317–420
 Southern and Northern dynasties,
 420–589

Sui dynasty, 581–618

Tang dynasty, 618–907

Five Dynasties and Ten Kingdoms,
 907–979

Song dynasty, 960–1279
 Northern Song, 960–1127
 Southern Song, 1127–1279

Jin dynasty, 1115–1234

Yuan dynasty, 1271–1368

Ming dynasty, 1368–1644

Qing dynasty, 1644–1912
 Shunzhi reign, 1644–1661
 Kangxi reign, 1662–1722
 Yongzheng reign, 1723–1735
 Qianlong reign, 1736–1795
 Jiaqing reign, 1796–1820
 Daoguang reign, 1821–1874
 Guangxu reign, 1875–1908
 Xuantong reign, 1909–1911

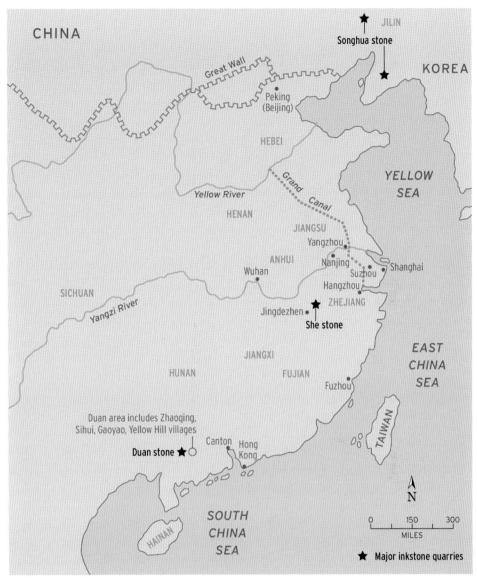

MAP I.1. Map of China. Shown here are the inkstone quarries and cities mentioned in this book.

THE SOCIAL LIFE
OF INKSTONES

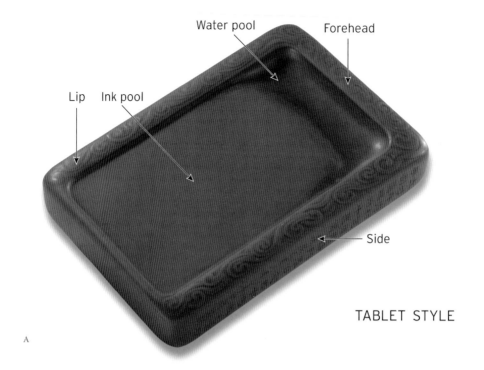

Water pool

Forehead

Lip Ink pool

Side

TABLET STYLE

A

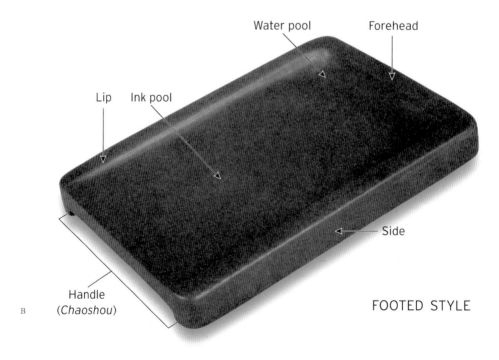

Water pool

Forehead

Lip Ink pool

Side

Handle
(*Chaoshou*)

FOOTED STYLE

B

FIG. 1.1. Parts of an inkstone, showing views of the front ("face"). The flat "tablet" (A) and the "footed" (B), with an indented bottom (*chaoshou*) for easy handling, are two of the most common inkstone styles.

Introduction

ONCE AN ESSENTIAL WRITING IMPLEMENT ON EVERY DESK IN EAST
Asia, the inkstone has remained virtually unknown in Europe and North
America. It is high time that we meet him. An inkstone, like a person,
has a face, a back, and often a lip, forehead, and feet as well (fig. 1.1). Also
called an ink-slab or ink palette, he even has a human name, Mr. Clay Water. Before
the age of fountain pen, let alone the typewriter, keyboard, or touchpad, the East Asian
writer and painter drew ink not from a bottle but from a fresh supply of his or her own
making. This was done by rubbing a moistened stick of ink-cake, made of soot and
glue, in a circular motion on an inkstone's "ink pool." By regulating the pressure applied
and the amount of water added, the user controlled the viscosity of the ink, which in
turn translated into a range of black and gray shades on paper.

Besides its essential function, an inkstone is also a collectible object, a father's gift to
his school-bound son, a token of exchange among friends, and an inscriptional surface
for encomiums. As such the stone is entangled with the culture of *wen* (writing, literature,
civility) and elite male subjectivity in its tangible material form. Usually no bigger than
an outstretched palm, the ink-grinding stone is the protagonist of this book, propelling
actions, movements, and emotional investment in the early years of the Qing empire,
from 1644 to the 1730s. It could be fashioned from kiln-fired sieved clay or other ceramics,
lacquered wood, old bricks, fallen tiles, glass, or semi-precious stones, but was most often
made from specifically harvested stones, hewn from quarries to be designed, carved, pol-
ished, sold, commissioned, used to grind ink, washed, repaired, gifted, sold, stolen, col-
lected, admired, studied, written on, written about, lost, and forgotten.

Inkstones occupy a conspicuous place in the early Qing political project. Their im-
portance stems in part from the very nature of imperial-bureaucratic rule: members of

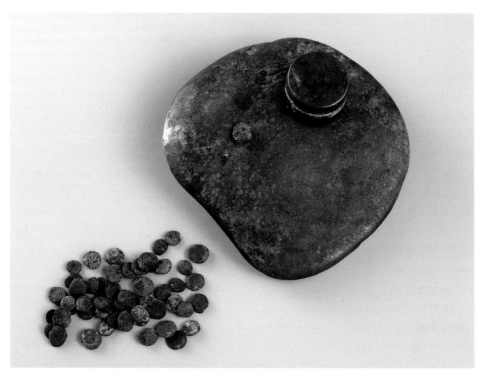

FIG. I.2. Western Han dynasty ink grinder (*yan* 研), pestle, and ink pellets. In ancient times, scribes made ink by crushing an ink pellet on a flat stone with a pestle (shown resting on the grinder), then mixing in water. This set was excavated from the tomb of the second king of the Southern Yue kingdom (r. 137–122 BCE). The inkstone (*yan* 硯) assumed its present form in the Wei-Jin period (265–420 CE) with the appearance of rod-shaped ink-cakes that can be rubbed directly on the grinding stone, eliminating the use of the pestle. Pebble stone grinder: L 12.5 cm, W 13.2 cm, H 2.8 cm; slate pestle: diameter 3.3 cm, H 2.2 cm; ink pellets: diameter 0.81–1.31 cm, H 0.23–0.42 cm. Museum of the Nanyue King Mausoleum, Guangzhou.

the court, from the emperor on down to the scribes and eunuchs, had to spill much ink in their day-to-day transactions. It is apt to take the meaning of civil rule (*wenzhi*) in its material sense, to "rule by the writing brush," which entails the diligent production of texts in the form of edicts, memorials, and veritable records, not to mention the mundane flow of requisition orders, tickets, and receipts that kept the palace machine running.[1] While this is a task faced by every dynasty, the minority status of the Manchu rulers created special challenges and opportunities to fashion a new material culture that promulgated the Qing mandate. Being a writing implement that embodies the Chinese literati culture of *wen* and small enough to be made and bestowed upon loyal academicians as gifts, the inkstone was uniquely suited to this purpose.

To follow the trajectories of the inkstone means to brave the Forbidden City and the quarries submerged under rivers, to see the world from the eyes of stoneworkers

who could hardly write and to socialize with scholars who took unconventional career paths. Through this journey one comes to a deeper understanding not only of the state of politics, art, and manufacture in a formative period of the empire, but also regarding such abstract topics as contending knowledge cultures, entanglements between words and things, as well as sensitivities about gender and embodied skills.

Our guide on this tour of small worlds is an enigmatic woman, about whom much has been written but little is known, who was one of the most accomplished inkstone makers of her day. Gu Erniang (fl. 1700–1722) was at once an extraordinary woman who managed to thrive in a world dominated by men and a rather typical widow who inherited her family trade in the artisanal quarters in Suzhou in the absence of able-bodied males in the patriline. Through Gu and her male patrons and clients we will meet a web of male artisans, Fujian natives all, who were just as skilled and were known to her, albeit not as famous. Although they only appear in three chapters, Gu and her fellow inkstone carvers are the drivers of this entire book, the chronological scope of which is demarcated by the decades in which they flourished, from the 1680s through the 1730s.

In this book I use "craftsman" and "artisan" more or less interchangeably.[2] Since the unstated gender of the normative craftsman in imperial China is male, I refrain from using craftswoman except when referring to Gu. My interest in inkstones, as well as in the people who quarried and carved them, stems from my desire to overturn an age-old Chinese predilection of "valorizing the *dao* (principles) and disparaging vessels (instrumental or tangible things)."[3] This hierarchy of head over hands permeates every aspect of Chinese life, from the curricula of schools to the psychic dispositions of people, and from status ranking to gender definitions (women from all classes being required to work with their hands).

Nowhere is this hierarchy expressed more blatantly than in a statement in the classic *Mencius*: "Those who labor with their brains govern others; those who labor with their brawn are governed by others." It was probably first intended as sagely advice to individuals with ambitions of dominion: use strategic thinking, not brute force, to prevail upon others.[4] In due time, the statement became both an accurate description of social priorities and prescription of an idealized social order. The priority finds concrete expression in the social structure prevalent in imperial as in present times. Often described in terms of the scheme of "four-folded people," an ideal society is ruled by the scholar ("those who labor with their brains"), followed in due ranking by the farmer and craftsman (both exerting "their brawn"), who could at least claim moral if not economic superiority over the merchant as their consolation prize.

The denigration of craftsmen is so pervasive and taken for granted that even when an occasional scholar set upon the idea of investigating craft skills, he had to subsume the latter into his theoretical framework when he committed his findings to writing before it became legible. The seventeenth-century philosopher Song Yingxing, author of *The Work of Heaven and the Inception of Things*, is a salient example, but the list can

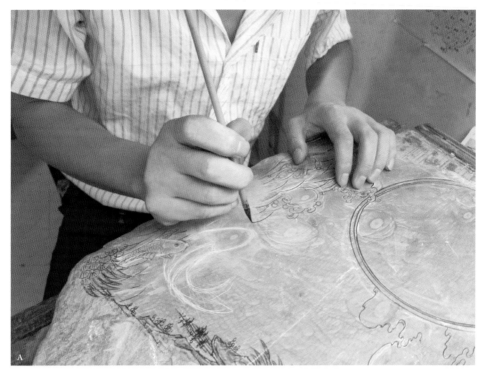

FIG. 1.3. Carving an inkstone. Insktone making involves an array of handiwork skills in the modern era: (A) plotting the overall shape and drawing the design onto the stone surface; (B) defining the contours of the design with a chisel; (C) carving the design in low, medium, or high relief with a knife, sometimes with the aid of a wooden hammer; (D) fine-tuning and polishing; (E) custom box-fitting, usually made of wood. The most important step in the premodern era, "opening the ink pool," escapes mention in this sequence. The gradient and smoothness of the ink pool determine the quality of the ink and the ease of grinding. In this omission one glimpses the transition of the inkstone from being a functional implement to a decorative object valued for its association with the exaltation of scholars in China's imperial past. Liu Wen, ed., *Zhongguo gongyi meishu dashi: Li Keng*, 74–76.

extend to many scholarly works circulating in Chinese and English today. The fault, then, lies not only in the enormous discursive advantage that scholars enjoy over the craftsmen (literate or not), but more fundamentally in the structure of scholarly knowledge and its standard of judgment, which is always a matter of malleable convention among the scholarly community in every time and place; it is the latter that deems one subject more worthy of research than another. In the field of Chinese studies today, so many scholars have constructed their self-images by identifying with the Song, Ming, or Qing literati that the latter's tastes and values have predominated in research agendas as in methods of study. In making the inkstone the protagonist of this book and the craftsman's skills its motive force, I intend to question this prevalent structure of knowledge and to introduce alternative standards of judgment.[5]

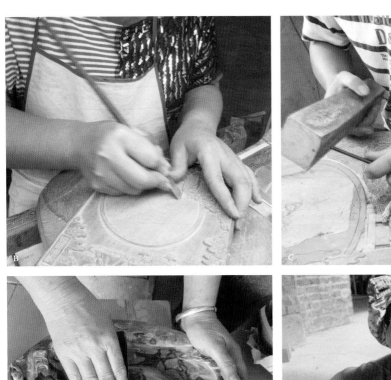
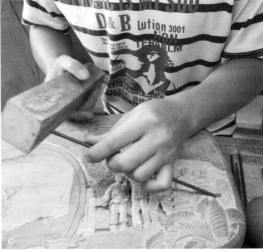
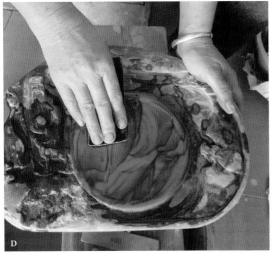
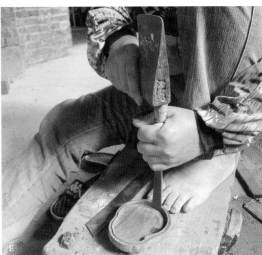

I seek entry into the craftsman's world by way of the things he made. Instead of proffering a high-sounding methodological statement, I refrain from writing about things I have not tried my hands in fabricating, nor do I discourse at length about specific objects that I have not examined in person. This stricture is particularly important given that my subject of study is a small dark purple (or occasionally green or yellow) stone wrought with subtle incisions and which is not primarily a decorative object. Even high-resolution photographs fail to capture the qualities most important to the Chinese craftsman or connoisseur: not just the form or design of the stone but the softness of touch akin to a baby's skin, the minute veins and other mineral features, and the wooden instead of metallic echo when tapped with the forefinger.

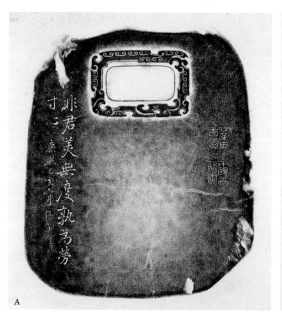
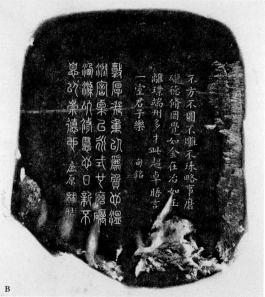

A B

FIG. 1.4. *Grotto and Sky as One* inkstone, ink rubbings: (A) front showing a rectangular water pool surrounded by an abstract *kui*-dragon; (B) back. Scholars composed encomiums and other inscriptions and had them carved onto the face, back and sometimes sides of an inkstone. Ink rubbings made of these surfaces circulated as works of art and calligraphic models, creating a stone-text interaction that inspired further rounds of writing. On this inkstone bearing a signature mark of Gu Erniang (not shown), her patron [Huang] Ren's encomium in cursive script dominates the left side of the face; on the back are encomiums of two of her other main patrons, [Yu] Dian's in regular script on the right, and Luyuan's [Lin Ji] in seal script on the left. L 23.5 cm, W 20.2 cm, H 3.6 cm. Palace Museum, Beijing.

This attentiveness to the stone does not mean that I ignore textual records—far from it. I came to a full realization of the power of texts when my earlier efforts to coax the stones, and the stones alone, to yield up their stories came up short (a costly lesson learned). Without the crucial *Inkstone Chronicle*, an account of Gu's patrons narrating their lives by way of the inkstone encomiums they composed (a genre I call "material biography"), there would have been no present book, not to mention my indebtedness to all the books and articles documenting the research by scholars who came before me. Texts are powerful conduits of information through time, and by reading them against the material remains one can glean their discursive limits, hence better able to read them well. The subtle and multiple meanings as well as omissions in the *Inkstone Chronicle* thus begin to reveal themselves. Also useful is to study the words carved on stones and the ink rubbings made of them—inkstone encomiums, printing blocks, and commemorative steles—as supplements to printed texts and manuscripts (fig. 1.4).

This brings me to an explanation of the presence of "scholars" in the title of a book whose very intent is to undo the prevalent hierarchy and restore the craftsmen to historical legibility. Once we depart from schematic descriptions of social order and idealized images of "the scholar," we begin to see that being a scholar was a matter of social performance that required assiduous maintenance, not to mention hefty financial resources. One was not born a scholar but became one, and this becoming was especially vexing in the early Qing when the ruling house was justifiably suspicious of the loyalty of Han scholars. In the spirit of affirmative action, quotas were allotted for candidates from three hereditary minority groups—Manchu, Mongol, and Chinese-banner (called Hanjun, or Chinese-martial)—in the civil service exams and in the bureaucracy, severely reducing the odds of Han Chinese scholars of achieving their ambitions.[6] As a fallback, many took up a trade that required literary skills, including medicine, painting, seal-carving, and antique-dealing to name the most common choices.

For this and other reasons, craftsmen became more lettered and professional in their dedication to their conceptual craft, which ushered in one of the most innovative periods of material culture in Chinese history. Conversely, scholars became more attentive to practical skills even as they struggled to hold on to their social label, which garnered respect that translated into higher prices for their works. For many like them, being a scholar is less a description of one's trade than an expression of an aspiration. The bulk of the present book is dedicated to showing what those "other reasons" for the elevation of practical skills might be. For the moment, it is important to emphasize that neither "scholar" nor "craftsman" were stable categories in the early Qing. Their overlapping resulted in the appearance of what for analytic purposes I call two kinds of people, "scholar-artisans" and "artisan-scholars" (the difference will become clear toward the end of the book), one of the most salient social phenomena of the eighteenth century.

In an essay that remains relevant decades after its publication, Igor Kopytoff re-envisions a thing from having an intrinsic nature to one whose multiple meanings are achieved at various stages in its social life, from making, consumption, collecting, and repair to loss or recycling.[7] While this was certainly the case with the inkstone, the same could also hold true for a *person* in the early Qing. Gu Erniang was born a daughter in a commoner family and became a wife, a widow, a crafts(wo)man, a brand, and a legend, in sequential order. Her colleague Xie Ruqi studied for the exam and made a living as a carver of seals and inkstones, but persisted in writing poetry; his son (another aspirant scholar and seal-carver) eventually amassed the requisite funds and patrons to publish his father's work. Another colleague, Yang Dongyi, studied for the exam but gave up the pretension and became known exclusively as an inkstone carver. This fluidity renders the English-speaking social historian's category of "class" (or its more flexible but still deterministic variant "status") difficult to wield regarding the issues of this book. As for the equally artificial category "gender," its relevance will become clearer after we learn what this woman and these men did with their mindful hands.

This book is structured as a succession of localized and partial perspectives, with only minimal efforts on my part to provide overarching arguments. I strive to be attentive to concrete, material descriptions, and in so doing learning to dwell in the world as a craftsman. Among the most salient insights gained when researching this book is the difficulty of generalizing "craft" or "craftsman": the rules of one trade were different from the next; the same artisan garnered different treatment from each patron. Generalization and abstraction are instead the métier of the scholar, whatever the languages used and subjects analyzed might be.

The usefulness of words and texts is none other than their power of generalization and abstraction: they allow the scholar to collect and curate the concrete so that the now abstracted assemblage can illuminate patterns across time and space. There is no gainsaying that I am a scholar writing a book, not a craftsman making an inkstone, but I try to be a different kind of scholar in seeing the world as a craftsman would, and in reading texts as anything but a transparent representation of "reality." My goal is not to disparage Chinese scholars—they had (and have) important roles to play in society—but to make these incessantly fame-seeking, wine-drinking, and poetry-writing men a bit strange. Only after the scholar's values and lifestyle are denaturalized can we begin to imagine other ways to make and be in the world.

Each of the five chapters of this book is set in a specific place: the Imperial Workshops in the Forbidden City, the Duan quarries in Guangdong, commercial inkstone-carving workshops in Suzhou and elsewhere in the south (two chapters), and collectors' homes in Fujian. In each place, those who make things and those who write interact according to a situated logic and local power dynamics that I try to elucidate. The observant reader will recognize that the artisans in the Imperial Workshops did not at all resemble the stoneworkers in the Yellow Hill villages, although both were craftsmen; likewise, the people who gave up their exam curriculum and took up a writing-brush-related trade lived in a world apart from those who persisted and captured high degrees and bureaucratic appointments, although both called themselves scholars. My strategy is to show the fluidity behind these labels in a variety of settings as they unfold in real time and in all of their contradictions without specifying beforehand what they might mean.

The very fluidity of coherent social labels (which correspond to what one might call "subject positions") may turn out to be the most salient finding for those readers patient enough to follow the itineraries of the inkstone in loops big and small. If this book has a thesis, it would be that artisan and scholar cease to be predetermined and distinct entities; in the overlap of their skill sets and knowledge cultures in unlikely corners of the empire, we may discern the transformations wrought by the social forces of the commercial revolution initiated in the late Ming and the political forces of the Manchu conquest in the early Qing.

The social life of inkstones that is to unfold in the following pages is a distinct early Qing story. The Manchus, an ethnic minority group who originated from the north-

eastern frontier of the Chinese empire, did not enjoy traditional mastery of the technical processes crucial to the governance of the vast empire on symbolic and material levels—textile, paper, and porcelain to name the most salient examples—before occupying the throne. Keenly aware of their lack, the Manchu leaders went about acquiring, transmitting, and systematizing artisanal and artistic knowledge with a seriousness unmatched by their Ming predecessors. To them, the power of technology—mastery over material processes, product design and making, as well as their attendant knowledge cultures—was coextensive with political power.[8]

The Qing respect for technical knowledge, however, should not be confused with the rule of "science" and experts in modern society. Technology did not exist as a field demarcated from politics, art, or culture; nor was the craftsman regarded as the auteur of things who is imbued with creative genius. Instead, the Qing leaders expressed their interests in artistry and technology by being attentive to the making of each *individual* product.[9] In this sense we may speak of the early Qing as a material empire, one in which control over material processes is crucial not only to provisioning the court but also to managing the resources and people in the realm and beyond—what would be called technology, economics, politics, and diplomacy in the modern world. The prince of this empire is a new coterie of managers who were knowledgeable about materials and respectful of artisanal skills. Their knowledge culture can be described as technocratic not by its modern definition but in the Greek meaning of the word: the power (*kratos*) of craft skills (*techne*).[10] Seldom has the culture of so few affected the lives of so many.

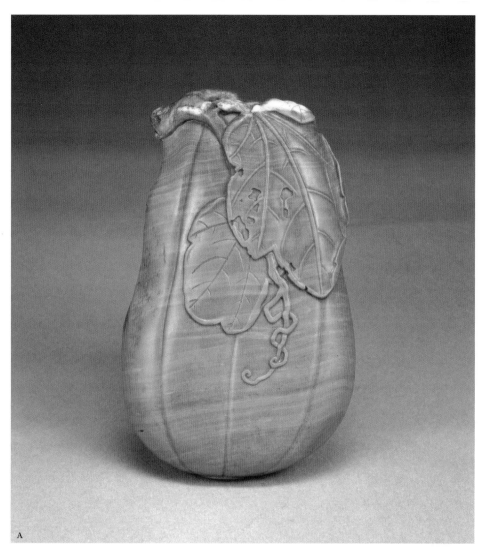

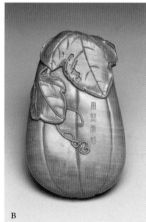

1

The Palace Workshops

THE EMPEROR AND HIS SERVANTS

O CCUPYING A CLUSTER OF BUILDINGS TO THE WEST AND NORTH-
west of the Hall of Supreme Harmony at the heart of the Forbidden City,
the Workshops of the Imperial Household (Zaoban Huoji Chu, hereafter
Imperial Workshops) were so saturated with motion and action that the
literal meaning of the Chinese verb "to work" in them seems most apt: "to walk and run."[1]
Founded by emperor Kangxi in 1680, the workshop system was responsible for the mak-
ing, repair, and inventorying of *all* the objects large and small required for the upkeep of
the imperial family and the ceremonial functions of the court. Cataloguing the tribute
goods received by the court as well as manufacturing the myriad gifts the emperor con-
ferred on favorite subjects and tributary states also came under its purview.

Specialized workshops organized by branches of knowledge appeared in 1693; by
the time records began to be kept systematically in 1723 there were over twenty of
these works (*zuo*), handling an array of materials and processes from enamel, scroll-
mounting, lacquer, jade, and leather to firearms and mapmaking. The number even-
tually grew to over sixty.[2] Inkstones were among the first objects made in the palace
workshops. There appears to have been an inkstone works almost as soon as the formal

FIG. 1.1. Inkstone shaped as a gourd with ingenious cover: (A) cover; (B) back of inkstone; (C) open
view, with cover on left and inkstone on right. The green Songhua stone is polished on the outside
to resemble a gourd cut from the trellis. When the viewer lifts the cover, he finds the jagged edges
of the inkstone (fitted perfectly to the cover) that look as though they were chiseled from the side of
the hill as Kangxi had discovered them. The raw strength of the hard Songhua stone is conveyed by
this ingenious design, which departs from the convention of an ink-slab encased in a box. L 14.6 cm,
W 9 cm, H 2.4 cm. National Palace Museum, Taiwan.

establishment of the workshop system; in 1705 Kangxi appointed two designated super-intendents and placed its jurisdiction under the Hall of Mental Cultivation, both suggesting increased workload. Although details are not known because of the paucity of recordkeeping before 1723, the Kangxi-era Inkstone Works was staffed by artisans from Jiangnan, in the south, who also carved ivory and jade, as was the customary practice in the subsequent reigns.[3]

It is perhaps not an accident that the heightened production of inkstones coincided with the Qing's transition from military to civil rule in 1681 after Kangxi quelled the rebellion of the Three Feudatories, thus securing the future of the nascent dynasty. The emperor's genius was to graft an unmistakable Manchu identity onto an instrument that signified Chinese literati culture by fashioning it out of a brand-new stone, later known as Songhua stone (after the Sungari river), quarried in the imperial homeland of present-day Liaoning, Jilin, and Heilongjiang, Manchuria. It is likely that the emperor made the "discovery" during his second pageantry there to report his triumph and make offerings to his ancestral tombs in 1682.[4]

The emperor recalled his delight in an essay: "On the slopes of Dishi Hill to the east of Shengjing [Shenyang], outcrops of rocks lie in abundance. The stone is strong and warm in substance, green and bright in color, and replete with brilliant patterned veins. When held in the hand it feels as though it is dripping with a lustrous tonic. Some people make knife or arrow sharpeners out of it. Upon inspection, I thought that it would make fine inkstones." Kangxi's use of such adjectives as warm and lustrous as well as the pun "patterned veins" (*wenli*, also the principle of textual composition) betrays his familiarity with the vocabulary of inkstone connoisseurship in the Chinese scholarly tradition, but his appreciation for a "strong" (*jian*) stone, which seldom appears in the literature, suggests that he had a mind and taste of his own (fig. 1.1). In any case, the emperor had craftsmen fabricate several inkstones in antique shapes for "testing." To his delight, he found that they yielded better ink than the green Duan stone, and "even those famed stones from the old pits [of the Duan quarries in Zhaoqing, Guangdong] have nothing over them." Kangxi had the new inkstones boxed in brocaded cases for display on his desk so that he could enjoy "intimacy with literature and ink everyday."[5]

The account conveys Kangxi's observant eyes, inquisitive mind, and predilection for experimentation. He also made no bones about the political utility of Songhua inkstones. In concluding his essay, Kangxi drew an analogy between the obscure stone, scattered in remote hillsides awaiting discovery, and the "concealed and dejected scholars" who "must be hiding in forested mountains or marshes in the realm. Repeatedly I have issued edicts to recruit them, enlisting their service from all directions, with the intention that no talent will be left unappreciated in the fields."[6]

Written on the heels of the elimination of the last substantive threat to Qing legitimacy and security, Kangxi's reiteration of his daily intimacy with "literature and ink" and appeal to hidden talent in the marshes bear an unmistakable air of a victor's ges-

ture of reconciliation. The transformation of knife and arrow sharpeners into grinding stones for ink epitomizes the shift in manner and style from military to civil rule. About a decade later, during Kangxi's third pageantry to his ancestral homeland in 1698, he identified more stones suitable for inkstones while hunting and foraging, including a green stone from Mount Ula in present-day Jilin. He may have also arranged for more systematic exploitation of the quarries. A new material culture of the Qing court, with dedicated operations in sourcing and making, was born.

Not long after, in the early 1700s, Kangxi began to bestow gift inkstones made of Songhua stones to Chinese scholars in his inner circle. In his New Year audience of 1703, for example, he gave one Songhua inkstone to each of the sixty Hanlin academicians assembled in his Southern Study in the inner palace. The appointment of two supervisors overseeing inkstone making and the relocation of the Inkstone Works to the Hall of Mental Cultivation in 1705 were likely measures instituted to meet the new and growing demand for gift inkstones.[7] Along with books and calligraphy in the imperial hand, gifts of inkstones sent an unmistakable message to their recipients, Chinese scholars all: I am one of you. Although motivated by political savvy, Kangxi's respect for Han literati culture was by all accounts heartfelt. This respect, however, should not detract from the fact that in its management and attitude toward material processes, the Qing empire represents a significant departure from its predecessor in principle and in practice.

A NEW TECHNOCRATIC CULTURE

The imperial workshop system is emblematic of a new Qing ruling style that can only be called materialist. The palace workshop was but the tip of an iceberg, a conglomerate of manufactories that also included the giant porcelain works in Jingdezhen and silk manufactories in the heartland cities of Nanjing, Suzhou, and Hangzhou, comprising the largest textile enterprise in the empire. The "material empire," of which the workshop system was a part, operated under the auspices of the Imperial Household Department (Neiwufu; literally, Bureau of Inner Affairs), a vast politico-cum-economic institution. Tasked with managing the finances and economic resources of the royal house, it was the emperor's "personal bureaucracy," staffed by his bondservant managers and assisted by a hierarchy of eunuchs, one that was parallel in organization and function to the formal bureaucracy staffed by Confucian scholar-officials.[8] Yet the nominal distinction between private and public is deceptive. The salt monopoly and the customs bureau, two of the department's most lucrative operations, are veritable public state functions in today's world as in the Chinese imperial tradition.

The scale and variety of the commercial activities conducted by the department are staggering, ranging from managing the imperial land estates and extending loans to salt merchants, to operating pawn shops and trading in jade, silk, copper, ginseng, fur,

Korean paper, and other commodities. Backed by imperial power, it enjoyed an unnatural advantage over the big merchant houses with which it competed for market share and profit. The modest name of Imperial Household Department belies the fact that it was a tariff authority, manufactory, trading house, real estate developer, commercial bank, and investment fund rolled into one, with cash assets reaching ten million ounces of silver in the early Qianlong years and an annual profit of 600,000 to 800,000 ounces of silver.[9] Magnifying its power, and further blurring the demarcation between the public and the private, the emperor often transferred bondservants from the department to posts in the regular bureaucracy. At the end of its formative era with the passing of Emperor Yongzheng in 1735, the rank of its managers reached the sizable number of 1,285.[10]

The corps of bondservant managers who operated such a vast manufacturing and commercial enterprise boosted a broad spectrum of managerial and technical skills. Characterized by a pragmatic problem-solving disposition, they constituted a new "technocratic" ruling elite who wielded the power of *techne* with a visibility in court and society that had no parallel in the previous dynasties. Leaders of a "logistical and epistemic culture of working" in which the efficacy of work surpassed the authority of words, they perpetuated what Chandra Mukerji has called "logistical power" and elevated it to parity with text-based scholarship in the Confucian hermeneutic tradition.[11] Although far fewer in number than the scholars, their institutional advantage allowed the bondservants to have a disproportional impact on society.

Both the recruitment and training of the bondservants as well as the organizational culture of the department were products of the historical experience of the Manchus, especially its innovative system of military-cum-civil organization called the Eight Banners. The Manchus, an ethnic minority group on the northeastern border of the Ming empire, rose to prominence in the late sixteenth century. As the loose federation of Manchu clans expanded by subduing its neighboring peoples from the 1580s through the 1620s, the subjugated were pressed into military service and organized into parallel banners after the Manchu prototype: one eight-banner set of Mongols and another of Han Chinese (called Hanjun, or Chinese-martial). All twenty-four banners achieved the hereditary status of privilege after the conquest of the Ming in 1644 and 1645.

Within each banner group there were three categories of people: the rank-and-file, bondservants, and household slaves.[12] The bondservants (*booi* in Manchu, meaning "of the house") were slaves or servants of various ethnicities, mostly captured in battle. Grouped within each banner in units called "arrows" (*niru*), bondservants performed such menial tasks as fishing, gathering honey, and farming their lord's estate, as well as serving as bodyguards at home and field assistants in battle.[13] After the conquest, their descendants who belonged to the emperor's house, or *booi* from the Three Superior Banners, became the mainstay of the Imperial Household Department. In structure, responsibilities, and personnel, the department can be said to be an extension of the earlier *booi* organizations.[14]

The nature of servitude of the imperial bondservants is particular and contained, almost paradoxical: personal slaves in perpetuity to the emperor, they were highly privileged in fact, albeit not in name. Special schools in the capital were established after the conquest to train them in the civil and military arts as well as a range of specialized skills.[15] The best graduates received appointments as clerk (*bitieshi*) and worked their way up the department hierarchy, or took the civil service exam and became high-ranking officials in the regular bureaucracy. Bondservants could own property, titles, and their own slaves.[16] In the eyes of the rest of society, the imperial bondservants constituted an elite corps with privileged access to the ultimate center of power. They were the only group in the empire who enjoyed access to the powers of both the emperor's personal bureaucracy *and* those of the formal bureaucracy, where quotas were reserved for them.[17]

Their generations-long servitude to and intimacy with their lords rendered the bondservants singularly trustworthy in the emperor's eyes, especially in handling such sensitive matters as money, manufacturing, or the European scientific experts in court.[18] The geographical concentration of the *booi*—the majority settled in Beijing, Shenyang, Chengde, and the imperial estates in Manchuria after conquest—as well as their hereditary status also fostered a close-knit camaraderie with a sustained culture of shared practical knowledge. In all of these aspects the bondservant could not have been more different from the Chinese scholars.

THE MIND OF THE POTTER: TANG YING AND SHEN TINGZHENG

Tang Ying (1682–1756), the supervisor of the Imperial Porcelain Manufactory from 1737 through 1756, articulated a new artisanal identity in his works and writings (fig. 1.2). A bondservant from the Plain White Hanjun banner from Shenyang, he entered the service of the department at age sixteen. His tasks in the Imperial Workshops included drafting porcelain design models as well as making and testing cannons. Without prior experience in firing porcelain, in 1728 he became the assistant of the supervisor Nian Xiyao, which paved the way for his subsequent promotion to the important post. Tang was also a prolific poet, painter, and playwright who incorporated eclectic vernacular colloquialisms in his writings.[19]

Despite his career as what scholars have agreed to be the most important technical innovator and manager of the Qing porcelain works, Tang Ying's self-identity is that of a craftsman—a potter to be exact—and not a scholar-official or bureaucrat. In explaining his choice of the title for one of his books, *Words from a Potter's Mind* (Taoren xinyu), Tang wrote:

> Every person is endowed with a mind [*xin*], and every mind is capable of
> words [*yu*]. . . . The potter lives in a potter's world; his life is punctuated
> with the potter's annual and daily rhythms; the human feelings of parting

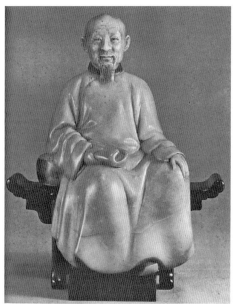

FIG. 1.2. Statue of bondservant Tang Ying (1682–1756), soapstone, 1750. Tang, a technocrat and innovator who rose to become the supervisor of the Imperial Porcelain Manufactory in Jingdezhen, Jiangxi, identified not with the scholars but with the craftsmen. Instead of commissioning portraits of himself painted on paper or silk as was customary for scholars, he had them fashioned by artisans in stone. This statue bears the mark of stone carver Wang Muzhai on the back of the ceramic armrest in the shape of a round seal. From Wang Shixiang, "Qingdai Wang Muzhai shidiao," *Meishujia* 22 (1981): 57–58; cf. Tang Ying, *Tang Ying quanji*, 653–54.

and union, of sadness and joy, also suffuse the potter's field of vision and emotions. [As for me,] even as I'm taking a sip or a bite, getting dressed or a rest, looking down or looking up, hiking the mountain or hobnobbing with friends, there is nothing that I do that does not come from a potter's mind. That is to say, there is nothing I express in words that does not come from a potter's mind."[20]

In arguing for the richness of the craftsman's interiority as well as the validity of his emotions and ways of being in the world, Tang Ying deliberately overturned the age-old hierarchy as stated in *Mencius* between those who labor with their brains and those who labor with their brawn. Refusing to be bound by this binary, which for Tang constricted the Confucian scholar, the technocrat claims both mind and hand as his métier, with the ambition of dominion over intellectual *and* material processes. This subtle shift in priorities, a direct result of the reorientation of the Manchu leaders, reverberated in the worlds of the early Qing craftsmen and scholars alike.

Even bannermen not directly in charge of imperial manufactories left their marks on the common culture in their valuation of artisans. A minor incident in the life of an official by the name of Shen Tingzheng illustrates how old patronage networks could facilitate new itineraries of knowledge. Shen hailed from a Bordered White Hanjun–banner family with traditional service to a princely house. When their lord ascended the throne as Emperor Yongzheng in 1722, Shen began his meteoric rise in the regular bureaucracy as one of Yongzheng's trusted lieutenants. Appointed provincial adminis-

tration commissioner (rank 2b), the former clerk was dispatched to Fujian to investigate a granary corruption case in 1726 and 1727.[21]

During his tenure in Fujian that lasted over a year, Shen kept company with a local Fuzhou artisan-scholar, Xie Shiji, who was an expert carver of seals and inkstones. Shen—who claimed that "I have 'read' many scholars in my life, / But no one is as extraordinary [qi] as you [ru]"—had taken a liking to Xie, to the point of bestowing him with the name Ruqi (Extraordinary-You). Henceforth Xie signed his works with his new name. Shen spelled out his admiration for Xie in a long poem that reads in part:

> At first glance he seems nothing special,
> But my delight overflows as our friendship deepens.
> In poetry he models after Du Fu,
> In calligraphy he comes close to [the master of cursive script] Huai Su.
> As deep as they are wide, his talents are hard to fathom,
> This person is beautiful beyond measure.
> All his talents and materials are well-suited to their use,
> In every task undertaken he excels over others.
> His hands are especially skilled in carving jade [stones],
> Indeed his skills approach the divine!

Shen began his tribute by identifying Xie (whom he called Xiezi, student Xie) as a scholar with the obligatory praise of his poetry and calligraphy, but ended by portraying him as a consummate craftsman who is true to both his talents and his materials.[22]

In valuing the skills of the craftsman to the point of seeing it as the true measure of a man, Shen Tingzheng reveals a subtle but seismic shift effected by the ascendance of bannerman technocrats like himself and Tang Ying. Although conversant with the Confucian classics—he used allusions from the *Book of Changes* and *Book of Songs*—Shen's vision of a worthy man (himself included) bears the face more of an artisan than a Confucian gentleman.

Turning to himself in the second half of his poem, Shen Tingzheng admitted that "I have no other hobby but this, / An addiction to inkstones, without regret." Xie Ruqi made at least one inkstone for his patron and wrote a poem in response to Shen's, using the same rhymes but in a more practiced hand.[23] The awkward phrasing and unstudied bantering of Shen's poem, qualities also evident in Tang Ying's prose and verse, highlights the alterity if not a hint of untroubled inferiority of the Hanjun bannerman in the face of Chinese literati culture, embodied in the inkstone. Although Shen was no stranger to the inkstone before arriving in Fuzhou, it is likely that he made the transition from being a clerk to a connoisseur only upon meeting Xie, who taught him the arcane knowledge of deciphering stones.[24] I point out Shen's pedagogy and his idiosyncrasies in phrasing and diction not to disparage him, but to highlight the presence in

early Qing society of a new bannerman elite to whom Han literati culture is not second nature and whose ethos is that of moving, doing, and making.

As they set about greasing the wheels of commerce and profiteering on behalf of the imperial family while furthering their own careers, the bondservant and bannerman technocrats brought subtle but perceptible shifts to Han literati culture through their everyday interactions with Chinese artisans and scholars. In formal and informal capacities, they facilitated the circulation of people and cultures of making in the Qing material empire.

LIU YUAN, MASTER DESIGNER IN THE KANGXI COURT

The itineraries of artifacts and skills also took the form of one-way traffic from society to the court, as the sui generis career of Hanjun bannerman Liu Yuan attests (fig. 1.3). A maverick product designer and master craftsman in the mid-Kangxi court in the 1680s, when the imperial workshop system was in its loosely structured and underdocumented infancy, Liu's career deserves scrutiny. Not only did he reveal the logic of the material empire and the centrality of inkstone-making in it, he was also the key figure in the devel-

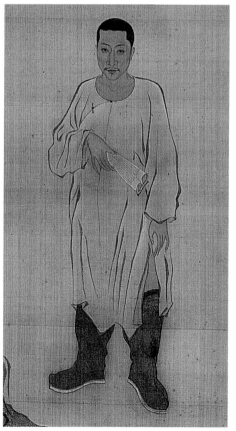

opment of an evolving and eclectic "Qing imperial style" that embodies the materialist mandate of the Qing, the personal taste of the emperor, and the skills of the craftsmen in his service.

Liu Yuan (ca. 1641–before 1691), a Hanjun bannerman from the Bordered Red banner domiciled in Xiangfu, Henan, defied conventional career paths and labels. Orphaned when young, he attended a local school but left to drift around the land, seeking a patron and purpose in life. His fate was sealed when in 1662 he settled in Suzhou, where for six years he pursued his interest in painting while serving as a retainer in the house of Tong Pengnian, a member of the powerful Hanjun bannerman Tong family

FIG. 1.3. Zhang Yuan (fl. seventeenth century), *Portrait of Liu Yuan*, 1655, detail, ink and color on silk, 128.9 × 33.9 cm. Zhejiang Museum, Hangzhou.

and who at the time occupied the post of provincial administration commissioner of Jiangsu (rank 2b). In 1699, Tong financed the printing of an illustrated book, *Pavilion of Smoke-like Clouds*, which includes annotated portraits of twenty-four chancellors of the Tang that Liu designed and drew with the intent of sending to the throne as material proof of his talents. Liu's self-promotion as one of the chancellors and his flattery of Kangxi as the sagacious ruler who employed them apparently worked, and Liu became a National University student in Beijing in the following year.[25] He received a bureaucratic appointment by 1677, as a secretary in the Ministry of Punishment (rank 6b), and was dispatched to the customs office at Wuhu, Jiangxi. When Liu was impeached from his lucrative post on corruption charges two years later, Kangxi recalled him to the inner palace where his real career began.[26] It was in personal service to Kangxi that Liu Yuan became instrumental to the forging of an early Qing imperial style as the designer of porcelain, official seals of the empress dowager and imperial consorts, as well as inkcakes, lacquer, and wooden utensils for royal use.

Although Liu Yuan can be said to have been an aspirant scholar, painter, and bureaucrat in his early career, he does not fit the conventional expectations associated with these roles. His patron Tong berated his willful mixing of disparate regional painting styles as "inconsistent" and "lacking in unified forms."[27] Tong is most perceptive in his remark, for creative eclecticism lies at the heart of Liu Yuan's artistry. His close friend and surrogate brother, fellow Hanjun bannerman and Xiangfu native Liu Tingji (1653– still alive 1715), described Yuan's calligraphic hand, a pastiche from various schools, as "odd and foreboding" and related that Yuan cared little about poetry, the requisite undertaking of Chinese scholars.[28]

Neither did Liu Yuan conform to the labels "craftsman" or "artisan" comfortably, since his livelihood depended on vassalage instead of running a workshop, and he did not make with his own hands many of the objects he conjured and conveyed in drawings or with wax models. These models, which ensured standardization, correct execution of imperial will, and transmission through time, were necessary only in the unique setting of the imperial workshop system.[29] There is no word in the early-Qing parlance for Liu Yuan's historic significance, but he can best be described as an expert in *disegno* in the Renaissance sense of the word, one who conceptualizes classes of objects across mediums by bringing formal properties in-line with their functions and materials.

It is tempting to view Liu Tingji's biographical sketch of Liu Yuan as analogous to Manetti's *Vita* of Brunelleschi, the seminal architect of the Renaissance. In his composition, Tingji brought into narrative form Liu Yuan's vita, thus imparting order to his disparate achievements as a designer and making them legible. He began with the nature of Yuan's mind, which is "keen, perceptive, delicate, and dexterous" (*cong hui qian qiao*). It is difficult to convey the feminine connotations of these words in English. The first three adjectives have traditionally been used only to describe gentry ladies and the last, females and craftsmen. In his inborn sensitivities Yuan was "entirely different from

others." After obligatory mentions of Yuan's calligraphy, painting, and poetry, Tingji used the term "dexterous" again, this time to refer to the things that he made, including ink-cakes and objects engraved with minuscule words. Lest any reader mistake Yuan for a mere craftsman, Tingji followed immediately with Yuan's discernment as a connoisseur, where his abilities in both making and authenticating objects are "surpassed by none." Later, he added that Yuan had amassed a collection of curios, all one-of-a-kind objects that no one has seen elsewhere.[30] A man with the delicate mind of a woman and the skilled hands of a craftsman; a man who was at once maker, collector, and arbiter of things, Liu Yuan embodied the multiple possibilities in subjectivities and attributes in the early Qing world. His unusual faculty with objects and ability to develop a distinct style (of *disegno*) from disparate elements were talents particularly suited to the technical-cum-political agenda of the Kangxi emperor.

In reality, when Liu Yuan was still serving in the Wuhu customs house his contribution as a court designer had already begun, as evidenced by an exquisite body of ink-cakes he designed for his master. On the occasion of the emperor's birthday in the third lunar month, 1678, he submitted one set as tribute, another set as Duanyang tribute in the fifth month of the following year, and a third offering in the sixth month. Although the exact number in each tribute offering is not known, the ink-cakes were meant to be ground up, hence submitted in identical multiples. But evidently they soon became too precious to use. Signifying the formal passage of Liu Yuan's ink from consumable to collectible, Qianlong had the stash he found in the Imperial Household Department warehouse boxed in sets of fourteen designs in 1738 and ordered duplicates made of some of the designs in 1770.[31]

Among them, the *Pine Moon* ink-cake (fig. 1.4) encapsulates the extent to which the sentimental exchange between master and servant was conducted by way of the material culture of writing as well as transactions between material and words. Although the details are murky, sometime prior to 1678, Liu Yuan had served Kangxi in the inner palace for a period of time, possibly as a maker of ink for private use and as a painter.[32] To convey his appreciation, the young emperor bestowed upon Liu four calligraphic words, "Pine wind water moon," which evoke a lyrical scene of a recluse listening to the wind whistling through pine trees and gazing at the reflection of the moon on water. In a gesture of extravagant gratitude (and vainglory), Liu Yuan built a pavilion to house the imperial calligraphy while serving at the customs house in Jiangxi.

This very building, or an idealized image thereof, appears on Liu's tribute ink-cake bearing the four imperial words. The shape of the ink-cake is as original as it is political: a circle on top of a square, evoking the traditional cosmological vision of a dome-shaped heaven on top of a flat, square earth. The placement of design motifs makes it clear that the emperor occupies the heavenly sphere and his subject, the earthy realm below. On one side, a pair of slender dragons nestling the words "Imperial fragrance" (or calligraphy) fills the circle; below, Liu's encomium narrating his gratitude, in over

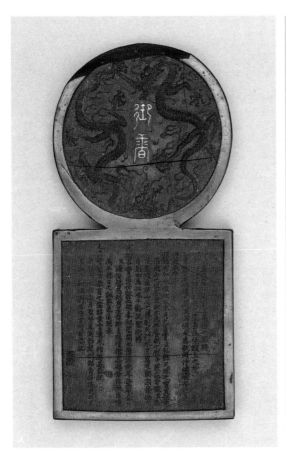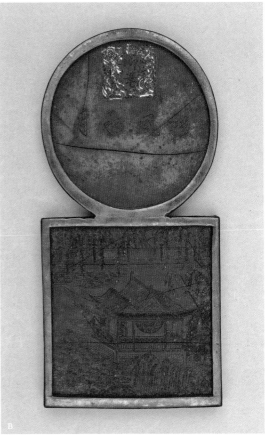

FIG. 1.4. Liu Yuan, *Pine Moon* ink-cake (renamed *Jingting* in the Qianlong era), one in the set *Imperial Fragrance*. (A) In the top disk: molded twin dragons surrounding a gilded inscription in seal script, reading "Imperial fragrance" (Yuxiang, or Yushu, Imperial calligraphy). In the bottom square: tribute by Liu Yuan dated third month, 1678. (B) In the top disk: gilded twin dragons surrounding a molded inscription in running script, reading "Imperial brush" (Yubi); a horizontal line below from right: "Pine wind water moon" (Songfeng shuiyue) in running script, originally from the hands of Kangxi. In the bottom square: a picture of a pavilion on water, presumably the one built by Liu to house his imperial gift. Palace Museum, Beijing.

200 minuscule characters, is fitted in the square. On the other side, a small pair of gilded dragons surmounts the words "Pine wind water moon" in the circle on top; a picture of a pavilion built in a lotus pond appear in fine relief in the square below. The picture illustrates the encomium on its verso side and encourages the viewer to flip the ink-cake front to back. Words and picture achieve material unity with the viewer's active participation. Circularity finds expression in another way as the emperor's words make a return trip, now inscribed not on paper but on ink-cakes wrought of pine soot and glue, ready to be ground down to produce more imperial words.

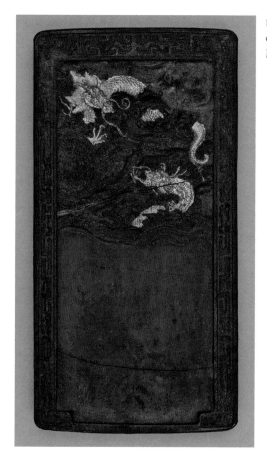

FIG. 1.5. Liu Yuan, *Song Inkstone* ink-cake, one in the set *Imperial Fragrance*. Palace Museum, Beijing.

Besides this contemporary reference, explicit or implicit references to Chinese antiquities abound in Liu Yuan's set of tribute ink-cakes: the twelve seals of Yao; jade disks; bronze mirror; Tang *qin*-zither; Song inkstone.[33] Similar to Liu's reference to the Tang loyal officials in his illustrated book, they conjure the past to lend legitimacy to the Qing. Liu's Tang chancellors did not at all look like those in antique paintings, nor did his *Song Inkstone* (fig. 1.5) resemble the ones favored by literati writers from the historical period. Innovation under the cloak of the old is the crux of Kangxi's political message, and in the hands of his perceptive servant Liu Yuan it became an underlying principle of early Qing imperial design.

LIU YUAN'S INTERMEDIAL DRAGONS

Liu Yuan is best known as a seminal designer for the newly reorganized Imperial Porcelain Manufactory, having supplied "models that number several hundreds" in the 1680s. Although these models are not signed, scholars have identified several dragon

vases as likely to be made from his design on the basis of comparison with his known corpus of drawings and paintings.[34]

The dragon in the art and material culture of the Kangxi court is a form-shifting creature, a protean symbol of imperial power inherited from the Chinese imperial tradition that had yet to be stiffened into the formulaic visage on Qianlong ware. In this dynamic atmosphere, Liu Yuan experimented with the dragon form in multiple mediums besides porcelain, including seal, ink-cake, and inkstone. In a formal capacity, he was ordered to design seals for the empress dowager (with a dragon finial) and imperial consorts (without). Although the exact seals cannot be identified, his friend Liu Tingji saw with his own eyes the wax models he made and submitted to the Ministry of Rites.[35]

A less official but no less significant project is the *Luminous Dragons* inkstone (fig. 1.6) Liu made out of old stock Duan stone, deep purple in color. Signed in a minuscule hand "Made respectfully in the fifth month, 1679 [by Your] insignificant servant Liu Yuan" and marked with a seal "Yuan" on the left side of the stone, it was his personal tribute to Kangxi.[36] Conversant with inkstone-making techniques in the southern workshops, he positioned the natural mineral markings on the stone prized by Chinese collectors ("scorched patch" and "rouge halo" in this case) at the center of the ink pool. Conventions aside, in its exquisite conceptual craft—the integration of design and workmanship—this inkstone was a virtuoso achievement unmatched in its time.

A dragon and the swirling clouds it sets into motion occupy the upper half of the front. Its head, dominated by a muscular anthropomorphic face with a strong square jaw, turns toward the right in three-quarters profile. In the opposite direction, the dragon's soft-edged horns arc backward as they hover over its flying mane, chiseled strand by strand as if combed by iron-wire. In his treatment of the head alone, Liu conveyed a dynamic tension that suffuses every corner of the inkstone. Even more remarkable is the articulation of planes. Although the stone is hefty with a thickness of six centimeters, Liu refrained from carving deeply into the surface. He manufactured the illusion of depth by meticulous manipulation of layers—by rhythmic alternations between building up and cutting down—and by deft use of soft, round profiles of uneven depths. The exaggerated S-shape of the dragon's body, for example, is rendered as almost a half-circle in cross-section arising from a depressed trough; its glistening scales are articulated in overlapping rolls that slither with each twist of the dragon's tail. There are no straight lines nor sharp edges on the inkstone, nor is there a flat surface except for the ink pool area (which is in fact slightly concave).

Instead of the appearance of a dragon being carved onto the surface of a stone, the overall effect is one of a dragon materializing from the core of the stone: a veritable three-dimensional materialization of *longde*, the virtuous power of the dragon, whose work is to transform the world by initiating action. Indeed, there is so much action and movement on the surface of the stone that it defeated the efforts of the artisans in Qianlong's court to render its likeness in *Catalogue of Inkstones from the Chamber of*

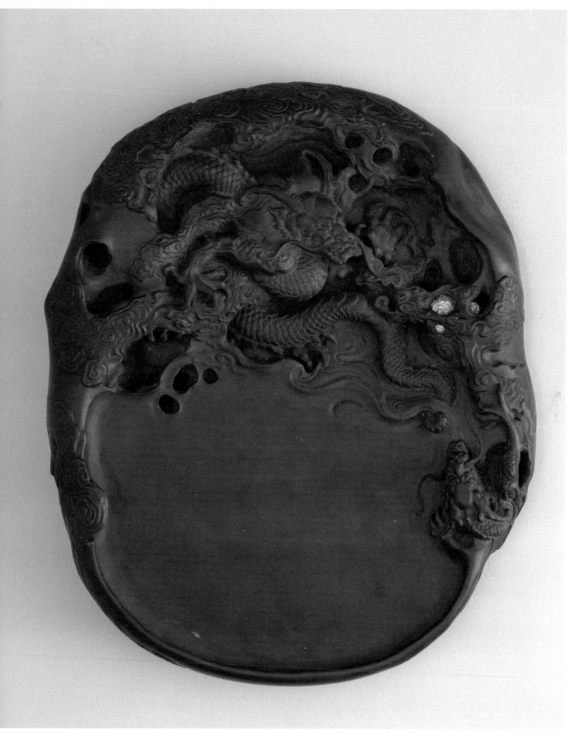

FIG. 1.6. Liu Yuan, *Luminous Dragons* inkstone, 1679. L 21.8 cm, W 18.2 cm, H 6 cm. Palace Museum, Beijing.

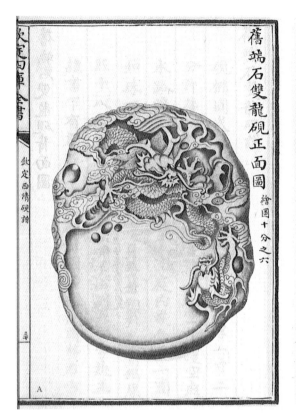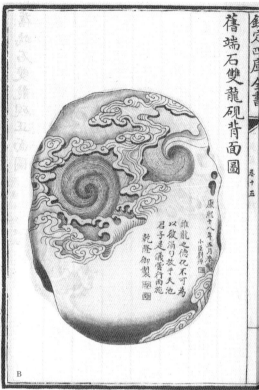

FIG. 1.7. Drawing of *Paired Dragons* inkstone (the new name of *Luminous Dragons*) in old Duan stone, (A) front; (B) back. From Yu Minzhong et al., *Xiqing yanpu*, 15.30a.

Western Purity, the imperial collection catalogue (fig 1.7). In spite of, or perhaps because of, their predilection to veristic precision—witness the ten-to-six scale and the chiaroscuro shading on the inner edge of the ink pool—the artisans failed dismally to capture the visage of the dragon, let alone its spirit.[37]

The dynamic action program designed by Liu Yuan is not immediately apparent to the eye. When this massive inkstone was first taken out of the box for my viewing in the Palace Museum, I only saw a confusing profusion of details, all in monochrome deep purple. It took prolonged examination, in cessation of the surrounding world, before the logic and fineness of Liu's craft revealed themselves. Meanwhile, at first encounter I was consumed by two incongruities, the first being the absence of a water pool (for temporary storage of water or ink) that is usually situated on the upper one-third of the front surface of an inkstone. As my mind's eye traced the direction of the swirling clouds and my fingers followed the channels on the stone's surface, it dawned on me that the inkstone is a simple hydraulic device: the water pool is the entire crevice underneath the dragon's head and body; upon grinding, the ink is directed into the pool

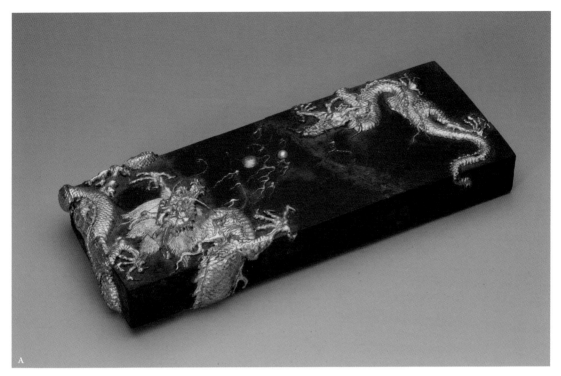

FIG. 1.8. Liu Yuan, *Virtuous Power of Dragon* ink-cake, one in the set *Imperial Fragrance*. (A) Front: the head and claws of a gilded dragon occupy the upper half of the ink-cake; its sinuous body "climbs over" to the side and back. A smaller gilded dragon frolics in the lower half; in between the two are a representation of a half pearl (gilded) and an actual pearl encrusted in the ink-cake. (B) Back: gilded inscription "Virtuous power of dragon" (Longde) in modified clerical script; gilded seal "Collection of the Celestial Storehouse in perpetuity" (Tianfu yongcang). Palace Museum, Beijing.

by way of sluices and channels, one example of which is the channel that bisects the tip of the dragon's tail; the three holes connected by narrow bridges at the upper left corner of the ink pool are the main conduits through which liquid ink sips into the crevice.[38] As black ink slowly fills the water pool, the body and head of the dragon must have appeared to be leaping out of the glistening surface.

The second incongruity that puzzled me concerns the three textured gold dots to the right of the dragon's tail and on which its eyeballs are trained. Upon envisioning the glistening ink flowing underneath it, I came to realize that they represent one golden pearl partially obscured by clouds. But why gilding? No inkstone surface had ever been gilded. I only came to a fuller appreciation of Liu Yuan's originality later when researching his ink-cakes, which are replete with gilded dragons in singleton and pairs. Gilding was an age-old *ink*-making technique! Around the same time of his designing an ink-cake that looks like an inkstone (the *Song Inkstone*), he made the

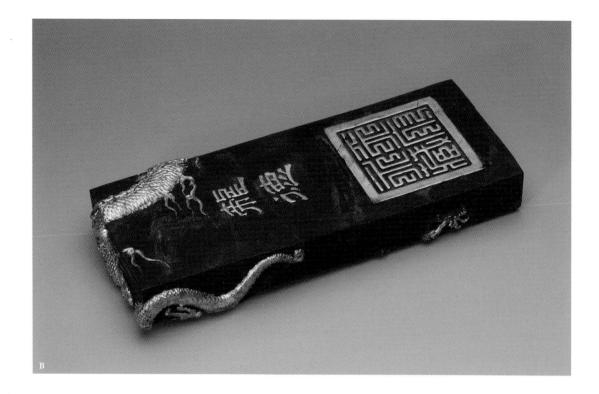

B

Luminous Dragons inkstone unique by applying an ink-cake technique to a crucial detail on its surface. This cross-medium referentiality may seem trivial, if not a tad too clever, but it is symptomatic of a key feature of the knowledge culture in the Qing Imperial Workshops: intermedial experimentation in techniques of making and decorating objects.

Two further details of Liu Yuan's remarkable conceptual craft are of interest here. The first concerns the smaller dragon hanging precariously on the lower edge of the right side of the stone, eyes also trained on the golden pearl (the line drawing is inaccurate in making it appear in fuller view and more secure than it is). Its body, supported by the outstretched claws of its right foot, hangs over the edge of the stone. The same treatment is even more prominent on the upper edge, where the patterns and textures of the clouds are carried around in a continuous plane to the back of the stone, where they cascade downward to meet two circular swirls of waves. In an ink-cake presented to Kangxi, the *Virtuous Power of Dragon* (Longde), Liu Yuan made this three-dimensional effect even more dramatic as he draped the entire body of a gilded dragon onto the back and side of a block of rectangular ink-cake (fig. 1.8). This "climbing-over" treatment of transitional planes, borrowed from antique jades, is a hallmark of innovations in material design in the early Qing that is especially visible in porcelain bowls and inkstones.

A second noteworthy feature of Liu Yuan's design language is the dynamic integration between the inkstone and its box. Never published with full views of all its surfaces, the box of the *Luminous Dragons* inkstone is as meticulously conceived as its content. Made of dark *zitan* wood, on the inside of the lid is a large round bead that revolves in its socket when touched. Apparently, the bead is carved using a similar perforation technique—so intricate that some observers named it "demonic craft"—used by Guangdong and Jiangnan carvers to fashion ivory balls in nested revolving layers.[39] But even more than this display of intermedial craft, the significance of the bead lies in its resonance with the gilded pearl on the inkstone. It was customary for artisans outside the court to custom-make boxes that conform to the shape of the finished inkstones using a variety of materials, usually hard and soft woods. But such deliberate effort to ornament the box according to the design program of the inkstone is rare. This attentiveness to the design and craftsmanship of the box emerged as a distinguishing feature of the court-produced inkstones in the later Kangxi and Yongzheng reigns.

Nurtured in Suzhou and other parts of the land where he was able to study collections of paintings and curios in private hands as well as to mingle with some of the most skilled Chinese artisans in the empire, Liu Yuan's delicate and innovative conceptual craft found expression in myriad material forms in the Kangxi court during the formative period of the Imperial Workshop system. The unsigned designs he made for imperial vessels survived him, but his friend Tingji lamented that the users no longer knew from whose mind and hand they come.[40] Be that as it may, Liu Yuan proved himself to be a key bridge-builder who creatively adopted aspects of Ming imperial and Chinese literati tastes to a new Qing mandate as well as being a mediator between the craft practiced by artisans in the south and in court. The magnificence of his dragons, materializing on porcelain vases, seals, ink-cakes, and an inkstone, attests to the extent to which political persuasion inheres in the power of finely wrought things.

IN THE "STYLE OF THE INNER COURT"

The first forty years of the Imperial Workshop system is shrouded in mystery because routine archiving procedures only came to be established in 1723. In the absence of written records, scholars have reconstructed a rudimentary picture from material evidence, but their attention is trained primarily on the porcelain manufactory in Jiangxi. Liu Yuan's intermedial practices and eclectic inventions inside the palace confirm that the same working principles also obtained: movement and experimentation. Movement refers to the creative mixing of craft traditions, especially by recruiting artisans from the south and Jesuits from Europe. Experimentation, in turn, involves inventing novel vessel shapes or transferring techniques developed on one material onto another.

From the start, the objective of the workshops is not only to provision the court but also the forging of a material culture new in form as in substance.

As the workshop system acquired more formal structures and as its operation became routinized, there ceased to be a space for such individual mavericks as Liu. His creative genius became "distributed" in the bodies of myriad artisans trained in the court or recruited from outside workshops. In the new system, the palace workshop became the key agency or motive force in the material empire, as the incubator of new material processes and forms. Some of the projects are veritable decades-long scientific experiments, as in Kangxi's and Yongzheng's sustained efforts in manufacturing painted enamel on porcelain, metal, and glass bodies.[41] Others, like inkstone-making, might seem mundane, yet by the very reason of their less strenuous technical demands there was more leeway for artistic innovation and the fashioning of imperial taste from new materials, colors, and forms. What art historians call "court taste" in the early Qing was a mobile complex that involved not only the personal preferences of the reigning emperor but also the collaboration of his bondservant workshop supervisors as well as the individual artisans who made, copied, and executed the designs.[42]

Being harder and denser than the Duan stone traditionally favored by Chinese writers and painters, Songhua stone (a generic name that includes varieties known as green "Duan," purple "Duan," Ula, and others) allowed for the making of inkstones of different shapes, tactility, and visual appeal. As a measure of how rapidly court tastes changed, the intermedial experiment of Liu Yuan conducted in the 1670s and 1680s using purple Duan stones, as innovative and refined as the results might be, was not to be repeated by the 1700s, becoming a specimen of the road not taken. The irregular outline and rounded edges of the freeform oval stone of Liu's *Luminous Dragons* inkstone as well as the visual vocabulary of a monochrome dark purple stone encased in a dark *zitan* wood box, apparently so fashionable and elegant a few decades earlier, seem irreducibly Chinese and dated in the face of the new Songhua creations.

A green Songhua inkstone that Kangxi gifted to his fourth son, Prince Yinzhen (later Emperor Yongzheng), bears witness to this transition (fig. 1.9). The unsigned stone features a design of father and son dragons frolicking, with a pearl identical in conception if not in exact positioning as the Duan *Luminous Dragons* signed by Liu Yuan (fig. 1.6). The unusual treatment of the Songhua pearl, coated with a red pigment, is so reminiscent of the gilded Duan pearl that the Songhua stone was likely to have also been made by Liu or by someone with access to his Duan model. The transference of design and craft from the Duan to the harder Songhua stone, however, created an entirely different visual effect. Compared with that on the purple Duan, the father dragon on the green Songhua stone, although finely incised, appears stiffer; the son dragon, the swirling clouds and the side edges of the lower half of the Songhua stone, although rendered in rhythmic curves, are streamlined and less dynamic.

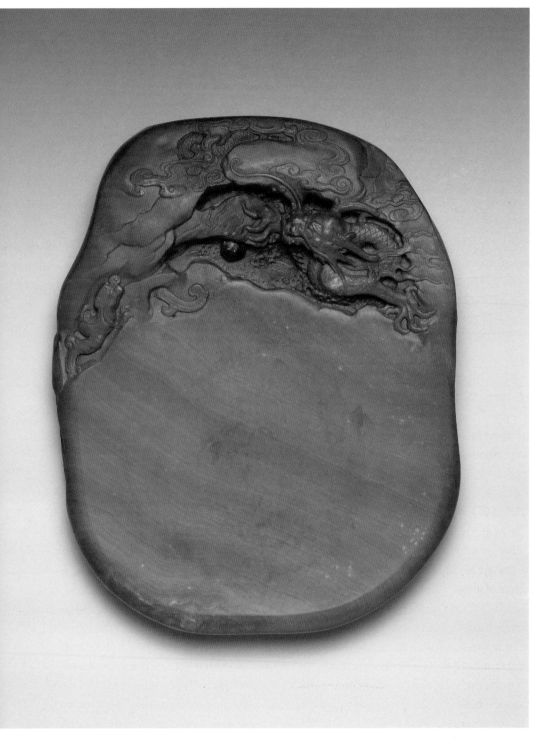

FIG. 1.9. *Dragon Teaching His Son* inkstone. L 17.9 cm, W 14.2 cm, H 3.9 cm. National Palace Museum, Taiwan.

FIG. 1.10. *Dragon and Phoenix* inkstone. L 14.7 cm, W 9.9 cm, H 1.6 cm. National Palace Museum, Taiwan.

Several other dragon or phoenix Songhua stones made in the Kangxi-era workshop represent the eventual abandonment of Duan sensitivities. In one exquisite example (fig. 1.10), the phoenix head on the upper-left corner of the ink-slab is so abstracted that only two eyes and a beak can be faintly made out. The body of the cascading feathers to its left is rendered as two parallel lines. Even more eye-catching is that the green ink-slab is presented in a purple Songhua-stone box integral to the design. Its lid features a purple dragon coiling on the scalloped rim—the mate of the phoenix inside—carved from the top layer of a stratified Songhua stone; the yellow underlayer stone brackets a plate of glass.

Thus the Songhua inkstone came into its own: slender, flat, and thin in profile, often showcasing light-colored green stones with bright green or purple veins or layers, they exuded a fresh, modern appeal even as artisans in the Kangxi workshop continued with the familiar decorative motifs of dragons and other auspicious symbols. Some one-off Songhua inkstones feature graceful organic forms—the gourd appears to be a favorite shape—but the majority are rectangular or oval with beveled edges turning at a ninety-degree angle.[43] The contrast attests to a bifurcated approach to inkstone-making in the Qing court: the streamlined silhouette of the geometric ink-slabs facilitates quantity production of near-identical gift items.

Even more striking are the boxes for both quality and quantity Songhua ink-slabs, now fabricated from such unconventional materials as cloisonné, maki-e lacquer, or perforated Songhua stone fitted with exotic materials including glass panels and fossils of fish.[44] In porcelain and painted enamel, the most significant innovations in technical and visual terms were made in the Yongzheng or even Qianlong reigns, but in inkstone-making a distinct Manchu court style had appeared as early as the last two decades of the Kangxi reign (1700s–1722). Using the newly discovered Songhua stones, creative combinations of materials and techniques never before associated with inkstone-making, not to mention coordinated designs integrating ink-slab and box, Kangxi and his artisans already achieved what his successor Yongzheng later articulated as "styles made respectfully in the inner court" (*neiting gongzao shiyang*).

YONGZHENG'S REVAMPING OF THE IMPERIAL WORKSHOPS

The operation of the imperial workshop system became rationalized under the watchful eyes of Emperor Yongzheng during his short but seminal reign (1723–1735). As soon as he ascended the throne, he formalized a chain of command over the flow of materials and information. By the mid-eighteenth century his efforts were codified into an operational sequence that involved six offices, each with its designated functions and record-keeping procedures. The emperor's orders regarding the types and quantity of things to be made in the workshops were first conveyed to the Project Management Office (Huoji Fang), which forwarded the orders to the specific works concerned. The Office of Auditing (Suandang Fang) estimated the size or volume of the articles and commuted the material and labor costs accordingly before the Warehouse (Qianliang Ku) would release the requisite materials and silver from its vault. The Office of Overseers (Ducui Fang) made sure that the work plan was followed without undue delays, whereas the Office of Accounting (Huizong Fang) reconciled the account books upon inspection of the completed order. At year's end, the books were sent to the Archive Office (Dang Fang) for storage.[45] A typical entry in the logbooks of the Project Management Office, which reads, "On xx day of xx month, His Imperial Majesty sent down orders for xx," makes it clear that the massive system of manufacturing, logistical supply, and record-keeping served the whims and needs of the emperor, and him only. The cross-checking and mutual surveillance ensured that both quality and quantity artifacts could be made in a cost-effective and time-efficient manner.

Yongzheng also expanded the management ranks of the workshop system as well as enhancing the recruitment and supervision of artisans in the individual works. Following the precedent set by Kangxi of entrusting the overall leadership to an imperial prince, he appointed his brothers, Prince Yi and Prince Zhuang, as grand ministers and supervisors-in-chief of the Imperial Workshops, reporting directly to himself.[46]

The princes headed a team whose office titles were borrowed from (and parallel to) the regular bureaucracy in some instances and invented ex novo in others. As workload increased, new positions were added in subsequent years. The structure initiated by Kangxi, rationalized by Yongzheng, and expanded by Qianlong was to remain operative until the end of the Qing. In official communiqués with the six ministries and the governor-generals in the formal bureaucracy, officers of the Imperial Workshops used terms of address that connoted the de facto parity in rank of these institutions.[47]

Besides the leadership team of trusted princes and bondservants, Yongzheng organized a parallel hierarchy of eunuchs whose jurisdiction and power were substantially reduced from their Ming heyday. As gleaned from the archives, the eunuchs appear most often as conveyers of the emperor's orders and artifacts from the warehouse. They also handled the recruitment of artisans from outside the palace. The custodians of technocratic knowledge thus shifted from the domineering eunuchs in the Ming court to trustworthy imperial princes, bondservants, and banner craftsmen in the Qing.

Each individual works was managed by a team of supervisor(s) (*baiitangga*; *zhishi*) and headmen (*bōsokuu*; *lingcui*, who were promoted from artisanal ranks and kept their hands in making things). The artisans, who numbered "several hundreds" in Yongzheng's reign, hailed from two main channels, each with distinct recruitment procedures and qualifications: (1) once every several years, scores of ("several tens") young members of the rank and file and bondservants from the Three Superior Banners entered the Imperial Workshops as apprentices or "trainees" (*xueshou xiaojiang*); when training was complete they became "craftsmen inside the house" (*jianei jiangyi*) or "house craftsmen" (*jiajiang*), also called "permanent salaried craftsmen" (*chiyin jiang*); (2) artisans recruited from private workshops throughout the empire, but especially from Jiangnan and Guangdong. Called "recruited craftsmen" (*zhaomu jiang*) or "craftsmen hired from the outside" (*waigu jiang*), they were meant to fill temporary needs, but some who had made themselves indispensable were also converted to "permanent salaried craftsmen." The recruited craftsmen were often brought into the palace with the explicit purpose of training those from "inside the house."[48]

By way of this innovative system, the most accomplished artisans in each trade in the empire became conduits of exchanges in craft skills between court and society. That the Imperial Workshops thus figured as the "agora" in a positive feedback loop of collective knowledge production in no small part accounts for the prospering of craft and manufacturing in court as in society in the early and high Qing.[49] Although the nomenclature of "inside" and "outside" makes it plain that the directives and initiatives came from the emperor above, the linchpin of the system was the cadre of craftsmen scattered in the empire, especially in the advanced regions of the south.

The overall success of the Qing in their technocratic rule belies the nagging day-to-day challenges in running the workshops. Soon after he arrived at the job, Prince

Yi issued a directive in the first month of 1723 urging the supervisors of the individual works to be vigilant in disciplining the craftsmen, who were found to be: "arriving late, leaving early, slothful, cunning cheats, fighting among themselves, making a loud racket, and violating rules of etiquette and propriety" in their workplace. The supervisors were themselves not beyond reproach; among their offenses was punishing their charge without authorization, "settling private scores under the pretense of public business" (YXD 1).

The problems subsided somewhat under the iron fist of Prince Yi, but several years later, in 1727 and 1729, Yongzheng was still complaining about the truancy of craftsmen, who were found to be sitting idle in the shops after their commissioned pieces were done instead of taking the initiative to furnish a supply of stock items (YXD 100, 157). Problems of theft continued as well, especially upon the death of Prince Yi in 1730. An outside ironsmith, for example, was caught making away with 8.36 kilos (14 catties) of iron in 1731 (YXD 204). But most serious was a clandestine system of unauthorized manufacturing that Yongzheng raged against in 1733, organized by none other than the head eunuch, who pressed or induced craftsmen to make knockoffs of imperial wares for sale in the market (YXD 247). Although detrimental to the interests of the emperor, such leakage further enhanced cross-fertilization in skills and tastes between court and society.

CRAFTSMEN AND EMPEROR, COPRODUCERS OF IMPERIAL STYLES

In spite of persistent disciplinary problems, Yongzheng applied himself to harnessing the artistic and material resources of his revamped workshop system to forge a new imperial style that bears his personal imprint. No object could be made and released into the world without his approval, often at every step of the design-make process. He punished workshop supervisors and scolded the craftsmen: inspecting a lot of 100 newly made glass snuff bottles, a stock gift item, he found forty-one that are "extremely vulgar; not good! What a waste of materials!" (YXD 122). He demanded repeated reworkings of models he deemed "vulgar" (*su; suqi*) or "dumb" (*chun*), with the hopes that they could be elevated to "elegant" (*xiuqi*), "delicate" (*jingxi*), "cultured" (*wenya*), and "even more *linglong* than this" (*zai linglong xie*).[50] Originally referring to the crisp clinking sound of jade, *linglong* connotes refined design and craftsmanship. After an outburst of Yongzheng's complaints, Prince Yi ordered his officers to locate and send up "models left of all the items that His Majesty has expressed a liking of, or all the previous models made for preapproval before work could begin." The supervisors of the Inkstone Works were made to go through a refresher course with their charge by studying every model the emperor had deemed worthy.[51]

Besides altering the general feel of an object, described in such ambiguous adjectives as "elegant" or *linglong*, Yongzheng also made specific interventions that required

knowledge of the raw materials and techniques of making. When Prince Yi showed him a boulder of natural cinnabar weighing 8.65 kilos (14.5 catties), Yongzheng ordered: "Take off the surface layer and try making some ink-cakes with it. Do not mix in synthetic mercuric sulfide; use only the natural ore." Emperors used cinnabar ink daily to mark memorials, but in this instance Yongzheng's technical proficiency exceeded that of a user perhaps because he had an interest in alchemy.[52] He was also a quick study. As he grew into his job, Yongzheng's orders became more specific as he came to recognize the technical limits of the palace workshops and the specific skills of individual artisans.[53]

Given Yongzheng's (in)famous attention to details and predilection for micromanagement, his interventions can seem excessive.[54] One extreme case concerns a project of making an improved replica of an amalgam statue of Guandi on horseback consecrated in a temple inside the Jingshan East Gate. Arguably it is not a typical example, for Guandi, a Chinese martial hero, was prominent in Qing court rituals. In the subsequent two months, through a succession of four wax models Yongzheng ordered alterations in Guandi's face, legs, mane of his horse, and the helmet of his attendant; the emperor's attention extended to such granular details as the degree of looseness of the hero's belt and the folds on his garments (YXD 268–69).

These back-and-forth exchanges between the emperor and his model-makers bring out their codependence in clear relief. Yongzheng often only had abstract qualities in mind at the beginning of a project; his preferences sharpened and found increasingly concrete form only upon seeing the model made by his artisans. He did not know what he liked until he saw what he did not like. Despite their absolute gulf in status and power, and for all of Yongzheng's knowledge and personal involvement, the emperor and his craftsmen were thus coproducers of his imperial style.

Knockoffs using pilfered materials and labor were detrimental not only to Yongzheng's economic interests but also his project of defining a distinct and exclusive imperial style. In 1725, when he saw samples of two intricate hatstands of ivory and brass submitted by Prince Yi, he cautioned that "they should only be made inside" and threatened punishment to those who might be tempted to leak the design to "people from the outside," as if in anticipation of the inevitable breach.[55] Yongzheng's rhetorical and artistic strategy of boundary-making was fraught with contradictions if not ultimately futile for the simple reason that by design his workshops thrived on a continuous mixing of artisans from "inside" and "outside" as its formula of success. This boundary had to be reiterated in spite of, or perhaps because of, the recruited artisans' constant movement into and out of the workshop system, as evidenced by the profusion of entries about the appointment, dismissal, and retirement of craftsmen in the archive. They did not even live in the palace compound at night.[56]

Five years into his reign, in 1727 Yongzheng became more history-minded in the fashioning of imperial style. He complained that in the past although the Imperial

Workshops made scant excellent objects, they looked imperial; now in excessive pursuit of craftiness (*qiaomiao*) the court fabrications had lost their distinctiveness. His unstated premise was that quality craftsmanship was in fact a trait of the outside workshops with which the court artisans had to strive to keep up. To reiterate the distinction between "styles made respectfully in the inner court" (*neiting gongzao shiyang*) and "the air [of craftiness] of things made outside" (*waizao zhiqi*), he ordered the workshops to save models in the form of specimens or drawings so that later artisans would be able to study them to ensure accurate transmission (YXD 81, 87). One detects a hint of defensiveness in Yongzheng's tone, who understood that his craftsmen were in constant competition with sophisticated artisans from workshops in the south.

Yongzheng's eagerness to "preserve" his style in models stemmed as much from his fear of attenuation of knowledge and skills among his artisans as from dilution of his imperial style.[57] Yongzheng's orders revealed his recognition that an imperial style was neither abstract nor generalizable. Such adjectives as "cultured" and "delicate" were but imperfect vehicles of communications with his workshop supervisors and artisans. No theoretical or linguistic construct, the early Qing imperial style was inhered in each object produced in the Imperial Workshops. As such, not only was style irreducibly material and specific, it was also dynamic. Precedents, in the form of models, served as technical reference in this cumulative process, but the standard of judgment was always modern and contemporary. After all, in Yongzheng's estimation imperial styles existed not in isolation but in comparison. For an object to be "imperial," it would have to be distinguishable from those made concurrently in workshops outside the court. It is this understanding of style-as-difference that drove the early Qing monarchs to incessant quests for new materials and new techniques.

THE INKSTONE WORKS UNDER YONGZHENG

With imperial inkstones, all Yongzheng had to do was to improve upon Kangxi's solid foundation by streamlining the logistics of production while adding his personal touches. The exclusivity of Songhua inkstones was secure due to Manchu monopoly over the quarries.[58] In a significant departure from the customary practice outside, in the Imperial Workshops artisans who carved ivory and made inlays from chiseled stones or mother-of-pearls on stone or lacquered wood bodies were the same ones who made inkstones. Hence the entries for the Inkstone Works in the logbooks are subsumed under those of the Inlay Works in 1723 and 1724 and under the Ivory Works from 1725 through 1734. Ivory and inkstone work was so intertwined that in 1735 the combined entity of the Ivory-Inkstone Works appeared.[59] Other workshops, notably the Box Works, often made the cases for the stones in a variety of materials.

Palace inkstone-makers appear in three categories. The main duty of the "inkstone craftsman" (*yanjiang*) was apparently fabricating near-identical gifts in bulk.[60] Those

in the two other categories, the "southern craftsman" (*nanjiang*) and "ivory craftsman" (*yajiang*) had more versatile skill sets, were better paid, and were sometimes summoned to help the emperor authenticate inkstones and other curios. These two categories were not distinct, as both labels were attached to multitasking artisans recruited from Jiangnan and Guangdong; some served a handful of years while others stayed for decades. One versatile artisan by the name of Shi Tianzhang, for example, was identified as a southern craftsman in one entry and an ivory craftsman in another. A bamboo carver trained in Jiading (a place synonymous with bamboo art), Shi distinguished himself as a carver of ivory and inkstones in the palace. He and his colleagues Suzhou native Gu Jichen and Guangdong native Ye Dingxin resided and worked in the imperial garden complex of Yuanmingyuan.[61]

Another southern craftsman by the name of Yuan Jingshao was the most trusted connoisseur in the early Yongzheng court. Besides stones and gems, he also evaluated and dated ink-cakes, porcelain, antique jades, bronze mirrors and censers, a gilded basket, and deciphered the archaic scripts on seals. Once he was asked to appraise an inkstone, probably made of Duan stone from Guangdong, which was unusually endowed with precious "eyes" on both its front and back. Yuan's verdict: "The stone itself is excellent, but the 'eyes' are faked."[62] Presumably, those objects he deemed fakes were returned to the sender or consigned to a dusty corner in the warehouse. Secure in their knowledge and, indeed, unquestioned authority over Chinese material culture, southern craftsmen were the elite corps in Yongzheng's workshops.

Yuan's colleague Gu Jichen had the audacity to refuse the emperor's order, and without consequences. Six days after receiving an order to prepare a model for the makeover of two rectangular inkstones because Yongzheng was unhappy with the patterns on their front, Gu responded with a detailed technical explanation (not recorded) and a taut conclusion: "Cannot be done." The matter was dropped.[63] As recognized experts in the Ivory and Inkstone Works, the southern craftsmen were the ones who translated the emperor's will into material designs and made model drawings for his approval. As such, not only were artisans recruited from the cultured southern regions the prime fashioners of imperial inkstone styles, they were also teachers who honed the emperor's judgment in matters of connoisseurship.

Compared to his keen interest in alchemical processes and painted enamel, Yongzheng's attention to inkstones appears more perfunctory, and in contrast to his micromanaging commands in the case of the Guandi statue, his work orders for inkstones often leave room for the artisans to improvise. Two years into his reign, he sent down a Kangxi-era red lacquered box with a green Songhua ink-slab inside as a model and ordered exact copies to be made with the exception of the lettering on the box, which was to bear the Yongzheng reign mark. He added, "Make another one or two green 'Duan' [Songhua] ink-slabs in a different design" without specifying which.[64] His relative inexperience had little to do with this uncharacteristic laxity,

A

for three years later, he made his trust in craftsman's discretion explicit in another order: "Make another box according to this model of purple 'Duan' [Songhua] stone with a *kui*-dragon motif and encrusted with glass. As for the inkstone inside, make whatever you wish."[65]

The command of "make whatever you wish" reveals a curious inversion in palace practice that stands as the distinguishing trait of Yongzheng's taste in inkstones: his conception of the ink-slab as a box-stone set, with his love of the container exceeding that of the implement inside (fig. 1.11). In 1725, when presented with four lacquered boxes, he instructed, "Remove the partitions inside; fit them with ink-slabs in green 'Duan' or Ula [both Songhua] stones made according to the shape of the boxes."[66] The emperor's creative energies were consistently lodged in the *containers*. In 1732, he sent an order to his trusted servant Nian Xiyao, then supervisor-in-chief of the Imperial Household Department, to "take the good lacquer varnish and make some small inkstone boxes in a variety of colors." Yongzheng even specified, "Tell him not to bother with outfitting the boxes with inkstones. After the boxes arrive, have the Imperial Workshops [in the palace] match them with green 'Duan' [Songhua] stones."[67]

FIG. 1.11. Inkstone in West Hill–stone bamboo-shaped box. (A) View of inkstone in box with cover opened; (B) back of inkstone. The cover of the stone box is fashioned as a bamboo segment overlaid with a stalk of brown bamboo. In contrast, the green inkstone inside is plain. The bamboo motif is borrowed from Han literati culture (see figs. 4.11–12 and 4.13), but the elaborate box in yellow stone is a Qing court invention. Inscribed on the back of the inkstone is Yongzheng's favorite encomium, "Hewing to quietude in action, / Thus the years everlasting." L 10.1 cm, W 6.3 cm, H 0.8 cm. National Palace Museum, Taiwan.

The customary practice in Chinese workshops was to first make the inkstone and then to match it with a custom box usually of wood, with ample space left for inscriptions. To inkstone makers in Suzhou or Guangdong whose artistry begins and ends with enhancing the natural shape and mineral features of the stone, the emperor's utterly alien mindset could only have seemed to be "the tail wagging the dog," to borrow an English-language expression. Yongzheng seems intent on making his mark by doing exactly this. The inverted target of Yongzheng's attention is reflected in a curious naming practice: most if not all the inkstones listed in the palace archives are described by the style and materials of the *boxes* first, as in: "West Hill stone—bamboo-segment-style box—green 'Duan' stone ink-slab." In contrast, Chinese connoisseurs name their inkstones by the origins of the stone and its mineral features, followed by the design. The box is never mentioned.

Yongzheng's tastes in inkstone boxes were inventive and original. He showed an early liking for a box in matte black lacquer, encrusted with a green jade shaped as a *ruyi*-scepter, and paired with a green Songhua ink-slab inside. The box as described bears traces of Chinese literati taste, but when paired with a Songhua ink-slab the set

exudes an air of the early Qing court that cannot be confused with anything made in the southern workshops. This is one of three inkstone sets Yongzheng ever described as "cultured" (*wenya*).[68] The second was also derived from Chinese form, a lotus leaf, but wrought of West Hill stone and encased in a brocade-covered cardboard box. West Hill stone, a light yellowish-brown in color, was not used in outside workshops.[69] The third, meanwhile, was a purely Manchu invention: a box of black-and-white agate or jasper paired with an ink-slab of West Hill stone (YXD 87). This admittedly limited number of examples suggests that by "cultured" Yongzheng had in mind a distinct Manchu court sensitivity that may make references to Chinese literati culture but is reconfigured in new combination of materials, colors, and forms.

West Hill was one of Yongzheng's favorite stones, perhaps because its yellowish hue sets off the characteristic bright green Songhua stone. When he found a box made of this stone and shaped as a section of bamboo stem (a green Songhua ink-slab inside) that had been fabricated some years previously in the palace workshop, he asked his workshop director to show the set physically to the inkstone craftsmen so that they might study it and model replicas after it. This practice is consistent with Yongzheng's use of models to foster his imperial styles.[70]

West Hill is merely one in a litany of stones commandeered from all parts of the empire that became ink-slab boxes.[71] In 1729, when his favorite governor-general Ortai submitted a lot of fifteen Wuding stones from the remote southwest, Yongzheng found one with "excellent patterns" and asked that it be made into an inkstone box that showed off the patterns to maximum advantage.[72] When presented with more exotic stones two months later, he opted to have a variegated stone with "brocaded" black-and-white veins and a dark brown kidney-shaped agate made into inkstone boxes.[73] None of these stones had been associated with inkstone-making in workshops outside the court. In fact, the choice of stone—any stone—for box-making was an affront to the sensitivities of Chinese scholars who treated their Duan inkstones as if they were babies needing cradling and protection from hard surfaces.

If the matte black lacquered wood and bamboo-shaped stone boxes made oblique references to Chinese literati tastes (the former in materials and the latter in form), in other inkstone orders Yongzheng ventured into terrain entirely his own, creating fresh visual and material possibilities. He used new materials that no Chinese would use to store inkstones because they are brittle and cold to the touch. In 1731, the Jade Works filled an order of eight etched-glass inkstone boxes.[74] Yongzheng tinkered with the format of the boxes, too, experimenting with composite boxes made of wood and other materials that contained a host of knickknacks beside the ink-slab.[75]

The most striking innovation in design occurred in 1729, when Yongzheng was presented with a She inkstone (from Mount Longwei in Shezhou, present-day Wuyuan, Jiangxi), a hard dark stone with veins that is not unlike some Songhua stones except in color. He liked the stone but disliked the box made from the root of an apricot tree,

a fashionable material among Chinese scholars who admired its rustic simplicity. The new box designed by Yongzheng, in brightly contrasting colors and spectacular form, can only be called the antithesis of the original: the lid made of purple stone with carved green stone patterns set on its surface; the bottom a tall footed pedestal in green stone; encomiums in lacquered words engraved on the inside of the lid.[76] Some ancient inkstones are footed, but an inkstone on a pedestal was as much a novelty at court as in society.

Yongzheng, always attentive to the color contrasts between box and stone, extended his coordinated sense to the environment created by the objects and furniture placed in a room, within what may be called an "architectural envelope." The black and white "brocaded" stone he singled out for box-making mentioned earlier was outfitted with another footed stand, this time of *zitan* wood inlaid with gold-plated copper wire. Teamed with a red inkstone, this must have made a dramatic display. Yongzheng appears more an interior decorator than an emperor or scholar when he instructs, "Good to match it with a potted scenery." Potted sceneries (*penjing*, "bonsai") are miniature landscapes of gem stones, rocks, plants, or fungus presented on stands for ornamenting desks and shelves; the Imperial Workshops had made many to Yongzheng's specification.[77] The transformation of the boxed inkstone from a writing implement to a prop for interior decoration was thus complete (fig. 1.12). In his obsessions with surface ornaments on the container, or a preference of form over content and function, Yongzheng can be said to have anticipated a salient characteristic (or demerit, depending on one's point of view) of the material culture in the court of his successor Qianlong.

Employing craftsmen who worked in multiple mediums, Yongzheng made inkstone sets according to inherited and invented models—in the form of drawings and actual objects—to perpetuate his imperial style. The new materials and designs he mandated are unique to his time and to his workshop. In all of these practices and results, the palace inkstones depart from those in Jiangnan and Guangdong, the places of origin of his recruited craftsmen. We can only conclude that Yongzheng's project of establishing an imperial style by defending the boundary between "inside" and "outside" found its most salient success in his Inkstone Works.

BETWEEN COURT AND SOCIETY: LIMITS OF THE IMPERIAL PERSUASION

The emperors Kangxi and Yongzheng set into motion two parallel transactions between court and society: in the circulation of things, a two-way track that channeled tribute gifts from local officials to the emperor and return gifts in the opposite direction; in the circulation of skills and knowledge, another two-way track propelled by the recruitment of artisans to serve in the palace workshop for a duration before returning to their trade. The tribute-gift loop had existed since the early empire, but the rotation

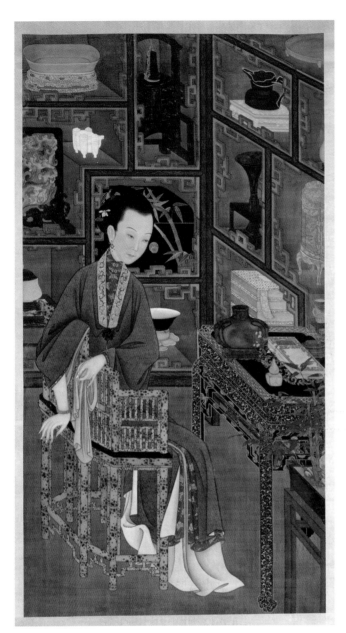

FIG. 1.12. "Beauty with Many-Treasures Cabinet." In one of a set of life-size paintings by court paint-ers commonly known as the *Twelve Beauties*, a Chinese lady sitting in front of a multicompartment cabinet filled with curios is shown gazing at the objects crowding a gilded lacquered table. A giant white inkstone on a perforated yellow stand catches the viewer's eyes against the black tabletop, next to an antiqued bronze vessel and a tiny white ceramic vase holding sprigs of flower. A bamboo pot-ted in an azure basin arches over from a low table to the right. The inkstone thus morphed from an implement on an austere scholar's desk into a decorative object. The *Twelve Beauties* were originally mounted as screens in Yongzheng's study when he was a prince. From *Twelve Beauties at Leisure*, detail, ink and color on silk, 184 × 98 cm. Palace Museum, Beijing.

of craftsman was a Qing practice.[78] The technocratic culture that arose from the historical experience and political project of the Manchus, institutionalized by the Imperial Workshop system and communicated to society by traveling bondservants and artisans, had considerable impact on the knowledge cultures of the empire.

Tribute gifts have a special valence in the Qing. Unlike the abstract creed of loyalty that found expression in behavior and in writing during the Ming, the personal servitude that bound the Manchu emperor and his bondservants (and extended in an attenuated form to all officials in the formal bureaucracy) had to be reiterated in material form at regular intervals. This fact alone made the flow of goods an essential component of Qing rule at a scale and with a frequency unmatched in the previous dynasties. The conveyance of tribute gifts enacted and reinscribed three sets of relationships that made up the Qing polity: from tributary states to the Qing empire, from regional governments to the court, and from individual officials above a certain rank to the emperor. Routine domestic tributes were mandated each year for the New Year, Duanyang (the fifth day of the fifth month), and the emperor's birthday, but other festivals also occasioned gifts to the court, at ruinous expense and posing logistical challenges to bondservants and bureaucrats alike.[79] The Qing was a veritable material empire in which everyone, from the emperor on down, knew the value *and* the price of things.

Although small, the inkstone had a conspicuous role to play as the emblem of Chinese literati culture and civil rule. The efforts expanded by Kangxi and Yongzheng in developing an imperial inkstone style and maintaining a supply of gifts signal their awareness of the symbolic value of inkstones to a minority conquest regime. On the eve of the arrival of envoys from the Qing's tributary states in autumn 1729, Yongzheng complained about the lacquer-boxed inkstone in the list of gifts to the Ryūkyū king and ordered that it be replaced by one made of stone from the storehouse. The king of West Sand Islands, in turn, delivered six Tuoji stones, a fine material for inkstone making.[80] The difference in attitudes toward inkstones between the Ming and Qing courts is telling. The Ming court seems intent on taking: the most desirable material for inkstone-making, the purple Duan from Zhaoqing, Guangdong, was mined under strict eunuch supervision and conveyed to the capital as tribute in the Ming.[81] The Qing court, in turn, seems more intent on giving. Many gift stones recorded by their recipients are standard-issue Songhua stones, but Duan inkstones also frequently appear.[82]

Given the magnitude and frequency of these material and human transactions, it is surprising that the boxed Songhua inkstone set that epitomizes early Qing imperial taste had no apparent impact on literati preferences. As far as I know, no artisans outside the court made inkstone boxes from stone in contrasting colors, let alone glass. Nor did the brightly colored and flat silhouetted Songhua ink-slabs ignite new fashions in the design of inkstones. Although the imperial largess elicited obsequious "memo-

rials to express gratitude," these superfluous words had no effect on the actual making, using, and appreciation of inkstones in society. The controlled supply of the raw stones and limited visibility of the finished product was undeniably a factor, but in itself it does not explain the virtual absence of Songhua stone in the established inkstone discourses outside the court.

The origins and properties of Songhua stones escape mention in the private writings of the recipients of imperial gifts in the early Qing, and there is scant description of them as objects of curiosity by the recipients' friends. The only written attempt to graft Songhua inkstones onto existing nomenclature came later in the Qianlong reign, in the imperially commissioned *Catalogue of Inkstones from the Chamber of Western Purity*, and even there it was consigned to the appendix. Wang Shizhen (1634–1711), a successful official and doyen of the Chinese literati circles in the early Qing, stood out as a rare exception. His curiosity was such that he tested a Songhua stone gifted by one of his many students in 1704. Wang described it as "dark red in color with white veins, covering the entire body in a pattern of brilliant clouds." The material and design of the box, following Chinese fashion, was not mentioned. Wang found its ease in yielding ink superior and rated Songhua on a par with the esteemed Lower Rock of Duan and surpassing Tiaohe, Longwei [She], and Hongsi, three famed stones favored by iconic Song connoisseurs.[83] This was no meager praise.

Despite this endorsement from the leading arbiter of tastes of his day, Songhua stones made no inroads into the evaluation scheme of Chinese collectors, who were then fixated not only on Duan stones from Guangdong, but on the relative positions of rocks from one particular shaft. Li Fu, a member of a circle of inkstone connoisseurs in his native Fuzhou, Fujian, failed to describe the Songhua stone bestowed on him by Yongzheng in his writings. He remained a steadfast devotee of Duan inkstones. His fellow Fuzhou connoisseur Zhou Shaolong, also favored with a Songhua ink-slab, left it to his son to record it, and only the inscription for that matter: "Hewing to quietude in action, / Thus the years everlasting."[84] Neither Li nor Zhou counted their Songhua ink-slabs as part of their prized inkstone collections.

Reading the voluminous connoisseurship literature that flew off the brushes of Chinese scholars in the eighteenth and nineteenth centuries, it becomes clear that the Duan or She inkstones favored by them and the Songhua stones promoted by the Manchu monarchs circulated in parallel worlds despite the documented crossings. If not for the curators at the National Palace Museum in Taipei who organized a major exhibition in 1993, few modern viewers would have heard of Songhua stones, let alone laid eyes on one. Although Kangxi and Yongzheng were powerful enough to impart new material styles and visual vocabularies onto a key Chinese writing implement, they were not powerful enough to alter the embodied sensitivities of Chinese connoisseurs, who carried on their love affairs with the deep purple Duan stone as if the brilliant experiments in the Imperial Workshops had never happened. In this silence we glimpse the

resilience of Han literati culture at a time when the rise of bondservants and the tech-nocratic culture they heralded cast a long shadow on the Chinese scholars' privileged claims on public life.

FIG. 2.1. Walking into White Stone village, Yellow Hill, Zhaoqing, Guangdong. Photograph by the author, Nov. 28, 2007.

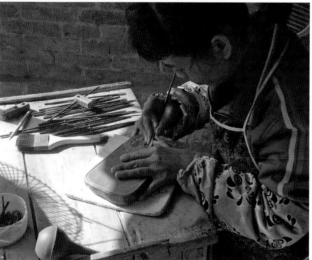

FIG. 2.2. Young woman carving an inkstone under natural light in the courtyard of her house, White Stone village, Yellow Hill, Zhaoqing, Guangdong. Photograph by the author, Nov. 28, 2007.

2

Yellow Hill Villages

THE STONECUTTERS

O N THE OUTSKIRTS OF THE WALLED CITY OF ZHAOQING IN GUANG-dong province, at the far southern edge of the empire, hundreds of households in a cluster of villages collectively called Yellow Hill (Huang Gang) have for centuries made a living exclusively from mining and carving stones from the nearby Duan quarries.[1] Although they also make knife sharpeners, mortars, and other household items, from as early as the sixteenth century the mainstay of their livelihood has been the scholar's ink-grinding stone. Many Yellow Hill families have entrusted the more delicate tasks of carving and polishing the inkstones to daughters and wives, leaving the men with mining and cutting boulders, fabricating boxes, and handling retail or wholesale businesses.[2] Many of these vertically integrated family enterprises, having prospered from the seventeenth to the early nineteenth centuries, are still operating today.

To understand the unique advantage the Yellow Hill families enjoy, one needs to visit the site and ponder the technology of writing, or, to be specific, the mechanics of grinding ink. From the Southern Song dynasty (1127–1279) at the latest to the present day, the most desirable material for inkstones in the entire empire has come from two mountain ranges on the banks of the Xi River and its tributary Duanxi.[3] Geologically, Duan stone is a shale whose main contents include mica, clay, and silica with traces of mineral salts—mostly iron, potassium, and magnesium—the source of its characteristic deep purple color. The foliated rock, formed by metamorphic compression over 600 million years ago, is fine-grained and of medium hardness (about 3.5 on the Mohs scale, or on par with a copper penny; by comparison, a lead pencil is 1 while a knife blade is 5.5).[4]

Before the modern advent of fountain pens, inkstones were first and foremost functional objects for the writer, calligrapher, and painter. To produce ink, the artist rubbed

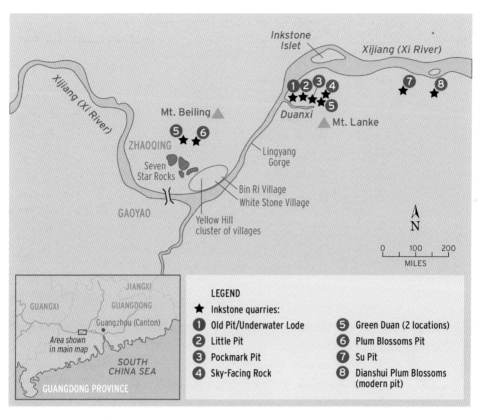

MAP 2.1. Locations of the main Duan quarries, Zhaoqing, Guangdong province. The best stones are found on the eastern bank of the Xi River, on Mount Lanke. The inkstone-making families of Yellow Hill cluster on the western bank, in the shadow of Mount Beiling.

a moistened ink-cake, a finger-length stick made of soot and glue, on the face of the inkstone in a deliberate circular motion. The technical requirement for the ideal ink-stone, encapsulated in the expression "producing ink without hurting the brush" (*famo er bu sunhao*) involves a fine balancing of opposites: the stone should be coarser and harder than the ink-cake (2.2–2.4 on the Mohs scale), but softer than the bristle of the brush.[5] Furthermore, the stone should have just the right absorbency—if too porous, the ink would disappear into the stone; if too impervious, the ink would be too thin. Duan stones, especially those from several select mines in Mount Lanke (a.k.a. Fuke) on the southern bank of the Xi River, fit the bill perfectly.[6] On the opposite shore, quarries on Mount Beiling have been exploited since the Song, but they are in general of lesser quality.

Although inkstones were indispensable to the world of learning and art, the makers of the implement barely register in the scholar's cognitive universe and order of knowledge. Having left no writings in forms that are legible to scholars, the stonework-

ers' lives are obscure, in contrast to the name Duan that has assumed mythological status among scholars, painters, and collectors since the late Tang dynasty (618–907). The quest for the most magnificent stone and secrets about its identification propelled an occasional scholar from the central plains to brave the journey to the Duan area. The calligrapher and inkstone aficionado Mi Fu (1051–1107), for example, boasted that he "had travelled to Duan" and "everywhere made enquiries from the stoneworkers"; his friend the poet-statesman Su Shi (1037–1101) was more an accidental tourist, being banished to a neighboring area in 1094.[7] By intention or otherwise, Duan legends and knowledge trickled to the heartland of the empire and found secondary and tertiary lives in notation books, a genre tailored for trafficking in gossip and anecdotes among the emergent scholarly elite in the tenth to eleven centuries.

OF FELICITOUS STONES AND WRITING

The felicitous union between the ink-grinding stone and writing is understandably a favorite theme to those whose métier is prolificacy in words. Given its explicit scholarly disposition, a tale told by the Northern Song collector He Wei (1077–1145) is striking in the agency it affords the stoneworker: it was a prospector in the Duan quarries who spun the legend about a magical stone and claimed credit for the literary flourish that ensued, *not* the metropolitan writer.[8] In He Wei's telling, a high official at court was such a lover of curiosities that he prevailed upon the magistrate of the Duan area to send choice stones. Hundreds of tribute shipments (bribery may be a more appropriate term) later, the perfect stone had yet to appear.

One day, a flying heron that landed in the middle of a pond caught the eye of a Duan inkstone worker (*yangong*): this was no place for a bird to stand. He found underwater a round boulder the size of a big rice scoop and notified the magistrate, who summoned a fleet of fishermen. When the boulder was conveyed to shore, one could hear the sound of water sloshing inside. Seeing this, the stoneworker congratulated the magistrate: "There must be a precious stone hidden inside, what we call a 'child stone.' We have a legend that says heaven gave birth to a supreme jade, which nourishes this pond. Its essence impregnates the rocks and becomes dispersed in the form of felicitous writings. Today it is in front of my very eyes." When he cut open the boulder, the stoneworker found lying in a ring of crystalline water a purple stone the size of a goose egg, which he bisected and made into a pair of inkstones. The high official was delighted, although it is not known if his writing became more inspired as a result.[9]

The fad of collecting curiosities in court and the corrupt culture of gift-giving that drove exploitation of local resources, features of the Northern Song political culture reflected in this tale, became tropes in subsequent lore about inkstones. But He Wei's story reveals even more about the complexes of local knowledge that governed life in the mining communities thousands of miles away from the capital. Beliefs about

the fantastical properties of materials from classical cosmology ran deep in vernacular thinking among stoneworkers. The gendered language of heaven—"gave birth to" and "impregnates" stones, for example—recalls the fecundity of the generative earth described in early medical and metallurgy treatises. Also striking is the imagery of a womb- or egg-like boulder, retrieved from underneath a pond, encasing a ring of water that nourishes a "child stone." Abstract correlative ideas about the resonance of materials find expression in the physical intimacy, indeed transmutation, between water and stone.[10]

The custodian of this and other useful knowledge in the Duan area is the stoneworker. He knows the terrain of land and water so well that the unlikely resting place of a heron rouses his suspicion; he wields the tools and skills to cut the stones and fashion them into inkstones that find their way to the scholar's desk and collector's cabinet. His words—"We have a legend that says. . ."—suggest that the community that has lived and died by the stone is steeped in histories of its own making, passed on from family to family and from generation to generation. Occasionally, the keen interest of the magistrate or itinerant scholar brought fragments of this living history into wider circulation in textual form.

THE TOOLS OF THE STONECUTTERS

The stonecutter's work begins not in the hills but in the foundry in his backyard. As recently as the 1970s, it was customary for each worker to forge his own tools: four types of chisels, from steel rods bought from ironsmiths in the Yellow Hill market, and four types of hammer, with heads of iron and handles of wood. Making one's own tools remains a prevalent practice today. The resilience of this centuries-old tradition can be explained by the simple fact that the chisel heads dull or bend during mining; the skills for routine repair derive from the knowledge of forging.[11] Far from being monolithic, the bundled skills required for extracting Duan stones are at once specific and dispersed, straddling fields that in the modern academy would be divided into smithy, metallurgy, carpentry, stratigraphy, and mining geology.

Forging tools is an exacting task in its technical and ritual demands.[12] Yellow Hill stonecutters make four types of chisels, of which the most useful is the "big chisel" (*dazuo*; A in fig. 2.3). Powerfully stout (10–25 cm long; 14–16 mm in diameter) with a flat blade, it is what the miner carries into the shaft of the quarry (paired with an "impact hammer" with a large cuboid head; C in fig. 2.3) to knock a groove that marks the outline of the boulder he wants to cut. When the groove is deep enough, he inserts the chisel to pry it loose from the bedrock. If the desired block is massive, he combines the heads of two "big chisels" in a V-shape.

Once both man and rock are safely out of the shaft, the quarryman switches to thinner chisels for more precise work (B in fig. 2.3). He uses the "shaping chisel" (*nan-*

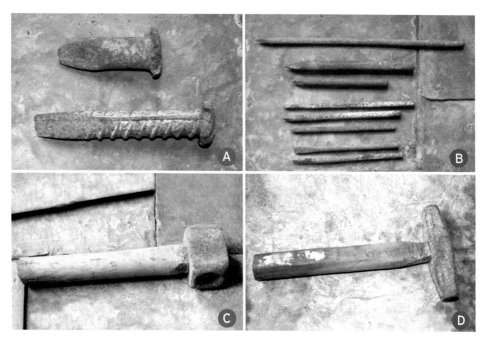

FIG. 2.3. Chisels and hammers used by Yellow Hill prospectors and miners. (A) Big chisels; (B) shaping chisels; (C) impact hammer; (D) fixer hammer. Courtesy of Chen Yu.

zuo), a slender rod (25 cm long; 8 mm in diameter) that terminates in a bull point, and a "shaping hammer" to chip away the jagged edges of the cut boulder and fashion it into a portable dimension. The "half intestine" (*banchang*), a longer chisel (30–50 cm long; 8 mm in diameter) also with a bull point, pries away the surface waste rock when inserted between the foliation. Lastly, the quarryman picks up a "flat chisel" (*bianzuo*) with a slanted head (20–25 cm long; 8 mm in diameter) and a "conditioning hammer" to straighten out the surface and edges of the usable stone, called somewhat misleadingly a "raw stone," which is now ready to be carried by porters back to the village.[13] A fourth kind of hammer, the "fixer" (D in fig. 2.3) is fitted with a precision head for the explicit purpose of mending the tear and bend on the chisel blades to ready them for another day of knocking and chipping.

Not only is each chisel head of a different shape, it also has to be made in a particular hardness optimal for its specific use. The skill of the forger lies in sizing up the color of the heated metal (called "yellow-white flower," *huangbai hua*) during quenching, achieving the desired strength by manipulating the duration and number of dips into water. This skill, honed from observation and sustained practice, cannot be learned from books. The tip of the chisel's handle also needs to be quenched, so that it is harder than the hammer, and formed into a rimmed bull's eye shape. The bull's eye is named "foot of the teacup," (*chabei du*; *caa4 bui1 duk1* in Cantonese),

whose profile it resembles (fig. 2.4). This seemingly minor procedure of shaping the "foot of the teacup" is shod in secrecy; interviewed stoneworkers suggest that all the skills involved in forging tools are family heirlooms, but this is the one that families are most reluctant to teach outsiders. By controlling the knowledge of chisel making, the Yellow Hill stoneworker families may not have effectively monopolized the quarrying process, but they at least created a high threshold for competitors to overcome before they can enter the trade.[14]

The "foot of the teacup" is where the hammer meets the chisel, a contact zone of ritual and vital significance. The rimmed treatment of the chisel handle minimizes slippage when struck, which could cause injury to the hands and worse, the stone. All mining operations are accident-prone; besides the usual perils of fractured bones and collapsed tunnels, the Duan quarrymen also had to contend with tigers and snakes while camping out in mountain caves.[15] It is perhaps no accident that they call the cuboid "impact hammer," weighing over 1.8 kg (three catties), by the moniker Wuding. Literally the "five strongmen," Wuding are heroes from the ancient southwestern kingdom of Shu, blocked from the central plains by the formidable Qinling Mountains. Enticed by the promised gift of five heads of life-sized stone cattle that excreted gold from the rival king of Qin, the Shu king recruited five big men to hack through the mountains and build a gallery road called the Stone Cattle or Golden Cattle Road. Instead of riches, however, the road conveyed the Qin army that vanquished the Shu in 316 BCE.[16] The slippage between the five cattle and five men is suggestive of a transfer of strength between animal and men, and of value between stone and gold. In naming their heaviest and most useful hammer Wuding, the Duan stoneworkers seek not only protection from falling rocks and poisonous snakes but also hefty muscles and financial returns.

FIG. 2.4. The "foot of the teacup" end of the big chisel. Courtesy of Chen Yu.

The story of the Five Strongmen, recorded in several annals, found its way to the Duan area by the Song at the latest, possibly via scholars dispatched to their posts as magistrates or judges in the region.[17] The tale underwent a subtle transformation as it sedimented in Yellow Hill. Whereas the narrative thrust of the written accounts focuses squarely on the Shu king's follies, the stoneworkers seize upon the superlative power and skills of the strongmen, whom they merge into one man and anoint as the patron saint of Duan inkstone miners and carvers. Although most stoneworkers may not have learned to read and write in a formal setting, they cannot be said to be "il-literate," because the words, figures, and values from literate culture (which may have originated from craftsmen in the first place) permeate salient aspects of their work, rituals, houses, and business transactions.[18]

Wuding presides over a host of communal rituals in the Yellow Hill villages that coalesce individual stoneworker families into flexible networks for pooling labor resources, trading materials, and sharing skills.[19] Some of these communal transactions involve the use of writing on stone and paper mediums. The birthday celebration of Wuding, which the Duan stoneworkers designated to coincide with the Bathing Buddha ceremony that marks the Buddha's birthday on the eighth day of the fourth month, is a prime example. On that day, tablets consecrated to Wuding and carved from local stones in the shape of an ancestral tablet are paraded in the Yellow Hill villages, followed by initiation ceremonies of apprentices. Modern experts have judged two of the extant tablets as dating from the Ming dynasty (1368–1644), according to the quality of the stone and style of carving. On one tablet, the carved thirteen-word inscription in clerical script identifies Wuding with the minister of works in the imperial bureaucracy and the other with an even more successful scholar, the grand guardian of the heir apparent. A third extant tablet, a 1946 stone copy of an earlier wooden one, identifies Wuding with Wenchang, the god of literature.[20] The persona of the strongman stonecutter has thus merged with the masters of scholarship and literature in Duan imagination.

If the bureaucratic language of the Wuding cult points to its external origins and connective functions within the community, rituals honoring tutelary deities as well as stoneworkers' incantations and jargons in the Yellow Hill dialect (a variant of Cantonese) provide glimpses into a world of vernacular knowledge that does not travel beyond the quarries. At the entrance of the most valuable quarry, the Old Pit, miners have straightened the face of a stone and etched three lines of words. The large characters at the center, "God of the Entrance of the Cave," transforms the stone into a luminous guardian (fig. 2.5). As the miners file into the tunnel, each intones, "Sorry to disturb you; we're here to start working!" The two other lines carved in smaller fonts on the stone make plain the miner's desires for prescience and strength: "Once I see [the stone's vein] I know" and "I raise my hand [holding the hammer] which is swift as a

FIG. 2.5. God of the Entrance of the Cave. Courtesy of Chen Yu.

dragon."[21] The Cantonese expression used for knowing, *tung1 hiu2* (*tongxiao*), connotes clear understanding that is instantaneous and intuitive.

If words etched in stone have talismanic value, the same is true for documents written by brush and ink on paper, although the latter is less prevalent in the everyday lives of the stoneworkers. Most visible for all to see are pairs of auspicious couplets, presumably from the hands of a scribe or local student, which stoneworker families paste on the front gate of their ancestral hall and next to Wuding's shrine on the birthday of their patron saint.[22] An iconic example reads: "Hacking through rocks, Wuding turns mountains into roads, / Making the inkstone into paddy field, we pass it down to our descendants."[23] The first line construes Wuding's heroic deeds as feats both empirical and metaphorical: road-building not only enables the conveyance of goods but is also a metaphor for opening a new lifeline. Dominated by the Lanke and Beiling ridges that nestle the quarries, the Duan area has scant arable land to sustain its population by farming alone. The phrase "making the inkstone into paddy field" (*yantian*) in the second line is thus an expression of gratitude and relief for the salience of the stone industry to the livelihood of individual families and to the local economy as a whole.

The phrase (or its fuller form, *yiyan weitian*) is also favored by scholars, especially as an encomium on their inkstones, sometimes paired with "plowing with the writing brush" (*bigeng*).[24] In the hands of scholars, the trope expresses a longing for escape from political and bureaucratic chores to a hermitic life given to poetry and wine, not a desire to farm. The image of the recluse "plowing" with his writing brush and inkstone conveys the scholar's self-important identities as writer. The self-perceptions and aspirations of the stoneworkers and the scholars could not have been more different.

Pondering the apparent contradiction that the makers of a key writing implement are not writers, contemporary scholars often lament their lost opportunity. This is not a productive way to approach the issue of artisanal literacy. A more relevant question

FIG. 2.6. Rubbings of inkstones as "models" from the Luo family, White Stone village, Yellow Hill, Daoguang era (1821–50). Inkstone-makers use rubbings of finished inkstones (what they call an "inkstone manual," *yanpu*) to transmit skills. The name of each design is often indicated in handwriting on the sheet (not shown). In the Luo and Guo families in White Stone village, Chen Yu has found rubbings that descendants claim date to the Ming. Masters give these "models" (*yang*) to apprentices during the initiation ceremony. In Bin Ri village during the Republican period, inkstone makers held exhibitions of their works after the ceremony, the only occasion whereby newcomers were allowed to make rubbings of the stones made by elders from other families. Courtesy of Chen Yu.

is, what is literacy useful for? Other than making talismanic stones, the miner has no use for the ability to write. Even for those craftsmen who specialize in carving words on stone, "literacy" is a graduated and task-specific skill: those who carve words on smaller-sized stones such as religious tablets or inkstones need to be conversant with the key calligraphic scripts, but the allusions behind words are of no consequence to them. Craftsmen who carve long informational texts on steles announcing a set of lineage rules or governmental decrees need to know the stroke order of the words they carve in order to place them neatly on a grid, but mastery of fancy scripts is less relevant.[25]

From the perspective of the stoneworker community, literacy is a useful skill when it comes to placating the gods, making business arrangements, promulgating clan rules, and dealing with the agencies of the state.[26] But the quarryman's métier, rooted in learning and transmitting knowledge about tool-making, prospecting, and quarrying, lies outside the realm of words and texts.[27] In the eyes of scholars, then and now, literacy is the pathway to the highest form of knowing, be it the moral philosophy of the Confucian scholars or the abstract theorizing of scientists. By extension, writing is the noblest act that enables expression of the self to like-minded friends, communion with the ancients, and the promise of immortality in the eyes of future generations of readers. This is a self-serving value judgment that derives from, and in turn reproduces, the socially superior status of the scholar. To maintain this fiction, scholars denigrate the knowledge embodied by the craftsman, and any knowledge that is not textualized, as unreliable. It is not so much the lack of source

materials, but the historian's insistence on the superiority of the written record, especially writings printed on paper, that continues to erase from scholarly discourse the craftsman and his way of knowing-making.

THE EXPERT KNOWLEDGE OF PROSPECTING AND QUARRYING

The lifting of imperial control over the choicest of the Duan quarries in the early Qing led to a flurry of private mining activities in the late seventeenth and early eighteenth centuries.[28] By then, many of the historic mines had been exhausted. Prospecting, what stoneworkers call "looking for the mouth of the stone," is thus an ongoing process crucial to survival if not prosperity. The experienced prospector packs his chisels, hammers, and foodstuff and heads to the mountains, lingering for days or even a fortnight. He forages from one gushing stream to the next, sifting through pebbles whose shell had been worn by current as they tumble from higher grounds. Once he spots a "stone seed," a pebble bearing patination that might indicate suitability for inkstone making, he hikes upstream to locate the exposed or even buried "stone source," conjuring the knack to "see through" or "penetrate rocks." At the source, he "eyes the course of the vein" to decide if it is operable. By custom, the prospector who finds a quarry has the right to exploit it, although the most desirable ones often came under the purview or even monopoly of the imperial court.[29] If the knowledge of the prospector and miner can be said to have an overarching structure, it is to be sought in the comingling of water and stone that suffuses his milieu, already evident in the story of the prospector and heron earlier.

The nature and expense of the mining operation are contingent upon the extent of this interpenetration. Of the three select quarries in the Duan area, the oldest and most desirable was the Old Pit (Lao Keng, also called the Underwater Lode, Shui Yan), which was first mined during the mid-Tang (618–907). The second in history and prestige, the Little Pit (Keng Zai), was a drift mine first opened in the Northern Song Zhiping reign (1064–67). The third, the Pockmark Pit (Mazi Keng), was discovered in the Qianlong reign (1736–95) and included both an underwater and a dry pit (fig. 2.7). To harvest from the dry pits, workers dug a tunnel into the steep hillside as they would any mine. The submerged pits, where the lode lay at a level below the bed of the Xi River, had to be dry before mining could ensue. Before the modern convenience of electric pumps, teams of workers were assembled with the onset of the dry winter in the tenth or eleventh month. Descending into the diagonal shaft, they formed an assembly line conveying water in clay pots. Manual removal of water required over 200 workers alternating in day and night shifts for over a month, leaving a mining season of three to five months. By the fourth month, rain would swell the river and the pit would again be submerged.[30]

The scholar-official Li Zhaoluo (1769–1841), a geographer who sojourned in Zhaoqing from 1820 through 1822 and the first to commit to writing the financial

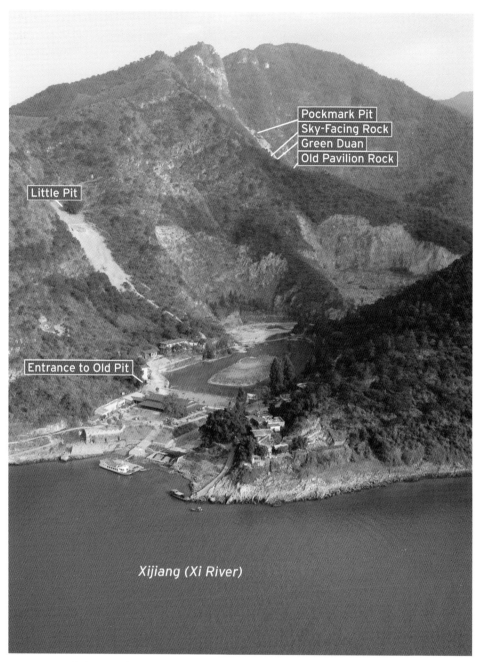

Pockmark Pit
Sky-Facing Rock
Green Duan
Old Pavilion Rock

Little Pit

Entrance to Old Pit

Xijiang (Xi River)

FIG. 2.7. Aerial photograph showing the entrance to the submerged Old Pit, Pockmark Pit, and hillside littered with waste rocks on Mount Lanke. Courtesy of Chen Yu.

and logistical arrangements of the mining operations, described the messy mixing of stone and water common in the pits as well as the corporeal nature of the extraction:

> All inkstone pits, be they on top of the mountain or at its foot, have water in them. To harvest the stone one has to first remove the water. Also, inside the shaft the air is warm even in the winter months, hence all must strip bare their bodies before entering. The tunnels are without fail pitch black, so the miners have to carry lamps. The lamps have no space to ventilate, so the soot from the burning coal all settles on the human bodies. Those who emerge from the tunnel are caked with yellow mud on their lower bodies and fumigated by coal on their upper bodies. Naked and squalid, they all look like ghosts.[31]

That quarrying Duan stones is filthy and backbreaking labor does not detract from the necessity of expert knowledge accumulated by way of the mindful eye and hand. Embedded in layers of waste rock, the raw material for inkstones is a snake-like vein (*shimai*) which measures about ten to thirty centimeters at its thinnest and forty to sixty centimeters at its widest. The lode, although hard and resistant to compression, is so brittle that the use of explosives would reduce it to rubble. Its delicacy mandates that the vein be harvested manually with hammer and chisel even in modern times. With each hammering, the miner intuits the trajectory of the hidden vein and moves with it: a little to the left; a little further up. The waste rock, called "the bones" (*shigu*), has to be left undisturbed or the tunnel may collapse.[32] The miner's survival thus depends on his expert knowledge, embodied and transmitted by sensory facilities.

According to Li Zhaoluo, when blocks of usable stones (called *liao* in today's parlance) are carried from the tunnels, workers mark the harvest date in vermillion and the lot is closely guarded. As the mining season comes to an end and the tunnels sealed, the investors and workers draw lots to split the bounty: seven parts for the former group and three for the latter.[33] Eventually the boulders pass into the hands of an "assessor" who has an uncanny ability to intuit what lies underneath the coarse shell of each boulder. Stone-workers envision each block in terms of four layers: a coarse top layer to be discarded, the layer underneath it and a base layer that are dry but often usable, and finally a core layer that would eventually be fashioned into inkstones ("the flesh," *shirou*). What we have just differentiated as four layers in analytic and conceptual terms is, however, inchoate visually.

It is the assessor who sizes up the surface of the boulder, visualizing the trajectory of the layers underneath as well as the type and location of the valued mineral features each piece may contain, which are to be showcased on the front of the finished inkstone. He has to plot the size and shape of the inkstones to be cut from the block by conjuring a three-dimensional map in his head. He then picks up the hammer and chisel to divide up the stone into individual raw pieces (*pu*), which will be sold to a collector or handed to an inkstone carver, who in turn makes the design and executes it.

The cunning knowledge of the assessor, or the ability of his eyes to "penetrate rocks," is rooted in his intimate knowledge of the geology of the pits often gained from early experience as a prospector and miner.[34] A faint green spot on the surface may well mean that a cherished "eye," which derives its yellow or green color from ferrous oxide, is buried inside, and so on. Indeed, the same skills of intuitive understanding and logical inference from seen to hidden phenomena, or from surface to interior, distinguish a successful prospector as they do a miner in the tunnel and the assessor breathing fresher air outside.

Connoisseurs have praised this expert knowledge of the prospector, miner, and assessor in terms of a familiarity with "the patterned principles of the lode" (*shi shanshi zhi wenli*).[35] But the scholar's terminology of moral philosophy seems alien to the local way of knowing, which as we have seen envisions the mountain as a human body with the structural integrity of "skeletons"; the lode is called a "vein" and the most lustrous part of the vein "flesh."[36] The body figures in the mining of Duan stones not merely as metaphor but at the center of the extraction of the stone. The image of the miner emerging from the underground tunnel captured by geographer Li Zhaoluo's documentary mode of narration is symptomatic of the lowly status of the stoneworker and his corporeal exertion: caked in mud and soot, the miner's naked body is ghost-like in that it is at once visible and invisible. Although striking in its visceral corporeality, the body is masked from sight by defilement, which renders it illegible in history.

The bundle of knowledge useful to the tool-forger, prospector, and miner is embodied, situated, and highly specific. The hardness of the chisel that the quencher calibrates and the power with which the miner strikes it both depend on the weight of the hammer used, which in turn varies with the density of the rocks in each cave. The prospector's celebrated eye that "penetrates rocks" is none other than a profound familiarity with the minute idiosyncrasies of the terrain above and beneath ground, as well as on land and in water. This knowledge is rendered in writing only in the modern era not because it is inherently resistant to textualization. It is because the Yellow Hill practitioners who are masters of their dense and foliated worlds have no use for abstraction, nor has it been in their interest to make the localized knowledge that has been their dominion accessible to others. To textualize and to generalize is the scholar's métier, not the stoneworker's.

THE SCHOLARS: TEXTUALIZING STONECUTTER'S KNOWLEDGE IN THE NORTHERN SONG

There have always been scholars in Chinese society, but the rise of the scholar (*shi, shidafu*) as a self-conscious group sharing a collective identity occurred only in the tenth to eleventh centuries. Members of this elite group forged an episteme rooted in lifelong immersion in the hermeneutics of classical books and the ideal of political service.

Equally important, but seldom acknowledged, is how useful practical and theoretical knowledge about inkstones was to the shaping of this new elite male identity.

The scholars who served in the court of the Tang (618–907) tended to hail from aristocratic families that had dominated politics for centuries. The decline of this hereditary elite in the eighth century and enlarged educational opportunities for sons from common families in the provinces set the stage for the rise of a new educated elite, the scholar, after the fall of the Tang and at the beginning of the Northern Song (960–1127).[37] The intellectual and artistic priorities that these men fashioned became so paradigmatic that they exerted lasting impact on the self-perceptions and values of scholars in subsequent dynasties. In particular, their antiquarian tastes, predilection for collecting vessels from the classical era (or ink rubbings of inscriptions on them), systematic research of ancient scripts, and emphasis on personal character in the calligraphic hand, all focused attention on the theory and practice of calligraphic writing.[38]

Knowledge about brush, inkstone, paper, and ink was crucial to the Northern Song scholar because he recognized that writing—his métier—was a practiced craft that could be improved by sharpening his tools. In this sense, the emergent literati set on establishing their "professional" identity can be said to exhibit a craftsman's cast of mind, although in their own eyes this by no means reduced them to the status of craftsman. Indeed, recent research shows that Song scholars took an active interest in the technology of writing and were often involved in the actual making of their implements. For example, Su Shi, a paragon of the new literati, taught an ink-cake maker how to improve his formula; his friend Mi Fu made some of the inkstones he used and was conversant with papermaking because he held that an understanding of the technique of mounting scrolls was essential to a connoisseur of antique paintings.[39]

In this milieu, specialized knowledge about identifying, using, washing, and repairing inkstones became one of the hallmarks of a cultivated man and a prerequisite of an accomplished artist. The inkstone figured not only as a key material factor in the scholar's craft but also an object of aesthetic contemplation, a subject of specialized research, and an attribute of the scholar himself. The beginning of a tradition of connoisseurship treatises on the inkstone in the tenth century is symptomatic of this development. The literary flourishes and discourses on the artistry of writing aside, the core of the connoisseur's knowledge, which pertained to the quality and features of stones, originated from the stoneworkers.

The scholar's identification with the tools of his trade was articulated with humor by the late Tang literatus Han Yu (768–824) who anthropomorphized the inkstone by giving him a personal name (Mr. Clay Water; Taohong Jun) and a place of birth. It reached new heights when the brush, inkstone, paper, and ink-cake were grouped into a system, under the name "Four friends" or "Four treasures of the scholar's studio," in the eleventh century.[40] Although he did not use this iconic name, a high-ranking official and member of an influential literary family, Su Yijian (958–996), was the first to discourse

on the four under a dedicated title, *Four Treatises from the Scholar's Studio* (Wenfang sipu). Revered as the progenitor of a genre and garnering an obligatory mention in subsequent works on the subject, *Four Treatises* is in fact an outlier in organization and content to the tradition it helped spawn. Su grouped information about each implement into four topics. For the inkstone, paper, and ink-cake: narratives, manufacture, anecdotes, and lyrical depictions; for the writing brush, in place of "lyrical depictions" a unique section on the skills of wielding the brush in calligraphic writing (literally "propensity of the brush," *bishi*). The writing brush received preferential treatment from Su, who deemed it the key to a writer's artistry.

Despite its consistent structure, *Four Treatises* is a loose collection of personal observations, hearsay, and quotations from historical and fictional accounts that harks back to the "notation book" tradition. The section "Manufacture," for example, contains a method for making sieved-clay inkstones, encomiums by an Eastern Han poet, and descriptions of the Duan inkstone as an exotic commodity from a distant and less civilized place: "People say that there is a river in Duanzhou called Duanxi; its stones make the most marvelous inkstones that activate ink that are extremely clean. In the river there grows a kind of algae that is lush and lovely. After the craftsmen finish carving, they wrap the inkstone with the plant. Therefore the stones can withstand the journey from beyond the mountains [Guangdong] to the central plains [of China] intact."[41]

In prefacing his descriptions with "People say," Su Yijian admitted that he had never been to Duan. He did not make claims for himself because his intention was less to proffer authoritative opinions and more to supply anecdotes as literary references for the scholar at drinking games to dazzle his poetic opponents. Art historian Craig Clunas has described this way of organizing information as a form of "aesthetics of multiplicity," whereby "more is more." Contrary to the analytic logic of the Aristotelian tradition, the anecdotalist is not compelled to fit every bit of knowledge into a coherent and hierarchal framework. Entries of disparate epistemological status can be aligned side by side; the list can grow infinitely. Although Clunas is speaking primarily of Chinese encyclopedias, notation books such as *Four Treatises* are perfect examples of this mode of knowing and reasoning, which he also calls "poetics of the list"—lists are not "raw data from which pattern can then be deduced (as they might be for Aristotle or Sherlock Holmes), rather they have the power to make and structure meaning in their own right." In this world, "the power of the specific . . . is greater than that of the systematic."[42] The stoneworker's method, especially that of the prospector, is ironically more in line with the deductive mode of Sherlock Holmes than Su Yijian's.

MI FU: THE CONNOISSEUR AS ARBITER

The critical discourse on inkstones took a decisive turn toward the systematic one century after *Four Treatises*, with the appearance of *An Account of Inkstones* (Yanshi)

by Mi Fu (1051–1107). It stands as the veritable progenitor of the genre of inkstone connoisseurship books that proliferated in the Qing and remained vibrant until literati culture declined in the nineteenth century. A seminal theoretician and practitioner in the history of Chinese calligraphy, Mi redefined the classical Jin model that began in the fourth century by suffusing it with the emphasis on individualistic style in vogue in the Northern Song. Mi, also a prolific painter and collector, was a man of "irrepressible energy" who was particularly apt in engineering his own persona in public and in posterity. *Account of Inkstones* is an indispensable part of his performance of the self as what art historian Lothar Ledderose calls "the paragon of the Chinese artist-connoisseur."[43]

Mi Fu's treatise begins with a manifesto that validates minority or contrarian opinions (that is, his own) in connoisseurship. Then follows the first of three sections called *pin* (to appreciate, classify, adjudicate, or arbitrate) in which he offers authoritative judgment on matters that befuddle the amateur. Sandwiched between the first (on the primacy of function) and the two other *pin* sections (on the nature of stones and historical evolution in the shapes of inkstones) are catalogue-style descriptions of the place of origin and quality of twenty-six stones, including one from Korea. At least the top of this list is ranked in descending order of appearance according to Mi's own experience of grinding ink with them.[44] *Account of Inkstones* differs from Su Yijian's in self-presentation, method, and structure of knowledge. In contrast to Su's self-presentation as an anecdotalist who jots down whatever drifts into his eyes and ears, Mi styles himself an authority and arbiter who, as an experienced calligrapher armed with comprehensive knowledge about all the salient quarries in the empire and beyond, is in a position to dispense judgment on the good, the bad, and the ugly.

Mi Fu adopted an objective perspective, that of the all-seeing eye of a god, and his method is the empiricist's creed of "I see it with my own eyes." Hence he took pains to state, regarding a recently harvested stone from the Immortal Ge Rock in Fangcheng, Tangzhou, that "I have seen scores of them." But as to the more popular Duan stones, he claimed that "in my lifetime I have seen five to seven hundreds."[45] Mi Fu described his method of connoisseurship with a profusion of the first-person pronoun: "All [the inkstones] that I adjudicate [*pin*] are those that I have seen [*muji*; literally, "struck with my eyes"], gathered in my collection, or used with my hands. Those I have only heard of, no matter how famous, I neither record them nor pass them on."[46]

Mi Fu's entry on Duan inkstones exemplifies his rhetorical strategy of conferring authority on himself. It is also carefully positioned and worded to intervene in the three major controversies among collectors of his day: the relative merits of Duan versus She stones; whether the valued "eyes" on Duan stones facilitates ink-grinding or are merely decorative; the true meaning of a "child stone." He began with geography of "The Rocks at Duanzhou": "There are four kinds [of rocks/locations]: the Lower Rock [Xia Yan], Upper Rock, Banbian Rock, and Houli Rock. Having been to the Duan area myself, I

FIG. 2.8. Mynah's eyes on stones mined from Little Pit (A.1–A.6, A.12), Pockmark Pit (A.7, A.8, A.11), and Plum Blossom Pit (A.9, A.10) in the industrial standards handbook promulgated by the Guangdong provincial authorities in 2006. From Guangdongsheng zhiliang jishu jianduju, *Guangdongsheng difang biaozhun*, 7.

know all details about it." Unlike Su Yijian's randomness, Mi's list is ranked in descending order of appearance.[47]

Of the stone at the top of his list, Mi Fu opined: "The stone is fine-grained, and when struck it gives a clear sound. Its mynah's eyes are round, surrounded by a ring of azure cloud that often sparkles brightly."[48] The mynah's eye, a high concentration of iron in mica that often appears in concentric circles of varying layers and colors (fig. 2.8), lies at the heart of a controversy among Song connoisseurs. Collectors came to value such natural mineral features and were willing to pay more for stones with them. The connoisseur Tang Xun (1005–1064) described this fashion in his *Record of Inkstones* (Yanlu): "In the main, [Duan stoneworkers] hold those stones with eyes as valuable. They call them 'mynah's eyes.' For a stone to have exquisite patterns is like wood with its grain."[49] His contemporary, the venerable scholar Ouyang Xiu (1007–1072), disagreed. Ouyang, the first to subject ancient scripts and rubbings to systematic study, kept his own set of notations on inkstones. He had a rather low opinion on the fad for Duan

FIG. 2.9. Wu Ligu, *Tang Yin's Peach Blossoms Hut* inkstone, 2003. She stones, a slate, share the dark purple color of most Duan stones but have distinct surface mineral markings. This one features a patch of "gold flowers" on its face, which modern carver Wu Ligu fashioned into the blossoms of a peach tree. On the ink pool underneath the tree another characteristic She feature, the wave-like "eyebrow mark," is visible. First mined in the early eighth century, She stones were conveyed to the Southern Tang (937–975) court in Nanjing as tributes. By the Song, about ten quarries in Mount Longwei (Wuyuan, present-day Jiangxi) had been exploited. Mining continued, albeit at a far reduced scale, into the Ming and Qing. At an average hardness of 4.0 on the Mohs scale, She stones are harder than Duan. L 21 cm, W 16 cm, H 3.5 cm. Courtesy of Wu Ligu.

stones in his day because "out of ten there are no more than one or two that activate ink." He dismissed eyes as "defects in stones."[50]

Mi Fu introduced a new perspective altogether with his ranked list of the four Duan quarries, his attentive descriptions of the characteristics of the eyes in stones from each of the first three, and his remark on their absence in the fourth. "Eyes" are useful because they allow the scholar to infer from the appearance of his inkstone the original

location of the quarry; they are valuable visual clues to authentication.[51] The same rhetorical strategy also allows Mi to weigh in on another controversy about the relative quality of Duan and She stones from Shezhou (fig. 2.9) by refining the terms of analysis. There is no typical Duan or She stone; the quality of stones from the four Duan quarries varies so much that one needs to be locale-specific in evaluations.

Mi Fu, who related that the Lower Rock quarry had long been closed in recent decades, could not have known that its stones had mynah's eyes had the Duan stoneworkers not told him so. On this and other fine gradations of stones from the four sites, Mi staked his authority on his own experience in the Duan area without crediting the actual source of his information. He mentioned the stoneworkers only when he needed to borrow their authenticity to shore up his own stance on another controversial subject: "I have everywhere made enquiries from the stoneworkers, who said there is no such things as the 'child stone.'" Although Song collectors believed "child stones" to be stones born miraculously from a large rock and paid a premium for them, Mi had long thought them foolish, believing instead that "child stones" were mere egg-shaped polished pebbles found in rivers.[52]

Otherwise, the stoneworkers of Duan appear in Mi's account as "natives" (*turen*; "men of the earth," a pejorative term that connotes a lack of civility) who were oblivious to the salutary qualities of Houli stone because they themselves did not grind ink. To Mi, the finest Houli stones could surpass even Upper Rock and Banbian Rock, but the natives used them to make children's toys and other trivial items.[53] In spite of, or perhaps because of, Mi Fu's obvious indebtedness to the stoneworkers of Duan, knowledge of the latter always appears in quotations, the very citation of which confers authority and authenticity on Mi himself. In this way, the establishment of the subject position of the scholar-connoisseur in the Northern Song goes hand in hand with the denigration of his inferior other, the craftsman (the stoneworker in this case).

For all their differences, Mi Fu is heir to Su Yijian in one important aspect: the shared strategic use of a discourse of function to police the boundary of the scholar-literati group. When Su explained his intentions of compiling the *Four Treatises*, he inaugurated a discourse of function that is his lasting legacy: "The purpose [*yong*, or utility] of the *Four Treatises* is none other than [promoting the artistry of] writing."[54] Mi Fu states in even more categorical terms: "The merit of a vessel inheres in its being usable. . . . When it comes to classifying and ranking inkstones, the most important criterion is its ability to activate ink; second is its color; the refinement or coarseness of its craftsmanship and shape comes last."[55] The emphasis of the primacy of usefulness allows the scholar-connoisseur to distinguish himself from his impostors, the dilettanti who have no mind for writing as a studied craft.[56] As for the stoneworkers who possess expert knowledge on the mineral features and geographical origins of the stones but do not use them to grind ink, the discourse of function reduces them at best to idiot savants in their own trade and anonymous native informants to the scholars.

The paradigm of the scholar-connoisseur established by the Northern Song paragons gained luster as it receded in time in the centuries that ensued. The supremacy of literati culture was solidified in the face of overt suppression by the Mongols who ruled China under the Yuan (1271–1368) and denigration on the part of the founder of the Ming dynasty (1368–1644). The emphasis on calligraphic writing as a craft and as expression of a man's moral qualities articulated by Mi Fu and his friends continued to structure the status gap between the scholar and the stoneworker.

By the eighteenth century, the body of inkstone connoisseurship literature in both the anecdotalist approach established by Su Yijian and the systematic format pioneered by Mi Fu had mushroomed.[57] Written knowledge about inkstones had become highly self-referential, consisting of quotations of quotations, and anthologized in multiple loops. The flourishing of a philological movement in the late eighteenth and early nineteenth centuries, called "Han learning," "plain learning," or "evidential scholarship," reignited scholarly interests in trekking to the Duan area to gain first-hand knowledge, but it did not alter the unequal relationship between the scholar and the stoneworker.

As historian Benjamin Elman explains, the slogan of the philological scholar is "seeking the truth from concrete facts" (*shishi qiushi*).[58] A salient pursuit of evidential research, studies of "metal and stone" (*jinshi xue*), inspired an empire-wide hunt for archaic scripts carved on stone steles or exposed cliffs, as scholars sought to ground their knowledge of history and art in direct encounters with ancient artifacts in situ instead of hewing to received traditions of textual transmission.[59] A full discussion of this diverse intellectual movement lies outside the scope of the present book, suffice it to note here that this hunt for inscriptions on stones in nooks and crannies of the land signified a renewal of the "I saw it with my own eyes" mode of knowing in inkstone connoisseurship inaugurated by Mi Fu.

This emphasis on being an eyewitness is manifest in a new visual depiction that had no precedents before the early nineteenth century: maps of the Duan quarries, carved on the very backs of the writing implement or incised in relief on wood blocks and printed as book illustrations.[60] In contrast to the "poetics of the list" that allows infinite multiplication of names in inkstone catalogues and notation books, these maps are necessarily selective in the information they present. By the eighteenth century, over seventy quarries in the Duan area had been exploited, each yielding stones with what connoisseurs claimed to be distinctive shades of color, surface mineral features, texture, and density (an elaborate nomenclature had developed to describe each one).[61] The schematic maps are not granular enough to show them all. The selection and visual strategy of the mapmaker are instead explicit pedagogical devices educating the readers about an ever-shifting internal hierarchy among the Duan quarries as new pits were opened or familiar lodes exhausted.

FIG. 2.10. Map of the Old Pit on the back of an inkstone. The inscription above the map describes the manpower needed to harvest the stones inside the tunnel. The rhetoric is identical to that of the printed map in He Chuanyao's treatise *Discerning Inkstones* (see fig. 2.12), but the numbers differ. L 13cm, W 12.5cm, H 2 cm. Tianjin Museum.

A map on the back of an undated Duan inkstone (fig. 2.10) that is likely from the nineteenth century offers a somewhat naturalistic depiction of the topographical features of Mount Lanke (unmarked on the map), terminating in a named summit in the upper right corner. Two labels mark the (accurate) locations of the Little Pit and Pockmark quarries nesting in the folds of the mountain. What appears as shading on the rubbing is a result of low-relief carving and skillful rubbing-making. Also visible in this veristic depiction are the human activities and sites of cultural memories that animate the place: among them a fisherman sailing downstream in a boat with a woven canopy typical of the region and two shrines central to seafaring and quarrying rituals.[62]

On the same map the viewer encounters a second, distinctly *un*naturalistic visual strategy that anticipates the X-ray: to the left of a shrine guarding the entrance to a quarry is a tunnel that to modern eyes resembles a digestive tract with seven lobes, each one named. The intuitive ability of the prospector to "see through rocks" has be-

come a form of visual representation. These are the shafts, cut more and more deeply into the belly of the earth as stoneworkers sought to follow the veins of the most desirable stone for inkstone-making in the empire, the finest of the fine Duan stone from the most celebrated quarry, the Underwater Lode. The arching tree on the lower left corner of the inkstone, the fluttering flag on a pole, and the forward-leaning body of a man rowing a scull all direct the viewer's gaze to the series of connected caves. Its frontal presentation constructs the viewpoint as being directly across the Xi River, which in reality corresponds to no human settlement; the vantage point is that of a bounty-hunter on the opposite shore bargaining for a ferry, his eyes fixated on the holy grail of inkstone making.

The general recognition of the Underwater Lode as the most desirable among the Duan quarries dates to at least 1600, when a celebrated mining operation yielded quality stones.[63] Single-minded pursuit of stones from this one quarry reached new heights in the nineteenth century. As more stones were retrieved from deeper recesses in the submerged tunnel, more people in the central plains became cognizant of the name, generating desire for the stone and knowledge about it among a new group of collectors. The aforementioned map on the back of an inkstone signals a new epistemic priority due to this "tunneling effect": a desire to see through the bedrock of Mount Lanke so as to discern the relative positions of the chambers dug during successive operations. The structure of knowledge has shifted from an ordering of the seventy-some quarries scattered in the Duan area to an ordering of the stones gathered from the *same* shaft of the submerged quarry but in different years.

This fixation on, and indeed the fetishization of, the inside of the Underwater Lode found graphic expression in a map carved on the back of another inkstone (fig. 2.11). The billowing waves dwarfing the semicircular boats and the foliated riverbanks direct the viewer's gaze to the outcrop of rock in an indescribable shape that juts into the river: the Underwater Lode, turned inside-out and replete with schematic lobes clearly labelled, appears more hollow than solid despite its larger-than-life size. An inscription on the front of the inkstone reads: "Made on mid-winter day, the year *bingxu* of Daoguang [1826]."

The maker or inscriber of both inkstones called their maps *tu*, which anthropologist Francesca Bray suggests is best rendered as "technical images" in this context.[64] To summarize arguments made thus far: the appearance of *tu*-maps, a new mode of visual communication about Duan quarries in the first half of the nineteenth century, serves to reorder the hierarchy of Duan stones. The emergent hierarchy at once positions the Underwater Lode as superior to other Duan quarries while inaugurating a system of internal differentiation within the former. More than displaying inert information, *tu* also works to incite action: in this case the quest of literarily grounded knowledge about the inkstone on one's desk, tracing its origins back to a particular cave on the southern edge of the empire.

FIG. 2.11. *Map of Duanxi* inkstone, (A) back; (B) front. The existence of an identical inkstone in the Tianjin Museum (Cai Hongru, *Zhonghua guyan*, 171) suggests that Guangdong artisans might have been both the instigators and benefactors of the fad in penetrative views of the Underwater Lode in the early nineteenth century. L 20.6 cm, W 13.7 cm, H 2.9 cm. Metropolitan Museum of Art, New York.

A

B

Seen in this light, some of the forces that propelled the appearance of maps of the Underwater Lode can be sought in the currency of the philological method of precise and impartial research, which encouraged more outsiders from the central plains to journey to Guangdong and more officials stationed in or passing by the Duan area to write about the geography and geology they observed with their own eyes.[65] The exorbitant prices that the limited supply of fine-grained stones commanded and the jostling in an overcrowded career path of scholars, who wagered that an expertise in inkstones might open doors to new patronage networks, also explain the zeal in the search for truth deep in the subterranean tunnels using an increasingly microscopic vision.

The visual trope of X-ray-like penetration is analogous to the rhetorical devices of "I saw it with my own eyes" or "I heard it from the native or old stoneworker" in the production of a reality effect: all are authority claims that are intrinsically paradoxical. Although both the visual and verbal tropes give the illusion of authentic on-the-ground knowledge, they also position the viewer or writer as an outsider who could not have crawled inside the shaft, no wider than 70 to 90 centimeters in diameter and submerged under water except during mining season. Even if he had been able to gain entrance during a mining operation, he would not have been able to see what he most desired in the dim illumination of burning wick dipped in lard. The problem was not one of visibility but epistemology. The challenge of the connoisseur—his "science" if one may—was to infer from the surface mineral features and color of the stone on his desk the exact location of its origins in the shaft (which grew to over 100 meters long by the nineteenth century). But the shaft, now emptied of its lode and the bedrock that encased it, yielded no clue to that correlation. All that one could have seen would have been subterranean puddles and piles of waste rock littering the floor. The would-be eyewitness would have found himself crawling naked in a tunnel, which was by defini-

tion empty and perhaps in imminent danger of collapse. The hypothetical situation is a near-comical refutation of the philological creed of "seeking the truth from concrete facts" gathered from personal observation.

But of course this inconvenient reality was never made explicit in the discourse. The knowledge useful to the inkstone connoisseur is constructed ex post facto and shored up by faith in the authority claims of someone *else*. It is the opposite of what is usually meant by authentic, in situ, or indigenous knowledge.

THE LOCAL EXPERT MADE HIMSELF KNOWN

Without crawling into the shaft, the expert who shifted the ground of knowledge about the Underwater Lode was He Chuanyao (fl. 1820s–30s), the writer of the slim treatise *Discerning Inkstones from the Treasure Inkstone Studio*, completed in 1827 and published about ten years later.[66] An aspirant scholar, He Chuanyao was a famous man in Gaoyao, a town directly upriver from the Underwater Lode, although Gaoyao was a very small place. His home, on the northwestern side of town, housed a collection of inkstones, heirlooms passed down from his father. Other local collectors praised it as impressive, but no one outside Gaoyao, let alone the province, seems to have heard of it. Nevertheless, He Chuanyao became the rare local expert who lived a stone's throw from the quarries and managed to garner enough logistical and financial support from visiting outsiders to have his treatise published.

Discerning Inkstones ruptures the existing discourse of inkstones in two ways. First, it is the first treatise to include maps of a Duan quarry—the inside and outside of the Underwater Lode in this case. The maps were drawn by a minor scholar by the name of Huang Peifang, who arrived in Gaoyao from Xiangshan, a town on the Pearl River Delta, to collect information for a gazetteer project. Most spectacular is the map of the interior of the Underwater Lode (fig 2.12), showing the relative locations and parameters of its four main cavities—the East Cave, Main Cave, Minor West Cave, and Major West Cave. The map on the back of the first inkstone discussed earlier is likely to have been modeled on his creation.[67] Besides the seeing-through view itself, another innovation introduced by He and Huang with this map is the measurement of space in terms of manpower. The total length of the shaft (and the distance between any two points in the tunnel) are calibrated in terms of the number of stoneworkers needed to line up the tunnel one-man strong; the height of the ceiling is indicated by "sitting man" or "standing man." This discourse of manpower, first introduced by geographer Li Zhaoluo, who wrote *Notes on the Quarries of Duanxi* during his sojourn in the Duan area in 1820 through 1822 and cited earlier, has now been expanded and given visual expression. The accent on logistics and labor management reflects the growing visibility of the "logistical and epistemic culture of working" in the Duan area in the early nineteenth century.[68]

Besides pioneering the visual technologies with his mapmaker, He made a second,

硯巌内圖

- Ⓐ Topographical features
- Ⓑ Names of quarries
- Ⓒ Notations of manpower needed
- Ⓓ Annotations by He Chuanyao and Huang Peifang

FIG. 2.12. Inside the Underwater Lode. A. Topographical features: (A1) Entrance to the cave; (A2) The Chest-Touching Stone; (A3) Mouth of the water trough; (A4) Back of Cart; (A5) Front of Cart; (A6) Plum Tree columns; (A7) Tiny Gatetower; (A8) Giant Pond; (A9) Swimming Fishes Isle; (A10) Entrance to West Cave.

B. Names of quarries: (B1) Temple Tail Cave; (B2) Flying Mouse Rock; (B3) East Cave; (B4) Wee Cave; (B5) Main Cave; (B6) Minor West Cave; (B7) Canopy Cave; (B8) Shuigui Cave.

C. Notations of manpower needed: (C1) Position of the first man; (C2) Fourth man; (C3) Sixth man; (C4) Fifteenth man; (C5) Eighteenth man; (C6) Forty-third man; (C7) Fifty-second man; (C8) Fifty-fourth man; (C9) [Another team of] thirteen men [drawing water]; (C10) Eighteen men [drawing water, seated].

D. Annotations by He Chuanyao and Huang Peifang: (D1) I group this stone [from Temple Tail Cave] with that from the East Cave because they are similar in quality and color; (D2) Whenever there is an operation [in the Underwater Lode], this cave is always sealed up and no stones are taken from it; (D3) The Wee Cave and Main Cave are not two separate entities—the door to the former is inside the latter; (D4) After the Canopy Cave, all [caves/stones] are part of the Major West Cave; (D5) This is where the Qianlong-era operations stopped; (D6) This is where the Jiaqing-era operations stopped. From then on, they have had to go high [to take stones from the ceiling]; (D7) This passageway is over one *zhang* [three to four meters] and no men sit here.

Diagram drawn by Huang Peifang. From He Chuanyao, *Discerning Inkstones*, no page.

perhaps even more far-reaching, intervention in the tradition of inkstone connoisseurship. In his text He summarily dismissed the cherished hierarchy held by out-of-province scholars since the early Qing: that the most superior stone hailed from the Main Cave, followed by those from the East Cave and the two West Caves.

Embedded in the structure of He's table of contents ("A ranking in descending order of the Four Caves") is his subtle albeit radical revision:

1. Major West Cave (including Canopy Cave)
 Appended: [Seven] quarries that resemble it: Old Su; Sky-Facing;
 Dragon Craw; Old Lode (Lao Yan); White Stripe; Little Pit; Pockmark
2. Main Cave (including Wee Cave)
 Appended: [Eight] quarries that resemble it . . .
3. Minor West Cave
 Appended: [Seven] quarries that resemble it . . .
4. East Cave (including Temple Tail Cave)
 Appended: [Four] quarries that resemble it . . .[69]

He Chuanyao simplified existing geography by subsuming three previously independent caves of the Underwater Lode (Canopy, Wee, and Temple Tail) under his nomenclature of the Four Caves. Furthermore, his organization elevates the Major West Cave, the most recent to open, to the pinnacle of the hierarchy. Also notable is the system of appendices he introduced of twenty-six quarries in the Duan area, called somewhat disparagingly "miscellaneous quarries" (zakeng, 1b). Some of them, notably the Little Pit and Pockmark Pit, were deemed separate and equally desirable by other connoisseurs. Their inclusion in the appendix is a double-handed complement. To be counted at all is a badge of honor, as several quarries esteemed at the time fail to appear at all. But in subsuming all worthy quarries to the Four Caves of the Underwater Lode, He Chuanyao established the supremacy of the latter by making the Lode the norm against which all other stones were to be assessed.

Understandably, the entry on the supreme Major West Cave is the first and the longest. A few excerpts convey He's rhetorical strategies: "[Stones from] the Major West Cave come in five strata. The top stratum is greenish-purple in color, of a coarse and thick substance [zhi]. . . . Next comes the second stratum. Its 'sky blue' [a mineral mark] appears as the color of the sky after the morning star has faded but the sunrays have yet to appear" (1b). He's lyrical description appeals to shared sensory experiences. Another characteristic of He's prose is that instead of justifying his valuation, the author simply listed the unique characteristics of each of the five strata (as well as two sublayers within the third stratum and three sublayers within the fourth stratum). Of the bottom sublayer of the fourth stratum, he wrote: "There are green 'five-colored nails' and white 'five-colored nails' [another mineral mark], both so hard that they repel the knife.

None of the stones from the 'miscellaneous quarries' have these features. Nowadays people use them to tell the stones apart, but they are in fact defects" (3b). The entire raison d'être of his knowledge system is the connoisseur's mandate of authentication. He comes to the aid of the uninitiated by making the distinctions between the authentic and the fake unequivocal and discernible. His lists of "Appended" quarries might as well read, "Beware of forgeries!"

In identifying the origins of stones and deciphering the authentic from the fake, He Chuanyao exudes a confidence rarely seen in other treatises. Instead of making claims that out-of-town authors staked on "natives" or "old stoneworkers," He simply stated what he knew in a deadpan tone of certainty. Adverbs such as "always," "inevitably," "never seen," and "occasionally" give the impression that he has seen it all and can size up any one stone in the context of a total system of comprehensive knowledge.

He Chuanyao grounded his authority on his judgment and sensory experiences: He "examined under direct sunlight" surface details (3a, 5b, 8b), "tapped [with the knuckles]" to discern if the echo resembles that of metal, wood, or ceramic tiles (2a, 9a, 13a), "turned the stone sideways" to make out the direction of the grain of the slate (13b), "scratched away" surface features with his fingernails to see how deeply embedded they were (5b, 15a), or "tested with a knife blade" to determine if a particular kind of joint in the stone was sandy or rocky in nature (9a). Each test, however intrusive, is necessary because it yields a sign about the exact origins of the stone, not only in terms of a certain quarry but the exact location of the chamber in the shaft. When all the signs are added up, the truth is revealed. He Chuanyao summed up his method: "Discerning [even slight] differences between [what appears] to be similar; discerning the [underlying] similarities from apparent differences" (17a). It sounds as if he had taken a page directly from the method of the philologists.[70]

To sum up, in his radical revision that places the Major West Cave at the top of the hierarchy of the Underwater Lode (and by extension all Duan stones, and hence all stones in the empire), He Chuanyao remade the structure of knowledge about inkstones in three ways: he redrew ("clarified") the parameters of the four caves of the Underwater Lode in a more precise manner; he devised a new classification scheme of the main Duan quarries; and he introduced a universalist discourse of "color" (the hue, mineral features, and other surface qualities pleasing to the eye) and *zhi* (nature, materiality, the quality that makes an inkstone conducive to grinding ink without hurting the brush) by which all stones are to be described and evaluated. The *zhi* of a stone is nothing mysterious; the experienced connoisseur can know it by closely examining, tapping, or scratching the specimen on hand.

He's ranking of the quarries and standards of judgment, unique in his times, circulated widely in the empire after a scholar with more respectable academic credentials, fellow Guangdong native Wu Lanxiu (1789–1839, 1808 provincial graduate), incorporated them verbatim in his own treatise completed around the same time, *Chronicle of*

Duanxi Inkstones (Duanxi yanshi).[71] A classicist at the Sea of Learning Academy in the provincial capital of Guangzhou (one hundred kilometers east of the Duan area), one of the regional hubs of philological research in the empire, Wu offered in his treatise comprehensive and impartial coverage of all salient systems of knowledge about Duan inkstones. One reader of this popular book, however, singled out He Chuanyao's opinion as the most "original, nuanced, and accurate," whereas the rest of the book seemed "nothing special." Another reader opined that He's ability to discourse on the minutiae of the real and the fake surpasses even that of experienced "old stoneworkers."[72] He Chuanyao's stands as the canonical view today.

THE STONEWORKERS, REDUX

He Chuanyao established his arguments by refuting two other groups of experts: a tradition of connoisseurship treatises written by scholars throughout the empire, and an oral tradition maintained by Duan stoneworkers in the Yellow Hill villages.[73] We have seen that following the example set by Mi Fu in the eleventh century, it had become customary for out-of-province scholars to interview stoneworkers and accord them authority as native informants. He Chuanyao, in a marked departure from this long-standing practice, reserved his most pointed criticisms for the latter.[74] Part of his disenchantment stems from the particularistic nature of the stoneworker's knowledge; it is useless to the scholar because it cannot be generalized. He recalled the frustration of a gazetteer editor who found that "every stoneworker tells a different story" (21a). The stoneworkers also promoted a different hierarchy of taste than He Chuanyao and his friends, who lamented that "nowadays the stoneworkers consider a pure blue-green hue [*chunqing*] the most desirable color," which offended the scholars' preference for deep purple, the canonical color for high-end Duan stones.[75]

But for He, the stoneworkers' biggest travesty is that they deliberately misrepresented the stones in order to aggrandize themselves. Going to great lengths to pull the wool over the public's eyes, they call a defective crack "cracked ice patch," an allegedly desirable mineral feature (4b, 5a); they invented the fancy term "rustic air" (*luqi*) to beautify what was in fact unredeemable dryness (15b); and they sold coarse slabs of bedrock worthy only to become knife-sharpeners or steles as antiques from the then-defunct Song quarry (9b). In what must have been an ingenious technical feat if He's accusation is true, the stoneworkers even hammered Old Su stones—which resemble those from the supreme Major West Cave except for the sound—to break their invisible veins, thereby coaxing a wooden instead of a metallic echo out of them (4a).

Indeed, He Chuanyao's reordering of the parameters of the Four Caves of the Underwater Lode and his reshuffling of their order of desirability are direct rebukes to the ingenuity and deception of the stoneworkers. He accused the latter of proffering the choicest stones from both the Main Cave and Minor West Cave as representative of

Minor West, leaving the lower-grade stones from the Main Cave to stand for the typical quality of the latter. This led unknowing collectors throughout the empire to rank Minor West over Main categorically. As He writes, this is a bad case of "extrapolation from one example to the whole," resulting in the erroneous damning of the entire Main Cave. Citing the wisdom of "various bygone elders" (*zhu gulao*) and his own experience of a multitude of questionable qualities of Minor West stones that he had examined, He revised the prevalent hierarchy by ranking Main Cave second and Minor West third (10b–11a, cf. 1a).

In between the lines, however, He Chuanyao's rebuttal of the stoneworkers provide the most reliable evidence in writing of the *substantial* but *hidden* discursive power and technical ingenuity of the stoneworkers of Yellow Hill. For centuries, they manipulated knowledge about Duan inkstones and the criteria of their assessment by dint of their privileged status as native informants to visiting scholars. The prevalent valuation schemes that connoisseurs had promulgated in their treatises ever since the time of Mi Fu were in fact by and large those of these craftsmen. They affected the vicissitudes of fads for particular hues and mineral markings by making new stones and desirable features available to the buyer. Their power to name new quarries, stones, and mineral features generated new tastes in the marketplace. When He Chuanyao accused the stoneworkers of (mis)naming stones, the offense was really one of usurping the métier of the scholar. (Mis)naming is exactly what He himself proceeded to do when he sought to set the record straight.

The scholar's predilection to generalize from the particular, to systematize knowledge, and to develop comprehensive all-seeing perspectives may appear to be superior to the piecemeal and localized knowledge of the stonecutters, but their difference is more one of style and rhetoric than substance. The connoisseur's task is in fact identical to that of the stonecutting prospector: to extrapolate from the surface features of a stone its origins in a certain part of the mountain or a certain geological strata. The prospector's knowledge is by no means less analytic or comprehensive than the scholar's. The scholar may have spoken more loudly and audibly across the barriers of time and space, but without the prospector-miner who found and extracted the stone from inside the tunnel and lived to identify them, there would have been neither Mi Fu's *Account of Inkstones* nor He Chuanyao's *Discerning Inkstones*.

He Chuanyao's efforts, although influential in changing the prevalent ranking of Duan stones among his readers, thus did not obliterate the natural de facto advantage enjoyed by the stoneworkers. He's lasting contribution was to produce for himself a new form of brush-based authority, thereby conjuring a new subject position—the local expert—as an alternative native informant to the stoneworker that outside scholars could call upon. The contest in naming and ranking, convoluted though it may be, reveals tensions and fissures in overlapping but contending knowledge systems involving agents occupying three subject positions on two shifting fronts: first, between the

out-of-province visitors and the local scholars who wrote, and second, between the scholars who wrote, foreign or local, and the stoneworkers who worked with both brain and brawn but not with the brush.[76]

In the final analysis, the showdown between He Chuanyao and the stoneworkers, two indigenous authorities, was a contest between two forms of power to dominate the Duan quarries and to profit from their dominion. He's resources stemmed from the writing brush, whereas the stonecutters depended on knowledge embedded in the tools they fabricated and honed for over a millennium while crawling in tunnels dug with their own hands. In light of the high prestige that literary culture has enjoyed in the Chinese cultural world and in the face of a centuries-long tradition of denigrating the craftsman, it is remarkable that the stoneworkers proved to be the scholar's match. The same, however, cannot be said of the inkstone carvers who might seem more advantaged in their relative proximity to the scholars.

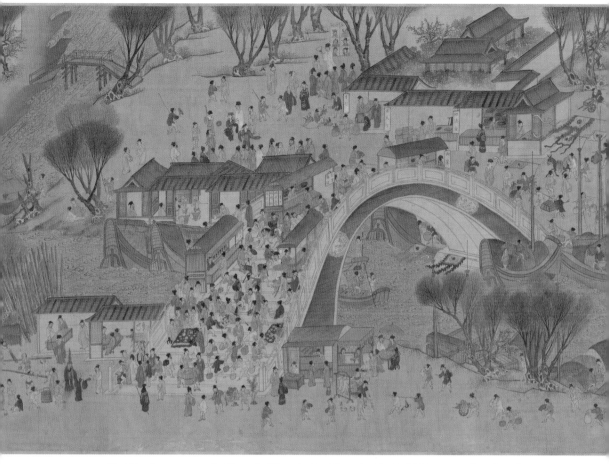

FIG. 3.1. Qiu Ying (ca. 1495–1552), *Along the River during Qingming Festival* (Qingming shanghe tu), detail showing shops, warehouses, and workshops. Under the bridge, porters unload cargo from river barges. Although modeled after an earlier painting by the same title and not specifically set in Suzhou, this painting by an eminent Suzhou painter captures what the hustle and bustle of the Chang Gate area would have been like. 987 × 30 cm. National Palace Museum, Taiwan.

3

Suzhou

THE CRAFTS(WO)MAN

THE LOCATION OF INKSTONE CARVER GU ERNIANG'S WORKSHOP, IN-herited from her father-in-law and thus not of her choosing, affirms the age-old recognition that commerce and handicraft are natural bedfellows.[1] Tucked in an alley a stone's throw from the hustle and bustle of Chang Gate, in the northwestern quadrant of the imperial city of Suzhou, the Gu shop was conve-nient to merchants from the surrounding countryside, faraway provinces, and foreign countries as well as aspirant scholars who, like migratory birds, crisscrossed the empire to try their luck at the metropolitan exams in the capital every three years. As the hub of water transportation in the heartland region of Jiangnan, Suzhou was an obligatory stop for many.[2]

Suzhou commanded attention from merchants and scholars alike because of its special status in the urban history of China. Two hierarchies of urban places existed in late imperial China: that founded by politics and that founded by commerce, and Suzhou occupied a privileged place in both.[3] In the Qing administration it was the seat of Suzhou prefcture (the eastern and western halves of the city were placed under the jurisdiction of two separate counties until 1724, when the eastern half was further split into two). But silk and cotton industries have been synonymous with Suzhou since the beginning of the sixteenth century, and the capital-intensive merchants and skilled artisans were its princes. The cotton industry alone employed one out of fifty people in the eighteenth century, when the population of Suzhou hovered around half a mil-lion.[4] In the western city, especially the area around Chang Gate where the Xu River met the Chang Gate Canal, the streets were packed with shop fronts, warehouses, lodges, weaving mills specializing in plain silk, patterned brocade, and gauze as well as cotton dyeing and calendaring plants. Whenever a cargo shipment arrived, a Qing

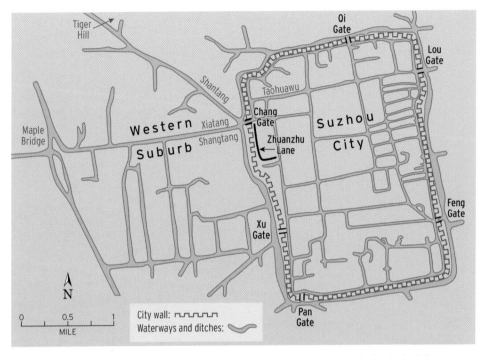

MAP 3.1. Suzhou city in the seventeenth century. The dense network of canals that linked the area inside the city walls with its vast western suburb effectively made Chang Gate the commercial hub of the greater Suzhou metropolitan area. Zhuanzhu Lane, the "Craftsmen Central" of the Ming and Qing empires, is located under the western wall, steps from Chang Gate. Adopted from Yinong Xu, *The Chinese City in Space and Time*, 158.

official complained, the already chaotic streets became so crowded that passers-by could hardly swing their arms as they walked.[5]

ZHUANZHU LANE

Steps away from the stench of the dye and the mechanical noise of the loom, artisans such as Gu Erniang, who made one-off items for a more learned and discerning clientele, congregated in Zhuanzhu Lane, an L-shaped alley about 551 meters long that extends from Chang Gate southward, in the shadow of the west city wall. Named after an ancient assassin who succeeded at his task by hiding a dragger in the belly of a fish served at a banquet, Zhuanzhu Lane had become known for a different art of deception in the seventeenth century: forging antique calligraphy and painting.

Li Rihua (1565–1635), a sought-after painter and authenticator, wrote of an unsettling experience in 1612. Upon viewing a set of calligraphic model books in a fellow-collector's house, he was "suspicious" but could not be sure that it was indeed forged

until days later, when a dealer friend confirmed that the work in question was from the hands of a "Mr. Ye, of Zhuanzhu Lane, Chang Gate."[6] He meant to flaunt his prescient suspicion, but a less-than-charitable reader may arrive at an opposite conclusion: Li was almost fooled. Eminent calligrapher Yang Bin (1650–ca. 1735) similarly flaunted his insider knowledge at the expense of officials obliged to send periodic gifts to their superiors: "Nowadays people value the calligraphy of Dong Qichang (1555–1635). Little do they know that those 'Dongs' that the officials procured and sent [as tribute-gifts] to the inner court are all from the hands of a Chen Chunzhong, of Zhuanzhu Lane, Chang Gate!"[7]

Li, a native of nearby Xiushui, was a frequent visitor to Suzhou, and Yang sojourned in the city. Although they lived a hundred years apart, the identical pattern in the way the two master forgers are introduced—location preceded by name (be it the more discreet Li who omitted Ye's given name or the more unabashed Yang)—suggests that forgery was a semiopen business and that Zhuanzhu Lane had become a brand. If the forgers' morals were in doubt, their artistry was not; in exalted fields such as calligraphy and painting where the "original" masters honed their skills by copying ancient models, "forgers" who could produce credible works would need to have undergone the same regimen themselves. That "Zhuanzhu Lane, Chang Gate" was recognized as the home of the most deceptive forgers can only mean one thing: only those craftsmen with the finest artistry, be they "forgers" or "legitimate," could withstand the high expectations and scrutiny associated with their address. In spite of, or perhaps because of, the notoriety of forgers, this Suzhou neighborhood became "Craftsman Central" in the empire in the seventeenth century.

The Manchu official Nalan Chang'an (1683–1748) captured the vibrancy of the neighborhood by plotting the shops in a panoramic description: "Zhuanzhu Lane, Suzhou: the workshops here all cluster in kind and line up one next to the other. There

FIG. 3.2. Zhuanzhu Lane, Suzhou, August 2015. Zhuanzhu Lane today is a quiet residential street. Although few Ming- or Qing-era houses remain, the footprint of cozy one- or two-story townhouses conveys a sense of the human ecology when the lane was the artisanal hub of the empire. Photograph by Dong Bo, Suzhou Art and Design Technology Institute.

are jade carvers, goldsmiths (literally, gold carvers), fine woodcarvers, bamboo carvers, lacquerers, interior furbishers, life-like portraitists, and embroiderers." Untranslatable in English, he used four different verbs for carving jade, gold, wood, and bamboo. In so doing he conveyed the variety of discrete skill sets displayed in proximity to one another and the possibility of their cross-fertilization.[8] Also noteworthy for the English reader is the composite trade rendered "interior furbishing," a group of artisans who worked in tandem with the architects or builders of a house (the "big wood"), but whose practices were considered an integrated field in itself. They include carpenters who built the window panes, doors, and furniture (the "small wood"), the plasterers of walls, and others.[9]

Chang'an went on to highlight two procedures so mind-boggling that observers had taken to giving them names. One, the "demonic craft" (*guigong*), involved the "illumination" of an artifact by a magnifying lens before the carving knife was applied. The other, "water basin" (*shuipan*), banished unsightly knife marks from the surface of a carved object by washing and abrading it with water mixed with sand. From contextual sources one can almost be certain that the former procedure was applied to carved olive or walnut pits and the latter, carved jade, but Chang'an omitted the material media in an otherwise specific description.[10] Did he not know? Not care?

Conveying the named procedures, not to mention the exotic-sounding *xianweijing* ("lens that reveals the infinitesimal," or magnifying lens), might in itself suffice to drive home Chang'an's main message: that whatever was made in Zhuanzhu Lane, "be it gold and silverware, glass and glazed tiles, silks and embroidered goods, are all exquisite to the utmost. They are known under the rubric of 'Su-ware' [*Suzuo*]." But to his mind, such cunning came with a price: the incessant pursuit of novelty that dazzled the eyes earned Suzhou craftsmen the accolade of "first in the empire," but it also lent their work a shade of shallowness. Beneath the skin-deep splendor, Su-ware was not made to last; many objects were even fakes.[11]

GU FATHER AND SONS

Nalan Chang'an did not mention inkstone workshops on Zhuanzhu Lane, even though he and Gu are roughly contemporary, and being a former clerk, he must have retained a professional interest in writing instruments. This omission is understandable given the prevalent attitude at the time that dismissed the skills of carving inkstones as more mundane than "demonic," the repetitive drudgery of nameless craftsmen. But changes were on the horizon. The unusual career of Gu Erniang and the efforts of several male colleagues known to her were instrumental to the emergence of a new view of inkstone-carving as an artistic venture and the modern inkstone as a collectible item that commands financial and literary attention in the late seventeenth and early eighteenth centuries.

A Suzhou scholar, Huang Zhongjian (1648–after 1717), inadvertently captured the subtle historical shift when he appended two encomiums he composed for an ink-stone Gu carved to his collected works. In an attached note, he explained how his tastes and incessant quest for perfection had been the driving force in the realization of the inkstone. His patronage of Gu's father-in-law was motivated by envy: "In my native [Suzhou], Gu Delin was skilled in making inkstones. Although others tried to imitate him, in the end they could not. Once he made an inkstone with a knotted design for my friend Xu Yunwen, which I admired a great deal. I therefore handed him two pieces of Duan stone." Gu's considerable local fame traveled by word of mouth; the connoisseur verified it with an actual product from Gu's hands before committing precious materials. Regrettably, Huang was unimpressed by the results but he did not blame Gu, recognizing that "the stones were not of the best quality, and their shapes were vastly different" from his friend's. Huang was about to locate a better stone and "order" Gu to remake it when the craftsman inconveniently died. The two verbs "handed" and "order" leave no doubt who was in the commanding position in this transaction.

More than ten years later, Huang finally bought for three ounces of silver a piece of stone that passed muster.[12] But by then even Delin's heir, Qiming, had died, and the former's (adopted) grandson Gongwang had been summoned to court to make inkstones. "There are no able hands left in Suzhou." He did hear that "Qiming's wife has inherited the family mantle. Before I realized it, her name has grown by the day." Even as Huang spoke of Gu's fame, he never once mentioned her given names (Erniang, Qinniang/ Qingniang, see later), preferring to refer to her by her kinship role ("Qiming's wife" here; "Wife of Gu Family" in his encomium). "In autumn of the year *renchen* [1712], I ordered her to make the stone into whatever design or shape she chose." The same verb choice, "ordered," suggests that Huang did not hold an inkstone carver in high esteem, no matter how famous and regardless of gender.

Erniang opted for the knotted design. That Huang was pleasantly surprised by her choice suggests that he had kept his unrequited desire from her. Upon closer inspection of the product, the client deemed only the knot wanting in being "too contrived" (*guoyu gongqiao*, literally too skillful and crafty), a departure from Delin's "archaistic simplicity" (*gupu*). But otherwise the inkstone captured the spirit of being "warm, pure, archaic, and elegant" (*wanchun guya*), which he took to be the signature style of the Gu house. The four adjectives, borrowed from literary criticism, were commonly used in praise of a poet's voice. Delighted that a "twenty-year-old wish" had come to fruition, Huang composed two encomiums for the inkstone, one admonishing his sons to "treasure it without letting go."[13]

Appended to a handful of Huang's colophons composed for paintings, this note— the only one about inkstones—offers a hint of the modern inkstone's reified status as a collectible object: procured at considerable investment in cost, taste, and effort, worthy of literary inscription, and valuable enough to be passed on to sons. Although Huang's

condescending attitude toward the carver suggests that the age-old bias against the craftsman was slow to change, the very fact that Gu Delin *had* a name, and that both he and his workshop were distinguished by a style of its own that was in turn imitated by others, signal a new reality.

The gulf in status between the connoisseur and the craftsman was more apparent than real, "status" being a function less of inherent abilities than self-claims and social judgment. Although affluent enough to live the life of a literatus and finance the publication of his own writings, Huang held neither a degree nor office because of his loyalist sympathies. Gu Delin, in turn, was trained in classical learning but gave up the scholarly path to take up inkstone carving as a form of livelihood. Gu's status as a "could-have-been" scholar known by not just his given name but also the self-chosen literary name of Daoren is the first piece of information that Zhu Xiangxian (c. 1670–after 1751), another Suzhou native about twenty years younger than Huang, chose to introduce Gu by. Zhu's attitude toward inkstone carvers is more respectful, possibly because of his own interests in craft, having authored a book on antique seals and compiled one on palindromes.[14]

In a collection of anecdotes, many about the legends of Suzhou, Zhu dedicated one entry to the Gu shop under the heading "Famous Hands that Made Inkstones," thereby elevating not only Gu but also the occupation of inkstone making (albeit as *hand*work). Upon introducing Delin's scholarly credentials, he went on to praise his work in the "objective" tone of an art critic, not the partial one of Huang's as a patron: "Whatever came forth from his hands, be they the finely wrought inkstones carved from [expensive] Duan and Longwei [She] stones or the casually executed but equally fetching ones from [cheap local] Hucun stones, are all natural, archaic, and elegant [*ziran guya*]. His name is recognized and respected in the world."[15] These adjectives harken back to Huang Zhongjian's description, suggesting a codification of the terms in which the Gu style was construed at least among local Suzhou writers. Upon further developments by Delin's daughter-in-law, they would become the touchstone of early-Qing "Suzhou style" in Fuzhou and Guangdong (see chapter 4). For an artisan, to be famous is to be famous for a recognizable style.

Although Zhu spoke of Gu Delin's fame, it is likely to have been localized and circumscribed, for these are the only two accounts of him by his contemporaries extant today. Nor is it possible to trace his oeuvre, since he left neither his name nor any other identifying mark on the inkstones he made. No one other than Huang and Zhu spoke of having viewed his work. By the Qianlong era, he was virtually forgotten by carvers and collectors alike even as his corrupted biography was enshrined in the *Comprehensive Gazetteer of the Jiangnan Region* (Jiangnan tongzhi) published in 1737 (see chapter 4). For all the attention on artisanal skills that immortalized Zhuanzhu Lane, the circulation of made objects—the material manifestation of skills—did not generate fame in itself. It was *words* in multiple media—signature marks and encomiums etched on

the object, transferred onto wet paper as ink rubbings, poems written on silk, laudatory remarks carved on wood blocks and printed on paper—that ensured an artisan's lasting and widespread fame, as Gu Erniang's case will attest.

The paucity of words by and about Gu Delin condemns him and other even less fortunate craftsmen to a loop of tautological oblivion—the less is written about him, the less famous he is and will become. The gaping holes in the genealogy of the Gu house, pieced together from the selective but largely congruous reportages of Huang and Zhu,[16] suggest that this "could-have-been" scholar-turned-inkstone-maker was famous enough to be dimly visible, but could not generate sustained attention or command enough cultural resources to leave a clearer picture of himself circulating in multiple loops of words across media.[17] If not for Huang who recorded his acquisitions with such precision, saying that his "twenty-year-old wish" was fulfilled in 1712, one would not have known that it was around 1692 when Delin made the knotted inkstone, shortly before his death. Zhu wrote: "When Delin died, his artistry [yi] was passed onto his son [whom Huang named as Qiming]. When the latter failed to live long, his daughter-in-law, née Zou, inherited the trade [ye]. She is the one whom people commonly call Gu Qinniang."

After a magnificent description of Gu's artistry as a legitimate albeit expedient continuation of the male line, Zhu related that since she did not have sons, she adopted two boys and taught them the veritable Gu trade, but one died at the time of his writing (not clear when). The other adopted son, a nephew of Zou's, took the name Gu Gongwang, self-assigned name Zhonglü, and outlived Gu Erniang (fig. 3.3). Zhu fretted, with Gongwang devoid of natural issue nor adoption, "to whom is he going to pass the mantle?" In hindsight, the answer is no one; the Gu house of ink-stone-making in Zhuanzhu Lane, Suzhou, died off after three male generations, its height achieved in the hands of a woman at the helm during the Zou interregnum (ca. 1700–ca.1722). Zhu described her works in these terms: "While being archaic and elegant [guya], they also exude an ornate splendor [huamei]." She was more famous than Delin and "peerless in her day."[18]

THE DEBUT

For all her fame and accomplishments, Gu Erniang remains frustratingly elusive. The notorious difficulty in compiling even bare-bones biographies of artisans stems from the fact that the key elements that scholars (then and now) deem worthy for a life narrative—year of birth, death, patrons and fellow students, and a résumé of writings and activities—were categories encapsulated in the Chinese genre of "chronological biography." They describe and prescribe a scholar's progress in lineal fashion. An artisan does not need a résumé of year-by-year output to entice buyers; the objects s/he makes are the best advertisement. The key to an artisan's success and livelihood is by nature

FIG. 3.3. Duan Inkstone in the shape of a slender gourd bearing the Zhonglü mark on its back; (A) front; (B) back. Purchased in an auction (Xiling Yinshe, spring 2014), this inkstone is of unknown provenance. Since it is one of three known inkstones bearing the Zhonglü mark, further research is needed to ascertain if the carver is Gu Gongwang. L: 12.8 cm, W: 3.7 cm, H: 1 cm. Collection of Wu Ligu.

A B

recursive, dependent as it is on continued access to raw materials and the marketplace in the form of individual clients or shops. Printed words would not hurt, but it is word of mouth that counts the most.

After ten years of research, I can only offer this sketchy biography of the most famous female artisan in the early Qing: née Zou, she was called Gu Dagu, Gu Qinniang (and its variant Qingniang), and Gu Erniang in her career as an inkstone maker. She received male patrons and colleagues in her workshop. She enjoyed a considerable degree of literacy and may have practiced calligraphy. As widow of Gu Qiming, she took over the Gu house established by Delin, and her enterprise flourished in Zhuanzhu Lane, Suzhou, between 1700 and 1722, the date of her last reliable work. She probably died in the mid- to late-1720s (she survived one of her main patrons Lin Ji, who died ca. 1725), but the latest possible date of an undated mourning poem is 1733. Her adopted son Gongwang survived her, but the workshop did not survive him.[19] To compound the difficulty of her biography, not one extant inkstone, inscribed with Gu Erniang's name or otherwise, can be unequivocally attributed to her. Although vexing, these silences and gaps in Gu's record are in themselves valuable clues to how her contemporaries regarded the female artisan and her work.

An unrivaled source on Gu Erniang's career is a compilation of inkstone encomi-

ums written by some of her long-time patrons, *Inkstone Chronicle* (Yanshi, 1733–46, see appendix 4 for its textual history). The collection was the lifework of Lin Fuyun (ca. 1690–1752), the son of bibliophile and court scribe Lin Ji and himself a patron of Gu's. It is from this work that we learn the latest possible year of Gu Erniang's debut as an inkstone carver is 1700, the year she remade an inkstone for Lin Ji (*Yanshi* C7.2a/A7.1b; no. 1 in appendix 1). Recalling that Huang Zhongjian ordered Delin to make his knotted inkstone around 1692, a time when Erniang's husband was still alive, one may surmise that Erniang established herself as the heir of the Gu house and became successful on her own within a handful of years. It was nothing short of a meteoric rise. Considering that Qiming died prematurely and on the heels of Delin's demise, it is likely that Erniang had already learned inkstone-making from her father-in-law and husband while both were alive. She may have learned by observing them work, like most apprentices, or received more formal instruction.[20]

As Gu Erniang began to attract notice, she became known by different names to different patrons. These names constitute a significant clue regarding the range of her contemporaries' reactions to the unusual specter of a *female* inkstone carver. On one end of the spectrum stands Huang, who in calling her "Wife of the Gu Family" betrayed the Confucian orthodox view that a woman's ultimate allegiance lies with her marital family, which takes precedence over the interests of her natal family and her body-self. It is in fact this mandate that renders Gu's career *un*problematic; the history of Chinese business corporations and lineages abounds with similar examples of sonless widows taking up the family mantle in the service of filiality.

The other Suzhou writer Zhu, meanwhile, related in a slightly scandalous tone that Gu's natal family was Zou, and that her adopted son was actually a Zou "passing off" as a Gu. Confucian teachings aside, a married daughter did not sever all ties with her natal family. Although still situating Gu firmly within a patriarchal structure, in calling her née Zou, Zhu hinted at the possibilities of dual allegiance for a woman, hence opening a space to reimagine Gu's career as an undertaking that cannot be comprehended entirely within the bounds of traditional wifely calling.

At the opposite end of the spectrum stand Lin Fuyun and his friends in Fuzhou, who in writing referred to Gu by the high honorific Gu Dagu or sometimes the less formal but still respectful Madame Gu (Gushi).[21] Fuyun once used an even longer honorific, Madame Gu, Lady Scholar of Suzhou (Wumen Nüshi Gushi). Both Dagu and Lady Scholar (Nüshi) were terms of address for learned women that were popularized in the late Ming, when commercial publishers vied to print the poetic works by female authors. The women thus honored were customarily not only talented writers, but also wives and daughters of scholars who held high degrees.[22] The transfer of these titles that honored a woman's literary talent onto a knife-wielding artisan connotes the high respect that Gu commanded among her most loyal patrons and the seriousness in which these scholars took the craft of carving stones. They regarded Gu (and themselves) as

artisans/artists undertaking a creative venture as worthy as the traditional scholarly arts of calligraphy and painting.[23]

In the middle of the spectrum lies the more personable address, Gu Qinniang ("Woman Gu"), which in local parlance is a cordial expression one uses not to refer to but to call out directly to (e.g., "Hey, you"). The origins of this term as an oral form of address hints at its local Suzhou roots and explains its phonetic variant, Gu Qingniang, which appeared in two eighteenth-century texts.[24] The transliteration of Gu's name from the tongue is a useful reminder that an artisan's name in both the literal and figurative sense (that is to say, fame) was contingent on word of mouth, especially in the initial stage of her rise.

Gu Erniang's many names, before their codification in subsequent texts, not only reveal competing visions about female gender roles, they also speak to a time when her work was more traceable to the immediate presence of her person, a moment before the work of texts—embellishment and standardizing—took over. When that happened (that is to say, when she became famous beyond her locale), a name occasionally used in her lifetime, Gu Erniang, became the common, unified term of address in texts and on inkstones, as her "signature mark." The name Gu Erniang thus came to stand in as the "author function" (artisan-function?), while the irreducible immediacy and multiplicity of the artisan's body-self receded from sight. In the distance, direct memories of Gu, just like genuine works from her hands, became irretrievable as those people who had direct access to her vanished one by one.[25] All that was left were words about her and inkstones bearing her name, a conjured web of lies that grew ever more fanciful.

THE CORPUS

A tight circle of Gu's loyal patrons in Fuzhou who honored her with the moniker Gu Dagu was responsible for the spread of Gu Erniang's name and work from Suzhou to the southern edges of the empire and the capital in the north. They did so by writing encomiums almost obsessively for the inkstones they acquired, with the intention of subsequently carving them onto the stones (which they sometimes did). It is important to note that in Gu's lifetime, it was primarily through word of mouth, and secondarily through the medium of encomiums carved on inkstones that her fame was cemented, not words printed or copied in book form.

A thorough search in the textual records written during Gu's lifetime has yielded a list of inkstones that Gu made for her patrons (appendix 1). Even a casual comparison with those bearing Gu's signature marks from major museum collections (appendix 2) reveals a glaring discrepancy—there is not a single overlap between the textual and visual archives, making it impossible to identify even one extant inkstone as unequivocally from Gu's hands. This mandates that the modern scholar treat the body of attributed extant inkstones with caution. A closer comparison between the material and

textual records reveals a further discrepancy: whereas the attributed inkstones "announce" the authorship of Gu primarily in the form of a signature mark, none of Gu's known patrons mentioned signature marks.[26] It is primarily the encomiums they wrote, or sometimes the explanatory remarks attached to the encomiums, that allow one to attribute these inkstones to Gu (see, for example, numbers 10 and 11, appendix 1). It seems reasonable to suggest that in Gu's lifetime, her patrons did not feel the need to advertise her authorship on the inkstones she carved in the form of signature marks because they had personal access to her and her work. The full implications of these discrepancies will be made clear later. Suffice it here to say that the textual record is where a reconstruction of Gu Erniang's corpus should begin.

The most conspicuous feature of the list of Gu's patrons and known commissioned work is its small size. Compiled from the only two reliable textual sources extant, one entry from Huang Zhongjian's collected works and Lin Fuyun's *Inkstone Chronicle*, the list identifies seven patrons and twelve inkstones (ten original commissions; two remakes.)[27] Another Fuzhou inkstone aficionado, Li Fu (1666–1749), is likely to have also commissioned inkstones directly from Gu although the details are not known.[28] In the span of the twenty-two years or more when Gu flourished as an inkstone maker, she must have carved more than twelve inkstones, but evidently none of the other buyers left records about their acquisitions.[29] Most likely, they did not care to save their encomiums for publication. It is not a coincidence that both reliable textual sources take the form of inkstone encomiums with appended notes, a genre that was only beginning to be codified into book form in the early Qing.[30]

Except for Huang Zhongjian of Suzhou, all of Gu Erniang's known patrons were Fuzhou natives, and were intimate with one another as calligraphy teachers/students, marital relatives, neighbors, and lifelong friends. Their frequent traveling in search of exam success and jobs brought them in and out of Fujian via two routes: the quicker but treacherous trek through the steep Xianxia Mountains, or the safer but slower itinerary involving a boat trip that passed through Suzhou. Some patrons, such as Chen Dequan, had one inkstone made by Gu, which he treasured so much that he took it to Beijing and used it for the next twenty years. Others, including Lin Ji and sons, Yu Dian (metropolitan graduate 1706, d. 1733), and Huang Ren (1683–1768), were repeat customers who maintained a sustained relationship throughout Gu's career.

Gu's loyal patrons probably introduced friends and associates to Gu in and out of Fuzhou. Besides Chen Dequan, Lin Ji and Xu Jun also brought along their Gu inkstones on sojourns in the capital. Huang Ren carried them to his post in Guangdong.[31] More importantly, in treasuring Gu's work and amassing a collection they established a receptive milieu in Fuzhou. Although Gu Erniang did not travel to Fuzhou, her work was available and familiar to many local artisans and scholars there. Yu Dian, for example, wrote of his pleasant surprise one day as he walked into the studio of a friend, painter Li Yunfu.[32] On Li's desk was a small inkstone that caught Yu's eyes, which he described

as "refined, subtle, proper, and elegant" (*xini zhuangya*). This must have been what Yu deemed Gu's signature style, for he claimed that "in one glance I could tell that it was made by Madame Gu" (*Yanshi* A2.11a).

Imperial officials assigned to Fujian were inevitably outsiders due to the long-standing "rule of avoidance" stipulating that a bureaucrat overseeing a district could not be native to that area. When they called on the local notables, especially Huang Ren, who was one of the province's foremost lyrical poets, they were brought into the circle of Gu's fan club and, upon departure for their next assignment, transmitted knowledge about Gu and her craft to other locales (see the example of Chen Zhaolun in chapter 5). Thus, knowledge about Gu's work may have spread to other corners of the empire by way of the transitory lifestyle mandated by the career paths of her scholar patrons.

THE COMMISSIONING PROCESS

Gu Erniang's Fuzhou patrons appear to have followed the procedures used by Huang Zhongjian when they desired an inkstone from Gu. No account books from the Gu workshop, or those from any inkstone workshop outside the court, have been found (if they ever existed).[33] In the absence of systematic information on prices and remunerations, these commissioning procedures gleaned from anecdotal evidence nonetheless reveal the tripartite criteria for assigning value to an inkstone: quality of the stone, fame of the owner(s), and fame/skill of the carver. The relative weight of the three depended to a considerable extent on the priorities of the individual concerned, but there were also larger historical shifts at work (see chapters 4 and 5, on fads of novelty).

The quality of the stone is paramount to both an inkstone's "functional value" as an instrument for grinding ink and its "aesthetic value," especially when the mineral features that occur on the stone surfaces become valorized (fig. 3.4; cf. fig. 2.8, mynah's eyes). It was customary for the future owner to procure a raw slab himself—the best that he could find or afford. This might come in the form of a gift, a direct purchase from the quarries, recycled from an old brick, tile, or inkstone, or, as is more often the case, a purchase of a raw, uncut stone from one of the many curio shops and flea markets in Beijing or Suzhou. The crown jewel of Lin Ji's collection, named *Ursa Major*, was carved by Gu Erniang from an exceptionally valuable Duan stone. Decades after the fact, Lin's son Fuyun recalled its origins with perfect clarity: "This inkstone was [carved from] an old stone quarried in the Xuande period [1426–1435]. In the year 1712, my late father bought it in the fair at Ciren Temple [in Beijing]. Madame Gu, the Lady Scholar of Suzhou, carved it. My father then used it when he wielded his writing brush in the inner court" (C4.4a). Although I have no information on Gu's payment in this and other cases, it is unlikely to have rivaled the cost of a quality stone, which represented

図A.18
図A.19
図A.20
図A.21
図A.22

FIG. 3.4. Five raw stones from the Old Pit with multiple markings treasured by Qing connoisseurs. From a handful of mineral features (such as mynah's eyes) identified by Song collectors, the nomenclature expanded to over thirty by the eighteenth century. When multiple markings coalesce on the surface of one stone, the price of the stone can become astronomical. Diagrams of stones from top left (labels of stone markings clockwise from top):

A.18: (a) mynah's eye; (b) sky blue; (c) blue spots, fine dust

A. 19: (a) mynah's eye; (b) blue spots, fine dust; (c) fish mew, scattered; (d) sky blue

A. 20: (a) banana leaf white; (b) fish mew, scattered; (c) sky blue; (d) rouge halo

A. 21: (a) fish mew, patchy; (b) rouge halo, horse-tail pattern

A. 22: (a) cracked ice; (b) jade thread; (c) fish mew

From Guangdongsheng zhiliang jishu jianduju, *Guangdongsheng difang biaozhun*, 9.

a considerable capital investment. This disparity between the cost of the raw material and the cost of "labor" might have at least partly accounted for Suzhou scholar Huang Zhongjian's patronizing attitude toward the craftsman.

Gu's other main patron, Huang Ren, recast the relationship between the patron, stone, and carver as one shaped equally by the agency of the patron, artisan, and the stone. Unlike Lin, Huang did not specify where he procured the uncut stone, a Duan stone with bluish-green specks ("blue spot") on its surface, an extremely valuable marking. For ten years he searched in vain for an inkstone maker worthy of it. One spring, he brought it to Suzhou, where Gu Erniang took a liking to it and the deal was sealed. Huang, touched by the "refinement of her artistry" and "the sincerity of her intent" composed a poem in her tribute and had it carved onto the inkstone along with his explanatory note (C2.3a/A3.2b).

In Huang Ren's rendering, the encounter between the patron and stone was predestined on a cosmological level, as was the encounter between the artisan and the stone. Ignorant of this cosmic plan, both the patron and the artisan relied upon their eyes and taste to exercise judgment in their decisions to buy or not to buy, to accept a commission or to refuse. The stone, too, for its part, was believed to have the ability to do its own choosing. Indeed, this was a highly romantic vision (Huang was an unrepentant romantic), one that mirrored the structure of fateful romance in popular fiction.[34] The vision found its way into a key aspect of Gu Erniang's lore: her snootiness was such that she refused to allow her knife to touch any stone not from the best Duan quarry.

Even allowing for literary embellishment on the part of Huang Ren, one sees a striking difference between him and Huang Zhongjian regarding the artisan's investment in the finished product. Both patrons concurred that the choice of the overall shape and design—a knot, a phoenix, or whatever—was the result of mutual consultation between patron and artisan.[35] But to Huang Ren, the role of the patron effectively ended there. For an inkstone maker of Gu's caliber, it was her prerogative to select her commission, her discerning eyes that intuited the most flattering treatment for a particular stone, and her skill in chiseling and polishing that brought the inkstone to its perfect fruition. Several other commissions by the Fuzhou group reveal a similar state of mind as the patrons approached Gu, trusting in the artistry they have come to expect from her.

A HIERARCHY OF SKILLS

In the autumn of 1700, Lin Ji's boat docked at Chang Gate, Suzhou, en route from his first sojourn in the capital back to his native Fuzhou. The previous year he had finally captured the provincial graduate degree at age forty, and earlier in the same year he had gained the attention of none other than the august Wang Shizhen (coincidentally the recipient of a Songhua inkstone mentioned in chapter 1). Wang entrusted him with a bundle of writings to edit, hand copy, and supervise the carving of its blocks—essentially to serve as the scribe and technical producer of Wang's latest book (*Essential Selections from the Works of Yuyang Shanren* [Wang Shizhen], Yuyang Shanren jinghualu, an exceptional production). It was a tedious and time-consuming task for Lin, albeit an honorary assignment that promised to enhance his profile among well-placed examiners as an aspirant scholar with exquisite calligraphic skills (see fig. 5.11). Feeling optimistic about his future, Lin went shopping. From Chang Gate he headed northeast to Taohuawu, a neighborhood lined with curio shops and woodblock workshops. In the shop of one Mr. Tong, he bought an antique inkstone wrought of what Lin deemed the superior grade of She stone. Carved onto the back was an inscription in semicursive script by the Yuan painter Zhao Mengfu, describing the stone as a parting gift from a friend dated 1309. On the left side, the Ming painter Wen Zhengming told of how he was smitten with the stone when a dealer showed it to him in a note dated 1539. On the

right, the prolific Ming collector Xiang Yuanbian left a line certifying that the stone was in his collection (C7.2a/A7.1b).

To a connoisseur of Chinese art, this is tantamount to finding in an estate sale a Michelangelo that had passed through the hands of Cézanne and Warhol. A modern collector might well suspect that it is too good to be true, but Lin seems to have thought otherwise. He listed the virtues of the inkstone breathlessly: "I love the warm, soft, and tender qualities [*shizhi wenni*] of this stone—it is a She stone of a superior grade. The dedicatory words of Songxue Weng [Zhao Mengfu] are written in brush strokes full of life and vitality. It is as precious as the fabled uncut jade of He." Even if he was not as gullible as one fears in taking it to be an authentic stone with the provenance of Zhao, Wen, and Xiang, at least Lin deemed the carved calligraphic lines a worthy reproduction of Zhao's calligraphy. For a modern reader, even this interpretation fails to blunt the force of the nonchalant revelation in the next line: "Unhappy with the tiny water pool and the tight ink pool, I gave the inkstone to Gu Dagu for her to enlarge these surfaces, and she changed its appearance instantly" (number 1, appendix 1). What kind of collector would openly tamper with an antique with such a provenance?

The departure of Lin's term, "uncut jade of He" (*He pu*), from the conventional expression "jade of He" (*He bi*) provides clues to his attitude toward craft and his criteria in evaluating an inkstone, thereby shedding light on his action. Bian He, from the ancient kingdom of Chu, found a piece of exquisite raw jade still shrouded in its bedrock and offered it as tribute to his king. The king, who mistook it for an ordinary rock, punished He by cutting off his left leg. When a new king came onto the throne, He sent his gift again, only to lose his right leg. It is not until a third king inquired about the rock that He convinced him to order a craftsman to chisel away the waste rock. The priceless jade was carved probably into a disk and became the insignia of the kingdom.[36] The story is often read as an allegory for a male subject's unflinching loyalty in spite of the stupidity of those in power. Jade of He is also commonly used as synonym for a precious object.

When Lin Ji compared his newly acquired inkstone to He's *uncut* jade, he called attention to himself as the prescient connoisseur who could see through the unassuming surface while highlighting the power of the craftsman's carving knife to bestow value (fig. 3.5). The inscriptions of Zhao, Wen, and Xiang were surely valuable, but in Lin's mind they are but secondary considerations. The natural quality of the raw stone, a She stone that is "warm, soft, and tender" is not only an aesthetic quality but also the most basic consideration regarding the intended purpose of an inkstone—to produce ink. This "functionalist" view of an inkstone propelled Lin Ji to skip down to nearby Zhuanzhu Lane from Taohuawu and to commission Gu Erniang to enlarge the water pool and the ink pool for ease of grinding ink and handling the writing brush. When making an inkstone acquisition, Lin Ji evaluated the stone as a scholar who cared deeply about both the craft of writing and carving stones.

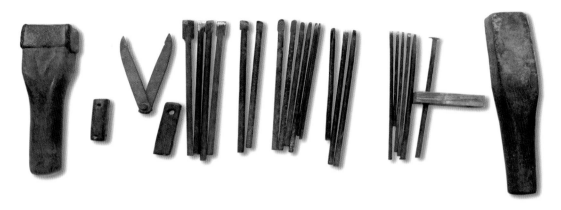

FIG. 3.5. The inkstone carver's tools. National Arts and Craft Master Li Keng uses traditional tools forged to his specifications. They include wooden mallets, chisels (pointed, slanted, and flat, each in three sizes), and carving knives (round, semiround, slanted, and flat). Other peripheral tools include rulers, polishing stone, and brush. From Liu Wen, *Zhongguo gongyi meishu dashi: Li Keng*, 76, 78.

To a calligrapher, the ink pool—a smooth and ever-so-slightly concave surface—is the crux of an inkstone. Its degree of smoothness depends on the density and porosity of the stone as well as its degree of concavity, the overall size and design, and the size of the brush for which the inkstone is intended. The verb used for the procedure, "opening the ink pool" (*kaichi*), connoted a creative act of initiation, one that endowed the inkstone with life. Far from being a remedial task, enlarging the ink pool of an old inkstone was such a delicate operation—requiring a sharp eye for curved lines, calibrated control of the hand, and respect for the existing design—that it ranked at the top of a hierarchy of an inkstone maker's skills.[37]

Although fixation on the ink pool manifested a calligrapher's obsession with the instrument of his craft, Lin Ji's eldest son Zhengqing (1680–after 1755) hinted at a desire for a smooth ink pool that exceeded functional concerns. He wrote of an inkstone that Gu made for his younger brother Fuyun: "This stone is Duan, from the Song Pit, and it is warm and soft. Upon chiseling and polishing by Madame Gu, the ink accrued [on the ink pool] as if it were an antique inkstone from hundreds of years ago." The antique-like patina heightened the appeal of the inkstone as an object of aesthetic appreciation (C4.6a/A1.5b-6a).

Perhaps both functional and aesthetic concerns were on Huang Ren's mind when he, like Lin Ji, entrusted an old stone with an illustrious provenance to Gu Erniang. Huang's bears a 1350 inscription from Yuan painter Wu Zhen. Bought from an old family in the capital, it was a hefty stone of over two inches thick and longer than one foot (Chinese measurements). Although not specified, the stone is Duan, as deduced from the two mynah's eyes on its surface. Involving more than enlarging the ink pool, the operation was one that Huang's friend Xie Gumei billed as a "remake" and took Gu two

months to complete (C7.3a). As in the case of Lin's commission, it is neither possible nor important to ascertain if the inkstone was "authentic."[38]

More interesting is how these two examples shed light on attitudes toward the craft of inkstone-making in general, and on Gu's career in particular. First, contrary to later claims, Gu handled a variety of stones, including the prized Duan, but also the equally fine but less prestigious She, which is harder and denser. Second, remaking an old inkstone was more demanding and esteemed than making one from scratch. Most interesting of all, despite a persistent gender stereotype that associates femininity with dainty objects, Gu's patrons did not refrain from entrusting oversized stones to her. In handling inkstones large and small, soft and hard, Gu transcended the strictures of gender expectations to a considerable extent. It would be wrong to say that as an artisan, Gu was genderless (her honorary name of Gu Dagu already marked her as female). But when her patrons deliberated if they should give a commission to Gu, her skills trumped her gender in their decision. Discussion in the next chapter will show the development of her ultra-feminine persona in the fertile minds of collectors and forgers who had no direct contact with her. For now, it is important to note a certain degendered aspect of Gu's persona in the eyes of her male patrons.

CARVING WORDS

As an elite inkstone maker at the top of her trade, Gu Erniang plotted the overall design according to the wishes of the patron as well as the particular shape and location of stone markings (if any), executed the design, and opened the ink pool. On at least one occasion, she also carved a picture of swallows with apricot blossoms on the back of an inkstone (number 8, appendix 1) as if it were a painting, an increasingly common way of embellishing the back surface. Significantly, to her Fuzhou patrons her job description did not include carving words, be it the encomiums or other inscriptions.

One simple explanation for this division of labor could be that most patrons would not have composed an inscription when the inkstone was still in the hands of the artisan. Typically, it was during the inkstone's subsequent social life that the patron had the chance to reflect upon its qualities, that friends were shown it at drinking or viewing parties, or that the stone was given away as a gift to a parting friend, eliciting further rounds of commemoration. The encomiums and notes, along with the names and seals of the writer(s), bear witness to the circulation and reception of an inkstone after it left the hands of the maker. The Fuzhou scholars would store away these slips of paper until the opportune moment came for them to carve the words onto the inkstones themselves, hire someone to do so (if the inkstone was still in their possession), include them in their collected writings, or compile the texts into a special collection consisting of nothing but encomiums (what would become *Inkstone Chronicle*).

On one rare occasion, Yu Dian had already composed his encomium by the time he commissioned Gu Erniang to make the inkstone. The stone, called *Supreme Simplicity* (Taipu Budiao), was left almost in its natural state, showcasing a wash of "banana leaf patch," an expansive stone marking on the front (almost certainly on the ink pool). Yu recorded the time and place of the commission: the tenth month, winter, 1709, while sojourning in Suzhou (number 2 in appendix 1). As for the encomium that celebrated the banana leaf patch, he first asked He Zhuo (1661–1722), a bibliophile and the most famous Suzhou calligrapher of his time, to write it, then entrusting its carving to an expert hand whom He recommended.[39] The extra effort of soliciting He's contributions and seeking out his approved carver took three days, but Yu seems to have thought it worthwhile. Pleased by the union of precious stone, skillful inkstone-making, and meticulous carving of words, he expressed the hope that the inkstone would remain in Yu's hands and become his family heirloom (C1.3a/A2.3a).

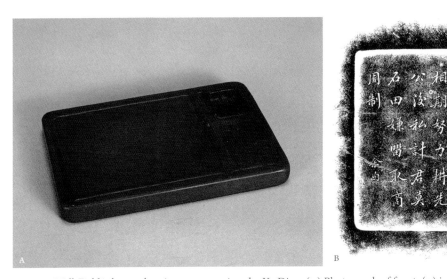

FIG. 3.6. *Well-Field* inkstone bearing an encomium by Yu Dian. (A) Photograph of front; (B) ink rubbing of back. The design of the inkstone expresses the classical well-field (*jingtian*) ideal of equitable land distribution described in the Confucian classics *Mencius* and *Rites of Zhou*. A community was to divide its fields into nine plots, a composition that resembles the character "well" (*jing* 井). Having pooled labor to cultivate the plot at the center, the "public field," each family would in turn work its own "private field." On the face of the inkstone, the character "well" delineates the border of the ink pool; the square water pool at the upper left corner is shaped as the character "field" (*tian*); to its right is the character "to preserve" (*liu*) carved in relief. Yu Dian's encomium on the back was composed specifically for this inkstone and written in his own hand: "Ploughing the fields in earnest, / We endeavor for the public before the private. / Do not disdain the stony field, my friend, / Preserve the institutions from the [classical] Shang and Zhou." L 16.1 cm, W 9.9 cm, H 1.7 cm. Lanqian Shanguan collection, National Palace Museum, Taiwan.

Yu Dian's matter-of-fact tone suggests that it was customary for him to hire a separate class of artisans to carve words onto inkstones. What he singled out for comment was the special care he took to ensure that both the writing and the carving of the text were of the highest possible quality.[40] Lin Ji, too, during two long sojourns in Beijing, acquired scores of inkstones from its well-stocked curio shops and markets. He had contact with Gu during this period; records show that he commissioned Gu to make the *Ursa Major*, the crown jewel of his collection, around 1712. But he saved all the encomiums he composed so that his Fuzhou disciples, the Yang brothers, could engrave them later. When they died without having done so, Ji's son Fuyun stepped in to perform the task himself.[41]

Indeed, the same division of labor obtained in the palace workshop during Yong-zheng's reign and continues in inkstone workshops in Guangdong today.[42] Guan Hong-hui (b. 1955), a female inkstone maker who operates a studio under her name not far from Yellow Hill, explained to me that she entrusted male artisans to carve words because the skills required are different.[43] In the eighteenth century as now, there surely were inkstone makers who performed both tasks (see the examples of Yang Dongyi and Dong Cangmen later in this chapter), but this does not belie the conceptual distinctions between the two. To be a master inkstone-maker means to excel in the exacting skill of "opening the ink pool" and in conceptualizing/executing the overall form and design. Although also a respected skill, the carving of words onto inkstones is subsidiary in importance to the creation of a surface that produces smooth and controllable flow of ink while being gentle on the brush and the hand that holds it.

In sum, the textual record left by Gu Erniang's Fuzhou patrons suggests that in the main (with the exception of Yu Dian's one commission), the words that appear on the inkstones made by Gu—be they encomiums, notes, or signatures and seals of her patrons—were of a time and space removed from her original workshop setting. All were carved by someone else. Further, none of her known patrons mentioned that she (or they) had affixed her signature mark on the works they commissioned. How, then, do inkstones bearing the signature marks of Gu Erniang turn up routinely in auctions and major museum collections in China today?

SIGNATURE MARKS

The early Qing luminary Wang Shizhen was said to have shown off a *Stars and Moon* inkstone bearing the mark "Made by Gu Dagu of Suzhou" to a small gathering at his studio.[44] This mark is rare, found only on another inkstone, a *Phoenix* (fig. 3.7A), that was in the collection of famed Republican-era connoisseur Zhu Yi'an (1882–1937). The majority of her signature marks follows the general pattern of "Made by xxx of Suzhou," but uses the name Gu Erniang. Occasionally "of Suzhou" is omitted, but "made by" (*zhi* or *zao*) is always part of the formula.

A

FIG. 3.7. A selection of inkstones with Gu Er-
niang's signature marks.

(A) *Phoenix* inkstone, ink rubbing. Signature
mark "Wumen Gu Dagu zhi" in clerical script
on back, lower left corner. Both the wording of
the mark and the choice of script are unusual.
Courtesy of Zhu Chuanrong.

(B) *Phoenix* inkstone. Signature mark "Wumen
Gu Erniang zhi" on back, lower left corner, in
seal script carved in relief. L 12.9 cm, W 9.5 cm.
Metropolitan Museum of Art.

(C) *Paired Swallows* inkstone. Signature mark
"Wumen Gu Erniang zhi" on back, lower left
corner in regular script. Tianjin Museum.

(D) *Paired Swallows* inkstone. Signature mark
"Wumen Gu Erniang zhi" on back, left side,
in seal script. Lanqian Shanguan Collection,
National Palace Museum, Taiwan.

(E) *Banana and Moon* inkstone, front. Lanqian
Shanguan Collection, National Palace Museum,
Taiwan.

(F) *Banana and Moon* inkstone, back. Signature
mark "Wumen Gu Erniang zhi," left side, in cur-
sive regular script. Lanqian Shanguan Collection,
National Palace Museum, Taiwan.

B

C

D

E

F

FIG. 3.8. Close-up of five Gu Erniang marks. (A) *Paired Swallows* inkstone, ink rubbing, Tianjin Museum; (B) *Banana and Moon* inkstone, National Palace Museum, Taiwan; (C) *Phoenix* inkstone, Metropolitan Museum of Art; (D) *Grotto and Sky as One* inkstone, Palace Museum, Beijing; (E) *Jielin* inkstone, Tianjin Museum.

Textual or graphic marks that allow one to identify the maker of an artisanal object have been common since the early history of material culture in China, especially on such prestigious objects as bronzes, lacquerware, ceramics, and textiles.[45] In the sixteenth century, identification marks proliferated in a range of other media, including carved bamboo, jade, ivory, rhinoceros horn, and stone. Broadly speaking, these marks served three, not necessarily mutually exclusive, purposes: bureaucratic monitoring of expenditure and quality control, as a brand advertising the workshop or artisan, and as an expression of the individual artisan's creativity.[46] Since Gu Erniang's patrons were private individuals known to her, there was no need for an impersonal form of bureaucratic control. Her signature marks were thus made to advertise her brand and/or to signal that she was an individual artist who claimed authorship over her work.

Even a casual glance at these marks as a set reveals their most striking feature: although the phrasing is similar if not identical, visually they bear no resemblance to one another (fig. 3.8). In the type of script used, placement on the inkstone, and carving technique, these marks could not be more different. The Beijing example (figs. 1.4, 3.8D) shows a huge signature mark in a seal script, carved in intaglio, that takes up almost the entire side of the inkstone. The Tianjin *Paired Swallows* inkstone (figs. 3.7C, 3.8A), in turn, features the signature mark on the lower left corner of its back, in neat regular script also in intaglio. Both its placement to the left of the swallows and apricot blossoms as well as the gourd-shaped seal underneath evoke the signature of artists on paintings. Although also placed on the left back, the mark on the MMA *Phoenix* (figs. 3.7B, 3.8C) appears more like a label than a signature. It is carved in seal script but in relief. The discrepancy is even more glaring when one considers the other examples: except for some superficial resemblance among the ones rendered in seal script (albeit in different wording), no two are alike.

Clearly, these signature marks are not from the same hand. Gu did not incise them. Nor could they have been brand logos left by text-carvers (hypothetically) hired by Gu's

workshop, for any workshop-directed effort would have aimed for at least a modicum of uniformity. What good is a brand logo if it is not recognizable? One may posit two possible sources for these marks. Some might have been carved on genuine Gu inkstones but not by anyone associated with the workshop. The owner might have added the mark when they subsequently decided to sell the work (to someone who otherwise had no way of knowing the authorship). But, as further analysis of the inkstones in the next chapter will attest, the majority of them were most likely downright forgeries. For the present analysis, suffice it to note that whoever affixed them, and whatever the degree of trustworthiness, Gu Erniang's signature marks would have been meant to refer a certain inkstone back to the singularity of her person, more specifically to her hands and artistry.

That the signature marks—intended as signs—appear in such divergent forms is curious. Technically speaking, it is relatively easy to duplicate words carved on the surface of one stone on another almost verbatim. Any experienced artisan could trace the outline of the strokes onto a piece of paper and transfer it onto another stone.[47] For centuries, this was how highly faithful copies of calligraphic model books were made, to the point where even experts could not tell the copy and original apart. That this was *not* done with Gu's mark suggests that the artisans who forged her marks (and perhaps the inkstone itself) did not have access to her original work; fortunately for them this did not matter, because neither did the buyers. This is indeed an apt description of the state of knowledge today, two hundred years after Gu Erniang's demise, but I have strong reasons to suspect that collectors in the eighteenth century beyond her immediate Suzhou and Fuzhou circles were no better informed.[48] The name Gu Erniang had become such a powerful sign that its mere presence, auratic or otherwise, augmented the value of an inkstone. In this talismanic economy, the rigors of connoisseurship and its goal of authentication mattered less than the contagious desire of owning a piece of the legend. Authentic or not, Gu Erniang's signature marks in all of their stylistic varieties provide solid evidence for an unprecedented phenomenon: a female inkstone maker had become a super-brand.

THE YANG BROTHERS

Gu Erniang enjoyed this special status in the history of inkstone making because she was a woman with superior skills. To substantiate this statement, and to gain further insights into the problem of forgeries, it is necessary to take a long detour to meet several male inkstone makers who were Gu's contemporaries. Fuzhou natives all, they formed lasting ties with many of Gu's Fuzhou patrons and were known to have carved multiple inkstones for them. All were familiar with Gu's work through these patrons. At least two left signature marks on their own carvings. And at least two had paid a personal visit to Gu in Suzhou. These webs of connections and convergence make the departure in their skill sets and career paths from Gu's particularly instructive.

The Yang brothers, Zhongyi and Dongyi, were from a family with a book collection, and may have followed the exam curriculum in their early years before abandoning any hopes of success.[49] They show up in the textual record as Lin Ji's students, receiving instructions in the seal scripts of the Qin-Han period (221 BCE–220 CE) requisite for seal carvers. Lin Ji, whose father and brother were collectors of rubbings and calligraphy model books, had a special interest in the technique of carving stones, considering it a necessary training of a calligrapher. Evidently he was grooming the Yang brothers to be makers of seals, inkstones, and steles. As educated carvers, they specialized in carving words, especially the archaic seal script valued by epigraphic scholars. His son Fuyun recalled that the Yang brothers were "extremely skilled in carving and engraving" and were responsible for carving Lin Ji's calligraphic works on stone for reproduction or as stele.[50] In itself, this was a respectable activity that scholar-calligraphers such as Lin Ji also engaged in, but Fuyun's choice of words betray his snobbish regard of the Yang brothers as less scholars than craftsmen.

Although Fuyun was younger than the Yang brothers, for example, he consistently referred to them as *zi* (boys; junior students) or *Yangshi zi* (sons of Yang); although sometimes used to confer honor onto a senior scholar, *zi* in this context is an address for a social inferior regardless of age. Even more revealing was Fuyun's narration of their apprenticeship in Lin Ji's studio: "I was then a young child with untufted hair [between three to eight years old]. As I tended to my late father, I often overheard his discoursing on the way of the carving knife with the sons of Yang. But being preoccupied with the exam curriculum myself, I had no time to study carving" (A10.13b). Even in a family as Lin's with a rather atypical heritage of respect for carving stone as the métier of the scholar, the demarcation between studying books and wielding knives still existed.[51] The same activity, carving stones, could signal two social positions; the distinction was a function of the career trajectories of the men concerned.

Lin Ji brought the elder Yang brother, Zhongyi, with him when he journeyed to the capital to pursue his own scholarly success.[52] It afforded a form of potentially enriching employment for Yang. Likely to be housed by Lin, Yang was expected to fulfill Lin's carving needs while cultivating new clients from Lin's growing circle of acquaintances. Unfortunately for both Lin and Yang, the latter succumbed to an illness and died just as he began to make himself known, leaving Lin with scores of encomiums awaiting their turn to be carved on the inkstones each was composed for (A10.13b). Comparable to the growing entourage of "personal assistants" or "advisers," subbureaucratic technocrats whom provincial officials hired privately to assist with a plethora of specialized tasks, the stone carver eked out a living by serving the scholar-official with an expert skill the latter needed. This form of itinerant employment appears to have been common for male inkstone makers. Yang Zhongyi's younger brother, Dongyi, first followed another Fuzhou scholar, You Shao'an (1682–still alive 1756; metropolitan graduate 1723), to Beijing, then trekked southward across the empire to Guangdong in 1725, where he

became one of two resident inkstone carvers of the newly appointed magistrate Huang Ren, another inkstone aficionado from the Fuzhou circle and, as seen earlier, a key patron of Gu Erniang.

In contrast to Lin Fuyun, to whom the Yang brothers were "not-quite" scholars, You Shao'an took pains to highlight Yang Dongyi's scholarly propensities. In You's telling, his relationship with Yang was couched in terms of friendship between equals. A neighbor and occasional calligraphy student of Lin Ji, You called Yang his "fellow classmate" and "my friend". Closer in age than Lin and the elder Yang brother, You and Yang Dongyi enjoyed a cordial rapport. In the spring of 1719, they were among a group of Fuzhou scholars who, upon finding themselves in Beijing, went on an outing to view apricot blossoms in the suburb. Came summer, You had failed his exam and set out for the long journey home. Yang Dongyi accompanied him at least as far as Jining in Shandong. You wrote of the two sitting by the pier, feasting on chicken, chives, and tiny dried shrimps, the local specialty, and downing cups upon cups of wine while vying to best each other on "book knowledge" (*paoshu*, literally "throwing books" [at each other]).[53]

In a pair of poems composed for Yang, You paid tribute to his friend by describing him as a scholar and more: "The books bequeathed by his ancestors are enough to sustain a scholar's career; / On the side he has plenty of other talents to spare." In his interlinear notes, You went on to describe what these are: "Dongyi excels in making exact and free copies of calligraphic models, carving steles and woodblocks, making inkstones and engraving stones. He is also skilled in wielding the painting brush."[54] This is a veritable description of the skill set of an emergent category of men I call "artisan-scholar." It is not known if Dongyi returned the tribute with a poem of his own, but it does not matter. In the world of scholarly etiquette, to be *sent* a poem, just as to be *invited* to view flowers with other scholars, conferred a vicarious status of "scholar" on the recipient. The contrast between Lin Fuyun's view of Yang as "not-quite" a scholar and You's assessment of "scholar and more" serves as a reminder that the so-called social status of a person was conferred by *others*, hence subjected to a degree of subjective judgment. The contrast also bespeaks a certain ambiguity in the early Qing about the very definition of a scholar and the rightful skills that he was supposed to possess.

In Guangdong, Yang Dongyi joined the entourage of Huang Ren, magistrate of Sihui, whose jurisdiction included the Duan quarries. Huang's attitude toward Yang's status seems to lie in between Lin's and You's. He called him his "friend" but also used a somewhat deprecating "Student Yang" (Yang Sheng).[55] Housed in a room in Huang's official residence, Yang's main duty was to make inkstones for Huang's own use and gift-giving. Yang also made inkstones of his own, at least one of which bore an inscription he engraved, and sent them to friends and patrons in Fuzhou as gifts.[56] Yang straddled the ink-pool-opening and word-carving divide that Gu Erniang maintained, as did other male artisan-scholars at the time.[57] In 1728, the younger Yang brother also died on the job after three years in Huang's service. It is not known if he ever left his

name on the many inkstones he made; unlike Gu Erniang he was not famous enough to have inkstones forged in his name. No inkstones bearing his signature mark have been found.

DONG CANGMEN

Joining Yang Dongyi under the shades of the tall sugar palm trees in the Sihui magistrate compound, chiseling away at inkstones, was another artisan from Fuzhou. This was Dong Cangmen, whom Huang Ren also called his "friend" and "Student Dong." Indeed, Huang and the other Fuzhou scholars mentioned Yang Dongyi and Dong Cangmen in the same breath so often that their individual identities gave way to the composite Yang-Dong or Dong-Yang. What little is known about Dong suggests an identical skill set and career path as Yang's. He gave up pursuing the exams and became an itinerant artisan-scholar, copying archaic seal scripts for study and reproduction, requisite knowledge for a seal carver. Like Yang, Dong was equally proficient in a range of stone media, notably seals and inkstones. He was a painter, known for the subjects of pine and bamboo, and seems to have enjoyed more attention than Yang in this regard. After his stint in Guangdong, Dong returned to Fuzhou where he suffered from poverty and frail health, moving frequently from one tiny rented house to the next, but was a regular in drinking parties hosted by local scholars.[58]

One significant difference between Dong and Yang, at least as presented in the extant records, is that Dong signed his carvings. An early twentieth-century Fuzhou collector wrote of having seen a Shoushan soapstone seal with an animal-shaped finial attributed to Dong, the name "Cangmen" etched in clerical script, although he did not attach an illustration. Another signature mark is found on a Shoushan stone brush rest fashioned in the shape of a mountain range with four peaks. The mark, also "Cangmen" in clerical script, is published but the whereabouts of the brush rest is unknown. A modern inkstone expert has examined two inkstones in private collections in China today with Dong's mark. One, an archaic style shaped like the Chinese character "wind," wrought of a valuable Duan stone from the Underwater Lode, bears the mark "Created by Cangmen" (*Cangmen zuo*) on its left side (fig. 3.9).[59]

Zuo is a significant departure from the "made by" (*zhi* or *zao*) in Gu Erniang's marks in that it can refer to all creative acts, including writing, composing, painting, or making an object, whereas *zhi* and *zao* are only used for material objects and paintings. At the risk of reading too much into one example, it is hard to resist the conjecture that Dong chose this ambiguous word to elevate the act of inkstone-making by comparing it to literary composition. The other inkstone identified with Dong is also carved from a fine Duan stone with sought-after stone markings. Rectangular in shape, it features a simple archaistic design, with a *kui*-dragon motif ringing the water pool. The back is almost entirely taken up by an encomium written (and carved?) by Dong in regular

FIG. 3.9. Duan Inkstone in the shape of the character "wind" (風), bearing Dong Cangmen's signature mark. (A) Front. The splayed sides of the inkstone are part of an archaistic design dating to the late Tang period in the ninth and tenth centuries. (B) Signature mark "Cangmen zuo" in clerical script on the side of the inkstone. Collection of Wu Ligu.

script: "Cutting [the jade]; incising it. / Warm, fine, and powdery soft. / Solid, dependable, and glowing, / The Gentleman's virtues. / —Encomium by Cangmen, Yu."[60] It was a cliché of scholars to compare a piece of stone to jade and use it to evoke a gentleman's (that is, *his* own) virtues. Yu is short form for Hanyu, Dong's given name.

To summarize, Gu Erniang, a widow who inherited the mantle of inkstone-making from her marital family, was on a different track altogether from the known male inkstone carvers of her day. The Fuzhou natives—Yang Zhongyi, Yang Dongyi, and Dong Cangmen—gave up early on the exam pipe dream. The proximity of their hometown to the quarries of Shoushan stone, a favorite soft stone for seals, allowed them to parley their early training in calligraphy and ancient scripts into a new career of seal-carving, a respectable undertaking for scholars since the late Ming.[61] From seal-carving they expanded to cognate fields of inkstone-making, printing block engraving, and other forms of stone carving, activities that few scholars dabbled in and traditionally consigned to people who, by a circular logic, were thus called craftsmen.[62] Some of the Fuzhou scholars—by "scholar" one means those who passed the exam and received a higher or lower degree; those who failed but did not cease to try; and those who passed and served as bureaucrats—eyed the artisan-scholars with a perceptible sneer; others admitted them into their social circles as virtual equals.

The artisan-scholar's socially ambivalent position notwithstanding, he embodied many skills and habits of the scholar; he could have been one of them. The twenty-first century observer may assume that, since the artisan-scholar also painted and wrote,

seasoned calligraphers and inkstone aficionados would favor him in their choice of inkstone makers, but this was not the case. All available evidence suggests that Lin Ji, Yu Dian, Huang Ren, and their friends reserved their most precious raw stones for Gu Erniang's hands, relishing the experience of grinding ink on her creations and expecting to pass them on to their sons. For specialized tasks such as carving words, and for the lesser but nonetheless valuable stones, they called on the Yang brothers and Dong Cangmen. The more pedestrian stones were consigned to myriad unnamed craftsmen. There was a clear gradation of inkstone-makers just as there was a hierarchy of skills in their minds. Gu occupied a unique position above and apart from the artisan-scholars and unnamed carvers.

There are three possible explanations for Gu's appeal: fame, gender, and skills. It could have been that the Yang brothers and Dong, being former students and fellow Fuzhou natives, were too familiar to be accorded greatness. Meanwhile, the very address of Zhuanzhu Lane, Suzhou, had become a brand in itself, which no doubt enhanced Gu's credentials. Gu's gender—her feat of being a woman in a nominally male profession—also contributed to her appeal. Her gender worked in Gu's favor in other ways as well. She never followed the exam path, nor, of course, did she abandon it; she was stationary instead of itinerant. Her very alterity marked her off as desirable, according to a similar logic as that of some late Ming critics who deemed women's poetry superior to men's because the former was unsullied by male concerns.[63] As a woman, Gu offered fresh eyes and artistic finesse to her patrons who were caught up in a craze for novelty in inkstone design and making.

Ultimately, however, neither fame nor gender is sufficient explanation for the behavior of the Fuzhou patrons, who had specialized knowledge in stone carving and exacting technical demands as calligraphers themselves.[64] The only adequate explanation is that these inkstone aficionados deemed Gu's skills truly exceptional. Besides her technical finesse, these patrons may have valued the Suzhou sensitivity that Gu embodied. Taking the superiority of Gu's skills in her patrons' eyes as a premise, we are finally ready to unpack two poems that shed significant light on the forgery of Gu's work.

Both poems are tributes to Yang Dongyi and Dong Cangmen, written by Gu's long-term patron and admirer, Yu Dian. First:

> In their times Yang and Dong were as skilled as Madame Gu,
> Following the footsteps of the famous name, they chiseled and polished.
> The shapes of hills and valleys, already envisioned in the mind,
> In their hands, their knives moved like demonic axes. (A8.6b)

The third line alludes to the literati painter of the highest order, who was said to paint from his mind's eye instead of following mimetic depictions of the external world. The "demonic axes" in the fourth line recalls the "demonic craft" that the bannerman offi-

cial Nalan Chang'an associated with Zhuanzhu Lane, mentioned earlier. The expression is standard praise for the canny knowledge of the craftsman.

The first line establishes equivalence between the artistry of Gu and Yang and Dong at the outset, which is indeed high praise for the latter in light of the gradation suggested earlier. Curiously, Yu couched it in the past tense that takes special effort to indicate in Chinese. One obvious reason is that Yang had already passed away by then. It also conveys a subtle hint of lament on Yu's part, as if he resented the fact that Yang and Dong failed to win the same recognition as Gu, even though they were just as capable. The "following the footsteps" in the second line, then, does not mean that Yang and Dong came after Gu in terms of chronology, but that they had consciously studied her works and learned from them. To put it even more blatantly, "following the footsteps" can also be rendered "imitating" or "approximating."

Whatever was the intention of Yang and Dong in approximating Gu's work, Yu made clear in a second poem that the outcome was the same:

> How fine, men of letters wielding the carving knife,
> So skilled in carving are Dong and Yang, with such elegant products.
> How deep, how shallow? Opening the ink pool depends on the mind's eye,
> People confuse them for the work of the Female Hand from Suzhou! (A8.7b)

Besides confirming that opening the ink pool was an exacting skill that Dong and Yang excelled in as much as Gu Erniang, this poem also suggests that one possible source for forged works of Gu was none other than Dong and Yang. With such knowledgeable and skillful imitators who enjoyed direct access to Gu's work (and person), it would be no wonder that there have been many finely rendered forgeries in the market that confused people in the early eighteenth century as well as today. Forgery is the highest form of flattery. Dong and Yang, in this scenario, would have agreed.

GU ERNIANG AT WORK

As much as I have strived to reconstruct Gu Erniang's workshop environment and the tools she used, a full picture is not possible because of the lack of sources.[65] A set of previously unknown poems, however, sheds new light on Gu's direct interactions with men, the level of her literacy, and her standing in the eyes of other accomplished inkstone-makers of the day. Their author, Xie Ruqi (whose name was bestowed by his bannerman patron, Shen Tingzheng; see chapter 1), is a significant seal-carver, inkstone maker, and calligrapher who flourished in the same Fuzhou circle. His trajectories overlap perfectly with those of such artisan-scholars as the Yang brothers and Dong but for a substantive difference: Xie managed to have his poetry collection pub-

lished. Although he was thus the most scholar-like of the Fuzhou artisan-scholars, I have classed him with the latter group because other than a short stint as a personal assistant, stone carving appears to have been the main source of his livelihood. Xie Ruqi was a collector of uncut Duan stones; he was described by Huang Ren, a self-professed inkstone addict himself, as having the same avocation; and he, like Dong Cangmen, left signature marks on his works (see fig. 4.6).[66]

The title of the set of five poems describes the occasion of their composition: "Dong Cangmen and I passed by Zhuanzhu Lane to visit Female Scholar (Nüshi 女士) Gu Erniang and we viewed inkstones." Xie was on a tour of Suzhou and this was likely their first (and only) meeting:

1.

The hero cherishes his sword and a man of letters, his inkstone,[67]
Equally extraordinary, [the two loves are] comparable in nature.
[We have] admired the female knight-errant of Suzhou,
Carving clouds,[68] chiseling jade, rivaling the work of heaven.

2.

Let Dong Yuan [?] discourse on the origins of inkstone annals,[69]
History is certainly present on the ancient lane of Zhuanzhu.
People vie to adore the way of embroidery of the Gu family,
[We] have espied its pure fragrance, launching into a discussion.

3.

From outside the boudoir window, bamboo silhouetted on the azure gauze
 curtain,
[We] poured spring water, polishing and washing an old inkstone with
 [the rare stone markings of] blue dots.
Copying Song designs, better than the original—unmatched in the world!
The "well" [井] inkstone with its horizontal and vertical lines and the "wind"
 [風] inkstone with splayed sides.

4.

The experts humbled in the face of a real expert,
Under flower blossoms, the Guzhu tea emits fragrance.[70]
[She] also excels in inscriptions, both carving and writing excellent,
Pure gold without impurity, perfect jade with no defect.

5.

The toiletry box, the tools, the stones speak the truth,
Longwei [She] stone, Lingyang [Duan] stone, come freshly off her hands,[71]
In the future the envoy in a light carriage[72] will enter [her name in] the annals,
People would surely say, she is another Madame Wei.[73]

The poems are suffused with overly polite terms of address and effusive praises typical of the genre. The lack of context makes it difficult to know how literally several of the lines should be taken. Still, as the only writer who visited Gu and left a record of her workshop environment, Xie Ruqi's poems allow us to envision Gu's studio in Zhuanzhu Lane, Suzhou, as a secluded space that is at once feminine and masculine. Groves of bamboo and flowering plants were being tended to in the inner courtyard or garden outside; gauze curtains—indeed, any curtains at all, even if not gauze—signaled elegance. The vocabularies used for window curtains (*lianlong*) and toiletry box (*xianglian*) are those reserved for describing the boudoir, but the activities that transpired were those associated with the scholar's studio: viewing inkstones, washing inkstones, pouring spring water, savoring rare tea, and discoursing on the profundities of artistry.

One of the names used to refer to Gu was contrived: "female knight-errant" refers not to Gu's deeds but is triggered by the association between the knife-wielding ancient assassin Zhuanzhu, whom many considered a hero, and the knife-wielding female artisan (an association common among those who spread her legends). The Madame Wei in the last line, however, represents an ingratiating tribute that is, although apt on some levels, certainly exaggerated. The historic Madame Wei (Wei Shuo, 272–349 CE) was one of the most famous calligraphers in history and happened to be a woman. She learned her art from her natal family, studded with calligraphers, and is thus comparable to Gu's inheriting the family mantle. One of her alleged disciples was the great calligrapher Wang Xizhi, which makes the comparison an extremely flattering assessment of Gu Gongwang, Erniang's disciple and heir. Beyond this, to deduce from this allusion that Gu Erniang was an accomplished calligrapher would be going too far.

Xie referred to Gu's literacy in another line, in the fourth poem: "[She] also excels in inscriptions, both carving and writing excellent." The unspecified subject is unproblematically Gu, but the message contradicts the division of labor between opening the ink pool and carving words observed by Gu's Fuzhou patrons. One may square it away by hypothesizing that since the Fuzhou patrons were expert calligraphers, they were meticulous about engraving words and preferred to engage only the best, but Gu had carved inscriptions for other patrons. Further research may lend credence to this hypothesis. Meanwhile, even a more cautious interpretation is significant: in the least, Gu enjoyed a level of proficiency with words beyond the strict functional literacy of a housewife, which the late Ming author Lu Kun specified as "a few hundred words" useful for household accounting, such as "rice" and "firewood."[74] When father-in-law Delin trained Erniang in inkstone making, he could have imparted knowledge about ancient scripts and ways of engraving them.

The visitor Xie unabashedly called himself and Dong Cangmen "experts" in inkstone making. From what is known about their work, especially Dong's ability to imitate Gu's work, this would not be an overstatement. It takes an expert to know an expert, and their respect for Gu's artistry should be taken as heartfelt. The third poem

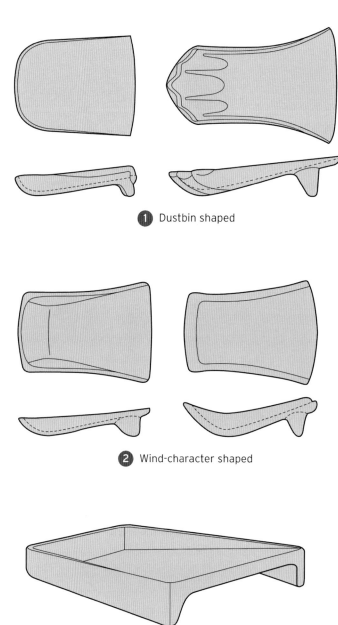

1 Dustbin shaped

2 Wind-character shaped

3 Modern footed shape

FIG. 3.10. Evolution of iconic inkstone shapes from the Tang to Song periods, showing the wind-character shape (no. 2) as a transitional type (which flourished in the ninth and tenth centuries) from the earlier dustpan shape (no. 1) with more curved sides (which appeared by the seventh century) to the modern footed format (no. 3) of the eleventh and twelfth centuries. Adapted from Ji Ruoxin, "Tang Song shiqi jixingyan."

provides tantalizing details about what transpired in this historic meeting, when two Fuzhou carvers exchanged views with their Suzhou colleague. The exchange was conducted not just verbally but also through actual objects: they viewed inkstones. The two shapes Xie mentioned, which resembled the Chinese characters "well" and "wind," are iconic shapes from the Tang and Song periods (fig. 3.10). Gu Delin was known for

his archaistic treatment, and evidently Erniang continued to make updated versions of these forms. The three also rolled up their sleeves to "polish and wash" an antique inkstone. The verbs may refer to washing off the sticky accumulation of old ink without hurting the patina of the inkstone, or it may mean a more aggressive polishing that amounts to remaking the ink pool.

There remains Xie's enigmatic reference to "the way of embroidery of the Gu family" (*Gujia xiufa*) in the second poem, which can be construed two ways. "Gu embroidery" (*Guxiu*) was a famous school of embroidery founded by women of the Gu family in Shanghai in the late Ming, becoming an exportable brand in the seventeenth century.[75] Xie may be straining to come up with tributes that encompass the Gu character (a usual move in the art of Chinese poetics as in flattery), and Gu embroidery—along with Guzhu tea in the fourth poem—are obvious candidates. Comparing Gu Erniang to the famed embroiderers of the Gu family pays tribute to female artisanal ingenuity and success. This interpretation is troubled by the awkward phrasing, "way of embroidery of the Gu family," which is seldom used to describe Gu embroidery. The phrasing puts an accent on *fa* (the way or method of making). Could it be that Xie was literally comparing Erniang's way of carving inkstone to the act of jabbing a threaded needle into a piece of silk?[76] I will return to this possible reading in analyzing the visual and material archives of inkstones attributed to Gu in the next chapter.

For now, the last word belongs to Gu Erniang. The Suzhou writer Zhu Xiangxian related that Gu (whom he called Qinniang) often discoursed orally on her philosophy of inkstone making in these words: "An inkstone is *carved from* a piece of rock; it would have to become round and lively as well as fat and opulent before the wonders of carving is made apparent. If the inkstone appears dull, dry, emaciated, and stiff, it is in fact the original face of the rock. Then what good did the carving do?"[77] These words highlight the transformative power of the artisan at work: her artistry is none other than the generative work of heaven's creation that bestows life onto the stone. Carving stone is thus the ultimate act of "culture" improving upon "nature."

With these same words, Gu also dispensed practical advice to inkstone carvers. The modern inkstone scholar and maker Wu Ligu finds the remark insightful. For Wu, to make a stone "round and lively, fat and opulent" the cutting has to be decisive, the overall design coherent, and the flow from one design element to the next seamless.[78] It takes an expert to know an expert. In both theory and practice, from all evidence Gu Erniang was a "real expert" indeed.

FIG. 4.1. *Apricot Blossoms and Swallows,* *kesi*-tapestry after Cui Bo's (fl. eleventh century) painting, Yuan dynasty, 104.8 cm × 41.5 cm. National Palace Museum, Taiwan.

4

Beyond Suzhou

GU ERNIANG THE SUPER-BRAND

ONE SPRING DAY NOT LONG AFTER LIN JI DIED (CA. 1725), HIS SON Fuyun called on Gu Erniang in her studio on Zhuanzhu Lane, carrying a recently acquired Duan stone from the then depleted Middle Cave. Earlier at home, in the process of sorting out his late father's unpublished poems, he found one dedicated to Gu. In it, Lin Ji adopted the same rhetorical strategy as Xie Ruqi's set of five poems discussed toward the end of the previous chapter, paying tribute to Gu by associating her with symbols both masculine and feminine: "The Weaving Maid bestows a piece of celestial stone, / In the earthy realm, an immortal holding a jade axe."[1] The "immortal" normally refers to the male woodcutter Wu Gang, who tried to fell a cassia tree on the moon. Upon hearing the lines, Gu pulled out a scrap of stationery paper and begged Fuyun to write them down for her. In return, she proceeded to carve on the back of the inkstone a picture of apricot blossoms and swallows and presented it to Fuyun. Thoroughly enchanted, Fuyun composed a note to be engraved onto the inkstone, complete with two seals.[2] It is not known if he eventually had it carved or not.

Gu's choice of apricot blossoms and swallows was not only appropriate to the season when the visit took place, it was also a versatile iconography that had broad appeal. The eleventh-century painter Cui Bo was among the first to have painted the motif, in a composition now preserved as a Yuan-dynasty *kesi*-tapestry (fig. 4.1). Swallows and apricots (which bloom in the third lunar month) are harbingers of spring, which is supposed to appeal to women's romantic sensibilities. Paired swallows, in particular, evoke an amorous couple. But since the apricot tree is also a euphemism for "the world of medicine" and the third month the appointed time of the civil service exams, apricot trees and swallows were talismans for health and success to men preoccupied by decid-

edly unromantic anxieties. Hence it was a popular theme in Ming and Qing material culture, not only in paintings and textiles but also on porcelain bowls and embroidery. Gu's impromptu selection of the motif for Lin's inkstone suggests a mental agility and a certain familiarity with the history of art.

THE TROPE OF APRICOT BLOSSOMS AND SWALLOWS

The motif can be seen on two inkstones in museum collections bearing Gu's signature marks. The first, named *Paired Swallows* (fig. 4.2; cf. fig. 3.7D, which shows a rubbing of the back), is part of the Hermitage of One Thousand Orchids (Lanqian Shanguan) collection housed in the National Palace Museum in Taipei.[3] It is a small but hefty inkstone that fits almost exactly in my palm. Scrutiny reveals that the two worm holes on one of the sides were scooped out with a curved-tip knife, and that the rugged surface of the rocks was painstakingly wrought by chiseling. Other signs of meticulous—perhaps overzealous is a better word—treatment abound. The overall effect of the rocky surface appears dry, even emaciated, the opposite of Gu Erniang's statement that the inkstone-maker's métier is to transform the "dull, dry, and stiff" stone into a round, lustrous, and lively presence.

The back of the inkstone is articulated into a flat pictorial surface by way of a raised frame. A pair of swallows in low relief dominates the space inside the frame: one swooping down with a flower petal in its bill, the other's mouth ajar in anticipation. In the upper right corner the name of the picture appears in running script: "Apricots and spring swallows." A signature mark in seal script, "Made by Gu Erniang of Suzhou," takes up the lower left corner and extends almost to the top. As if the disproportionally large characters were not eye-catching enough, the artisan positioned a large mynah's eye to their left and interrupted the stone frame to draw the viewer's gaze to it.

FIG. 4.2. *Paired Swallows* inkstone bearing a "Wumen Gu Erniang zhi" mark, (A) front; (B) back. L 6.7 cm, W 7.2 cm, H 2.1 cm. Lanqian Shanguan Collection, National Palace Museum, Taiwan.

Similar to the treatment of the stony outcrops on the front and sides, the paired swallows and flower petals on the back of the inkstone are more finely rendered than the photograph and rubbing can do justice to. The feathers on the head of the upper swallow, neatly lined up, are articulated by short strokes incised by tapping the tip of a sharp knife. The feathers on the bodies of the two birds, however, appear slapdash and the four wings, mechanical. The single flower to the left of the lower swallow's foot is depicted by outlines of the four petals in relief and a raised dot in the center. In spite of, or perhaps because of, fine treatment of some individual elements of the birds and flowers, the overall effect of the picture is one of contrivance. Although not unskilled, the craft is unimaginative.

The swallows and apricot flowers of the Taipei inkstone appear all the more formulaic when compared to one in the Tianjin Museum also named *Paired Swallows* (fig. 4.3, cf. fig. 3.7c which shows a rubbing of the front, back, and sides). This latter inkstone is of a functional size common in the period and shows signs of use.[4] The upper, left, and right edges of the face are ringed by an archaistic pattern of swirling clouds, dynamically rendered in low relief. That the cloud motif was not repeated beyond the two corners on the lower edge saves the inkstone from a monotonous symmetry; this treatment is conventional for almost all Ming and early Qing rectangular inkstones. But there is nothing conventional about this inkstone.

When I first viewed this inkstone, I thought the work skilled but unremarkable. Having since studied close to a hundred inkstones from the period, I subsequently realized how much it stands out from the others after a revisit. The swirling clouds in a nonrepetitive pattern animate the entire face of the inkstone. The soft round corners of the stone, accentuated by a slight downward dipping profile of the outer corners, harmonize with the round corners of the ink pool. The straight lines on the sides of the stone and the ink pool are tempered by beveled edges. Although rectangular in shape, the inkstone emits a rounded softness as if all the straight lines were curves. The liveliness of the swirls and curves makes the stone, a Duan, appear powdery to the eye and warmly smooth to the touch (like a baby's skin in the parlance of Qing connoisseurs). Of all the inkstones I have come to know, attributed to Gu Erniang or otherwise, this one comes closest to her professed goal of transforming the dry and dull stone into one "round and lively; fat and opulent." In itself, of course, this does not constitute proof that this (or any other) inkstone is from Gu's hands.

The pair of swallows and fluttering apricot flowers on the back of the inkstone are rendered in low relief on a borderless ground. The composition, down to the posture and placement of the birds, is almost identical to the Taipei *Paired Swallows* (fig. 4.2). The only difference is the addition of two buds and one blossom in the space beneath the lower swallow, and one gourd-shaped seal underneath Gu's signature mark.[5] Although the wording of the mark is the same, this one is in regular script with each stroke rendered by two applications of the knife from the left and the right, a method

A

FIG. 4.3. *Paired Swallows* inkstone, (A) front; (B) back. L 18 cm, W 12 cm, H 3 cm. Tianjin Museum.

called "double-cutting" (*shuangdao*) that approximates the pressure applied by the calligrapher's hand wielding a soft-tipped brush. The text in the upper right corner is also different; this one reads, in seal script: "A flower petal in the mouth; an excess of emotions." Both this line and the text of the seal are in Lin Fuyun's notation cited earlier.

Despite their similar compositions, the Tianjin *Paired Swallows* exudes a painting-like quality lacking in the Taipei stone. The smaller size of the signature mark helps, as does the absence of a picture frame. Unlike European oil paintings, Chinese scrolls are not framed, only mounted on paper and silk. When hung on the wall, a painting does not demarcate itself from its context, creating a more continuous relationship between figure and ground.[6] But the most important factor in the painterly appearance of the picture is the exquisite craftsmanship that rendered the swallows' eyes, plumage, and the apricot blossoms in ways that at once highlighted and concealed the traces of the knife. If the artistry of an ink painting inheres in the execution of the brush strokes, the artistry of carving a painting on stone inheres in the knife stroke. It is futile to try to

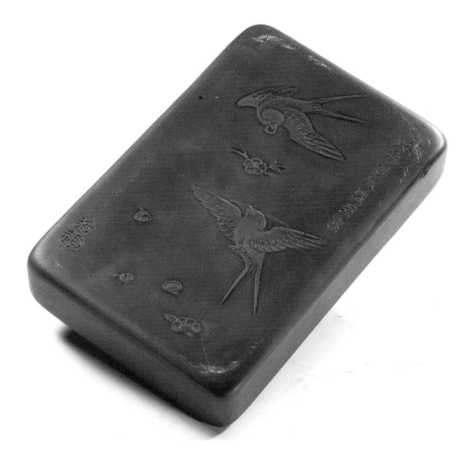

B

duplicate the traces of brush strokes and the flow of the ink on a stone surface, because the stone is stiff and the knife edge, unlike the tip of the brush, unyielding. In contrast to the painterly brush stroke with its dark (when the brush is wet with ink) and light (when the brush becomes dry) washes of the ink, the stone carver evokes directional movement by the orientation of the slashes in conformity to the outline shape of a space. The way to a painterly image on stone is to invent a distinct visual language and technique by attending to the material specificities of the stone medium.

Two such techniques stand out in the Tianjin *Paired Swallows*. The first is a combined use of low relief and intaglio carving to achieve a three-dimensional effect on a flat smooth surface.[7] The five-petal flower midway between the mouths of the two birds, the visual focus of the picture, is an example. The ground on which the flower is depicted is on a slightly lower plane than the surface, while the outline of the five scallop-shaped petals is etched in a barely perceptible relief.[8] The stone in the tiny area inside the petals (what shows up in the rubbing as five white patches shading into grey edges) is gently scooped out to a level lower than the ground. In each scooped space,

ultrafine incisions made with the tip of the knife depict the pistil and stamens schematically: the anther with a horizontal slash; the filament supporting it with a vertical line under the slash; the stigma with a cluster of tiny dots. The result is not a life casting of a flower—the petals, stamens, and stigma are rendered in negative space here on the inkstone. Nor does the carved flower resemble the flat images painted with a hair-thin brush in the genre of *gongbi* ("crafty brush") painting of flower and birds. The life-like quality of the apricot blossom on stone—it casts a faint shadow under the light—is rooted in its tactility. The smooth transition of the different planes from low relief to intaglio and incised line, executed within a space smaller than a finger tip and in a profile that appears almost flat in cross-section, creates visual pleasure and invites subtle running of the fingertip over the alternating convex and concave surfaces.

Another example of the adroit handling of calibrated gradation of planes can be found on the underside of the right wing of the lower swallow. The flight feathers of the two swallows are treated differently although both are highly veristic, with the anatomically correct nine primary feathers on each wing. Each vane of feather on the wings of the upper swallow is articulated, complete with the rachis and barb. Ironically, the effect is less than satisfactory, as the vanes terminate abruptly at the lower edge as if they run out of space. The artisan switched strategy with the lower swallow, rendering in full contour only two rows of feathers. The rest of the wing is treated more schematically, with slashes running in parallel lines to evoke the alignment of plumage. On the right wing, in the zone where the shorter row of feathers meets the dotted lines, the artisan made a depression extending almost the entire length across the wing (impossible to see in either the photograph or the rubbing) to ease the transition and create the illusion of volume. This juxtaposition of low relief and intaglio also invites the fingers to caress the carved surface.

The slashes, made by tapping the tip of the carving knife on the surface with measured force, represent the second stone-specific technique that heightens the painterly quality of the image. The wings, head, and body of the lower bird are animated by these slashes, as are the head and body of the upper bird. Like the stamens and stigma of the flower, these lines are so faintly etched onto the stone that they appear as if they were jabbed not by a knife but a sewing needle. The slashes, evenly lined up in rows, resemble embroidery stitches. Could it be that the artisan who carved the swallows and apricot flowers was informed by an embroiderer's sensitivities, and was perhaps even incorporating embroidery techniques?

The differences between the two mediums should be noted at the outset. In embroidery, especially Suzhou-style embroidery where a veristic painterly effect is paramount, the key skills that the artisans honed are related to color manipulation: modern practitioners dye their own flosses to achieve a diverse and even spread of neighboring shades; sometimes over four hundred shades are needed for one composition. In stitching, too, the challenge is to line up one stitch after the next rhythmically so that

FIG. 4.4. Two variations of the "hairy stitch" (*shizhen; shimao zhen*) used by artisans of Gu embroidery to render feathers and furs. (A) Top: enlarged detail of *Squirrels and Grapes* album leaf. Bottom: schematic drawing showing long and short stitches in overlapping layers, the stitches in each row being of uneven length. (B) Top: enlarged detail of *Consort Wen Returning Home* album leaf. Bottom: schematic drawing showing long and short stitches aligned row by row in a flat layer. From Shanghai Bowuguan, *Haishang jinxiu*, 209, courtesy of Yu Ying, Shanghai Museum.

FIG. 4.5. *Apricot Blossoms and Flying Swallow*, one leaf from Gu embroidery album of flowers and birds, detail, 24.8 × 22.9 cm. From Shanghai Bowuguan, *Haishang jinxiu*, 123, courtesy of the Shanghai Museum.

the stitches would blend naturally (fig. 4.4).[9] To make the embroidered surface as flat as possible and to avoid jagged or block-like color transitions, Suzhou artisans use extremely fine needles and split a piece of floss into as many as thirty-two strands.[10] The same obsession with naturalism in coloring is clearly not applicable to inkstone carving. Where the embroiderer uses color to achieve volumetric and vivid effects, the stone carver uses texture and tactility.

One album leaf from a masterpiece of Gu embroidery from the sixteenth century, entitled *Apricot Blossoms and Flying Swallow*, depicts a single swallow frolicking in the

branches of an apricot tree (fig. 4.5). In flight with outstretched wings, the bird tilts its head upward and opens its mouth in anticipation of a falling petal. The bodily posture is different from either bird on the Tianjin inkstone, but the rendering of the plumage is remarkably similar. The left wing of the embroidered swallow is also demarcated into three zones, with two layers of vaned contour feathers topped by a more inchoate layer represented by parallel slashes. The rows of "hairy stitch" that fill the body of the embroidered bird run in the same direction as those on the lower carved bird. The arc where the tilted head of the embroidered bird overlaps with the neck is treated not as a smooth line, but as a blank space in between two hairy surfaces. The same treatment is evident on the upper carved bird where the head meets its upper body, and to the same feathery effect.[11] Since the techniques of embroidering are intrinsically different from stone carving, it would not be right to suggest that the carver borrowed embroidery techniques. But the visual evidence of intermedia crossings strongly suggests that the carver of the Tianjin inkstone was familiar with Suzhou-style embroidery in general, and perhaps the works of Gu embroidery in particular.[12]

Gu embroidery, a brand associated with the genteel women of the Gu family (no relations to Erniang), originated in sixteenth-century Shanghai. Its critical and commercial success led to the development of workshops geared toward both domestic and foreign markets in the neighboring areas in Jiangsu province, including Suzhou. By the eighteenth century, Suzhou had emerged as the center of "Gu embroidery" and it was expected that local daughters, from both genteel and lower-class families, would practice the craft to enhance their value in the marriage market. Although there is no hard evidence, Gu Erniang had most likely learned embroidery and taken in piecework to supplement household income, as was customary for Suzhou girls before marriage. But this in itself does not constitute proof that the Tianjin *Paired Swallows* inkstone was by Gu Erniang.

The circumstantial evidence in favor of the attribution is considerable: in design and execution, this inkstone fits the adjectives that she herself and her patrons used to describe her work. The design is archaistic and simple; the carved face of the inkstone is rounded, lively, and opulent. The scene of swallows and apricot blossoms is collaborated by a reliable textual source to be a pictorial motif that Gu did carve. The painterly quality of the image, epitomized by the meticulous treatment of the plumage, betrays knowledge about Suzhou-style embroidery. This possibility is reinforced by a cryptic line in a poem by fellow inkstone carver Xie Ruqi, whom one may recall had visited Gu and had either viewed works of embroidery in Erniang's studio or paid tribute to Gu by comparing her to bygone embroiderers of the Gu family. Last but not least, the fineness of the Duan stone, not to mention the superior conceptual craft of the Tianjin *Paired Swallows*, befit Gu's reputation as one of the most accomplished inkstone makers of her day.

But even when all the tantalizing circumstantial evidence is taken together, they fail to clinch the case. This inkstone is the most likely to be from Gu Erniang's hands among

the ones I have studied, but there is no conclusive evidence on the attribution of this or other stones given the present state of knowledge.[13] Without even one incontrovertible benchmark against which others can be compared, all efforts to authenticate Gu's work will remain guesswork. Collectors in China will continue to seek knowledge about the holy grail, as the difference between an authentic and fake Gu stone can amount to hundreds of thousands of dollars. There is always hope that a significant source will be brought to light. For the present book, however, the sleuthing for an authentic inkstone from Gu Erniang's hands ends here.

PLACE, MEDIA, AND SUPER-BRANDS

The quest for the authentic, although a worthwhile goal of connoisseurship that has produced useful knowledge, ultimately detracts from the most significant aspect of Gu Erniang as a historical phenomenon: her development from a local artisan into a super-brand. Analysis of a group of extant inkstones against the textual sources allows us to document this process in detail.

By super-brand I mean not just a very famous brand, but also one that functions like a "super-sign." A super-brand, one may say, is not a self-contained style but a "het-ero-cultural signifying chain" that cuts across the semantic fields of two or more media and locales.[14] The quest for the authentic Gu is not so much wrong but wrong-headed: it literally sends one heading in the wrong direction. The search for authenticity requires a regressive referral back to a single point of origins (her hands or workshop), whereas mapping Gu as super-brand requires dispersal, a movement away from an alleged origin to take stock of all the artifacts that were taken as believable works of hers.

Even the fakes, and in fact especially the fakes, are instructive of the heterogeneous cultural milieu of the art market, from the early eighteenth century to today, in which supplies and demands for Gu's inkstones were realized. The circulation of texts about her (accurate or otherwise) in both published and manuscript formats worked in tandem with the buying, selling, gifting, and collecting of "her" inkstones to create a desire for Gu Erniang that remains unabated today. As time went on, both the media of text and stone became ever more fanciful. To trace this signifying web requires attentiveness to the specific sites where these media were produced as well as accounting for the ways in which knowledge, tropes, and sentiments traveled across media and locales.

From this perspective, the *Paired Swallows* inkstones constitute a portal to two salient aspects of the super-brand phenomenon in the eighteenth century: its multisited and intermedial nature, and the prevalence of tropes (visual and textual) as a strategy for gaining recognition. The exquisite workmanship of the *Paired Swallows* in Tianjin serves simultaneously as the trademark for Gu Erniang and for Suzhou. The pursuit of a hairsplitting fineness to the detriment of one's eyesight (recall the descriptions of "demonic craft" by Manchu official Nalan Chang'an) is a distinguishing feature not only

of inkstone carving and embroidery, but also of jade-carving, another craft for which Suzhou had come to be renowned in the eighteenth century. The internal mechanism of this intermedial formation of the Suzhou super-brand, one that is rooted in the geographical proximity of these workshops to one another on or near Zhuanzhu Lane, awaits future research.

Suffice it to note here that in matters of craft knowledge as in identity formation, encounter with the other is a significant catalyst. The making of a discernable Suzhou style, what Chang'an called "Su-ware," was aided by Cantonese craftsmen working in and out of Suzhou: "The craftsmen from Guangdong are also renowned for their meticulous skills. Hence the colloquial expression: 'Guangdong craftsmen; Suzhou design/model [*Guangdong jiang, Suzhou yang*].' Their work can be grouped under the rubric of Guang-ware [*Guangzuo*]."[15] The palace workshops, we may recall, constitute an important site for Suzhou and Guangdong craftsmen to rub shoulders with one another. The relationship between Suzhou and Guangdong craftsmen in court as in society was at once imitative and competitive. Echoing the prevalent judgment of his peers, Chang'an found Guang-ware wanting: "Suzhou craftsmen are very clever in constantly presenting something fresh. The Guangdong craftsmen, goaded by the former, gave up their old styles and tried their hands at inventing a new distinct style of their own. But they failed."[16] Chang'an's judgment is biased, but he disclosed one important rule in the market of artistic craft in the eighteenth century: the success of a place-based super-brand requires the establishment of a recognizable style *across media*. There would have been neither Su-ware nor Guang-ware if all that were made in the workshops were ivory balls.

In the field of inkstone making, the key players in this game of imitation and competition were artisans not only in Suzhou and Guangdong, but also in Fujian.[17] Guangdong inkstone carvers suffered from anonymity despite their natural material advantage. Fujian carvers fared better in the early Qing, despite the apparent lack of a local inkstone-caving tradition. The local craft that did flourish since the late Ming was seal-carving, especially in the provincial capital of Fuzhou, which was in relative proximity to the quarries of desirable Shoushan stones. Fujian artisan-scholars who were classically educated but had at some point abandoned the exam ladder increasingly turned to carving seals. They were not as famous as such masters as Wen Peng, founder of the so-called Suzhou school of seal carving, but some managed to leave their names in the history of the craft during its formative period.[18]

Xie Ruqi, the Fuzhou-based artisan-scholar who visited Gu Erniang in Suzhou, was one such expert whose approach to inkstone making was nurtured by this local tradition of seal-carving, of which he was a notable practitioner in the early eighteenth century. Seal-carving involves two distinct operations, often by different hands: carving the finial on top, which is a miniature three-dimensional sculpture, and the incision of words on the other end where the impression is to take place, a flat surface carved either in relief or intaglio. The carving of words, be it a name or a poetic line, is analo-

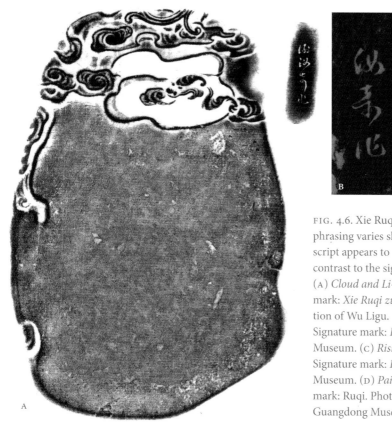

FIG. 4.6. Xie Ruqi's signature marks. Although the phrasing varies slightly, the writing in running script appears to be from the same hand, in contrast to the signature marks of Gu Erniang. (A) *Cloud and Li-Dragon* inkstone. Signature mark: *Xie Ruqi zuo* (Made by Xie Ruqi). Collection of Wu Ligu. (B) *Clouds and Moon* inkstone. Signature mark: *Ruqi zuo* (Made by Ruqi). Tianjin Museum. (C) *Rising Sun Over Waves* inkstone. Signature mark: *Ruqi zuo* (Made by Ruqi). Tianjin Museum. (D) *Paired Phoenix* inkstone. Signature mark: Ruqi. Photograph by the author, at the Guangdong Museum.

gous to the carving of encomiums on an inkstone in that it requires familiarity with the history of calligraphic scripts and increasingly fell under the rubric of epigraphic scholarship. The carving of the top knob, in turn, benefits from knowledge of the decorative motifs on archaic vessels in bronze and jade, especially mythical animal forms. Since Xie Ruqi was one of the few inkstone makers in Gu's times who also left his signature mark and several of his signed works are extant, it is possible to gauge the difference that seal-carving made to his inkstone craft.

The two inkstones by Xie Ruqi in Tianjin are named after different sceneries—*Clouds and Moon* (fig. 4.7) and *Rising Sun over Waves* (fig. 4.8)—but the design elements are in fact variations of the same theme. The ink pool is rendered as a round surface that dominates the face of the inkstone (the full moon or the sun), and the soft curls of clouds or waves surrounding it cleverly hide the water pool while providing contrasting texture and decorative relief. "Clouds and moon" is a common design in Qing inkstones, and Xie's is a particularly fine sample of the genre. The clouds veiling the moon on the right and lower sides are rendered in subtle layers of low relief in curvaceous but unbroken lines. The rounded softness of the overall effect is reminiscent of

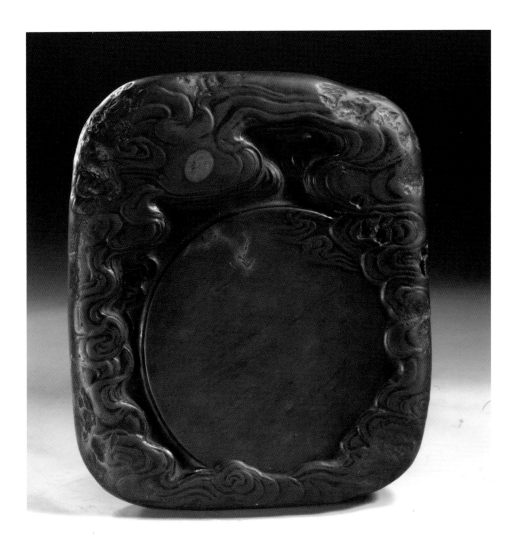

FIG. 4.7. Xie Ruqi, *Clouds and Moon* inkstone, front, L 15.7 cm, W 13.3 cm, H 3 cm, with encomium by Huang Ren on back (not shown). Tianjin Museum.

Gu's *Paired Swallows* in Tianjin. On the left side, the clouds are lifted from the moon. In between the arc of the moon and the departing clouds is a deep trough cut in high relief, a technique seldom seen in Suzhou inkstones. A comparison with the largely flat profile of another *Clouds and Moon* in Tianjin (which coincidentally bears the mark of Gu Erniang) underscores this point.[19]

Xie's *Rising Sun Over Waves* showcases high relief carving in an even more dramatic fashion. The billowing waves lapping over the lower edges of the rising sun are rendered meticulously: each wave is sculpted as a tactile entity in mezzo relief; the cresting movement of each is given material heft in the form of parallel lines combed

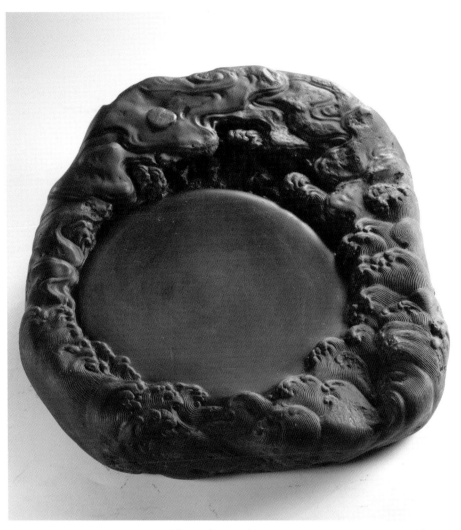

FIG. 4.8. Xie Ruqi, *Rising Sun over Waves* inkstone, front, L 19 cm, W 18 cm, H 3.8 cm, with enco-
mium by Lin Ji on back (not shown). Tianjin Museum.

through the body of the wave, like the tail of a meteorite mapping its trajectory. The
finely incised combed lines recall those of the dragon's mane in Liu Yuan's *Luminous
Dragons* inkstone (fig. 1.6). In the upper half of the inkstone face, the ocean gives way
to the sky as the waves morph into clouds, retaining their form but losing the combed
lines. Where the rising sun meets the clouds, a series of deep cuts render the water pool
into a rugged grotto. The technique of high relief and open work is unmistakably that
of Fujian seal-carving.[20]

Given the friendship between Xie Ruqi and several of Gu's known patrons, includ-
ing Huang Ren, it is virtually certain that Xie had studied the inkstones made by Gu

and possibly those of other Suzhou carvers that these collectors brought back to Fuzhou, even before his documented visit with Gu.[21] His friendship with fellow inkstone maker Dong Cangmen, who served as Huang Ren's resident inkstone carver in Guangdong, suggests that Xie also gained access to the knowledge of Guangdong carvers at least vicariously. In light of the super-brand status of Gu and Suzhou, and the fact that the Fuzhou inkstone-making tradition was a more recent development, it is tempting to view this relationship between Gu and Dong and Xie in terms of master and apprentices.[22] But future research may bear out my hunch that on the level of skills and conception of craft, it was more of a two-way exchange.

The Guangdong craftsmen, for their part, have proved to be quick learners of metropolitan styles and shrewd marketers (their skills were never in doubt in my mind). Having watched how Dong and his colleague Yang Dongyi worked, having discussed the fine points of Fuzhou and Suzhou carvings with them, and perhaps even having studied the Gu Erniang stones in the personal collection that the magistrate brought with him, they invented a genre of inkstone all their own called "Sihui style" (*Sihui kuan*). The carving, one imagines, incorporated Suzhou, Fuzhou, and Guangdong sensibilities and techniques. These stones bear spurious inscriptions by Huang Ren and were encased in boxes made of *zitan*-wood inlaid with a piece of jade on the front and lacquered on the inside.[23] Some inkstones made in the palace workshop are boxed in a similar manner (including Liu Yuan's *Luminous Dragons*), an indication of communion between the court and the southern edge of the empire, most likely through the local craftsmen recruited to work in the imperial Inkstone Works.

The early Qing world of Duan–inkstone making was thus a vibrant and innovative one, with the traveling of craftsmen, styles, and techniques across provinces and media. The more visible developments—the appearance of Gu Erniang and Suzhou as super-brands, the explosion of new inkstone designs, the experimental blending of carving techniques, growing respectability of the craft, and the development of encomiums as a specialized genre—are but the tip of an iceberg. Less conspicuous but also integral to the development of the artistic craft of inkstone making was the knowledge of the unnamed carvers, quarriers, and curio shop owners; the butlers (allegedly even monkeys) who washed the inkstones or ground ink; not to mention the millions of students who wrote essays in their daily grind.[24] Each in their own ways, these people altered the look and feel of the inkstones found in museums or collectors' cabinets today.

Future research may also reveal specific exchanges between jade or lacquer carvers and inkstone makers in court as in society. The more one shifts attention from the superstars and seeks connection across the spectrum of artistic practices, the less meaningful it becomes to attribute authorship of any object to an individual. Acknowledging this larger cross-media and multisited milieu, of which the super-brand phenomenon is only a part, also helps explain why so many early Qing inkstones, with or without attributions to Gu, are by and large similar to but slightly different from one another.

The two *Paired Swallows* examined earlier show the tendency for Gu inkstones to cluster in recognizable groups organized by visual tropes (paired swallows and moon in the clouds, for example; see five others in appendix 2). The Taipei and Tianjin *Paired Swallows* both bear Gu's mark, albeit in vastly different script and size. The composition of the apricot and birds motif of the two is similar, but the conceptual craft is not. The National Palace Museum in Taipei has a third inkstone that is remarkably similar to the Tianjin one except for the placement of the inscription and seal, and instead of Gu's signature mark it alludes to her authorship by indexical logic: it bears the seal of her main patron, Huang Ren (in the form of his courtesy name Xintian).[25] It is possible that one, both, or all three of these stones are those fakes made by Dong-Yang, their Guangdong colleagues, or others imitating them. But the logic of forgery is inadequate to explain the clustering of early Qing inkstones into recognizable tropes and the subsequent proliferation of the number of tropes as well as the variations within each trope. Neither can the common Chinese practice of copying exemplary works of art as homage or pedagogic exercise account for the phenomenon. To the modern mind, both the forger and the copyist would aim at producing facsimiles as close to the original as possible (the difference between a forger and copyist is only in intent). But a stone that shares a trope with another is always visibly different. What desires and knowledge that structured the market of artistic craft could this proliferation of tropes be bringing to the fore?

The trope of the phoenix is associated with Gu Erniang's super-brand even more than the paired swallows. It, too, is solidly linked to Gu's hands by way of a textual reference in *Inkstone Chronicle*, an encomium by Lin Fuyun's son in this case:

> Replete with grace from Mount Cinnabar Grotto,
> The phoenix turns and soars.
> Made by Gu Dagu,
> Scooped from the Lingyang [Duan] quarry.

Mount Cinnabar Grotto is a mythical mountain where the phoenix nests.[26] The original language for the second line literally reads, "Turns and flies over [some unspecified boundary or obstacle]." This original and specific expression seems odd in an otherwise hackneyed composition until one realizes that Lin could be referring to a striking technical feature of the phoenix trope: a three-dimensional crossover treatment of the edges of the inkstone that makes the phoenix appear to be perching on the top edge of the stone, draping its upper body on the face of the stone and its tail on the back. The unspecified boundary or obstacle that the phoenix flies over is the edge of the inkstone, especially the upper side.

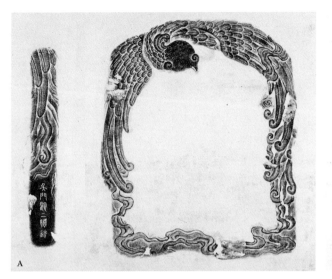

FIG. 4.9. *Phoenix* inkstone with signature mark "Wumen Gu Erniang zuo," ink rubbing. (A) Side and front; (B) back, Several of Lin Ji's and Huang Ren's seals and encomiums appear under the plumage. L 21.5 cm, W 18.1 cm, H 2.6 cm. Palace Museum, Beijing.

The basic compositional concept of the phoenix inkstones is remarkably consistent. As this typical sample (fig. 4.9; cf. fig. 3.7A) from the Palace Museum in Beijing shows, the phoenix head is placed near the upper left corner of the stone, its neck twisted as the head turns to face the right (the "turns and soars" in Lin's encomium). To its left and right the bird spreads its two wings like a parting curtain, draping its impressive plumage on the left and right edges of the stone. The curls of the feathers are carried over to the back of the stone, vane by vane and barb by barb. In physical shape and format, the phoenix trope is a radical departure from the swallows and apricots, which involves an image imprinted on the flat back surface of an inkstone. The latter's independence from the front makes it a decorative motif interchangeable with any other. The phoenix, in contrast, is integral to the shape (always slightly irregular in outline), design, and structure of the inkstone. The lower rim of the front is demarcated as a raised edge of a size comparable to the other three sides (and usually finished with swirling clouds in low relief to harmonize with the plumage), making the face of the inkstone appear like a shallow dish rimmed evenly on all four sides. In tandem with the crossing over of the plumage, this articulation imparts a three-dimensional heft to the inkstone.[27] The stone invites one to pick it up and to turn it over in one's hands.

Modern connoisseurs of ceramics have called this treatment of an animal or a decorative motif crossing from the inside surface of a vessel to the outside "climbing over the wall" (*guoqiang*). Jade carvers appear to be the instigators of climbed-over dragons, which allows references to antique jades while displaying their daring open-work

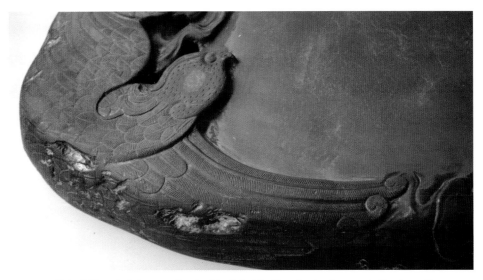

FIG. 4.10. *Paired Phoenix* Inkstone, detail of the left side. Despite the damage to the stone, the transition of the plumage from the front of the inkstone to the side is visible. Guangdong Museum. Photograph by author.

techniques. Ming jade carvers such as the famous Lu Zigang, for example, fashioned jade cups with sinuous dragons poaching on the rim or on one side as ergonomic handles. In the early Qing, this technique crossed over from jade to porcelains, ink-cakes, and inkstones. The *Virtuous Power of Dragon*, an ink-cake designed by Liu Yuan dated 1678 (fig. 1.8), features a gilded dragon that wraps itself on the top edge and side of the rectangular stick of ink. Ceramic artisans adopted the three-dimensional carving technique to painting on a flat surface. One early example of this is a blue-and-white bowl (dated ca. 1700–1710) in the Victoria and Albert Museum, which depicts a curling dragon whose upper body is on the inside while its belly flops over the edge and the tail trails along on the outside.[28] The mechanism of transmission of the climbed-over animal between the court and the Suzhou workshops is a rich topic for further research. Present evidence suggests that this intermedial journey was a distinct early Qing development. In inkstone carving as in ceramics, as far as I know there is no comparable treatment of carried-over motifs before the early Qing.

The novel presentation of the climbed-over phoenix on inkstones puts a premium on the artisan's ability to visualize the alignment of the feathers on the key transitional zone of the inkstone's upper edge, which is 2.6 cm thick in the Beijing example, so that the feathers appear to wrap naturally around the front, back, and side. The challenge is to conceptualize these sides simultaneously as connected (depthless) surfaces and as constituting a three-dimensional object with material heft. The artisan of the Beijing phoenix fared brilliantly on this score, although the rest of the inkstone lacks vitality.

Each vane of feather expands as it is folded around the edge, filling the space of the 2.6 cm–thick top in a dynamic expansionary gesture. The vanes of plumage, neatly arranged in layers, fan out and fall one after the other toward the left or right before making another dip and cascading onto the back of the inkstone.

I have viewed five of these phoenix inkstones, two bearing Gu Erniang's mark and another, Xie Ruqi's.[29] Although the quality of overall craftsmanship varies, the treatment of the carried-over plumage is inevitably the most exacting part of each stone. The artisan appears intrigued if not excited by the possibilities that the new challenge presented. The trope spins off to variants showcasing the same treatment, such as a *Paired Phoenix* bearing Xie Ruqi's mark in the Guangdong Museum (fig. 4.10) and several *Parrot* inkstones with shorter curled plumage. Xie's twin phoenix is a veritable example of a fusion of Suzhou and Fuzhou techniques. The heads of the two phoenixes, dominated by the giant green stone "bird's eye" markings, are articulated with the same embroidery stitching-like slashes on Gu's paired swallows. The plumage draped over the sides appears to be rendered similarly. But the water pool, a deep recess behind ribbon-like clouds, is cut in open work typical of Fuzhou seal-carving. Steeped in the tradition of high relief and open work honed in carving the top knobs of seals, Fujian artisans pushed the logic of bridging adjacent planes associated with the super-brands of Gu and Suzhou to new heights.

THE THREE-DIMENSIONAL INKSTONE

The *Bamboo Stem*, an inkstone in the form of a cut bamboo stem or culm in the Tianjin Museum, is the hallmark of this development (figs. 4.11, 4.12). The bamboo stem is squashed to accommodate the format requisite of inkstones—flat surfaces on the face and back—but is otherwise veristic. The artisan treats this visually complex stone as simultaneously a canvas and a full-bodied object on which to realize iconic representations of a growing bamboo plant. On both upper and lower ends of the stone, the cut ends of the thick bamboo stem and the diaphragm inside the cavity are visible. The face of the inkstone is trisected by two wavy lines, each line demarcated into a raised ridge and a groove that looks like a capital *M* in cross-section. The profiled line is a precise rendition of a bamboo node: the lower ridge is the "sheath ring," which is a scar after the sheath leaf falls off, whereas the upper scar is a stem ring, which marks the point where the stem had stopped growing. The row of beads above the stem ring depicts the stump of roots that had since fallen off. Since roots typically grow from the rhizome nodes at the base of the plant, these beads mark this segment of the culm as the lower stem protruding from the ground. Indeed, growth and the threshold of transformation is the theme that unifies the different parts of the inkstone conceptually; the unity is achieved not just by way of the iconography of a bamboo plant.

The ink pool occupies the segment on the stem between the two nodes, called the internode. On the upper right corner of the ink pool, a convoluted pit (the water pool)

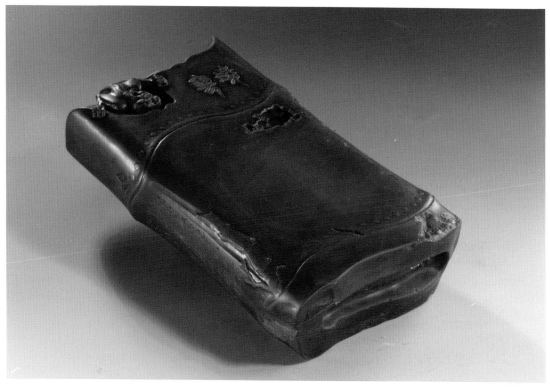

FIG. 4.11. *Bamboo Stem* inkstone, L 19.8 cm, W 12 cm, H 4.7 cm. Tianjin Museum.

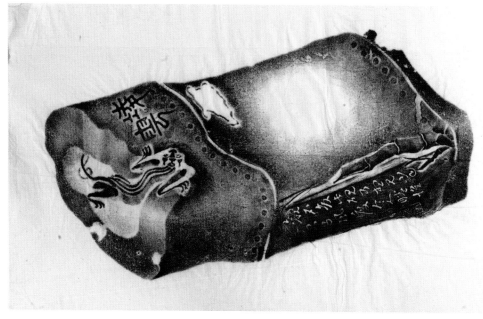

FIG. 4.12. *Bamboo Stem* inkstone, ink drawing, view from top side showing a *li*-dragon peeking from crevice. Tianjin Museum.

resembles a hole that has been nibbled away by a strong-jawed insect that managed to chew through the fibrous culm, which rarely happens in real life. The offending creature—the same mythical *li*-dragon commonly found on the knob of Fujian seals—may well be hovering on the upper edge, peeking out from a giant crevice it had chewed away, claws and beady eyes visible. The lower half of its sinuous body, carved in open work, is nestled in the cavity of the stem and in full view from the top side of the stone, as the creature appears hanging by its tail and hind leg. In comparison to this audacious rendition, the carried-over treatment of the phoenix's plumage appears flat. The *li*-dragon, in full-bodied form, is not just three-dimensional but also, caught in the act of chewing through time, hovers on the threshold to four-dimensionality.

A second technique of transition across planes is used in the bamboo inkstone, in the form of two wavy nodal rings continuing on the sides and looping around the back of the stone. The body of the inkstone is thus made to become the body of the squashed bamboo stem. But immediately the artisan disrupts this facile illusion by adding on the upper third of the back of the stone a branch of foliage carved in low relief. There is no crossing over of surfaces here: the branch originates from the stem ring on the left side and leans right; the upper blades of leaves stop short of the top edge of the stone. The containment of the foliage within a definite area and entirely on the back of the stone renders the latter into a flat tablet-like surface, ready to be inscribed by its scholar-owner.

Another disruption of surfaces is seen near the lower corner of the front of the stone. At exactly the point where the front surface rounds off to the side of the stone, a protruding bamboo that looks like a cross between a rhizome and a broken stem rises from the nodal line and creeps upward along the edge. Behind the protruding bamboo at the base, a small branch that looks like a sprouting shoot extends leftward to occupy the space on the side of the stone, then arches back toward the edge. It is difficult to describe the bamboo parts verbally because the image is not entirely biologically accurate, but their visual function of virtuoso technical display is unmistakable.[30] It seems as though the artisan is saying: it is not difficult to carry over one motif (be it bamboo nodes or phoenix plumage) onto three surfaces; neither is executing a carryover in three-dimensional open work. I can do that *and* treat the edge as if it were a flat canvas by painting on it.

The artisan did not leave a signature, but both the iconography of the *li*-dragon and the carving technique connect it to Fuzhou, as do the inscriptions on the stone. Carved on the back is a long encomium in prose, dated 1635, by Cao Xuequan (1574–1646), a Fuzhou native who was a Ming official, poet, and bibliophile.[31] Cao was one of the most famous local sons of Fuzhou, a martyr to his dynasty who hanged himself when the Qing conquered his hometown in 1646. On the left side of the stone is an inscription by its one-time owner, Li Fu (1662–1745), the Fuzhou scholar-official who remained mum about the Songhua inkstone gifted from Yongzheng: "Viewing Shicang's [Cao's cour-

tesy name] inkstone, I can visualize his gentlemanly countenance in the bygone years. Overcome with emotions by this [connection with Cao mediated by his inkstone], I could hardly contain myself." Thus the two inscriptions cemented a link between two people sharing a native place but separated in time. There is some doubt about the dating and authenticity of Cao's encomium.[32] Although the complex representational game evinced by this inkstone is rather unique in the Ming as in the Qing, the virtuoso carving techniques, ornate painterly effect, not to mention the three-dimensional impulse, are typical of the early Qing milieu.

To return to the discussion of the technical innovations and regional traveling of artisans and craft knowledge that undergirded Gu Erniang's rise as a super-brand, the material evidence, when subjected to a technique-based analysis, clearly suggests the following trajectory: Suzhou inkstones were recognizably "Su-ware" in their painterly effects, wrought of a meticulous attention to the coherence of the overall design and calibrated treatment of the layering of the relieved surfaces. The manipulation of low relief and shallow intaglio ("suppress the ground while making a faint relief") allows the artisan to achieve a subtle transition in textures and visual effects analogous to the naturalistic color transitions in Su embroidery. The artisans in Fuzhou, for their parts, introduced a new iconography, *li*-dragons, into inkstone making. Fuzhou inkstones showcase risqué high relief and open cutouts that are techniques of seal-knob carving. A narrow bridge of stone, in the form of a cloud or a dragon leg, often tops the scooped-out cavities (mostly the water pool) to add visual intrigue.

From a pursuit of three-dimensionality on a surface one progresses to a conception of the entire inkstone as a three-dimensional object. (At this point, it becomes difficult to identify the distinct contributions of the locales, as new ideas bounced back and forth in shorter and shorter loops.) The squashed bamboo stem shows the conceptual reorientation needed, and the technical challenges involved, in the abandonment of the concept of an inkstone as a piece of stone with six independent sides. Tang and Song inkstones often take the form of a four-legged animal, a dustpan, or a bell (see fig. 3.10), but their objecthood is of a different order. The *Bamboo Stem* is at once a segment of a bamboo stem and an inscriptional surface that looks like a bamboo stem, a complex game of representational switch-hitting. The phoenix trope, with its draping plumage that visually connects all but the bottom side of the stone without the pretension that the inkstone is a phoenix, is a transitional type. If the flat tablet inkstone encourages fondling, or running one's fingers over its chiseled and polished face, the new inkstone-as-object urges one to pick it up, turn it around and over, and marvel at its ingenuity.

THE LITERATI LANDSCAPE OF WANG XIUJUN

The work of a prolific but enigmatic inkstone maker Wang Xiujun was instrumental in taking the pursuit of three-dimensionality and painterly effect in another direction,

as a landscape. His exact dates are not known, but he was roughly contemporaneous with Gu Erniang, Yang Dongyi, Dong Cangmen, and Xie Ruqi.[33] Although the circumstances of his training and career are too opaque to allow a precise mapping of his trajectories in relations to the artisans in Suzhou and Fuzhou already discussed, his work completes the picture of the range of technical innovations in inkstone making in the early Qing.

Wang Xiujun's lyrical vision is evident in his take on the cut bamboo trope in a *Bamboo Stem* inkstone bearing his signature, Xiujun, in the National Palace Museum (fig. 4.13).[34] Instead of playing the complex representational game of the Tianjin stone, Wang fashioned his stone as if it were an actual section from a stem of square bamboo. The length of the inkstone is one internode plus short fragments of the adjacent two. As in the Tianjin stone the nodes are biologically correct, complete with the sheath ring and stem ring in an M-shaped profile. The back appears as a natural section of a bamboo stem cut vertically along the grain. The cavity inside the stem serves as a natural "handle" (*chaoshou*), a trough on the back of footed inkstones that allows them to be picked up without touching the face (fig. 1.1A). In spite of, or perhaps because of, its deceptive simplicity, the smallish inkstone, fashioned from a powdery smooth Duan stone with a bit of yellowish waste rock retained on the upper right corner, has a powerful three-dimensional presence. The carving brings forth both the "stone-ness" of the material and the "bamboo-ness" of the representation.[35]

In his well-researched notation book, the official and jurist Ruan Kuisheng (1727–1789) placed the career of Wang Xiujun in the context of the professionalization of the crafts, a process that began in the late Ming and flourished in the early Qing. In a notation entitled "Experts famed for their skills and artistry" (Jiyi mingjia), Ruan contrasted the career of a successful craftsman favorably to that of a failed scholar, whose age-old aspiration is to live on forever through his writing: "In the past, people who managed a trade [*zhi yiye*] and specialized in one vessel [*gong yiqi*] have gone very far in becoming known to the world, even attaining immortality."[36] Ruan's intriguing use of the term "people" allowed him to avoid calling them by the usual label of "craftsman," which still carried deprecating implications. The verb choice of *zhi*, which I rendered "to manage," connotes expert knowledge in a dedicated field and is seldom used to refer to a craft. These word choices, together with the title of the notation, signal Ruan's respect for a new kind of artisans who manage to distinguish themselves and leave a mark in the world by honing their skills in a specialty craft, far preferable to those scholars who "hold fast to their ignorance, sit bored on their thumbs, or die without ever winning a degree or post; all perish in oblivion."

By "the past" Ruan meant the recent past of the late Ming. He went on to name twenty-eight artisans, using the same verb *zhi* almost every time, which is properly understood in this context to mean "specializes in" or "excels in." The list includes some famous artisans such as "Lu Zigang specialized in [carving] jade" or "Bao Tiancheng

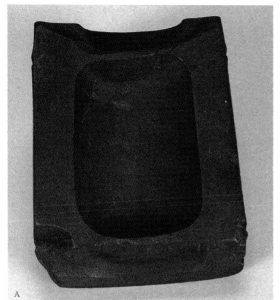

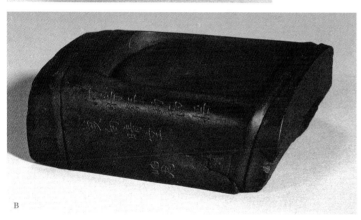

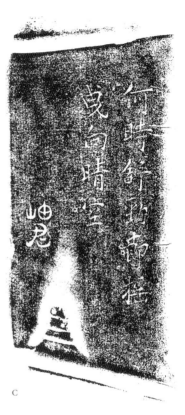

FIG. 4.13. Wang Xiujun, *Bamboo Stem* ink-stone. (A) Back; (B) side view showing Wang's encomium and signature mark "Xiujun"; (C) ink rubbing of side showing Wang's encomium and signature mark "Xiujun." L 10.8 cm, W 9 cm, H 3.9 cm. Lanqian Shanguan Collection, National Palace Museum, Taiwan.

A

B

C

specialized in [carving] rhinoceros horn," and such famous family businesses as the "embroidery of the Gu family," but many of the artisans named are rarely mentioned in other sources. The fields they represent include bamboo carving, pewter, fan-making, inlay, gold smithy, *tong*-copper, string instruments, lacquer, censer, printing stationery paper, and candle making. The list ended with the Ming literati painter Wen Zheng-ming—no craftsman—who exhibited the professional artisan's insistence on noncompromising quality, "only inscribing on square fans."

The short list for the early Qing consists of crafts not mentioned in the Ming roster: "Recently, Xue Jinchen specialized in mirror-making; Cao Sugong specialized in ink-cake making; Mu Dazhan specialized in carving words; Gu Qingniang and Wang Youjun specialized in inkstone making; Zhang Yuxian made bamboo vessels with a

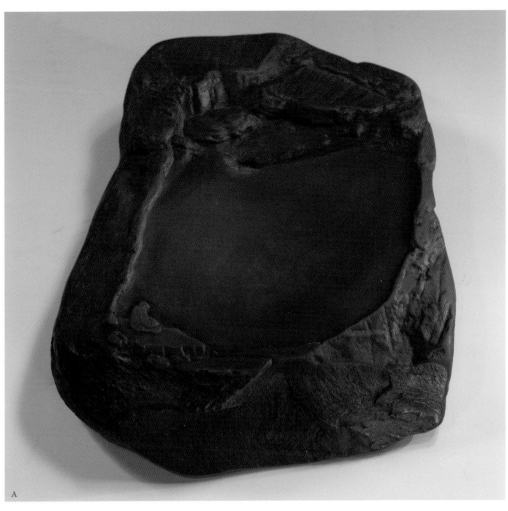

FIG. 4.14. Wang Xiujun, *Landscape* inkstone. (A) Front; (B) ink rubbing of back and side showing signature mark "Xiujun." L 24.5 cm, W 20.1 cm, H 4.8 cm. Tianjin Museum.

fire-writing-brush. They were all famous in court as in society. Surely they would be able to pass on [their artistry] to posterity."[37] The careful reader may notice that Ruan gave Wang Xiujun's name as Wang Youjun. Xiu 岫, an uncommon word which means "grotto," is often mispronounced "You."[38] The sound Youjun thus hints at the oral channel through which his name spread, similar to the case of Gu's name Qinniang/Qingniang.

Even more than his bamboo stem, the hallmark of Wang Xiujun's contribution to the development of three-dimensionality in early Qing inkstone making is his reinterpretation of the literati landscape-painting genre in stone medium. The *Landscape* inkstone at the Tianjin Museum demonstrates the sophistication of both his conceptual

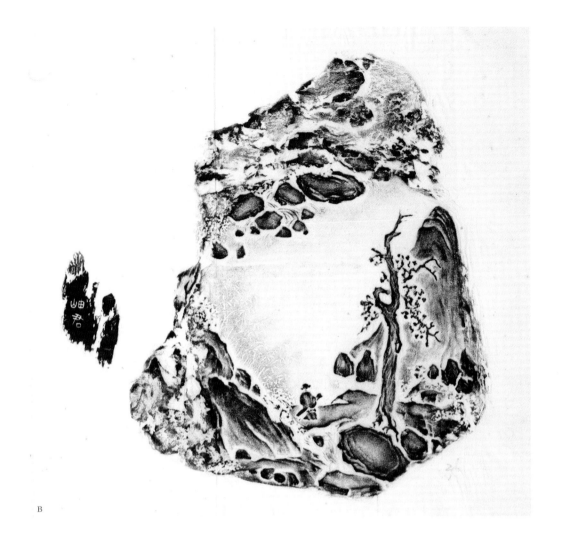

B

craft and carving techniques (fig. 4.14).[39] The irregularly shaped inkstone is fashioned as if it were a naturally found boulder; its unusual large size broadcasts a hefty "stone-ness." The ink pool, the surface used to grind ink, appears as a body of dark water that dominates the face of the inkstone, perhaps a mountain lake revealed by chiseling away the outcrop of rocks. The stillness and depth of the pool is accentuated by the place-ment of a milky patch that appears to float on its surface—an ingenious use of a natural stone marking, reified by connoisseurs as "banana leaf white." On the lower left corner of the inkstone, a hermit sits on a platform gazing at the water. The image relates this inkstone to a common iconography of literati painting, beginning with Wang Xizhi watching the geese.

But the artisan took advantage of the stone medium to go one step beyond just im-itating the iconography of painting. Reversing the instinct of an inkstone carver, who

spent years honing the skill of hiding the knife tip and rendering the chiseled stone surface as smooth as possible, Wang left conspicuous chisel marks on the rocks, especially visible on the lower right corner. The directional traces of the knife and the jagged edges where the rock flakes off create the illusion that the inkstone, with its apparition of a man contemplating a pool of water, was cut directly from the side of a mysterious mountain and transported onto one's desk. The juxtaposition of deliberate artifice and (manufactured) naturalness creates a loop of escalating viewing pleasure that hovers between belief and disbelief. When the viewer gives up and reaches to touch the surface, the pool of water is smooth and warm to the touch, as is the rugged cut surface of the mountain rocks.

The landscape scene on the back of the inkstone presents another common iconography of literati painting, that of a hiker on a mountain path, a *qin*-zither in his hand. A tree with one branch twisted behind the trunk stands in front of a mountain peak, or a rock that looks like a peak. The branches and foliage of the tree lead the viewer's sight from the rocks on the lower edge of the inkstone toward the empty space in the middle, now understood as a quiet pond. On the opposite shore, in the upper one-third area of the inkstone, the shallow water flows through pebbles that emerge from the water surface before disappearing into the edge.

The landscape on the back is carved primarily in low relief, with some virtuoso display of techniques such as the overlapping tree trunk over the twisted branch. But the most inventive treatment is with the boulder to the left of the man, seen in the rubbing as an outcrop leaning away from his body. What the rubbing cannot show is how deeply recessed it is. The material beneath the surface is scooped out, creating a steep trough that one can almost dig the pinky finger into. From the perspective of the man, the boulder is a full-bodied object jotting out from the ground. The area on the inkstone to the left of the boulder is replete with knife marks, crossing over the side and merging with chiseled marks at the lower right corner of the face. Instead of the painter's use of shading or blotting with a brush to create a three-dimensional rocky effect, the carver cut into the stone itself. On the side of the inkstone, he signed his creation "Xiujun."

This inkstone is a cross-medium translation of a literati painting.[40] With Gu's *Paired Swallows* in Tianjin, we have seen her adaptation of the painter's brush to the flat, hard surface of the stone, creating a painterly effect by tending to the material qualities of the stone. Wang Xiujun went one step further by incorporating a self-conscious three-dimensionality to landscape scenery, so that the painterly effect is achieved on a sculpture-like surface replete with relief and texture. Far from accidental, the knife marks were deliberately applied and then smoothed out, but made to appear as "natural" cuts. With this game of self-referentiality and self-conscious artifice, the Duan stone is fashioned into a wild rock. Another sign of Wang's attentiveness to the stone medium is the larger size of the two men than those commonly depicted in paintings. So, too, is the cropped frame of the landscape on the back of the stone, which pushes the scene of

action to the foreground. It would have been futile to depict the fore, middle, and far grounds in an iconic Song landscape painting on a stone surface without the possibility of manipulating graduated shades of color.

As inkstone carving developed into a specialized field with dedicated artisans in the early Qing, it began to incorporate the sensitivities and techniques of such other fields as painting, embroidery, and seal-carving. But it is important to stress that since, as Gu Erniang stated, "an inkstone is a piece of stone," inkstone carving needs to address the stone-ness of its material. In so doing, the artisans developed a craft that is related to these cognate fields but ultimately distinguished from them. The innovative works of Gu Erniang, Wang Xiujun, and others are thus signs of a growing "professionalization" of inkstone makers and their craft as a specialized field of knowledge, as writer Ruan Kuisheng suggested.

In this context, it is interesting to note several differences between the signature marks of Xiujun and Gu Erniang. Conforming to the habits of male inkstone carvers of the time (Cangmen and Ruqi, discussed earlier), Wang Xiujun signed his work by his given name only. In dispensing with the family name, the male artisan broadcasted his identity as a singular person.[41] Furthermore, both Ruqi and Xiujun developed highly individualistic signature styles that are consistent from one stone to the next, the former in a running script and the latter in an eclectic script with rounded strokes he invented. In contrast, Gu's marks vary widely in script and style from stone to stone (figs. 3.7, 3.8, 4.9, 4.15). The phrasing of Gu's mark, which seldom varies, appears more like a trademark in identifying the location of her workshop (Wumen, or Suzhou) and in containing the word *zhi* or *zao*, both connoting "manufacture." It is hard to escape the impression that the male inkstone makers presented themselves as individual artisans, artists even, whereas the stones bearing the mark of Gu Erniang announce their nature as being manufactured in a workshop in the very composition of the sign that is supposed to be the hallmark of her singularity and irreducible presence.

THE (FAILED) TROPE OF THE MUSHROOM

This impression of large-scale workshop manufacturing—systematic forgery—becomes ineluctable when one encounters the recurrent trope of mushroom inkstones bearing the Gu Erniang mark. With successive pursuit of three-dimensionality, an inkstone becomes an object figuratively and literally. The mushroom trope represents the tail end of this trend of reification.

One example of the mushroom trope is in the collection of the Palace Museum (fig. 4.15).[42] The Duan stone itself is slightly coarse, but the fine workmanship of rounded corners and edges gives it a warm appearance. The face features a large crescent-shaped water pool—much larger than is necessary for practical use—the ground of which is incised with lines that radiate from an imaginary mid-point.

When one turns the inkstone around, it becomes clear that the lines are to be the gills under a mushroom cap. The curved line which separates the water pool from the rest of the inkstone (the ink pool) is carried to the sides and over to the back, where it bisects the inkstone into two zones. The upper zone is blotted with dimples (the white patches on the rubbing). At the center of the radiating gills in the lower zone, a mushroom stem rises and falls to its right, overlapping with the rim before terminating into a flattened volva.

The artistic intent of the mushroom is similar to that of the cut bamboo stem—to render the inkstone into a botanical object. But unlike the cut bamboo inkstones in Tianjin (figs. 4.11, 4.12) and Taipei (signed by Xiujun; fig. 4.13), this mushroom effects an awkward objecthood. The artisan appears to have overplayed his hand in the three-dimensionality game. The first failure is the curved line that is carried over from the division between the water pool and ink pool on the face to the sides and back, which (unlike the nodal rings on the bamboo stem) does little to unify the face and back surfaces. Nor does it have any equivalent in real life. Its primary function appears to be as a conceptual boundary that marks off different planes represented on the inkstone.

The back of the inkstone is neither veristic nor pleasing to the eye. The top half, a dimpled canopy, looks like a descending screen that threatens to cover up the bottom half. After much strained effort, I came to the interpretation that it was perhaps meant to indicate that the mushroom cap had been folded down. The bend of the convoluted stem that spills over the rim makes it look as though someone had squashed a folded mushroom and pinned it under a plate of glass. The artisan had attempted a complex game of illusion that exceeds the portrayal of three-dimensionality: crowding the same plane are visages viewed from different perspectives. But it fails to excite. Instead of inviting the viewer to caress it, or to pick it up and turn it over, this mushroom inkstone stops one in puzzlement.

Highly skilled forgers continued to turn out similar inkstones bearing the Gu Erniang mark throughout the Qing and into the twentieth century—the woven colander is one example of a related trope—but the frontier of technical innovations had shifted to other media than inkstones.[43] With the trope of the *kui*-dragon water pool (fig. I.4), viewers come to associate the author-function of Gu Erniang with an archaistic simplicity. With the trope of banana leaf (see fig. 3.7E), lyricism; paired swallows, a painting-like effect; the phoenix, a wall-climbing technique; the mushroom, woven colander, and lotus leaf, an object-like verisimilitude.[44] The diverse techniques and styles encompassed by the super-brand of Gu Erniang show no signs of abetting even today. Often when a collector publishes a catalogue of his holdings or an auction house opens its doors to a preview, new tropes are brought to light.[45]

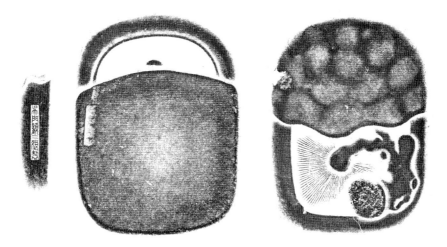

FIG. 4.15. *Mushroom* inkstone bearing "Wumen Gu Erniang zhi" signature mark on its side, ink rubbing. From left: side of inkstone; face; back. L 15 cm, W 8 cm, H 1.9 cm. Palace Museum, Beijing.

TEXTUAL TROPES

One particularly intriguing aspect of the phenomenon of the super-brand of Gu is that besides signature marks and visual tropes, her authorship is often asserted by a third means—texts carved on the stone in the form of encomium, poetic line, or prose. Sometimes her authorship is simply stated in a narrative history of the inkstone's making. The most famous example of this trope is one carved on the back of an inkstone called *Entwined Gourd and Butterfly* in the Capital Museum of Beijing (fig. 4.16): "This inkstone was made by Lady Scholar Gu of Suzhou. It took over three months before completion. Touched by the refinement of her craft [*gong zhi jing*] and the endurance in her heart [*xin zhi ku*], I write this remark. Li Yunlong (Lincun)."[46] A friend of Huang Ren and Lin Fuyun, Li Yunlong (d. early 1750s) was a member of the second-tier of the Fuzhou circle of inkstone collectors, but his contributions to *Inkstone Chronicle* do not include this remark.

The impulse to engrave the history of an inkstone on its very surface is motivated in part by fear of oblivion. In chapter 3, I discussed Huang Ren's romantic view of a cosmological link between the raw stone, patron, and artisan that makes them destined to find one another. The notation in which he expressed this view is worth translating in full in the context of the present discussion on tropes and oblivion: "I have been carrying this stone in my sleeves for almost ten years." From the context, it is clear it is a raw Duan stone with the precious stone marking of "blue spots."[47] Huang continued, "This spring I brought it to Wu [Suzhou]. Gu Erniang of Suzhou saw it and took a liking to it; she then made me this inkstone. Delighted by the refinement of her artistry [*yi zhi jing*]

and touched by the sincerity of her intent [*yi zhi du*], I wrote a poem for her and have it engraved on the back of the inkstone so that the people who handled this inkstone after me would know its story" (A3.2b, C2.3a). Huang's fear is that an inkstone, especially such a valuable one, would be pried from his hands all too soon, the stone lost to him and its history lost to the world. The more alienable a precious item becomes, the more imperative it is to make it bear witness to its own history. The engraved inkstone thus takes on the commemorative function of a stele, cementing its inception and asserting its presence against the onslaught of time. As will be discussed in the next chapter, Huang's fear of the alienability of inkstones was fully justified.

Above and beyond the confluence in sentiments, Li Yunlong's notation and Huang Ren's also share some key phrases: "touched by" and "refinement of craft/artistry." Even more glaring is the identical parallel construction, "the refinement of her craft/artistry" followed by "the endurance/sincerity of her heart/intent." This trope of parallel construction has in itself become an identifying mark of Gu's authorship. This fact casts into doubt the authenticity of the Gu attribution on the *Entwined Gourd and Butterfly* inkstone, by all accounts a finely wrought one.

An even more iconic textual trope is the poem that Huang wrote in Gu's tribute that follows his note, which eventually found its way onto inkstones of all sizes, shapes, and persuasions (e.g., figs. 3.7C, 4.9):

> One inch of Ganjiang [sharp blade], cutting into purple clay,
> The sun begins to set on Zhuanzhu Lane.
> How has it come to pass that the hands that make the loom sing "ya-ya,"
> Have cut through all ten miles [of quarries] along the river in Duanzhou?[48]

The poem is vintage Huang Ren in its challenging rhymes (*ni, xi*, no rhyme, *xi*), audacious coupling of violence/menace and refined skill, not to mention the overt romantic sentiments. It became one of the best-known poems by Huang as well as the most recognizable and enduring identifying mark of Gu Erniang despite the fact that she was not even named in it.[49]

FROM SUPER-BRAND TO MYTH

Almost as soon as the "one inch of Ganjiang" poem began circulating, forgers seized upon it and engraved it onto the back of inkstones to pass the works off as hers. The scholar poet Yuan Mei (1716–1797) wrote of one such inkstone in his well-known collection of essays, *Suiyuan on Poetry* (Suiyuan shihua). A friend of his bought an inkstone in Nanjing with the poem inscribed on its back; it is identical to the one cited here, with Huang Ren's name switched to one Liu Ci. The note attached to the poem is a chimera concocted from three unrelated works by the Fuzhou circle: "Gu Erniang of Wumen

FIG. 4.16. *Entwined Gourd and Butterfly* inkstone, ink rubbing. L 17.8 cm, W 12.7 cm, H 4.5 cm. Capital Museum, Beijing.

made me this inkstone; I wrote this poem for her. The Gu shop is in the old quarters of Zhuanzhu." To enhance the reality effect, the forgers concocted a date: autumn, 1718.[50] When Yuan spoke of the inkstone to another friend, Gu Zhuting (no relations), the latter added even more tantalizing details: "When Gu Erniang makes an inkstone, she can tell if the stone is fine or coarse by testing it with the tip of her shoes. People therefore call her 'Tiny-Footed Gu' [Gu Xiaozu]."[51] The line between super-brand and myth is thin, and with this gaze on Gu's small feet it has been crossed. There is no evidence one way or the other if Gu Erniang had had her feet bound, but by the late eighteenth century when this conversation took place, the binding of women's feet had acquired unmistakable erotic connotations.[52]

Myth-making is intrinsic to the phenomenon of a super-brand. As the artisan and her work travel in people's imagination, they lodge their desires and fantasy into the brand, and in so doing making it their own. Once it began to circulate, the image of the tiny-footed Gu proved irresistible to collectors and scholars.[53] Each retelling alters the context, introduces confusing errors, embellishes it with new details, and enhances the credibility of the image simply by making it more familiar. Take, for example, the rambling memoirs of his collecting activities by the late Qing Suzhou painter Xu Kang (b. 1814), a pastiche in which hearsay, verifiable texts, annotations by him or others, as well as remarks by ancient and modern people run in succession and without discrimination, resulting in a dreamy landscape of words that befits the title of "Traces of Bygone Dust and Shadows of Dreams."

Xu recounted having acquired three inkstones bearing Huang Ren's encomiums before the Civil War between the Qing and the Taipings (1851–64), which were presumably lost. When peace returned, he bought a fourth, *Clouds and Moon*, with a depiction of the Red Cliff on the back with a colophon by the Qianlong-era scholar-official Fu Wanglu and the mark on its left side: "Made by Gu Erniang of Suzhou." Half of this inkstone perished in a fire in a town called Wuxue in northern Hunan when a friend by the name of Pan Shupo took it there. The granular specificity appears to be a tease for the philological scholar, because the details can never be ascertained. Xu went on to recount Huang's career as a magistrate in Guangdong, cited his tribute poem for Gu (now credited to Huang's friend Liu Ci), and cited Yuan Mei's *Suiyuan on Poetry* as his source. He then mentioned someone by the name of Chen Xingmen from Zhejiang who also had a tribute poem for Gu, which can be found in his poetry collection (indeed, but his name was Xingzhai, not Xingmen).

Finally, Xu stated that in the annotations to Huang's poetry collection there is a legend concerning Gu Erniang: "By kicking the rope that connects to the shaft [of the pulley conveying stones from the quarry pit?] with her slender foot, she can discern if the stone is fine or coarse. The ancients spoke of butchers who could tell if a pig is fatty or lean by treading on it, just as Cook Ding could dismember an ox with his eyes closed. This is a magical skill indeed!"[54] If the intrepid reader looks up the annotations

to Huang's 1,700-page poetry collection, s/he will find that the source of the annotation is none other than Yuan Mei's *Suiyuan on Poetry*. Thus one single source travels across time and genres, spinning tall tales and attesting to Yuan Mei's own super-brand status. The details about the shaft and rope are Xu's embellishments, but they did not have as much leg as Yuan Mei's.[55]

Under the fig leaf of a discourse of skill—the ability to discern the inner qualities of an uncut stone *is* a skill valued by stoneworkers—myth-makers in the Qianlong era and after shifted popular attention from Gu's hands to her feet. Although Gu's patrons were certainly aware of the uniqueness of her female gender in a male profession and did not shy away from using feminized terms to address her, they paid tribute to her by a well-chosen mixture of masculine and feminine allusions. The scholars and collectors who commissioned works from Gu regarded her as a skilled artisan, not a subject of male curiosity. The eroticization of Gu Erniang in public imagination is tantamount to her deskilling as an artisan, the exchange of a productive body for an ornamental one.

NO PLACE FOR WOMAN IN THE PATRILINE

If the eroticization of Gu Erniang occurred after her death, a controversy surrounding the genealogy of the Gu workshop that flared up during her lifetime is equally revealing of the gender bias prevalent in the early Qing world. The instigators of the controversy were the editors of the imperially commissioned *Comprehensive Gazetteer of the Jiangnan Region*, compiled from 1731 to 1736 and published in 1737. Social historians value Chinese gazetteers as a reliable historical source, and this Qianlong edition of the Jiangnan Gazetteer is deemed particularly authoritative. In format and coverage, the 1737 gazetteer is an improvement over its predecessor, the Kangxi edition of 1683, compiled when the nascent dynasty had yet to fully establish itself.

In one of the new sections entitled "Art and artistry" (Yishu), Gu Erniang makes an oblique appearance in the company of painters, physicians, astrologers, and instrument makers from Suzhou prefecture to those in the know: "Gu Shengzhi, courtesy name Delin, is a native of Wu county [Suzhou]. His father, Gu Daoren, was skilled in making inkstones, hence people called Delin 'the Lil' Daoren.' All of the inkstones he made are emulations of ancient styles; they are simple but refined and worthy of appreciation. Upon the death of his son, his daughter-in-law became the sole inheritor of his craft for over twenty years."[56] The last sentence acknowledged Erniang's contributions, but the fact that she was identified only by her kinship role betrays a logic of inclusion that is less than salutary. The sudden appearance of Gu Delin's father in the historical records brings this logic to the fore.

Readers who have a very long memory may recall that this genealogy of the Gu workshop appears to resemble the one given in chapter 3, but in fact it is radically different in one crucial detail. The Suzhou scholar Huang Zhongjian, who ordered Gu

Delin to make him an inkstone, did not mention that Delin had a father already in the profession. Zhu Xiangxian, the Suzhou writer contemporary to Erniang, mentioned three generations of Gu artisans by counting her as the second; there is no mention whatsoever of Delin's father. Zhu, in fact, stated that Daoren was Delin's self-assigned literary name, *not* his father's. The saying that Delin had a father by the name of Gu Daoren originated with the imperially commissioned encyclopedia *Complete Collection of Illustrations and Writings from the Ancient to Modern Times* (Gujin tushu jicheng), compiled from 1701 to 1706, with a revised version printed in 1726.[57] Whatever the reason, this change in the Gu genealogy diminishes Erniang's place in the Gu artisanal tradition, admitting her into the genealogy only as an unnamed placeholder. The editors seem to imply that there were only two legitimate generations, from father (Daoren) to son (Lil' Daoren).[58] The reasoning is rooted in the principles of patrilineality and patriarchy that have structured the private genealogies of lineages and families of the land. According to this logic, a daughter is excluded from the genealogy of her father altogether; a wife is admitted only as the mother of sons. Because of the authority of the official gazetteers, this version of the Gu genealogy became enshrined as the standard down to the present.[59]

In the face of what they perceived as an unfair dismissal of Gu Erniang's artistry, Zhu Xiangxian and some of Gu's patrons proffered an alternative narrative. The effort of Lin Ji, in particular, is couched in such a way that leaves no room for doubt. In the preamble to his poem dedicated to Gu (which opened this chapter), he stated: "The Gus of Suzhou have been famous for making inkstones for three generations already. Looking backward, Dagu inherited [the artistry] from her father-in-law; looking forward, she taught her heirs. And her work is especially elegant, archaistic, and coherent [*guya huncheng*]. For this reason, I dedicate this poem to her."[60] Lin Ji, a scrupulous writer, has taken care in each sentence to emphasize Erniang's rightful place in the artisanal lineage of the Gu family as a protagonist instead of a placeholder. He makes no mention of Delin's father, and in his word choice of "already" he places the accent of the sentence squarely on "three generations."

Lin's most deliberate rhetorical strategy to rescue Gu from erasure is his use of the construction "looking backward" and "looking forward." Positioning the subject in a straight line of generational descent, these expressions are standard parlance of compositors of genealogies; the nominal unstated subject is the patriarch, be he father or son. In using these expressions, Lin unequivocally placed Gu Erniang at the center of the line of patrilineal transmission—she was the one looking up to inherit the craft and looking to the future to pass it on. Having clarified Gu Erniang's genealogical standing, Lin Ji offered a second, and more relevant, criterion for judgment: her work is the most accomplished of the three generations.

There is no conclusive evidence that can settle the issue of Delin's name and the profession of his mysterious father, although my wager is that Huang and Lin, being

Erniang's patrons, and Zhu, being a local contemporary to Gu, are more reliable than the gazetteer editors. Ultimately, the defensiveness of Lin Ji's tone and his deliberate rhetorical strategy are in themselves the most revealing. Through them I have come to realize how Gu Erniang's seemingly innocuous artisanal career, so respected by her patrons, could have been taken by some of her contemporaries as an affront to the patriarchal family.

GU ERNIANG AND INNOVATIONS IN EARLY QING INKSTONE MAKING

The hands of forgers, ranging from highly skilled to inept, are clearly behind the proliferation in the variety of tropes associated with Gu Erniang and the multiplication of the number of samples within each. Forgery lies at the heart of the recycling of pastiches of textual tropes, but with the visual tropes one discerns another hidden logic at work, that of experimentation. The author-function of "Gu Erniang" was associated with intermedial innovations that enhanced the veristic and three-dimensional qualities of an inkstone. Other artisans studied these techniques on stones attributed to her and her male colleagues. Upon seeing how the openwork of mythical animals perched on seals could be transferred to the water pool, or the climbed-over treatment translated from a bamboo stem to a phoenix, they pushed the envelope and went one step further, inventing, for example, a mushroom whose very flesh is the body of the stone.

Having witnessed the remarkable productive energy among artisans and scholars in the southern regions of the empire, one may arrive at a more balanced assessment of the dynamics of early Qing technocratic culture, at least as it pertains to inkstone making and related crafts. The early Qing monarchs' valuation of craft and science, epitomized in the operations of the Imperial Workshops, established an empire-wide framework for the circulation of skills, craftsmen, and things between court and society. What might have appeared in chapter 1 as a top-down system of material statecraft controlled by a vigilant emperor and his tireless bondservants is revealed to be more multivalent and involving more agents, each masters of their own small worlds.

The creative energies and desires unleashed by the late Ming commercial boom did not disappear with the collapse of the Ming house and the protracted pacification of the Qing. The embodied skills of the empire's most accomplished artisans and the social networks that enabled their transmission subsided, only to reemerge in familiar and unexpected places in the 1680s. Liu Yuan's prolific career as a court designer encapsulates the productive potential of the new synergy between court and society. Although his talents found material expression in the Imperial Workshops, Liu owed his craft to his early experience in workshops in the southern regions of the empire, especially the carvers and painters in Suzhou.

Gu Erniang's life and work coincided with the maturation of the artistic trades in the 1700s through the 1720s: as more educated people entered the trade and more scholars

diverted their energies to craft, the southern workshops became more professional and specialized. Intermedial experiments in designs and techniques as well as competition among workshops and individual artisans are all symptoms of this development. Between the invention of Songhua stones as multicolored box-slab sets in court and the intermedial experiments with painterly and three-dimensional effects in the southern workshops, these decades constitute one of the most innovative periods in Chinese inkstone making.

The curious phenomenon of Gu's subsequent development into a super-brand attests to the maturity of a collector's market in modern objects of art in the Qianlong era, a culmination of developments underway since the late Ming. In the next chapter, we continue in the company of the Fuzhou aficionados, exploring their approach to writing as a material craft and their careers as inkstone collectors. We thus will complete the picture of the emergence of inkstone making as a field of expertise and the modern inkstone as a collectible item by glimpsing the power of market forces at work.

That "Gu Erniang" encompasses an extraordinarily wide range of techniques, styles, and tropes does not seem to have bothered her enthusiastic collectors in the high Qing (and today), and is in fact taken as the very sign of her virtuosity. When the market thrived on incessant pursuits of novelty, few cared to remember that Gu's Suzhou and Fuzhou patrons, a handful of people who knew and commissioned works from her in person, preferred simple and archaistic inkstones that must have appeared plain and downright boring in the mid- and late Qing marketplace. For all the love, attention, and care they lavished on the inkstone as an object of art, those scholars and collectors regarded the inkstone first and foremost as an instrument for grinding ink.

FIG. 5.1. Looking north from Guanglu Lane. On the left, the receding line of whitewashed walls indicates houses on the west side of Zaoti Alley; at its end is Huang Ren's house, occluded by a construction crane in this picture. On the right, the tall grey wall demarcates the outer limits of Lin Ji's home. Photograph by the author, Dec. 2012.

5

Fuzhou

THE COLLECTORS

I N 1731, CHEN ZHAOLUN (1700–1771), A NEWLY MINTED METROPOLITAN
graduate from Hangzhou in the empire's heartland, arrived in Fuzhou on the
southeastern coast to take up his first official post.[1] There, in the gazetteer bu-
reau, the young scholar found a group of like-minded colleagues, including the
talented Fuzhou native Xie Gumei, and at the end of a day's work they often broke out
wine and discoursed on poetry into the wee hours. One evening, Chen espied a poem
written in a slender elegant hand on the bureau's wall. Thinking that the poet must
have been an ancient, Chen lamented that he had no opportunity to pay his respects.
Imagine his surprise when he learned that not only was the poet alive, but he was also
a local who lived near by.

After a sleepless night, Chen could no longer contain his excitement. He rose after
the rooster crowed thrice and strolled to Guanglu Lane, a fabled address in the south-
western part of the city. Named after a Song official who chanted poetry at an ancient
temple that had long since vanished, the neighborhood had been home to prominent
families since the tenth century. Its roster of residents was particularly impressive in
the Ming and Qing; many of the mansions they built are still standing today.[2] A short
alley no wider than two meters led to the quarters of the poet, who turned out to be
none other than Huang Ren (1683–1768), a childhood friend of Xie Gumei. Having
just finished his morning bath, the fifty-year-old Huang emerged shortly to greet the
unexpected (some would say rude, for calling so early) guest clad in leather slippers.
Over thirty years later, Chen could still recall the impressive image that Huang cut, as
if he were a character making an entrance on stage: "I thus see: his eyebrows and beard
sharp as a dagger, his pitch-dark pupils glistening like dots of lacquer, his face smooth
and fair-skinned, and conversation tumbling from his mouth like water from a hang-

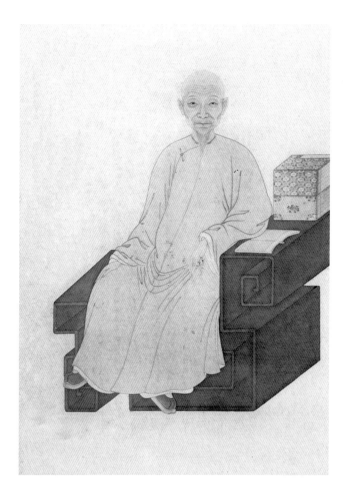

FIG. 5.2. Portrait of Huang Ren. From Ye Yanlan and Ye Gongzhuo, *Qingdai xuezhe xiangzhuan*, no page.

ing cliff."[3] In a few brush strokes Chen captured not only the visage, but also the untrammeled and bon vivant spirit of the most legendary inkstone aficionado in Fujian, known as Ten-Inkstone Huang or Mr. Ten Inkstones (fig. 5.2).

Thus began a friendship that was fraught with status differentials but sustained by shared love for the craft of poetry. Chen, although junior in age and less accomplished as a poet, held a higher degree and would eventually occupy higher-ranking positions in his official career. Huang, disgraced by malicious slander and ousted from office in 1727, was politically dead and possibly even toxic when he returned home in 1731. For these reasons, and perhaps also because of an unstated metropolitan snobbery that deemed Fujian provincial, Chen refrained from calling Huang "teacher" even as he admitted to "gaining improvement whenever I chanted his works." Decades later, he acknowledged the indelible impact of his Fuzhou friends: "My calligraphy has evolved because of Xie [Gumei], and my poetry has become more powerful because of Huang."[4]

What Chen did not mention was his no less edifying tutelage in the art of inkstone connoisseurship. During drinking parties, poetry contests, and viewings of calligraphic models, he made the acquaintance of the local inkstone and seal carver Dong Cang-men, inkstone aficionado and inscription carver Lin Fuyun, as well as other friends of Huang and Xie. An outlier to the world of stones, Chen was probably unaware of his good fortune of being initiated into one of the empire's most learned and innovative circles of inkstone collectors, centered in the very neighborhood of Guanglu Lane. We have encountered the key members of this circle—Lin Ji, Yu Dian, and Huang Ren—as patrons and clients of Gu Erniang. This chapter focuses on the centrality of inkstones to their masculine identities and sociabilities, the connections between collecting, scholarship, and political careers, the formation and dispersal of inkstone collections in a rapacious market, as well as the entanglements of locale, sentiments, and knowledge thus engendered.

Three years into his sojourn, Chen Zhaolun left Fujian in 1734 to pursue career advancement in the capital. In the seventh month, after Chen's luggage had been packed and all the farewell parties attended, Lin Fuyun rushed to show him a newly compiled manuscript of inkstone encomiums, an early version of what would become the *Inkstone Chronicle*, and begged for an endorsement. Feeling put upon, Chen dashed off one congratulatory poem before departure and promised to send a better-crafted matching set to those by Huang Ren and Yu Dian from the road. As Chen traversed the steep Xianxia Ridge, thieves broke into his luggage and stole a cache of uncut stones along with parting gifts of inkstones from his Fuzhou friends, probably mistaking the heavy bundle for bars of silver and gold.[5] Being so small and portable, a requisite item in every scholar's luggage, inkstones are movable goods in the literal sense of the word. The poems they left alone.

Chen Zhaolun had barely arrived in Beijing when Lin Fuyun's letter caught up with him, urging him to make good on his promise. Lin and his brothers hounded not only Chen, but also relatives, neighbors, acquaintances, and strangers to contribute endorsements for the manuscript. The enthusiasm—bordering on desperation—with which the Lin brothers instrumentalized their social networks to launch the book belies the curated images of gentlemanly leisure presented in the chapters and the pathos of romantic nostalgia they evoke. Lin evidently believed that the past and future of his family fortune depended on the success of this compilation of inkstone encomiums. How did so much come to ride on scant words jotted on scraps of paper or carved on the back and sides of a palm-sized stone?

THE FUZHOU CIRCLE AND *INKSTONE CHRONICLE*

The Fuzhou circle of inkstone aficionados, which thrived from about the 1700s to the 1740s, was comprised of three layers: the inner core was made up of a score of men

who grew up as neighbors, studied with the same elders, were related by kin or marriage, and shared the same socialization process and cultural resources (see appendix 3, "Members of the Fuzhou Circle"). The bulk of *Inkstone Chronicle* features the encomiums they wrote for each other's inkstones. A second tier consisted of relatives and friends of the former. These were mostly Fuzhou natives, but a handful were officials posted to Fuzhou such as Chen Zhaolun. They knew some of the core members, but might not have known one another. Besides contributing to *Chronicle*, they also had occasional transactions in words and stone with the core group. The outermost layer was a fringe group consisting mostly of high officials, examiners, artists, and others cultivated by the core, especially the Lin brothers. Many had no contact with the other two layers beyond contributing congratulatory poems or prefaces to the compilation.

The social history of the inkstone circle mirrors the organization and textual history of the book itself (see appendix 4, "Textual History of *Inkstone Chronicle*"). As told by Lin Fuyun's eldest brother Zhengqing, the genesis of both the inkstone circle and the book can be traced back to his father Lin Ji's studio, in the 1680 and '90s. Ji was an aspirant student in his early twenties who exerted himself in making free-hand and traced copies of antique inscriptions originally carved on bronze vessels and steles. His eldest son in attendance, too young to hold the brush, was assigned the job of washing the soaked inkstones (thus began Zhengqing's own lifelong love). Often joining Lin Ji was his friend Yu Dian, of the same age, and a neighbor about twenty years their senior, Xu Yu (ca. 1650–1719).[6] Xu, a calligrapher and painter, was the scion of a major literati family that had made Guanglu Lane its home for generations. The three forged a "fellowship of stone" (*shijiao*). When a good inkstone came into their possession, they would write encomiums and carve them onto the stone.[7] The parity accorded to the two kinds of stone media for writing—ancient stele and modern inkstone—is unusual and significant, as is the accent placed on writing as a material, embodied activity: the dripping ink; the hand carving of the encomiums. To Zhengqing, both the stones and the embodied skills comprised part of his family heritage.

The stones and skills were also shared, and the fellowship of stone became enmeshed in the upbringing of the next generation, the core of the Fuzhou circle of connoisseurs. Xu Jun, the son of Yu, and Huang Ren, the son of Yu's younger sister who lived next door, pursued the exam curriculum together and called on Lin Ji for calligraphy lessons. After Lin Ji left home to launch his career, the younger generation congregated in Lychee and Water Manor, the resort property of Ji's father Sun (1618–1709; provincial graduate 1654) on the outskirts of Fuzhou city. There, in its pristine gardens and ponds, they joined the Lin brothers as well as the latter's maternal cousins Chen Dequan and Xie Gumei, all residents of Guanglu Lane, to study and party. Their teacher, Ji's elder brother Tong (d. 1716), was an accomplished epigrapher. When Lin Tong accompanied his father to his magistrate post in Sanyuan, Shaanxi, an area economically poor but rich in antiquities, Tong collected a cache of ink rubbings of antique steles, especially

FIG. 5.3. Hua Yan (1682–1756), *Banquet in the Apricot and Plum Garden on a Spring Evening*, 1748. Under flowering trees and flickering lantern light, four friends wearing scholar's hats and two teenage students with tufted hair (seated lower right corner) while away the evening viewing antiques. An inkstone and writing brush stand ready to record the encomiums and poems they compose. Detail, ink and color on silk, 180 × 95.5 cm. Tianjin Museum.

those from the Zhao mausoleum of Tang emperor Taizong, and spent the rest of his life studying them.[8] Memories of their lessons and carousing in the Lychee and Water Manor would become the group's private Camelot, a foundation of solace whenever they encountered career frustrations later in life. Looking back four decades later, fellow student You Shao'an coined the term "fellowship in stone since our teenage years" (*zongjiao shijiao*) to highlight the enduring impact of inkstones and steles in their intellectual and emotional formations.[9]

FIG. 5.4. Xie Gumei (Dao-cheng), calligraphic scroll dedicated to childhood friend Lin Weiyun, Lin Tong's son, 1733. Collection of Huang Yizhu, Fuzhou.

The group dispersed as each left Fuzhou for the exam circuit, but reunited when, at various junctures in the 1710s and '20s, they found themselves taking the exam or awaiting a job in Beijing, where they "brewed tea, discoursed on art, shared wine, and chanted poetry." They reveled in poetry contests, "keeping time, drawing lots, taking turns in harmonizing one another." Huang Ren remembered with particular fondness the company of Xu Jun and Xie Gumei, along with Zhou Shaolong and others, "just like the good old days in the Lychee and Water Manor."[10] The Beijing home of Lin Ji, in the Liangjia Yuan neighborhood in the Xuannan district where many of the Han literati lived, was a favorite gathering place.[11] From there it was an easy stroll to the flea market on the grounds of the Ciren Temple, held on the first, fifteenth, and last days of each month, where they vied to spot valuable inkstones for a song.[12] Their encomiums grew in number along with the variety of inkstones, but most were too busy to have them carved. It is a remarkable feat that everyone in the core group, with the notable exceptions of Huang Ren and the second-generation Lin brothers, succeeded in capturing the metropolitan graduate degree, even if their bureaucratic careers turned out to be lackluster (see appendix 3).

The next chapter of the inkstone circle unfolds in Fuzhou in the late 1720s. With the death of Lin Ji and the travels of his eldest son, Zhengqing, the mantle passed onto Ji's third son, Fuyun, and the retired Yu Dian; Huang Ren joined them when he returned in 1731. With their hopes of career success dashed, they indulged in inkstone connoisseurship when they were not eking out a living (and perhaps using stones to booster commissions for their writings.) They studied one another's collections and composed encomiums, and Lin eventually carved many onto the stones. Lin Fuyun boasted: "We thus set off a trend [in Fuzhou], people would judge whether a man is elegant or vulgar by the presence or absence of a [good] inkstone on his desk. Further, they would not consider a stone worthwhile unless they manage to procure an encomium from the metropolitan governor [Yu Dian]." Therefore, Fuyun continued, "I decided to gather up the inkstones from the

various families, make rubbings and copies of their encomiums, and compile this volume of *Inkstone Chronicle*."[13] He worked feverishly and completed the first draft in 1733.

Although he did not state it explicitly, Fuyun's incentives were twofold: to augment the cultural capital of his Lin family and to spread the fame of the Fujian circle of inkstone aficionados to other parts of the empire, especially the capital and the cultural heartland of Jiangnan. Old friends from the second-tier of the inkstone circle were contacted. Many in the third layer, the fringe group, were drawn into the widening circle as the manuscript circulated. In 1746, Lin Fuyun produced a codified version of *Inkstone Chronicle* six years before his death. His sons continued with the project of writing encomiums, carving them, and expanding the net, but the romance of the stone began to be cast increasingly in the past tense. Nor did the book bring exam success for his sons, as Lin Fuyun had hoped. No one in the next generation except for Huang Ren's nephew became a metropolitan graduate.[14]

By the time the Fuzhou circle acquired a textual expression of their "fellowship of stone" in 1733, three key members had died (Lin Ji in ca. 1725, Xu Jun in 1730, and Yu Dian in 1733), many encomiums remained uncarved, mere scribbles on paper, while some of their best inkstones had already been lost or sold. It is important to recognize that *Inkstone Chronicle* commemorates a social group whose members saw one another as adults at best intermittently; it documents the inkstone collections of each *as if* they were intact series neatly lined up on cabinet shelves. This phantom quality is key to understanding the format and emotional content of the work.

Lin Fuyun made a crucial editorial decision in the codified version of arranging the chapters by the author instead of by the stone, which means that if Huang Ren and Lin Ji each wrote an encomium for one of Yu Dian's inkstones, the texts would appear in separate Huang and Lin chapters. If Yu did not write an encomium for his own inkstone, the inkstone would not appear in the Yu chapter. Furthermore, the encomiums that Huang wrote for his friends' inkstones also appear in the Huang chapter.[15] As such, the codified *Inkstone Chronicle* is less a compilation of inkstones than of encomiums intended for inkstones. Taken together, the chapters record the inkstones that the Fuzhou group bought, viewed, and studied in each other's company over time. In that sense it conjures into textual existence a Fuzhou-based collection that is virtual, shared, and premised on a notion of collective interpersonal "ownership." At the same time, within the parameters of his chapter, each collector presides over all the notable stones in his personal collection, including the ones already lost, as well as his friend's stones that he had the pleasure of viewing and contributing an encomium. In an economy of alienable things, the encomium has come to stand in for the reality of the material inkstone. A pristine collection is only possible as a *re*collection on paper.

The collectors in the Fuzhou circle stand out as three-dimensional characters on the pages of *Chronicle*, replete with personalities and idiosyncrasies, as is the tangibility of the lifelong networks they forged, wrought of a tangle of residential, paternal

kin, maternal kin, and teacher/student relations that often extend to several generations. Ironically, in a book so centered on inkstones, the inkstones appear dismembered and dematerialized, too insubstantial to bear the weight of the poignant emotions invested by their one-time owners: the reality of their love for the inkstone and for each other.

GENESIS OF INKSTONE COLLECTING IN THE NORTHERN SONG

Inkstone collecting, like the collecting of any object, depends on a host of social and institutional factors. In the early Qing, the activities of the Imperial Workshops, the tribute-gift culture of the court, the opening of new Duan quarries in Zhaoqing, the artisan's refinement of craft skills, and the resulting profusion of new designs and techniques all contributed to a supply of inkstones unmatched in variety and workmanship in the previous dynasties. The stories of the Fuzhou collectors show equally dynamic forces at work on the demand side. The development of their individual desires and tastes occurred in the context of a competitive market (in objects of art as in human male talent) that placed a premium on specialized knowledge. Indeed, it is the accent on craft skills in the early Qing that distinguishes the status and appearance of the inkstone as well as the nature of connoisseurial knowledge from the preceding Ming period, as will be seen later.

The forces that made the inkstone a collectible object of art—a critical mass of informed collectors, a market with mechanisms of evaluation, a body of critical writings that refer to one another, and a vital field of material production—were fully visible by the tenth and eleven centuries. Calligraphy and paintings, both seen as manifestations of the artist's individuality, had been the first objects of art to become collectibles for their intrinsic aesthetic qualities, already the case in the fourth century during the Six Dynasties period (220–589).[16] Inkstones had been used to grind ink and no doubt cherished since the Han, and the color and patination were eulogized in scattered poems in the Tang.[17] But the inkstone became a category of collectible object only when a specialized literature such as Mi Fu's *An Account of Inkstones* and others appeared in the Northern Song. Indeed, the empirical tone, "national" coverage, and notational form make Mi's treatise an apt practical guide for the novice collector. Mi Fu's discourse of function, or insistence on the primacy of the inkstone's instrumental value, represents his efforts not only to police the boundary of the emergent literati group, but also to establish a hierarchy of value in a nascent and fragmented market governed by multiple standards.

When the cultural image of "the inkstone collector" began to coalesce in the Northern Song, its salient face was that of Mi Fu. A self-styled eccentric, the artist provided ample grist for the making of a personality cult. The Huizong emperor, it was said, once summoned Mi Fu to compose a poem and write it on a screen. At the end of his

FIG. 5.5. Du Dashou (fl. early seventeenth century), *Appreciating Inkstones*. The cult of the inkstone connoisseur first emerged in the Northern Song but reached new heights in the early Qing. The long fingernails, billowing sleeves, and headgear announce him as one who engages in neither manual labor nor military vigor. The palpable glee on the two men's faces is an expression as much of private delight as shared membership in a privileged male status group. This painting in its entirety shows the two connoisseurs in a garden; to the left of the image is a complete calligraphic transcription of an early twelfth-century inkstone manual, *Duanxi yanpu*. Detail, painting and calligraphy, 195.9 × 27.5 cm. Bequest of John B. Elliott, Class of 1951, Princeton University Art Museum.

virtuoso performance, the calligrapher snatched the imperial inkstone, still dripping with ink, and stashed it inside his robe. Having been sullied by his mortal hands, Mi volunteered before the stunned emperor could respond, the inkstone was now unfit for imperial use, so it might as well be his. In another account, Mi's friend turned the trick on him, soiling Mi's precious new acquisition by grinding ink on it with his saliva, hence forcing Mi to gift it to him.[18]

Carried to its extreme, the trope of the inkstone lover as a trickster morphed into that of the greedy official who stopped neither at demanding bribes nor extortion in pursuit of coveted stones. Its corollary, the principled official who refuses to pocket even one inkstone offered by his grateful constituency, came to take on the face of another Northern Song official, Bao Zheng (999–1062), renowned for his incorruptibility.[19] These stories make it clear that the inkstone was no longer a mere writing instrument; exquisite inkstones could fetch much more than their material and functional values. In a deal brokered by two powerful friends, for example, the historic Mi Fu was said to have traded a giant mountain-shaped inkstone, one with the exceptional provenance of having been in the collection of Southern Tang ruler Li Yu (r. 961–975), for a slice of a real mountain—a piece of wooded property in the Beigu Hills, Danyang, Jiangsu, on which he built his studio.[20]

It takes a long time to create a market, and at its early stage the market of inkstones was dictated more by individual desires and case-by-case negotiations than historical precedent. In a pair of studies of the prices of paintings and objets d'art in Europe since 1750, Gerald Reitlinger proposes that prices were determined by two conceptually distinct markets, that of genius and that of craftsmanship. "An objet d'art must have had at some time or another a calculable basic cost, compounded of time and materials, whereas the work of genius has never been regarded in that way." In the craftsmanship or skills market, the value of an object is a function of its replacement cost, or the cost of raw materials as well as the investments of time and skill on the part of the artisan.[21] By dint of its purpose as an instrument to grind ink, the inkstone straddles the two conceptual markets of value from the inception of its history as a collectible object. The quality of the stone matters to writing as an embodied craft, as Mi Fu articulated. The inkstone also naturally lends itself to personal association with the genius writer, calligrapher, or painter who used or inscribed it.[22]

The genius market was clearly at work in the eleven century; witness the run on inkstones associated with Su Shi and other luminaries from the recent past in the accounts of literatus He Wei (1077–1145). He, a native of Pujiang (in modern Fujian) who was twenty-six years Mi Fu's junior, described an informal circle of about a score of inkstone aficionados that included his father, brother, and friends. His father, a scholar, was a protégé of Su Shi. One friend appears to have known Mi Fu.[23] Active in the waning years of the Northern Song, He and his friends visited each other and others to view acquisitions, name inkstones, write encomiums, and trade treasures.

One friend, calligrapher Xu Cai of Wuxing (modern Huzhou), was an "addict of inkstones" since infancy who made a habit of telling his friends that his ultimate wish was to be interred in a tomb whose wall was wrought of his inkstones instead of bricks (9.8b). He Wei singled out Xu's collection for special mention: nearly a hundred stones, replete with "significant items from four directions [of the empire]." A "powerful man" in court was said to have "several hundreds" (9.7a).[24] He Wei identified both collections by way of its crown jewel; Xu's was further described in terms of the five most notable stones. Age and provenance (the fame of its former user or owner) appear to be as important as the properties of the stone itself. When the latter was mentioned, it was its color, surface patination, and "eyes" that were singled out, contrary to Mi Fu's priorities stated in *Account of Inkstones*.[25] Internal ranking of the stones that one has amassed, by the collector or others, was necessary before the collection could be recognized. However, there appear to have been multiple standards and criteria of judgment.

A structure of desires was in place—the personality cult of male artists and writers, the fad of antiquities, and elite male sociabilities and competition—but a pricing structure had yet to form in the early years of inkstone collecting. The aestheticized inkstone, one may say, had yet to become a veritable commodity. In this situation, the taste and political prerogatives of the court, especially those of the highly refined Emperor Huizong, no doubt played a key role in establishing standards of value and taste, as scholars have shown.[26] He Wei's circle of collectors, however isolated and truncated a case, afforded a corrective view from the everyday practice of the emergent literati group. In the eyes of these private collectors, the court and its coterie of "powerful men" were not true arbiters of taste but predators who took more than their share by demanding tributes or "seizing by force" (9.7a).

Relying on their own tastes and networks, the literati connoisseurs constituted an alternative economy. He Wei used the verb "to exchange" or "to trade" to describe a mechanism of arbitration based entirely on the mutual agreement of the two collectors involved: a friend offered his Duan inkstone braced by refined iron, a Tang product from the famed craftsman Guo from Qingzhou, to He Wei in exchange for a painting of magpie and bamboo by Su Shi. The offer was accepted (9.9b). Another friend offered his family heirloom, a purple Duan stone shaped as a toad, inscribed with the self-assigned name of Tang poet Li Shangyin (ca. 813–ca. 858) in ancient seal script and stored in a box bearing an encomium by Su Shi, to He Wei in exchange for a scroll by Su Shi in "drunken cursive" script. The offer was declined. From the dirt accrued on the crevice of the stone, He Wei deemed it to be "indeed several hundred years old" but repeatedly refused the swap. His friend eventually made the trade with another friend, who promptly offered the inkstone as a tribute to the court (9.2a–b).[27]

These descriptions of the inkstones, at once specific and formulaic, constitute a new genre of writing—the inkstone catalogue—the codification of which collectors like He Wei contributed to. Their exchange transactions depended not on a market with estab-

lished prices, but on a shared language based on common experience: a "true purple color," the telltale sign of a genuine Duan stone, is this and not that shade of purple. The basic components of the catalogue entry that emerged are familiar to the modern collector: location of the quarry; shape and form of the inkstone design; color; stone markings; magical and sensual qualities; former user(s); provenance; words inscribed and script used.[28] Once established, the format and nomenclature became conventional in subsequent connoisseurship literature, setting not only the parameters for the valuation of inkstones but also the baseline for development in designs and form.

THE MASCULINE OBSESSION

As inventors of a tradition and celebrated paragons, Su Shi, Mi Fu, and other Northern Song connoisseurs had an indelible impact on the Fuzhou circle of inkstone aficionados in the eighteenth century. They undertook the same activities—shopping, viewing, inscribing, and gifting. Also comparable are the forces that shaped the formation and dispersal of their collections beyond personal taste: the court, powerful men, and the market. Part of the reason for this resemblance is self-conscious imitation; Huang Ren, for example, grew up in the house of his maternal grandfather, Xu You (1615–1663), who admired Mi Fu so much that he named his studio "Befriending Mi" (Miyou Tang). But a deeper, structural reason is that the inkstone, as an emblem for the supreme values associated with writing, literature, and culture, had lain at the heart of the masculine identity of the literati since its inception as a social group in the Northern Song.

The inkstone was a constant presence in the psychic, everyday, and public lives of the male literati. Among the enduring legacies of the Song forebears was the association of inkstone loving with the cult of the male genius artist or writer on the one hand, and with the formal and informal economies of gifting by the male public official on the other. Knowledge about inkstones was thus gendered (elite) male, along with the privilege of writing on and about them. Women could be culturally acceptable *users* of inkstones, as the growing respectability of women poets and painters in the seventeenth century attests. The inkstones supposedly used by several woman writers, such as the courtesan Liu Rushi and the fateful maiden Ye Xiaoluan, became sought-after collectibles in the Qing. But inkstone collecting and its related connoisseurial research remained a thoroughly masculine activity. In the Song as in the Qing, heirlooms were passed on through the patriline, from father to sons, along with rubbings of antique writings; the exchange of inkstones and encomiums cemented male friendship in and out of bureaucratic careers. And, could the lore of ink frozen dead on a wintry stone in the frigid exam cubicle be anything but thinly veiled disguise for male anxieties about writer's block or even worst, the specter of exam failure?

This persistent masculine bias is all the more remarkable in light of the fact that not only were members of the Fuzhou circle loyal patrons of Gu Erniang, but many

boasted educated women poets and painters in their extended or immediate families. Several were even married to talented women although none of the wives appear to have saved, let alone published, their prose and verse.[29] Lin Ji's wife Zhang Roujia was learned enough to have assisted him during his stint as an editor of the imperial encyclopedic project, *Complete Collection of Illustrations and Writings from Ancient to Modern Times*.[30] Her learning is known to posterity only because her nephew Lin Weiyun (d. 1736) recalled a scene of Zhang teaching her twelve-year old grandson, Wan, one late winter night. Zhang, pointing to a She inkstone in front of her seat, challenged the boy: "Can you compose an encomium for it?" She was visibly pleased when he rattled one off. There are two conflicting versions as to what ensued. According to an earlier version of *Inkstone Chronicle*, Weiyun and Zhang each composed a sequel to Wan's exercise. Zhang's reads:

> Carved from the essence of the She River,
> A companion to the quiet virtue of the gentleman.
> The infant grandson chanting books,
> The white-haired one, already midnight—
> Facing each other across the chilly desk.
> Seeing you, so young and precocious,
> I feel the jagged edge of time passing.[31]

The author of this fine poem was unequivocally Madame Zhang according to the earlier version of *Inkstone Chronicle*. In his preface to this volume, her son Lin Zhengqing stated in no uncertain terms that the collection of inkstone encomiums began with his father Lin Ji's *Ursa Major* (carved by Gu Erniang) and "ended with my fifteenth nephew Wan's encomium and the inscription by my mother, Madame Zhang, hence making it clear that this chronicle refers to the family heirloom of the Lin family."[32] In a later version, however, Weiyun's sequel was deleted, and Zhang's composition became *his*. Gone, too, is the reference to his mother and the pride of the Lin family in Zhengqing's preface. Without further information, it is impossible to settle the authorship of the poem.[33] Whichever may be the truth, the enigma itself brings to the fore a salient feature of the textual practice of the Fuzhou circle: the near absence of women in men's recollections of their experience with inkstones. And when women do appear in the interstices, their voices are presented in quotations, accessible only through the retelling of the male ventriloquists.

The occultation of Huang Ren's wife, Madame Zhuang (her given name is not known), is an even more striking example of this dynamic. If Huang had not recalled half a poem thirty-five years after she wrote it, there would have been no trace of her literacy. Seven years into their marriage, the young bride found herself alone, again, on New Year's Eve. Huang, having taken (and failed) the metropolitan exam for the

third time, was sojourning in the north. She sent him these lines: "Ten thousand miles, wintry night, the exile repelled thrice. / Seven years, New Year's Eve, five absences from home."[34] The emotional impact of the well-crafted lines hinges on the term "exile repelled" (zhuke), an allusion to the tender friendship between two equally great Tang poets, Du Fu and Li Bo. When Li was sent into political exile and not heard from again, the weary Du dreamed of him thrice and recounted his anguish in two poems, "Dreaming of Li Bo." Madame Zhuang took the allusion from these lines: "South of the river, the land of miasma, / The exile went silent." The allusion is apt on multiple fronts: not only did Du's three dreams resonate with Huang's three exam attempts, Zhuang was also able to convey multiple emotions economically. She delivered her fondness for her husband, her mild chiding for his failure to write, and hope for his imminent triumph and return (they both knew the dramatic irony: when Du was dreaming of Li, unbeknownst to him the latter had already been pardoned and was on his way home.) And no one would have found her immodest for obliquely comparing herself to Du Fu when she paid compliment to her husband by calling him Li Bo.[35] The two lines etched such a deep impression on Huang that he embedded them, the second line verbatim, in one of twenty-eight mourning poems for her when she died in 1744. If not for him, her wit and familiarity with Tang poetry would have been lost to history.

In another mourning poem, Huang divulged the even more surprising news that his wife had loved inkstones and had at least one significant stone to her name. She had acquired the Duan stone when she accompanied him to his post in Sihui. The stone is of superior quality; Huang described it as "fine and tender of skin, enlivened by a purplish green luster." Carved on its back was the inkstone's romantic name, *Springtime Crimson* (Sheng chunhong), an allusion to a eulogy of a She inkstone by Su Shi. Huang did not disclose how Zhuang came to possess it, nor did he explain who did the naming. What he intended to convey was his wife's profound love for the inkstone. He used the same two verbs normally reserved for male connoisseurs, "to keep" (xu, also used for the keeping of a pet, maids, and boy actors) to refer to her ownership, and "to fondle incessantly" (mosuo bu qushou) to describe her attachment. When they retreated from Guangdong in disgrace in 1731, they had to hire their own boat. Zhuang "carted away neither peacock feathers nor bright pearls [treasures of the south], / Bundling only one slab of *Springtime Crimson*." She kept it for the rest of her life. After Zhuang died, Huang found the inkstone in a dusty box, the ink traces on the stone still fresh as if they would stain his clothes. He cried.[36]

Madame Zhuang is unequivocally female, but her gendered persona oscillates between male and female in Huang Ren's portrayal. In setting up a deliberate contrast between the love of such worldly goods as feathers and pearls and one inkstone, he explicitly compares his wife, as a *woman* who has no use for adornment, to such incorruptible Song officials as Zhao Bian, who retired from office holding only one inkstone. By extension, Huang thus portrays her as his alter ego, an upright official who, despite

his love of inkstones, did not abuse his power while overseeing the jurisdiction of the Duan quarries. The ambivalence bespeaks the extent to which the nominal inkstone lover was gendered male in the early Qing. He had to use such masculinized verbs as "to keep" and "to fondle" because the entire language of inkstone connoisseurship was gendered masculine.[37] Indeed, so pervasive was this bias of male ownership that throughout the Qing and up to the present, observers have cited this poem as "proof" that the *Springtime Crimson* belonged to Huang Ren. A corrupt version of the poem also predominates, whereby Zhuang is misidentified as Huang's concubine. It seems that few are inclined to believe that a proper *wife* and dutiful mother could love an inkstone.[38]

Focusing on the poetry exchanged between husband and wife in Jiangnan, previous scholars (myself included) have painted a one-sided picture of gender relations in the Ming and Qing based on the model of companionate marriage. The masculine nature of the inkstone obsession serves as a useful reminder that for all the emotional and intellectual resonances between men and women in a scholarly family, the gender lines were more resistant to change when it came to the love and daily experience of things. This was especially so when the object concerned—the inkstone—was so entangled with the growing pains, informal and formal networks, and career anxieties of men.

BUILDING A COLLECTION: FAMILY INHERITANCE

The bulk of Huang Ren's emotional and financial investment was in his inkstone collection, already considerable when he was a young student at Lychee and Water Manor. The collection acquired a formal presence when the thirty-seven year-old scholar decided to build a study to house it (1719–20). The name of the study, "Studio of Ten Inkstones" (*Shiyan xuan*), is transferable, equally applicable to the man, his writings, and his stones. It names Huang's first poetry collection and inkstone collection, and "Ten Inkstones" became Huang's moniker. When Huang took up his post in Guangdong, he hung a sign on his study and it figured as another "Studio of Ten Inkstones." The name became so famous that even Emperor Qianlong (r. 1736–1795) boasted, apparently without credible evidence, that he managed to net four of the ten.[39] Lin Fuyun also amassed a sizable collection, especially during his final years in Suzhou, but it did not acquire a name or accrue fame.[40] What makes a collection different from a pile of stones? What is in a name?

The unique *Inkstone Chronicle*, supplemented by the prose and poetry of the core group and extant inkstones bearing their inscriptions, allows the historian to attempt an answer by reconstructing Huang Ren's lifelong collecting activities. Craig Clunas's *Superfluous Things* and other studies of the genre of so-called manuals of taste have established the importance of consumption to the definition of elite men's identities in the seventeenth century, at a time when social relations were unmoored by the sil-

ver economy. Studies of such late-Ming collectors as Li Rihua and Xiang Yuanbian, in turn, have mapped the contours of the alienability of such "high-end" collectibles as paintings, calligraphy, and rare books.[41] To date, however, there is no study of the formation of a collection of objets d'art in the early Qing, in large part due to the scarcity of sources. The following account, however sketchy and lacking in such quantitative information as prices, sheds light on the forces that drove the markets of a less exalted category of collectible item, in a locale outside Jiangnan, and in the decades before the prosperity of the Qianlong reign.

The first salient observation is the extent to which the inkstone collections of the Fuzhou group were products of the early Qing milieu; they were all first-generation collectors. Huang hailed from an old family whose ancestral home is in White Cloud Homestead, Yongfu (modern Yongtai), a mountainous area thick with camphor trees about eighty kilometers to the southwest of Fuzhou (fig. 5.6). His great grandfather, a successful Ming scholar-official, bequeathed real estate (including the Huancui Lou in Jiyan that Ren kept as a retreat, the ancestral home in Linfeng, and the Dongjing Shanfang at the foot of the former), rare books, and a handful of old inkstones he used for collating books. Huang had taken a fancy to the stones when a child.[42] But Huang had to build his inkstone collection himself, either purchasing them from shops and private collectors ("old families") or buying uncut stones and commissioning artisans to make them.[43] The market was the main venue for acquisition.

The same is even truer for Lin Ji and his sons. The Manchu conquest was a disaster for the Lins, a gentry family that owned properties inside Fuzhou city and in the surrounding hills. In the violence that ensued, the family income was so decimated that when peace returned, they had to rent out half of their ancestral home on Guanglu Lane, a stone's throw from Huang Ren's residence, while the entire family crowded into the remaining three sets of rooms.[44] Although the Lins were a successful enough scholar's family, the Lin brothers did not start off the Qing with any notable inkstones. Lin Zhengqing remarked in 1733, "My family has a collection of over ten inkstones; they were all polished by my late father [Ji], who also carved the encomiums on their backs." In a later version of *Inkstone Chronicle*, Lin Fuyun inserted a line into his own preface, "My forefathers have bequeathed many inkstones."[45] It contradicts Zhengqing's statement and everything else we know, leading to my suspicion that Fuyun was trying to pad the record.

Even for an inkstone collector as dedicated as Huang Ren, the inkstone was only one category in a package of collectibles, which might include paintings, calligraphy, rare books, rubbings of ancient writings, and other small objects of art such as carved jade for the scholar's desk. There is no specific mention of notable paintings from the Ming or earlier in the family holdings inherited by the core of the Fuzhou circle, although this lacuna may be a function of their investment in other things. In contrast, ink rubbings figure prominently in the emotional and intellectual lives of Huang Ren, Xie Gumei, Lin Ji, and his sons. Lin Ji was bequeathed a cache of rubbings which his

FIG. 5.6. Huang Xiulang, Huang Ren's eighth-generation lineage grandson, in the courtyard of Huang Ren's birthplace and ancestral home, White Cloud Homestead, Yongtai, Fujian. Photograph by the author, Dec. 2012.

father and elder brother collected in Shaanxi in the 1660s, as noted earlier, the basis of his epigraphic passion and calligraphic vision.

Huang and Xie, too, each inherited a sizable rubbing collection. The wording in Huang's recollection of them betrays his recognition of an ambivalent ownership: "In Gumei's Twin Plum Pavilion and my Studio of Ten Inkstones, one finds in storage rubbings of Han and Tang steles, bound in sets, that number over a hundred each." The rubbings were housed in their personal studies where they enjoyed ready access, but the verb "stored" suggests custodianship. "Every day we took them out and sat with each other, collating them while attaching inscriptions and colophons." Both Huang and Xie applied themselves in augmenting their inherited rubbing collections by way of purchases from "derelict stores in obscure villages" as well as gift exchanges with each other and with Lin Zhengqing.[46]

Most memorable was the manner in which Gumei and Zhengqing celebrated Huang Ren's birthday in 1719. They hung their friend's portrait on the wall of his western studio and offered a libation. Also displayed for their viewing pleasure on the whitewashed walls, in a certain order of ranking or sequence, were precious scrolls, singleton copies

of artwork, and the rubbings from a stele depicting the statues of six horses guarding the Tang emperor Taizong's mausoleum or a painting based on the rubbings.[47] In the midst of their binge drinking and carousing, a dealer arrived trying to interest them in a set of old rubbings of seminal Tang and Song works carved on the Wuxi cliffs in Hunan, which they inspected under candlelight and which Gumei was particularly fond of.[48] We do not know if they ended up purchasing it. We only know that Huang recalled the merriments of that day forty-three years later when he was feeling melancholy on his eightieth birthday. Xie Gumei had long died, and the rubbings held by both families had dissipated. "Not a single set is intact."[49]

Besides rubbings, Lin Ji and Yu Dian appear to have inherited Ming books from their fathers, and applied themselves in hand-copying them to transmit the works and as calligraphy practice.[50] Lin Ji, in particular, was a bibliophile who seems to have been seized by a visceral fear of the transience of words, especially those of Fujian writers. A tireless copyist, he "collected" books by copying fragments borrowed from other families and stitched them into complete editions.[51] He also bought books from academies and distraught families with hard cash. One of his ambitions was to reassemble the

writings and library of Fuzhou native and Ming loyalist Xu Bo (1570–1642), which were dispersed during the Qing occupation of Fuzhou in 1675. Lin Ji bought about two thousand volumes from Xu's grandson and was overjoyed when Zhengqing found another fifty-some titles decades later. Ji collated Xu's works and compiled a volume of his colophons, hoping to eventually committing them to print.[52] Through his diligence and unflinching sense of mission, Lin Ji built a collection of ten thousand books, including hundreds of rare copies.

Divided by temperament and intellectual commitments, Huang Ren and Lin Ji exhibited divergent personal motives for collecting inkstones. Lin Ji's son Zhengqing described Huang's affliction as in-born and inexplicable: "Born three thousand and several hundred miles from Duanzhou, his spirit and desires have nonetheless been bound up irretrievably with slabs of stone from the Upper and Lower Rocks."[53] Huang Ren, heir to the late-Ming cult of *qing* (emotions; sincerity) and the quintessential "addict" connoisseur, was a man of excess who loved his playthings: besides inkstones he also dabbled in small desktop items as jade, was knowledgeable about Shoushan stones, commissioned skilled carvers to make seals out of them, and is known to have owned an album of finger paintings by Gao Qipei (1660–1734). But his inkstones comprised the romantic poet's singular obsession and legacy; he loved his inkstones (and other mortal friends) as extensions of his self.[54]

In contrast, Lin Ji the professional scribe was cautious and serious, as if weighed down by the responsibility of magnifying the Lin family and his native place. He reserved his greatest love for rare books, professing to be a salivating glutton or a compulsive hoarder when he came across them.[55] Although no less attentive to and knowledgeable about inkstones than Huang, Lin valued the inkstone as a professional implement, a form of cultural capital to pass on to sons, and a medium for research in epigraphy. To really know the ancient scripts on the steles, he maintained, the scholar would have to learn to carve them himself. I will return to the epistemic implications of this radical view in the epilogue. Here, suffice it to note that Lin and Huang represent two poles on a spectrum of attitudes toward their inkstone habit; each of their friends in the Fuzhou group settled somewhere in between.

USEFUL AND SPECIALIZED KNOWLEDGE IN THE MARKET

Whatever the collector's aptitude and financial means, knowledge about the market was the key to success. The verb "to exchange" that describes the acquisition method of He Wei and his fellow collectors in the eleventh century gave way to "to sell" and "to buy" in the writings of the Fuzhou circle.[56] The unabashed mercantilist nature of the transactions bespeaks the extent to which the inkstone had become a commodity in the early Qing. To build a collection meant to be an informed shopper. Useful knowledge pertained to access and assessment, by nature local and specific: which old family in

Suzhou was motivated to sell, who could proffer an introduction, how to negotiate the maze of vendors in the Ciren Temple in Beijing, if a certain stone was worth the asking price, and who could be trusted to authenticate a stone? In the early Qing, such information was neither public nor printed; it circulated by word of mouth, intersecting the myriad literati networks that channeled the movement of aspirant scholars, exam candidates, and job-seekers crisscrossing the empire.[57]

Huang Ren began his acquisitions early, taking advantage of the frequent trips to metropolitan centers demanded of aspirant students.[58] In the capital, he probably received introduction to the Ciren Temple dealers and old families from Lin Ji. Visiting the temple market became a ritual whenever they met up in Beijing; twenty years after the fact, Huang recalled a particularly enjoyable visit with Lin in 1714 when he netted several stones.[59] But Huang's fondest memory is reserved for his sojourns as a young student in Suzhou, often with Xu Jun, where he had the most edifying experience. The pair enjoyed excellent access to collectors, dealers, and artisans in Suzhou, the most sophisticated art market in the empire. Lin Ji and Yu Dian both stopped there routinely en route from Fuzhou to the capital in the 1700s, making purchases and commissions. Even better, in 1714 Xu Jun's father and Huang's maternal uncle, Xu Yu, was appointed the magistrate of Changzhou, the eastern part of the city of Suzhou, and served there until his death in 1719.[60]

In Suzhou not only did Huang and Xu make the acquaintance of Gu Erniang, they also solidified their connoisseurship knowledge by honing the skills of the "connoisseur's eye" that only came with close examination of extensive quality collections. In a tribute to Xu Jun after his death in 1730, Huang remembered his best friend by way of their shared tutelage in Suzhou:

> The Rocks Upper or Lower; the Caves East or West;
> The Poet of Dingmao [Xu Jun] excelled in telling the stones apart.
> Deep in memory's recess, brisk autumn, the lodge went quiet—
> Silver hooks, iron strokes, in front of he who carved the insect script.[61]

The "lodge" refers to the Fuzhou Association in Suzhou, where the two stayed. The first two lines refer not to arcane geography but to the most important aspect of connoisseurship knowledge in the early Qing, the ability to discern the origin of a Duan stone, down to its exact location in the quarry, from the subtle variations in stone markings. Since the date of mining operation in each location is more or less known, knowledge about the precise origin of a stone forms a reliable basis of its dating. The Upper and Lower Rocks, the exact location of which is controversial, are part of the exalted Old Pit, as are the East and West Caves (see fig. 2.12).

A second and equally important aspect of the knowledge of the connoisseur, at least for the Fuzhou group, is revealed in the last line: epigraphic knowledge and skills in

carving ancient scripts. "Silver hooks" is a euphemism for calligraphic writings, and "iron strokes" refers to the carving of words onto stone with a knife, often called by the Fuzhou group an "iron writing brush." *Diaochong* (literally, "carving insects"), or what I have rendered "carved the insect script," alludes to a remark by the Western Han scholar Yang Xiong (53–18 BCE). Yang opined that the insect and the seal scripts, two of the ancient "eight Qin scripts" that constituted a Han student's basic education, were of minor concern to the mature scholar.[62] By extension, "carving insects" has come to mean a minor pursuit, especially a craft skill, that is too trivial to engage a serious scholar's mind. Although Huang Ren cited Yang, he disagreed with his assessment. In his mischievous contrarian mode, Huang insisted that *carving* the insect script can be a worthy act. In his interlinear note to the poem, Huang explained that Xu Jun had indeed carved encomiums onto his inkstones when he sojourned in Suzhou with Huang, and Huang was said to have done the same. Being Lin Ji's calligraphy students, they had taken Lin's radical approach of integrating writing and carving to heart. Intimate knowledge about how the ancient scripts were carved no doubt aided the authentication of the inscriptions on antique inkstones.

In praising Xu Jun's uncanny ability to distinguish between stones mined from different parts of the same quarry, Huang used the verb *jian*, which carries a more specific meaning of "to authenticate." Huang Ren often played that role for his fellow collectors. When Li Yunlong, a friend and a member of the second tier of the Fuzhou circle, bought a large rectangular inkstone in an antique store, he took it to Huang and had him authenticate, identify, and date (*jianding*) it. Huang himself depended on the eye of an elder, Weng Luoxuan (1647–1728), veteran connoisseur and longtime friend of Lin Ji and Xu Yu, when it came to identifying quarry locations. In a 1723 note Huang attached to an antique inkstone, he explained, "The Underwater Lode has three caves—East, West and Middle. The Middle Cave had long been depleted. Mister Luoxuan recognized that this stone is from the old Middle Cave, which makes it all the more precious."[63]

Both the knowledge and language of inkstone connoisseurship became highly technical in the early Qing. If a buyer needed expert knowledge (or an expert friend) to navigate the market, the process of commissioning the making of an inkstone was even more taxing. The first step was to procure an uncut stone. You Shao'an, a fellow student from the Lychee and Water Manor, wasted no time in visiting Huang Ren in Guangdong in 1725, soon after the latter took office near the Duan quarries. You appeared to be conversant with both the language and protocol of sizing up Duan stones. When Huang presented him an uncut stone as his arrival gift, You made this mental note: "Wide of forehead and slender of chin; slightly slanted. Color banana green, with a touch of yellow cloud on the edges. Looks like a recent product from the Underwater Lode." Huang saw the slight disappointment on his face and introduced You to his predecessor, who evidently kept a cache of old stones. There, You met his match: "Almost half a foot in length but not as wide; over an inch thick. Wrapped in layers of brocade pouches, it has already been chis-

eled and shaped. I see that its color resembles that of pork liver. When placed in a basin of water under the sun, there emerges a faint burnt mark as if charred with an iron. Is it from the dry quarry? Underwater? Or Li? I cannot tell for sure."[64]

Although You was stumped by the identification, the standard similes he used to describe the colors of stones (banana green; pork liver) and his adherence to the catalogue format developed by He Wei and other Song collectors (length, width, shape, color, stone markings) bespeak familiarity with the connoisseurship literature. The practice of inspecting the stone in a basin of water under light, a technique still used today, suggests that You's knowledge did not derive entirely from books. But You was out of his depth when it came to the actual designing and carving, which he entrusted to his friend Yang Dongyi, the expert carver who trained with Lin Ji and who was You's travel companion. Yang closely examined the two stones for an inordinate amount of time before concluding that from a technical point of view, "it is best for both inkstones to have both a water pool *and* an ink pool."[65] But the design motif of each was an aesthetic decision that Yang left to You's discretion.

The premium placed on craft knowledge on the parts of both the collector and maker of inkstones is a hallmark of the market in the early Qing. Such Song collectors as Mi Fu can surely be said to have valued specialized knowledge in their attentiveness to the location of quarries and the properties of stones from each. But when one reads their treatises against early Qing discourses such as You Shao'an's, the difference in technical specificity is striking, as is the latter's proficiency in a precise language of description. Not only is the level of specialized knowledge that circulated in the market, artisan's workshop and the collector's bookshelf higher in the early Qing, it is more dispersed across the social spectrum and geographic distance.[66] You Shao'an's relationship with Yang Dongyi suggests that the collector had to be conversant with the exacting language and carving techniques to be an informed "consumer" and that the artisan had much to teach the scholar.

If the value of the Song inkstone was the product of both the genius and craftsmanship markets, the difference between the Song and the early Qing situations is not so much an increase in the relative weight of the craftsmanship market, for there was a concomitant increase in the celebrity value of the user, carver, and encomium writer of an inkstone in the eighteenth century. Rather, the key difference lies in the heightened importance placed on skills and specialized knowledge in the determination of who would accrue fame as a "genius" collector or maker.

MODERNITY AND NOVELTY

The circulation of skills and knowledge in the early Qing market provided the impetus for innovations in carving techniques and styles already seen in the last chapter. Indeed, the adjectives "new," "extraordinary," and "fresh" recur in *Inkstone Chronicle*,

in both their descriptions of inkstones and in others' tributes to the group.[67] A taste for novelty in design and execution, however, does not mean ostentation but quite the opposite. The Fuzhou circle tends to prefer understated designs, often drawn from antique shapes and motifs, meticulously conceived and carved to magnify the natural features of the stone.[68] The encomiums they composed for each inkstone, always forming a metaphoric continuum with the design like the colophons of a literati landscape painting, constitute an important element of their innovation. They played a sophisticated game whereby the most innovative aspect of an inkstone might not be readily visible to the casual or uninformed viewer. A magnificent inkstone that was designed, carved, and inscribed by Lin Fuyun, *Fishes in Spring Water*, exemplifies this aesthetic (fig. 5.8).

Yu Dian captured the unique moment represented by the early Qing in the history of inkstone collecting in an encomium of remarkable acuity:

> The Tang people valued the Duan stone,
> But they only recognized its surface features.
> The Song people knew how to discern the materials,

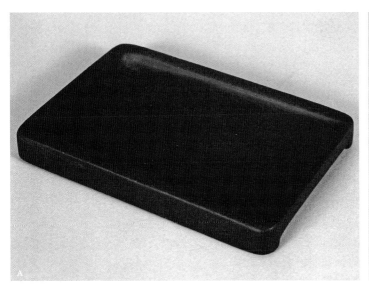

FIG. 5.8. Lin Fuyun (Lunchuan), *Fishes in Spring Water* inkstone. (A) Front; (B) back. Although invisible to the casual viewer, the back of the inkstone is convex, its gentle bulge coinciding with the two fishes frolicking in the lapping waves of the swollen water. In the space above, Fuyun inscribed a saying from the Song philosopher Zhu Xi in seal script: "When one is so still one begins to move; like fishes in spring water," followed by Fuyun's finely-etched annotations in regular script (both texts in *Yanshi* C6.4a). The inscription is dated the third month, 1750. It is the last known work of Lin Fuyun, who died two years later. Coincidentally it is one of two inkstones mentioned in *Inkstone Chronicle* that can be unequivocally identified as being extant today. L 14.8 cm, W 10 cm, H 1.7 cm. Lanqian Shanguan Collection, National Palace Museum, Taiwan.

Sorting the stones by principle for their rosters.
As for craftsmanship, it has to await the present era,
Bearing deep into the marrow, skills honed to the utmost.
The stage we have entered is the best ever,
How can old things ever hope to hold our fancy?
The fineness, purity, and elegance, impossible to put in words!
Pity the wise men from the past who never saw them.[69]

Yu's statement, so modern in its celebration of the present over the past, construes his world as the golden age of inkstones, the result of the culmination of Song knowledge of the materiality of stone coupled with a contemporary drive for technical finesse and stylistic innovations. Yu's dismissal of the rarefied Tang and Song inkstones on the basis of crude craftsmanship is shocking but entirely congruent with the priorities of the Fuzhou group. But the curious historian wants to know: whatever happened to the intervening dynasties, the Yuan and the Ming, which Yu fails to even mention?

The Fuzhou circle had indeed studied or acquired a handful of antique inkstones from the Song, Yuan, and Ming dynasties. In a slim section in *Inkstone Chronicle* dedicated to encomiums on antique inkstones, one finds the mention of a Song inkstone dated Zhenghe 7 (1117) purportedly once owned by the Ming collector Xiang Yuanbian; an inkstone attributed to the Song writer Lu You (1125–1210) in Gao Fenghan's collection and viewed by Lin Zhengqing; an inkstone attributed to the Yuan painter Zhao Mengfu, which Lin Ji engaged Gu Erniang to recarve; another inkstone with Zhao's encomium; an inkstone attributed to the Yuan painter Ni Zan with an encomium by Ming collector Li Rihua; an inkstone attributed to the Yuan painter Wu Zhen, which Huang Ren had Gu Erniang recarve; and another of Wu's dated Zhizheng 21 (1284), still in Huang's collection in 1750.[70] All of these names, including those of collectors Xiang Yuanbian and Li Rihua, carried a premium in the genius market, with forgeries being common. Whatever their reliability, the most glaring fact about these inkstones is their paucity in number relative to the number of contemporary inkstones the Fuzhou collectors held (see the "Number of inkstones in *Yanshi*" column in appendix 3.) The underrepresentation of Ming inkstones is even more drastic: the *Chronicle* chapter includes only one, from an obscure Fuzhou local.

Ming inkstones are characterized by their hefty size and skilled but uncomplicated carving (fig. 5.9). Cai Hongru, the retired curator of inkstones at the Tianjin Museum, relates that the look is so distinct that antique dealers have given it a name, "Da Ming ware" (Da Ming zuo).[71] It is doubtful, however, that these Ming stones attracted much attention in their lifetime. There was no lack of inkstone collectors in the Ming; the aforementioned Li Rihua, for example, named one of his studies the "Six Inkstones Studio." Such Ming arbiters of taste as Gao Lian, Wen Zhenheng, and Chen Jiru all discoursed on the merits of various quarries in Duanzhou, the ins and outs of Duan

FIG. 5.9. Drawing of a Ming inkstone. *Drawings of Antique Inkstones Held by Mister Huang Xingtian*, an unpublished accordion-bound book, bears a spurious attribution to Huang Ren and is presented as his writing. Organized chronologically, with drawings of Tang, Song, Yuan, and Ming inkstones, it appears to be a pedagogical device for the novice inkstone connoisseur in the late Qing and the Republican periods. *Huang Xintian xiansheng guyantu*, Harvard-Yenching Library.

versus She stones, the relevance of stone markings, the proper way to wash an inkstone, and so on in an abstract, pedantic tone.[72] To my surprise there is little discussion of the kinds of Ming inkstones people actually collected or interactions between collectors and artisans with the same granularity as in the early Qing cases.

One explanation for this lacuna is that the Ming inkstone market appears to have been two-tiered: there was scant interaction between the market in contemporary stones, which people used daily, and the market in antique stones, which were worthy of collecting (and grinding ink in an extravagant gesture). An early hint of this bifurcation is the list of goods confiscated from the powerful former grand secretary Yan Song's (1480–1565) home after his fall from grace. In the list of valuable items transferred to the warehouse of the Imperial Household Agency appear sixteen "antique inkstones": two Han, two Tang, three Song, one Korean (Koryŏ), and others classified

by the materials. In a separate list of mundane items to be sold off for cash there appears, mixed in a batch of brushes, ink, and other contents from a scholar's drawer, forty-eight inkstones wrought of green or purple stones.[73] Li Rihua, who drew up a list of twenty-three categories of collectibles in descending order of value in his eyes, began with calligraphy from the Jin and Tang, followed by paintings from the Five Dynasties, Tang, and Southern Song. The first nine places were reserved for calligraphy, paintings, and rubbings. Ranked thirteenth is "Tang inkstones," the only kind worth collecting.[74] Seen in this light, the practices of the Fuzhou collectors represent a direct rebuttal of the antiquarian tastes and privileging of calligraphy and paintings that prevailed in the Ming, and continued in the Qing in some quarters.

Scattered evidence suggests that even in the early Qing, the taste of mainstream collectors in the heartland of the empire tended toward antique inkstones associated with medieval celebrities. The Suzhou bibliophile Wang Xiaoyong (fl. 1727) related that there were "three famous inkstones in our world." The first was the *Imperial Gift* (Laiyan) inkstone attributed to the Daoist alchemist and calligrapher Tao Hongjing (456–536). The stone was a longtime family heirloom of Suzhou bibliophile and calligrapher He Zhuo (1661–1722), who named his studio and rare book collection in the capital "Imperial Gift Inkstone." The second was Mi Fu's *Inkstone Mountain*, which poet and inkstone-lover Zhu Yizun once brought to Suzhou and showed his friends there. The third was the *Jade Belt* that belonged to the Song martyred general Wen Tianxiang (1236–1283), an heirloom in the house of Song Luo (1634–1713). Song, the son of an academician and a favorite official of Emperor Kangxi, was one of the most important collectors of his time. He Zhuo and Song Luo were known to the Fuzhou group, but in terms of purchasing power they were in a league of their own.[75] Against the conservative tastes of the metropolitan connoisseurs, the new standard of judgment articulated by Yu Dian is as radical as it is audacious: modern inkstones are more valuable simply because they are more skillfully made than the Tang, Song, Yuan, and Ming ones. Although disadvantaged in their access to traditional resources, regional collectors like the Fuzhou group began to join the market in considerable numbers as peace returned to the empire in the late seventeenth and early eighteenth centuries. They soon made their presence felt.

From this perspective, among the salient changes the Fuzhou collectors and the artisans in their company ushered in was an inversion of the bifurcated markets, in which modern stones had occupied the lower end and antique stones the higher. By personal example, they elevated contemporary inkstones, carved by themselves or members of their circle and bearing their encomiums, a category of collectible objects worthy of emotional and financial investment. They did so by making craft skills and expert knowledge their main assessment criteria and by deeming artisanship a scholar's métier to the point of wielding the "iron writing brush" themselves. Similar respect for craft on the parts of two painters and inkstone connoisseurs contemporary to

the Fuzhou group (discussed in the epilogue), Jin Nong (1687–1763) and Gao Fenghan (1683–1749), suggests that these priorities constituted a wider early eighteenth-century phenomenon. The lower-end or quantity market was still saturated with stones that provided for the daily grind of millions of students in the empire, but the quality market was irrevocably changed.

GIFT INKSTONES

A collection, writes Susan Stewart, "comes to exist by means of its principle of organization" and classification. Depending on what the principle might be, some collections are finite whereas others have open boundaries. Either way, in organizing the objects into a series, the collector extracts them from their origins and reframes them as simultaneous with one another.[76] Although similarly formed by an act of world-making and manipulation of time, a collection in early modern China is less predicated on the destruction of context. Two contexts are particularly relevant to the framing of collections of masculine objects such as the inkstone: the vertical descent of the patriline and the horizontal webs of friendship and patronage.[77]

The term the Fuzhou circle used consistently to refer to their beloved things is *jia-cang*, literally that which is stored in the family or home. It can be used as a noun ("our collection") or as transitive and intransitive verbs ("we collected"; "stored in our house"). When the son of Zhou Shaolong, a member of the Fuzhou core, remarked after the death of his father, "There are still over ten inkstones collected in our family," the term takes on the explicit meaning of a family heirloom.[78] The wide semantic field encompassed by the Chinese term dulls the sharp demarcation between a personal holding and a shared one, and the question of when and how does a personal collection become a collective heritage is seldom asked. Indeed, due to the experience of shared upbringing, common patronage networks, and frequent exchanges of tokens and knowledge, the Fuzhou core group embraced a strong sense of shared, collective ownership of the inkstones that passed through their hands. Their "fellowship in stone" was etched on the very surface of the inkstones they bought, carved, viewed together, or relayed from one corner of the empire to the other: a dense web of interlaced encomiums, specific to the journey and the sentiments of the individuals involved, altered the appearance of the inkstones (fig. 5.10).

This sense of shared ownership and history that the stones and encomiums made visible is the key to understanding the nature of gifting activities of the Fuzhou circle. Within the core group, a traffic in gift inkstones accounts in no small part for the accumulation, and conversely the dispersal, of their personal collections. Gifts of inkstones marked life transitions, cemented friendship, and lubricated patronage networks of the Fuzhou group.[79] Of the five cardinal relationships in ethics, gift inkstones were conspicuous in four—lord and minister, father and son, elder brother

FIG. 5.10. Drawing of the *Stone Field* inkstone in Emperor Qianlong's collection. (A) Front; (B) back. Inscribed on the back of the inkstone are encomiums by Yu Dian (right side), Lin Ji (middle rectangle), and Yu's note to Huang Ren (upper left corner): "Respectfully presented to Mr. Xintian for his appreciation." Although the authenticity of this inkstone cannot be ascertained, it is such an apt material expression of the "fellowship in stone" enjoyed by Yu, Lin, and Huang that if it did not exist it would have to be invented. Huang Ren's lineage, the Huangs of Linfeng, opened its 1780 genealogy with a verbal description of this inkstone in a section entitled "Imperial Insignia." Yu Minzhong et al., *Xiqing yanpu*, 17.2a–b.

and younger brother, and between friends. The only relationship built on other material exchanges was husband and wife. What historian Natalie Davis calls a "gift register" or a "gift mode" operated in tandem with the market mode in the creation of value and meaning; the former also played a role in determining the design motifs of the inkstones.[80]

Gifts of inkstones were punctuation marks in the private and public lives of scholars, beginning with a father's gift to his son when the latter learns to write. After You Shao'an netted two fine uncut Duan stones in Guangdong, he intended the more recently mined stone as a gift to his son and settled on the design of a sieve, a common shape of Tang inkstones. A reference to a line in the *Book of Rites*, "the son of a good

maker of bows is sure to learn how to make a sieve," the sieve (*ji*) is a shorthand for "inheriting the father's mantle."[81] You composed an encomium and had it carved on the inkstone's back. You's son turned out to be a disappointment at the exam, but cherished the inkstone for over twenty years.[82] The large number of sieve-shaped inkstones that circulated may thus have been more indicative of parental expectations than antiquarian tastes.

When the filial son remembered his father, the style of the inkstone he chose may also have been integral to the shape of his memories. The most important lesson that Xu Jun, who served his father Yu for sixteen years, took away was reduced to two words: "sealed lips." In 1724, when Xu passed through Suzhou, where his father died at his post five years prior, he was overwhelmed by a sense of loss. Subliminally, Xu Jun commissioned the making of an inkstone in the shape of a sealed pouch. Only afterward did he begin to make the connection; a sealed pouch was an allusion to his father's admonition. He wrote an encomium to commemorate a lesson well learned.[83] The profusion of inkstones in the shape of a sealed pouch, too, may be less indicative of an antiquarian trend than the perils of wrongful speech in the treacherous waters of early Qing bureaucratic life.

The pouch-shaped inkstone took on a more ambitious meaning in an encomium that Lin Ji gifted to You Shao'an after the latter failed his metropolitan exam in 1718. The defeat was particularly disappointing, as his fellow classmate Xu Jun who took the same exam was triumphant. To console the despondent You, Lin Ji wrote, with his characteristic wry humor:

> The uncut jade is not yet hacked,
> Sooner or later you will come begging for Chang'an rice.
> Take this pouch now: go net ten thousand things.[84]

To "beg for Chang'an rice" is a euphemism for accepting bureaucratic employment. You celebrated the encomium as a felicitous omen when he eventually succeeded in 1723; when deployed to his post at the Ministry of Justice he told everybody who would listen about it for years (Xu Jun's father's admonition clearly did not apply to him.)

Some gifts were less felicitous. These "gifts gone wrong" were just as integral to the bureaucratic and social lives of the male literati, as Huang Ren knew only too well. By the time Huang attended the funeral of his maternal uncle Xu Yu in Suzhou and returned to Fuzhou in late 1719, he had amassed a significant inkstone collection (the exact number is not known). Although he would live on for another forty-nine years and acquire a lot more stones, he and his friends concurred in hindsight that this was the zenith of his collecting career. Huang selected ten crown jewels ("only those wrought of the finest stone *and* craftsmanship") of the collection, built a study to house them, and named it "Ten Inkstones." Thus he cemented a reputation in and beyond

Fujian.[85] Although acquaintances and strangers vied to view Huang's collection, few managed to set eyes on the ten crown jewels. Even more curiously, neither Huang nor his friends divulged the exact names or identities of the ten, other than that they were all Duan stones. Of the three so identified, one was named *The Ten Inkstone Studio* and its encomium appears in *Inkstone Chronicle*, but there is no clue about its design. The second, Gu Erniang's remake of Yuan painter Wu Zhen's stone, was known because of a casual remark by Xie Gumei. The name of the third, *Twelve Stars*, became public only after it was lost.[86] Such are the ironies of fame. Huang Ren sought to avoid exposure, and his friends were protective of his privacy. But the more secretive they were, the more his reputation spread.[87]

The *Twelve Stars* was gifted to Zhao Guolin (1673–1751), the most powerful official to enter into the orbit of the Fuzhou group. Zhao, a native of Shandong, was an energetic man with shrewd survival instincts that allowed him to assail waves of political intrigues in the court. By all accounts a capable and conscientious administrator, Zhao rose through the ranks quickly. He served as administrator of the Commission of Fujian Province (1727–1729), and then as the governor of Fujian (1730–1734). A known connoisseur of inkstones, he became intimate with the Fuzhou group and promoted their careers diligently. He hired Xie Gumei as an editor at the gazetteer bureau and later Xie garnered a promotion to the capital due to Zhao's recommendation. When the Yongzheng emperor's censors threw Yu Dian in jail for seditious writing, Zhao bailed him out. Yu gifted at least two inkstones to Zhao, complete with encomiums so effusive that they border on the obsequious. Years later, Zhao applied himself in editing Yu's collected works. The august governor took a particular liking to Lin Fuyun, bringing him to the capital when Zhao was promoted to grand secretary in 1739. Until Zhao's retirement in 1743, Lin stayed in Beijing and carved many encomiums for Zhao's inkstones, including one carved on a gourd-shaped gift stone to mark Zhao's retirement. Zhao expressed genuine regret that he failed to land Fuyun any desirable appointment before his departure.[88]

There is no reason to doubt that the "fellowship in stone" between Zhao and his protégés was not heartfelt. But the sheer disparity in bureaucratic rank and power means that these exchanges occurred in a different gift mode than the father-son or friend-friend exchanges described earlier. Instead of a gift of inkstone or encomium to repay (or to anticipate) a gift of the same, the exchanges between Zhao and Yu or Lin took the form of a gift of stone and encomium in return for political intervention. There is no record of Zhao as the giver of any inkstones to the Fuzhou group. Yu and Lin evidently considered their gift inkstones insignificant tokens of their sincere gratitude, and the fine line of civility and reciprocity is upheld. The line was crossed in the case of Huang Ren's "gift" of his *Twelve Stars*, which Huang privately decried as an act of "artful theft and/or outright snatching."[89]

Zhao was oblivious to Huang's seething anger, just as he seems oblivious to his own

overwhelming power, as those holding high positions often are. If he wasn't he would not have recounted the story in a long encomium that was carved onto the said stone by none other than Lin Fuyun. In 1733, the governor's son obtained an introduction to Huang and managed to "borrow for viewing" some of his stones. His father fell in love with the *Twelve Stars* and arranged to send Huang a birthday present in the form of silver ingots. Huang took the hint and "gifted" it to Zhao. It became the crown jewel of Zhao's collection.[90] But such is the complicated nature of fraught relationships like this that later, to congratulate Zhao's promotion, Huang dispatched a gift to Beijing without prompting, a Duan inkstone called *Cloud and Moon*, which is the name of Zhao's studio. Zhao composed an encomium in 1741 and had it carved on the stone, had a rubbing made of it and sent it as a return gift to Huang, who responded with a set of four poems.[91] Civility was restored, and the rounds of exchange now resembled a routine gift mode among scholars.

Huang Ren's loss brings out in clear relief the sad truth that embedded in the very forces that built bureaucratic careers—patronage networking—were forces of entropy that dissipated collections when one was the lesser party in an unequal power relationship. Since exposure incurs the danger of loss, there is no wonder that Huang and his friends refrained from broadcasting the contents of his collection. Lin Fuyun suffered an even more blatant theft when his family's crown jewel, the *Ursa Major* carved by Gu Erniang and used by Lin Ji during his time as a court scribe, was stolen by thieves from his premise shortly after Ji's death. Through some mysterious circumstances, it fell into the hands of a friend who returned it, to Fuyun's great relief.[92] It was at best a mixed blessing to have a famous stone. Loss and alienation are the flip side of fame. Yu Dian's ambivalence about fame is understandable in light of the predatory behavior that prevailed in both the gift and market registers. He went one step further, introducing a moralist discourse in his disapproval of female fame and praise of hermitic scholars who hid their writings (even as his retrieval brought them to light). Yet Yu Dian did not have trouble enjoying the recognition that attended his own growing fame as an encomium writer.[93]

So, wherein lies the difference between a collection and a pile of stones? A collection is made into a series by ranking—or at least identifying one or more crown jewels. But that judgment has to be accepted by connoisseurs outside the circle of a collector and his friends, who are powerful enough to gain access to the collection.[94] The fame of the collector and the quality of his collection enters into a duel with the eye of the outside authority. The crown jewels are pried away, their very alienability the strongest evidence for their superior quality. A collection, in this sense, is formed by contradictory logic and exists as a pristine set only in retrospect—the very act of social recognition sets the process of dispersal into motion. By the time the collection is recognized, the best has already been lost. It is this internal contradiction, and not just a rapacious market, that lies at the root of the pervasive nostalgia that plagued many a collector.

Fuzhou connoisseur Li Fu, a member of the second tier of the *Inkstone Chronicle* circle, articulates a sense of anticipatory nostalgia in a collector's seal he carved onto many of his inkstones: "Once it was kept at Li Lushan [Fu]'s place."

WHAT REMAINS

Acts of artful or blatant thefts exposed the fault lines in the more egalitarian gift mode, one premised on a concept of shared, collective ownership that undergirded the "fellowship in stone." I have argued that this attenuated sense of individual ownership contributed to the speed of the inkstones' alienability. Adding to the instability is a weak sense of the integrity or discreteness of an object as a thing in itself. A slippage between an inkstone and its assorted encomiums is, after all, the premise of *Inkstone Chronicle*. To capture this sense of dynamic relationship between things and people (both always in the plural), realized in a constant movement of interchanges, I propose "assemblage" as a more suitable term than collection. At the center of an assemblage is less a tangible inkstone than tangles of social relations.

But this emphasis on collective or shared ownership should not be carried too far. However obscured, the lines between personal and shared holdings did exist, as the distress caused by the thefts showed. In fact, it is the inherent contradiction between two coexisting regimes of ownership that lies at the heart of the dissipation of assemblages: an expansive regime of socialized ownership lubricated by voluntary gifts and a zero-sum regime of personal ownership made manifest by involuntary gifts and outright theft. In real life the distinctions are often hard to draw, based as they are on relative and subjective judgment; the transfer of Huang's *Twelve Stars*, for example, is a gift or purchase to Zhao but a theft to Huang. But the conceptual distinction is still useful to maintain in that it explains a paradox in the system: the forces that built an assemblage are the ones that would tear it apart. Inkstone assemblages are not only unstable but tend to be small in number, no more than a hundred even among the Fuzhou circle.[95]

Huang Ren managed to hold on to many of his inkstones, despite constant rumors that he had lost them all; he began to sell them off only toward the end of his very long life to make ends meet.[96] Although many of the Fuzhou collectors expressed hopes that their sons would inherit their inkstones, what remained was never an entire assemblage, only fragments of it. Nonetheless, in the final analysis, Huang Ren, the Lin brothers, Yu Dian, Xu Jun, Xie Gumei, You Shao'an, and other core members of the Fuzhou circle can be said to have passed on family heirlooms wrought of something less tangible but no less valuable—a family name, an expectation to succeed, a web of social connections in Suzhou and the capital that promised to open doors. The genealogy of Huang Ren's lineage, compiled by his two nephews who studied with him and completed in 1780, opens with a detailed description of a *Stone Field* inkstone bearing

Huang's seal that ended up in Emperor Qianlong's collection (see fig. 5.10). The descriptions take the form of an entry reproduced verbatim from the imperial inkstone catalogue completed in 1778.[97] An inkstone that was irrevocably lost to the family thus figured as its proudest heirloom.

Lin Fuyun managed to pass on the *Ursa Major* and other inkstones of emotional and artistic value to his sons. But for the Lin brothers and sons, their most substantive inheritance took the form of the embodied knowledge of calligraphy as well as its cognate skills of carving words on stone and copying book pages to be carved as printing blocks in vintage book productions (fig. 5.11). Lin Fuyun continued to thrive as a maker of inkstones and carver of encomiums after his father's passing. The model pages (*yang*) for the printing blocks of one of Huang Ren's poetry collections, *Slips of Fragrant Grass* (Xiangcao jian), were written by Fuyun's son Wan around 1766. When Yu Dian remarked, "The métier of the Lins of Guanglu Lane from one generation to the next is

calligraphy," it was no empty praise. A specialized craft was the Lins' most secure form of patrimonial goods and means of livelihood.[98]

Given the speed with which assemblages were formed and dispersed, words carved on stones signaled not permanence but anticipatory alienation. Whatever the legal concept of property, "ownership" of an inkstone was understood to be temporary and partial instead of absolute, more a graduated form of custodianship of varying time spans and degrees of emotional involvement. The artisan did not own the inkstone s/he made; artisan's marks connoted not authorship but the potential alienability of the stone, the fear that the embodied connection would soon be lost upon completion of the object. Collector seals and encomiums signaled more a one-time custodianship than ownership, with the fear, almost the expectation, that the stone would soon slip out of one's hands. The specter of uncarved encomiums, ink traces still fresh but the stone already lost, haunted the collector like unrequited love or homeless ghosts.

The more futile words become, the more faith is vested in them. Indeed, the remarkable degree to which "ownership" of art and objects of art is a function of literary production is a striking feature of the seventeenth and eighteenth centuries—whoever wrote about a thing "owned" it in perpetuity. Hence Ming collector Li Rihua habitually copied down the inscriptions of painting and calligraphic scrolls he did not or could not buy; it was a form of "owning" the art. Lin Ji's incessant copying of books was psychologically comforting because it was a form of collecting that could multiply indefinitely as long as his wrist was strong and his inkstone robust. When everything is alienable, writing and inscribing constitute the most agentic act and the most reliable relationship a man can form with a piece of stone.

Lin Zhengqing articulated the entanglements between stone, text, and a male literatus's desire for immortality in an encomium for one of his inkstones. Its name, *Ocean of Ink*, harkens back to the originary inkstone invented and used by the legendary cultural hero, the Yellow Emperor. It reads:

> Originating from the Yellow Emperor,
> Handed down without revision.
> Receptacle for a dollop of ink,
> Verily, a minor ocean.
> Essays to manage the world,
> Transmitted through ten million years.
> The stone and ink coagulating,
> This, is where "this culture of ours" coheres.[99]

In prefiguring the permanence of words on the unchanging format of the ink-slab, Lin announced a new conception of writing that can only be called materialist in nature. So, too, is his novel literary imagination of the coagulation of stone and ink (*shimo*

xiangnian). This curious phrase is no mere literary flourish; early Qing collectors believed that when the ink-cake rubs against the surface of the inkstone, a streak of stone dust is worn off and mixed in with the ink.[100] In this material fact of the corrosion of stone, Lin Zhengqing staked his hopes for the permanence of male public writing.

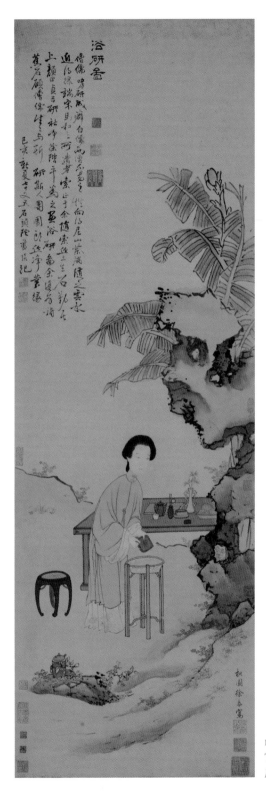

FIG. E.3. Lan Ying (1585–ca. 1668) and Xu Tai (fl. seventeenth century), *Washing the Inkstone*, 138 × 45 cm. Tianjin Museum.

Epilogue

THE CRAFT OF *WEN*

M ANY OF THE INKSTONE ENCOMIUMS THE FUZHOU COLLECTORS wrote are cast in a modern free form, alternating between rhymed prose, unmetered, and metered verse. The studious Xie Gumei, however, reminded his readers that both the format and style of the genre was steeped in tradition: "To inscribe an encomium [*ming* 銘] is to make one's name [*ming* 名] known. The ancients inscribed encomiums on sacrificial vessels to admonish themselves." The original mediums for encomiums were bronze sacrificial vessels from antiquity such as the basin from the Shang and the tripod from the Zhou. Xie went on to outline the codification of the genre in the Spring and Autumn period, beginning with an encomium celebrating Wei's vanquishing of the kingdom of Xing in 635 BCE. The development of the genre culminated in historian Ban Gu's encomium, carved on a stone stele on Mount Yanran (Hangayn Nuruu in modern Mongolia), to mark the victory of the Han empire over its archenemy the Xiongnu in 89 CE.[1]

The bloodthirsty military exploits and chest-thumping victory rituals that gave rise to the encomium as a public genre had little bearing on the private ambitions and pleasures of the Fuzhou collectors. But Xie Gumei's history illuminates one significant aspect of *Inkstone Chronicle* that has been hidden in plain sight until now: the innovative sleight of hand that made inkstones, not bronze vessels and steles, the medium for encomiums. The Chinese language is an accomplice; the word "stone" (*shi*) can refer to inkstone, stele, and even serve as a short form for "metal and stone," a field of knowledge commonly rendered epigraphy. But the conflation of inkstones, bronzes, and steles that characterizes the Fuzhou collector's scholastic and artistic practices runs deeper than semantics.[2]

Lin Ji, Huang Ren, and Xie Gumei inherited rubbings of antique scripts originally carved on steles. They, along with Ji's sons Zhengqing and Fuyun, bought, exchanged,

and studied rubbings taken from famous steles or inscriptions on cliffs as the basis of their calligraphic and scholastic practices. In so doing, they partook in the antiquarian trend, an emergent force in the intellectual and artistic worlds since the late Ming period in the seventeenth century. By the second half of the eighteenth century, the transition of what Benjamin Elman terms "from philosophy to philology" was complete. The larger history of this turn to evidential or exact scholarship lies outside the temporal and topical scope of the present study. My modest goal in this chapter is to advance a hypothesis, that the Fuzhou collectors' contribution to this larger development is rooted not in their textual studies, but in their craftsman-like approach to writing and knowledge. Taken as a whole, the material and textual outputs of the Fuzhou circle, in the form of carved inkstones, calligraphic scrolls, and encomiums collected in *Inkstone Chronicle*, manifest an episteme, nascent since the late Ming, that construes classical scholarship ("theory") and textual production ("writing") as material and embodied practices ("making"). I term this episteme "the craft of *wen*" (word, writing, male literati culture).

There are tantalizing personal connections between the Fuzhou scholars and the core community of early Qing evidential scholars in Jiangnan. Among the scholars who contributed endorsements to *Inkstone Chronicle* was the young Qian Daxin (1728–1804), a phonologist and etymologist who would become one of the most prominent figures in Han Learning.[3] An even more direct connection is Lin Ji, who studied briefly with the Suzhou classicist Wang Wan (1624–1691), an early proponent of the Plain Learning school of evidential scholarship. Wang's longtime disciple Hui Zhouti (1691 metropolitan graduate) was the grandfather of Hui Dong (1697–1758), who would become a seminal leader of Han Learning in Suzhou. When Lin Ji bid his teacher farewell on the eve of returning to Fuzhou in the late winter of 1690/91, Wang gifted him a poem that includes the line, "My humble Plain Learning awaits your transmission." The flattered Lin named the studio he later built in his Fuzhou home Plain Learning (*Puxuezhai*), its title plaque written in Wang's hand.[4] Both Han Learning and Plain Learning were forerunners of the evidential or philological scholarship that became dominant several decades after Lin Ji's death.

Wang Wan's high hopes for Lin Ji to transmit Plain Learning to Fujian were not met. Or, to be exact, they were met not in the conventional venues of academic instructions and treatises but in the unlikely venue of artisanal practice. In her brilliant revisionist study of late Ming scholar Song Yingxing's *The Work of Heaven and the Inception of Things*, Dagmar Schäfer has shown that Song's efforts were more a form of colonizing than innocent promotion of artisanal knowledge; Song sought to subsume the craftsmen's knowledge in divergent fields under a unified Confucian framework of moral philosophy. Lin Ji and the Fuzhou circle exhibited a second and to my mind more radical approach to artisanal knowledge. They concentrated on one field, stone carving. Instead of writing or theorizing about it, they sought to embody it by taking

up the métier of the craftsman in everyday practice. In so doing, they brought together disparate fields of knowledge and practice, from epigraphy, calligraphy, painting, seal carving, and inkstone making to book printing. In their embodied practice, albeit not in the world at large, the lines between the scholar and the craftsman, as well as distinctions between thinking/knowing and making, ceased to be meaningful.

THE MATERIAL CRAFT OF *WEN*

Lin Ji epitomizes this vision of epigraphic scholarship and writing as irreducibly embodied material craft. In the 1733 afterword for *Inkstone Chronicle*, his son Fuyun located the genesis of the book and of this episteme in the epigraphic collection of his grandfather Lin Sun in the Lychee and Water Manor, where the young Lin Ji received instruction alongside his friend Yu Dian from the elder. The availability of this trove cemented their epigraphic approach to calligraphy without giving up the conventional approach of learning from Jin-Tang model books. "His calligraphy emulated the style of Jin and Tang, and he applied himself to the analysis of the origins and evolutions of the [antique] seal and clerical scripts."[5]

Unlike most scholars of his day, however, Lin Ji wielded a writing brush in one hand and a carving knife in the other. He reasoned: "Unless one is deeply knowledgeable with the history of scripts [*zixue*] and the way of the carving knife [*daofa*], how can one ever hope to etch [one's writings] on metal and stone, thus transmitting them to posterity?"[6] Then follows Fuyun's recollection of the tutelage of inkstone carvers Yang Zhongyi and Dongyi at his father's studio, recounted in chapter 4 in the context of the artisans' training. In Lin's mind, inkstone carving, like copying manuscript pages and carving printing blocks, is integral to scholarship because stones and blocks are the essential media of the transmission of culture and learning. The medium, Lin insisted, is inseparable from the message.[7]

Persistent and painstaking embodied practice is Lin Ji's way of insinuating himself into intellectual lineages and patronage networks. The pages that Lin wrote out with his brush, stroke by stroke and line by line, as the model for the printing blocks of the posthumous works of his teacher Wang Wan, represent Lin's early efforts to put his convictions into practice. He finished writing out the fifty chapters, totaling about 362,500 words, in twenty months and in two disparate locations: an average of 600 words per day without figuring in time needed for travel or rest. Three similar projects for two other powerful patrons drove Lin Ji to exhaustion (see fig. 5.11).[8] Lin's subsequent career as a court scribe was the outcome, not the cause, of this episteme, which he personified and taught to his sons and neighbors. The engagement of scholar-calligraphers to write the models for printing blocks that were subsequently carved by named artisans was a new fashion for private publishing in the early Qing. This collaboration of calligraphers and carving experts produced a number of exquisite books, of which Lin Ji's were

often-cited exemplars. Such emphasis on the craft of reproducing words, in turn, was part of a larger attentiveness toward collecting, collating, and annotating ancient and modern texts integral to the epistemological shift toward evidential scholarship.[9]

Besides knowledge about stones and ancient scripts, in Lin Ji's prose writings he also exhibited familiarity with building and facture, from surveying the land to configuring the orientation of houses. The considerable number of essays he crafted about the construction of his studios, the desired orientation of the Lin ancestral grave, and various building projects that he did not live to complete, attests to his attention to concrete details and conversance with some technical vocabulary. These essays, complements to his inkstone encomiums, reveal that Lin Ji adopted a craftsman's attitude toward writing, calligraphy, fengshui siting, design, and building. He cared about craft, submitted to strenuous regimens to hone his skills, was conversant with the technical language and materials, and partook in the actual process of making.[10]

As teacher to his sons and the younger generation of the Fuzhou group, Lin Ji instilled this hands-on approach, along with respect for craft and artisans, within the wider circle of scholars and students in Fujian. Not only did the accumulation of major collections of modern Duan and She inkstones in Fuzhou augment the knowledge base in the southeastern edge of the empire, they also initiated a trend of requesting well-known local writers to compose encomiums besides writing encomiums of one's own. Huang Ren described the symbiosis between words and stone: "A mere piece of stone, vying to be ranked and commented on, / Unless it is being inscribed on [by a famous person] it is nothing extraordinary."[11] An inkstone was considered naked without the embellishment of *wen*, in the form of encomiums carved on its back and sides.

Thus carved, the inkstone literally took the function of both stele and printing block, as the physical medium for the dissemination of epigraphic and literary knowledge. Huang Ren praised Yu Dian for heralding a trend in Fuzhou, where all manners of people desired his encomiums, and once the words were carved onto the inkstone, "In just the right size, people vie to make rubbings, / Sawing off a slab of inscriptions on cliffs to take it home." Yu Dian lamented his misfortune when a newly bought inkstone of his, with a freshly carved encomium from the hand of Lin Fuyun, fell victim to his own celebrity. So many people asked to borrow it to make a rubbing of the calligraphy that the inkstone, already thin in the body, broke and could not be used again.[12] On one of his inkstones, Huang Ren had two short passages carved in the ancient "stone drum" script, the study of which grew popular in the early Qing due to the personal interest of Emperor Kangxi. Huang's inkstone was likely a handy model for local students who desired rudimentary knowledge about the stone drum or big seal scripts.[13]

The prevalent practice of "borrowing [inkstones] to make a rubbing" thus opens our eyes to a form of small- or short-loop circulation of knowledge at the vernacular level, among the poor, the young, or people on the fringes of the literary world who were not well-connected enough to gain access to actual rubbings of ancient steles. Al-

though inconclusive, there is scattered evidence suggesting that earlier versions of *Ink-stone Chronicle*, no longer extant, were wrought of rubbings of the inkstones themselves and that some students were advised to study and copy the volume as a calligraphic model-book.[14]

Without exaggerating the marginality of Lin Ji and the rest of the Fuzhou circle, it is important to recognize that the episteme of *wen*-as-craft they espoused was a radical, minority practice associated with a certain degree of cultural and geographical marginality in the early eighteenth century. Although the majority of the Fuzhou core hailed from families of means, earned the highest degree, and travelled frequently to the Jiangnan heartland and the capital, they were acutely aware of their provinciality. Lin Ji, for one, complained bitterly about his hampered access to rare books in Fujian. One may think of their passionate advocacy of modern inkstones on the basis of superior craftsmanship as an ingenious way of turning a necessity into a virtue: they could not afford to compete with the metropolitan families, the emperor's favorite officials, and newly rich merchants for antique inkstones from the Tang and Song dynasties.

JIN NONG AND GAO FENGHAN

A brief comparison of the encomiums and material craft of the Fuzhou group with that of another marginalized scholar, painter, and inkstone-maker from Shandong, Gao Fenghan (1683–1749), is instructive on this and other scores. Gao, along with the Yangzhou-based painter Jin Nong (1687–1763), were two other contemporaries who compiled the encomiums they wrote into volumes. The Lin brothers prevailed upon both to contribute endorsements for *Chronicle*, thereby enlisting them in the fringe group of the Fuzhou circle. Jin, a scholar-turned-painter who studied epigraphy from He Zhuo, narrated in an unhurried voice: "For thirty years my biggest addiction has been inkstones. Wherever my shoes take me, I wrote rhymed prose to rank and authenticate [*pinding*] [the inkstones I viewed]. They have numbered over a hundred; seven out of ten are encomiums written for others and three out of ten are for myself. These have been committed to print." The blocks for the volume, *Inkstone Encomiums from Dongxin's Studio* (Dongxinzhai yanming), was carved in late 1733.[15] A close friend and neighbor of seal artist and calligrapher Ding Jing (1695–1765), Jin Nong also carved seals, and is said to have carved inkstones to supplement his livelihood.

If Jin Nong sounds genial but distant in his endorsement of *Chronicle*, Gao Fenghan's is riddled with anxiety about being upstaged. He begins by stating his own grandiose intentions of compiling an "inkstone chronicle" according to the genres of historical narratives established by Han grand historian Sima Qian so that he could "make public [his collections] to those who love antiquities as much as I do." In his own telling, Gao had made close to a hundred inkstones from various kinds of stone and fired sieved clay, wrote and carved encomiums on them, and made rubbings of his creations, which

FIG. E.1. Jin Nong, two pages from *Album of Inkstone Encomiums Handwritten by Jin Nong* (Jin Nong shu yanming ze). One, entitled "Encomiums for *Mouth* inkstone, written for my wife [lit., inner person]," reads in part: "No [prattling with] a long tongue, / No showing of teeth. / Such is a fitting inkstone for the boudoir." 22 × 13.5 cm. Guangdong Museum.

he bound into volumes. He took care to make pictures of twelve stones that were particularly splendid to ensure their preservation. As he indulged his passion, Gao claimed, "I became oblivious to other pleasures, nor did I care if there were other inkstone lovers in this world. Seeing this volume from Taofang [Fuyun's studio], I was so startled that I lost my stride."[16]

The twelve pictures did not survive. When Gao died, he left representations of 165 of his inkstones, including 112 rubbings, bound in four accordion-style volumes. Over a century after Gao's death, a succession of artisans made reproductions of these rubbings out of carved stone and wood blocks. Eventually published under the title of *Inkstone Chronicle* (henceforth "Gao's *Chronicle*" to avoid confusion), they became the most famous document of inkstone making and collecting from the eighteenth century, surpassing in renown the Fuzhou volume by the same name, which was not published until the twentieth century.[17]

The subject positions and social trajectories of Jin Nong and Gao Fenghan are similar, despite their geographical remove: Jin was a native of Hangzhou in the lower Yangzi heartland, whereas Gao's domicile was in remote Laizhou, Shandong, at the northeastern edge of the empire. Jin never captured any degree. Gao earned the lowest degree of cultivated talent (which made him eligible to sit in provincial exams) and served as substitute county magistrate in several locales on recommendation, but higher honors and secure appointments eluded him. Both traveled widely in the empire, in search of patrons and employment, and it was when they both sojourned in Yangzhou (1737–1741), the home of the richest merchants and art patrons in the empire, that they befriended each other. Jin Nong became one of the most important painters of the eighteenth century. Gao, too, secured his place in history as a prolific painter, calligrapher, and inkstone maker.

Modern scholars are likely to classify Jin Nong and Gao Fenghan as painters and artists, subjects of analysis in art history, in opposition to the Fuzhou group of scholar-officials, the subjects of intellectual and social history. These labels mandated by modern disciplinary boundaries, however, obscure both the differences *and* similarities among them. The most substantial difference between Jin and Gao on the one hand and the Fuzhou group on the other is not that the former painted whereas the latter studied books, but it lies in the metropolitan graduate degree attached to the curriculum vitae of many of the latter. Their social posturing as a scholar was thus more believable, although ultimately the degree did not make significant difference in terms of career advancement.

In spite of this difference in credentials, the day-to-day activities of the "painter-artists" and "scholars" were remarkably similar: incessant traveling, network-building, poetry-writing, painting, inscribing colophons on paintings, collecting rubbings and stones, research in ancient scripts on rubbings, calligraphy writing in ancient and invented modern scripts, composing encomiums, carving stones, and the constant worrying about money. This cluster of activities, I suggest, are the mundane manifestations of the episteme of "the craft of *wen*" described in abstract terms earlier. The epistemological shift toward evidential scholarship was not the work of such philologists as Hui Dong, Qian Daxin, and other academicians in the metropolitan areas in Jiangnan, Shanxi, Beijing, and Guangdong alone. The circulation of stones and ancient scripts in multiple short loops in artistic studios and remote local places was an integral albeit overlooked aspect of this process.

There do exist significant differences in craft practice between Gao and the Fuzhou group. Although both the Fuzhou *Inkstone Chronicle* and Gao's *Chronicle* are compilations of handwritten and hand-carved encomiums on inkstones, they diverge in format and intent, and they evince two distinct modes of entanglements between the artisanal hand, writing, and stone. Gao was the head of an efficient workshop, supervising a team that turned out a large number of inkstones that were marketed as one-off items from

FIG. E.2. "Inkstone made by the *jia* [house/workshop] of Gu Qingniang." Gao Fenghan, who wrote this inscription in 1738, did not divulge the basis of his attributing this stone to Gu Qingniang, a variant of Gu Erniang. Ink rubbing of face, diameter 14.2 cm. From Gao Fenghan, *Yanshi*, 264.

the hands of a master, no different from the promotion of his paintings and calligraphy. He trained his son, grandson, and nephew as apprentices in calligraphy and carving words.[18] They helped with the mundane tasks but the artistic vision is uniquely Gao's. His is both a vertically integrated enterprise and a one-man show of Gao Fenghan the virtuoso artist. Lin Ji, Lin Fuyun, and Yu Dian may appear craftsman-like relative to mainstream scholars who continued to regard composition as disembodied, mental exercises. When compared to Gao Fenghan, however, they were "boutique" connoisseurs who procured exquisite Duan or She stones from named quarries, stayed up all night to think up the most appropriate encomiums, and spared neither time nor effort to have them carved onto the stones.

The pages of Gao's *Chronicle* are bursting with his irrepressible energy and prolific output: he bought cheap stones or picked them up off the streets; he chiseled them into awkward shapes; he etched the encomiums in oddly sized scripts on impulse (fig. E.2). Then he sold or gave the inkstones away. Gao Fenghan was poor and often sick, and this was no "artist" persona. His meager economic resources impacted his art and his craft. He did not carve a lot of Duan stones, preferring the cheaper baked sieved-clay blocks

bought wholesale from vendors from Tongzhou.[19] To economize, he sliced a thick Duan inkstone cross-wise and made two thinner inkstones out of it (106). Gao was a consummate tinkerer who could not rest even after his right arm was paralyzed by a stroke, reducing him to using his left hand to write, paint, chisel, and carve. Bothered by an empty seal box gathering dust, he was delighted that one inkstone scrap was about the same size so he fashioned it into a seal fitted to the box (286).

Gao took pride in utilizing humble materials, identifying hidden treasures, or turning natural defects on stones into virtues.[20] Sometimes it was his superior carving skills that turned a leftover stone into a masterpiece (126), or his discerning eye that identified an unimpressive looking stone, bought from a minor shop attendant in Chang Gate, Suzhou, as being verily a Mi Fu (38). Once he caught from the corner of his eye a glistening purple stone peeking from a pile of rags in a vendor's basket on the streets of Nanjing. The inkstone turned out to be extremely sharp and thus suited for executing large-sized paintings that require ample ink; it "yielded" more than several hundred large paintings without retooling (70). The prolificacy of the artist is grounded in the material fecundity of his stone, and it was not beneath Gao Fenghan to account for the productivity of both in terms of quantifiable output.

The description of his sharp Nanjing stone was but one of many instances whereby Gao wrote about his art-making with a mindfulness about measurement, duration of time, and repetition that is characteristic of a craftsman. In an even more graphic example, he recounted how a common stone he bought in a Huizhou market ended up accompanying him on the road for almost ten years, producing bushels upon bushels of ink. He (and the stone) worked so hard that the surface of the thick slab was worn down to the shape of a hollow bowl: it had become a mortar (66). Gao later found poetic justice in the inverse when, in writing a gigantic sign for a client, he had to "draw ink from several inkstones, amounting to over three bushels [shi]." So much ink was needed that none of the usual receptacles was big enough, but Gao solved the problem by commandeering his medicinal mortar, effectively turning the latter into an inkstone (206).

The difference between the Fuzhou group and Gao Fenghan is thus a matter of temperament, resources, and aspirations. Gao saw the various aspects of his art—poetry, painting, calligraphy, and stone-carving—as an integral whole, all evidence of his irrepressible creative genius. For Lin Fuyun, the poised and finely etched words of his encomiums bore witness to the scholarly pedigree of his family and native place. Their tastes in inkstones, too, could not have been more different in material and style. In his attitudes toward material craft, Gao was an "artisan-scholar" whereas Lin was a "scholar-artisan," the subtle difference of which will be expounded on shortly.

It is important to emphasize that they partook in the same cultural and intellectual milieu of the early Qing world. Above all, both Gao Fenghan and the Fuzhou collectors evince a relentless love for modern stones and a boundless faith in the creative capacity and skills of the modern craftsman, especially themselves. In a world animated by com-

mercial wealth and where quotidian life is studded with possibilities of new discoveries, "how can old things ever hope to hold our fancy?" (to return to a quote from Yu Dian). Antiquarianism—the insistence that the past can be known only through the vigorous, critical lens of the present—is paradoxically the most modern intellectual and artistic impulse of all.

FROM SCHOLAR-OFFICIAL TO SCHOLAR-ARTISAN

In describing the inkstone collecting activities of the Fuzhou group, I have emphasized such subjective factors as the structure of desires and emotional investments in stones. I have also sought to depict the formation of a market in the inkstone as a collectible item and to discern the standards of value guiding the former. I have refrained from using the common explanation that amassing a collection enhances one's "status" in the competitive intellectual and commercial worlds of the seventeenth and eighteenth centuries, however truthful this statement might be. I have opted to tackle the issue of status last, because status is no longer a given attribute, and the static picture of some collector climbing the social ladder the rungs of which were known and predetermined misses the most important part of the story: how inkstone collecting and the material knowledge required to succeed allowed one to negotiate a new elite male subjectivity.

The most visible sign of trouble in the status system was the disintegration of the label of "scholar" as a coherent entity. The first wave of change was spearheaded by the growing intellectual and cultural sophistication of merchants. Merchants amassed enormous wealth after the integration of China into the global trading network in the early seventeenth century. The attendant development of silk, cotton, and ceramic manufacturing, among others industries, as well as regional economies of cash crops wreaked havoc in the agrarian social order down to the lowest levels of society. As merchants became richer, they turned to pursue scholarship; as scholars were drawn into a cash economy, building publishing enterprises or peddling exam guides, they had to be even more adamant in proclaiming their insulation from commerce to validate their claims of moral superiority. But rhetoric notwithstanding, by the seventeenth century "Confucian merchants" had emerged as the most visible sign of a de facto accommodation between scholarship and commerce. The new label of *tongren* (knowledgeable man, literally, "man who connects/knows") described a class of highly educated scholars and collectors from Huizhou merchant families (it no longer seems apt to call them merchants) who became arbiters of intellectual and artistic tastes in the eighteenth century. One salient example is the bibliophile and connoisseur of seals Wang Qishu (1728–1799).[21]

The second wave of change in the order of things entailed the elevation of artisanal knowledge that made inroads into all levels of society in the early Qing, in count-

er-distinction to the official exam curriculum based on moral philosophy and intuitive learning. It is important to emphasize that this change was a one-way street: scholars (or people intent on becoming scholars) taking up a profession as carvers of stone or makers of things. Unlike the rise of merchants, the reshaping of the scholarly identity did not entail the success of craftsmen in insinuating themselves into the scholarly world. No Chinese scholar, however respectful of material crafts in practice, went as far as the bondservant Tang Ying's unabashed self-identification with the craftsman in assuming the "mind of the potter."

The elevation of artisanal knowledge thus had the ironic social effect of further obscuring the artisans and a hardening of status differentials between the scholars and those unlettered stoneworkers in the quarries. In chapter 4 we saw how a group of Fuzhou carvers—Dong Cangmen, Yang Dongyi, Xie Ruqi—became "artisan-scholars" who straddled two previously disparate worlds. They abandoned the exam career to take up stone carving professionally, incorporated seal carving techniques to develop a Fuzhou style of inkstone making, and thus made a name for themselves in scattered regions of the empire. I call them *artisan*-scholars to highlight the fact that their fame, métier, and livelihood were rooted in their craft skills.[22] Scholarship mattered to the extent that since the late Ming, a degree of classical learning was considered advantageous if not indispensable to the skill sets of a seal or inkstone carver.

In their emphasis on skills and dependence on material craft for livelihood, not to mention their meager or nonexistent exam success, Jin Nong and Gao Fenghan were kindred to these artisan-scholars. But artists and painters like them had to try doubly hard in the game of social posturing so that their output would be appreciated and enter critical discourse as *literati* painting. Jin Nong sought to be remembered by the inkstone encomiums he wrote, like a scholar, and not by the inkstones he carved and sold. Gao made rubbings of the inkstones he made, but he presented them as tokens of his creative genius and not as manuals for training apprentices.

The group of Fuzhou collectors represented in *Inkstone Chronicle* were equally conversant with the properties of stones and many were highly skilled in wielding the carving knife, but their *social and cultural postures* were different: they did not give up the pretension that their vocation was classical learning. The most important prerequisite for this claim was independent economic means to sustain a scholar's lifestyle. These commonly took the form of family land holdings, such informal or extrabureaucratic jobs as private teaching, editing, and personal assistantship (all competitive jobs that required connections and cultural capital to acquire), or, in a pinch, family heirlooms to sell off. Some aspirant scholars eventually succeeded in scaling the official ladder; others served only briefly before being forced to retire; yet others never made it but hoped that their sons would succeed. Having a skilled hand in calligraphy and stone carving, not to mention a famed inkstone collection, could help a scholar and his sons garner notice in the competitive marketplace for talent.

The conventional name for this group of people is scholar-official, in honor of the Confucian adage that becoming an official is the ultimate goal of scholarship.[23] But the Manchu's discriminatory policies as well as the sheer growth in eligible candidates conspired to make office-holding a pipedream for the majority of educated men in the early Qing, not to mention that political persecutions made it treacherous for the chosen few. The surfeit of wealth from trade and manufacturing that circulated in society also allowed more scholars to opt out of officialdom, contributing further to the splintering of scholar and official.[24]

To reflect these new political and economic realities, and to more accurately describe the intellectual orientation and everyday preoccupation of the Fuzhou scholars, especially the Lin brothers and sons, I propose the new label of *scholar*-artisans. The difference between the artisan-scholar and the scholar-artisan is subjective and subtle, but the consequences are real. Social status, or the status distinction between scholar and artisan to be exact, has become largely a matter of performance, posturing, and self-claims that are subject to social perception and judgment. Those who succeed in being known as more scholar than craftsman are those who can summon enough economic and cultural capital to substantiate the claim. The objective forces that contribute to the rise of both groups are one and the same—the circulation of technocratic culture in loops of various lengths and reach, making inroads even into the world of epigraphy and classical scholarship.

To correct the teleological master-narrative of the scientific revolution in Europe as a purposeful march toward modernity propelled by the genius of inventions, historians of science have painted a more nuanced picture under the rubric "vernacular science," paying special attention to local networks of knowledge production and transmission—what they call "distributed cognition" or "distributed knowledge." In the sixteenth century, a new philosophy or "artisanal epistemology" was formulated in artisanal workshops across Europe, a precursor to the scientific revolution in the seventeenth century. For artisans, the experience of things was bound up with the experience of their bodies.[25] The scientific revolution in Europe no longer appears to be entirely, or even fundamentally, the work of individual genius: knowledge was created socially and collectively. Such invention did not involve radical *ex novo* breakthroughs, but rather the reconfiguration of existing stores of knowledge.[26]

Could it be the case that the episteme of the craft of *wen*—practiced by Gu Erniang in Zhuanzhu Lane, Suzhou; Lin Fuyun, the Yang brothers, and Xie Ruqi in Fuzhou; the unnamed carvers in Guangdong; Liu Yuan and others recruited to the Imperial Workshops in the early decades of the eighteenth century—established the parameters of corporeal and material experience needed for evidential scholarship to be thinkable, thus anticipating its flowering in the Qianlong and Jiaqing periods, much as the sixteenth-century artisans laid the groundwork for the theoretical turn of the scientific

revolution in Europe? On this, the stones fall silent. For this hypothesis to stand, future scholars will have to substantiate it, wielding the carving knife in one hand and the computer keyboard in the other, coaxing the stones to yield up more of their secrets.

GENDER AND THE CRAFT OF *WEN*

If a common pool of craft skills—the craft of *wen*—shared by some scholars and artisans facilitates the coming together of the subject positions of scholar and craftsman, thus troubling the workings of class or status, the impact of skills on the entrenched gender hierarchy in society is less perceptible. To understand why this is so, Jacob Eyferth's formulation of a paradox in the location of skills is helpful. Craft skills, Eyferth reminds us, are at once embodied by the individual craftsman and socially embedded, distributed, and transmitted.[27] The same is in fact even truer for the skills of the scholar. The body is the sine qua non of the Chinese scholar's training and métier, be it the ability to memorize the classics by recitation, grasping the subtle meanings of the commentaries, wielding the writing brush by suspending the wrist above the desk, eyeing the right consistency of the ink, or imbuing poetic diction and rhymes. The identification of scholars as "those who labor [only] with their brain," to return to Mencius, is thus empirically unsound. Scholarship *is* a material craft.

Their substantial differences in lifestyle, habits, rhythms of work, and remuneration notwithstanding, Chinese scholars were craftsmen in practice if not in name and self-image. In spite of, or perhaps because of, this de facto proximity, scholars had an axe to grind in downplaying the materiality of their output (manuscripts, books, painting scrolls, and album leafs) as well as gainsaying their vital dependence on powerful patrons and money, thus drawing an ideological distinction between themselves and the craftsmen (as well as the merchant). This anxiety lies at the root of the denigration of craftsmen in the writings of scholars in Chinese history.

As such, the psychological origin of discrimination in class or status is no different from that in gender. The elite man's belittling of woman as by nature "difficult to manage" and inferior in ritual position has to be understood as a veiled acknowledgment of her *indispensable* presence in everything dear and essential to his life: mother of his patriline, preparer of his meals and libations, maker of his clothes and shoes, and gratifier of his erotic needs.[28] The persistent identifications of the material pursuits of *wen*—books and inkstone-collecting—as masculine in nature are ideological assertions. However empirically unsound, this fiction has to be reiterated all the more in an age when the first teachers of most educated men were their literate mothers, when women artists sold their paintings to support their men, and when women wrote, edited, and published books in substantial numbers—what else would they have used if not inkstones? In an age when romantic men vied to collect inkstones used by famous women writers and artists, the extent to which women themselves remained invisible

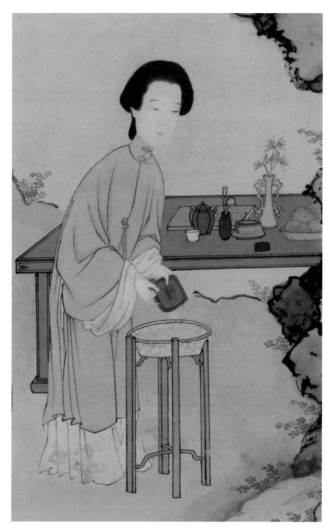

FIG. E.3. In this rare depiction of a lady washing an inkstone, the artists pictured her alone in a garden; on her desk are a pot of tea, a tea cup, a book, a sprig of flowers in a vase, and a plate of fruit. They evoke the privileged leisure of the male connoisseur. Lan Ying (1585–ca. 1668) and Xu Tai (fl. seventeenth century), *Washing the Inkstone*, detail, 138 × 45 cm. Tianjin Museum.

as users and collectors of inkstones is indeed surprising. Even Huang Ren had trouble admitting his wife and daughters into his inkstone-loving club because there was no historical or linguistic precedence for it.

The second half of Eyferth's assertion, that craft skills are socially embedded, highlights the importance of personal networks as a veritable form of knowledge/power that inherently disadvantaged women. Sheer access to information, be it in the form of antique rubbings, rare books and manuscripts, master paintings, or a collection of inkstones, is contingent upon gender as much as class. Before the age of public libraries or museums, the ability to own, borrow, view, or hear about any and every scrap of paper and every shard of stone was a privilege calibrated by the width and breadth of one's social network. It was by controlling access to their books and things that elite men

perpetuated their superior position at the expense of men from poor families or inaccessible places and all women, barred as they were from the old boys' networks. The knowledge/power of the scholar and connoisseur, like his craft practice, was material and social in nature.

The world of the craft trades was more of a meritocracy than the world of scholarship, although the former was not immune to the gender bias prevalent in society of which it is a part. Trained in the textile arts and other material crafts such as pickling and husbandry at home, women constituted a source of skilled and inexpensive labor for home-based and commercial manufacture throughout the empire in the Qing.[29] In contrast to inkstone collecting, the carving of inkstones was not thought of as an inherently male undertaking. The stoneworker households in Yellow Hill have been known to entrust the carving to their wives and daughters, whose work found their way to the desks of millions of students in the empire. Identified in writing since the sixteenth century as "the female hands of Yellow Hill," they are said to have numbered "five hundred," which should be taken to mean "a substantial number."[30]

As the only named female professional in the high-end inkstone trade in the early Qing, Gu Erniang was a peerless woman and a singular phenomenon. The respect she garnered on the basis of her superior artistry from her Fuzhou patrons and fellow male carvers—a measure of the latter's esteem for craft skills—signaled the dawning of a new world in which a woman was evaluated by her abilities, rather than her appearance or procreative functions. The behavior of other male scholars, such as the editors of the official history who allowed her only the role of a placeholder in the genealogy of the Gu house, serves as a sobering reminder that entrenched gender bias could not be changed by the work of one woman alone, however remarkable she might have been.

Appendix 1

INKSTONES MADE BY GU ERNIANG MENTIONED
IN TEXTUAL SOURCES CONTEMPORARY TO GU

(Translations given only for those encomiums pertinent to Gu Erniang)

APPROXIMATE DATES KNOWN

1. *Zhao Songxue's [Mengfu]* inkstone 趙松雪研 (*Yanshi* A), *Dugu's* inkstone 獨孤硯
(*Yanshi* C)
 Date: Late autumn, 1700
 Patron: Lin Ji
 Place of Commission: Suzhou
 Stone: Top-quality She
 Inscriptions: (Back?) Encomium by Zhao Mengfu, dated eighteenth day, third
 month, 1309:
 余將北行, 獨孤長老攜此石見惠, 感其情契, 俟他日乞歸, 與結山林緣, 暢敘幽
 情, 以娛暮景, 信可樂也 (至大二年三月十八日, 孟頫識於清河舟中, 行書,
 長印: 子昂)
 (Left side): Encomium by Wen Zhengming, dated fifth day, tenth month, 1539:
 嘉靖己亥十月五日, 忽有人持此石來觀, 把玩恍然若失者累日, 因傾貲購得之,
 真希世寶也 (楷書, 印: 徵明)
 (Right side): Encomium by Xiang Yuanbian: 墨林山人項元汴家藏真賞
 Other Information: Note by Lin Ji
 "In late autumn of the year *gengchen* [1700], I passed through Suzhou on my
 way home from the capital. Docking at Chang Gate, I procured [this stone]
 from Mr. Tang of Taohuawu. I love the warm, soft, and tender qualities of this
 stone—it is a She stone of a superior grade. The dedicatory words of Songxue
 Weng [Zhao Mengfu] are written in brush strokes full of life and vitality. It is
 as precious as the fabled uncut jade of He. Unhappy with the tiny water pool

and the tight ink pool, I gave the inkstone to Gu Dagu for her to enlarge these surfaces, and she changed its appearance instantly. (Note by Luyuan, Ji, regular script.)"

庚辰秋杪歸自京師, 過吳下, 停舟閶門, 得於桃花塢之湯氏, 愛其石質溫膩, 歟之上品, 松雪翁跋語, 筆法生氣奕奕, 珍同和璞, 微嫌開池小而墨堂狹, 因付顧大家廓而大之, 頓改舊觀 (鹿原佶識, 楷書)

References: *Yanshi* C7.2a, A7.1b

2. *Supreme Simplicity* (a.k.a. *Banana White*) inkstone 蕉白硯; 太樸不雕研 (*Yanshi* A2.3a)

Date: Tenth month, 1709

Patron: Yu Dian

Place of Commission: Suzhou

Stone: Duan with banana white marking

Inscriptions: Encomium (carved) by Yu Dian:

"Red spiral marks faintly visible through the banana leaf patch, / Supreme simplicity, without carving, an extraordinary fragrance. / Treasure it—count on it to bolster our camp."

蕉白隱現朱螺文, 大樸不雕含奇芬, 寶此可以張吾軍

Other Information: Note by Yu Dian

"In winter, the tenth month of the year *jichou* [1709], I was sojourning in Suzhou when Gu Daniang/Dagu [*Yanshi* A has both words; in *Yanshi* C, *niang* was crossed out and *gu* inserted; *Yanshi* B uses Gu Dagu] made this inkstone for me. The three-line encomium I prevailed upon Mr. He Qizhan [Zhuo] to render in his hand, and the word carver was someone whom he approved. It took over three days to complete."

己丑冬十月, 客吳門, 顧大娘／家 為造此硯, 用銘三語, 索何屺瞻先生書之, 鑴手亦先生所素許者, 越三日而竣事

References: *Yanshi* C1.3a, A2.3a

3. *Knot* inkstone

Date: Eighth month, 1712

Patron: Huang Zhongjian

Place: Suzhou

Stone: Presumably Duan

Encomiums (not known if carved):

"Knotted inkstone is its name, / Made by Wife of the Gu family. / A quality stone, finely wrought, / Treasure it without letting go."

"Neither round nor square, / Its order follows the material. / Is it a warning to me? / Keep your words sealed in a knotted pouch."

是名索硯, 顧家婦製, 質美工良, 寶之勿替
不圓不方, 依質成章, 似為予戒, 言括其囊
Reference: Huang Zhongjian, *Xuzhai erji*, 27–458

4. *Ursa Major* inkstone 奎硯
 Date: 1712 [stone bought in 1712, my guess is that it was made soon after]
 Patron: Lin Ji
 Encomium (Carved):
 曜合緯聯天降符, 撰賦紀瑞帝曰都, 鳳池捧硯徵斯圖 (紫薇內史臣佶)
 Another encomium by Fuyun (carved):
 "This stone is from an old cave opened in the Xuande period. My late father pur-
 chased it in the market at Ciren Temple [in Beijing] in the year *renchen* [1712]
 and entrusted it to Madame Gu, Lady Scholar of Suzhou, to carve. He used it
 when serving as a court scribe for twelve years and brought it home with him
 when he retired. Not long thereafter he passed. In the following year, thieves
 broke into our home and the inkstone ended up in Taijiang [an area near Fu-
 zhou]. Mr. Jiang retrieved it and returned it to me. As Master Gongyang said,
 'A precious jade is the treasure of the state. Write about it when you acquire
 it; write about it when you lose it.' May my sons and grandsons guard it in
 succession. Etched in the *renzi* year of the Yongzheng reign [1732] to express
 my bereavement."
 硯為宣德時舊坑, 歲壬辰先君子購於慈仁寺集, 磨礱於吳門女史顧氏, 揮毫於
 絲綸閣下者, 十有二年, 攜歸偕隱, 未幾捐館舍, 越明年不戒胠篋, 遂入臺
 江, 江氏來歸我, 公羊子曰: 寶玉大弓, 國寶也, 得之書, 喪之書. 子孫其世守
 勿替. 雍正壬子鐫此以志風木之感.
 Stone: Antique Duan, harvested Xuande era (1426–1435)
 Reference: *Yanshi* C4.4a

5. *Well Field* inkstone 井田硯
 Date: By 1713. The encomium was written at the latest by 1733 and the stone had
 been with Chen for twenty years, thus it was made at the latest by 1713.
 Patron: Chen Dequan
 Encomium (not known if carved):
 "Born in Guangdong, / Journeyed to Beijing. / Madame Gu of Suzhou, / Drew me
 the well-field. / Companion in office and in retirement, / The shadow of my self
 for twenty years. (Dequan, running script.)"
 產於粵, 遊於燕, 吳顧氏, 畫井田, 伴我芸閣歸林泉, 如影隨形二十年 (德泉. 行
 書)
 References: *Yanshi* C3.1b, A5.4a; cf. Chen's poem C8.14b, A8.14a

6. *Song Cave* inkstone 宋坑硯 (*Water Lode* 水坑 in A)

Date: By 1717 (likely a newly made inkstone that Fuyun picked up in Suzhou en route to Beijing).

Patron: Lin Fuyun

Stone: Antique Duan, Song dynasty "Water Lode" 宋水坑

Encomium (not known if carved): By Lin Ji, winter 1717

水崖之精琢乃成, 子能寶之實家楨 (丁酉冬日鹿原)

Other Information: Lin Ji's note in *Yanshi*

"Son E [Fuyun] came visit in Beijing, bringing an inkstone made by Gu Dagu and asked me to write an encomium."

羪兒來省視, 攜顧大家所製硯乞銘

Lin Zhengqing's note in *Yanshi*

"This is a Song Cave stone that is warm and firm. Having been polished and carved [hand-carved in *Yanshi* A] by Madame Gu, ink accrued on it as it would on an antique inkstone several hundred years old. Now it is even more worthy of appreciation."

此石乃宋坑, 溫而栗, 經顧氏磨礱[手琢 A1.5b], 墨積如數百年物, 尤可玩.

References: *Yanshi* C4.6a, A1.5b-6a

7. *Grace of Moon* inkstone 月儀硯[1]

Date: Encomium dated the ninth day of the ninth month, 1722; thus the inkstone was made the latest by 1722

Patron: Xu Jun

Encomium by Xu Jun:

"A raw jade from Duanxi, the color of night pearl, / Scooped from underneath the dark dragon's jaw. / The widow of Suzhou, with hands of Nuwa, / Refining stones as if mud, so skilled in cutting and carving. / The clam-shaped stone, chiseled into the new full moon, / Silky flow of autumn water in a serene river. . . (The ninth day of the ninth month, the year *renyin* [1722]. Daoist Adept Xuecun, running script, seal: Xuecun.)"

端溪璞玉夜珠色, 探向驪龍頷下得, 吳趨孀女女媧手, 鍊石如泥工剪刻, 蚌形琢出月初圓, 秋水澄江練一幅, 案旁亦有玉蟾蜍, 對此垂涎敢吞蝕, 鏤肝刻腎玉川子, 箋奏天工枉費墨, 何如研露寫烏絲, 翠袖佳人勤拂拭 (壬寅九月九日, 雪邨居士, 行書, 印雪邨)

Other Information: This encomium elicited Xie Gumei's 1739 note, recalling in 1726 he visited Xu in Beijing on a snowy evening; Xu painted the plum branches while his wife Madame Lin Shouzhu dotted the blossoms.

Reference: *Yanshi* C3.3a

8. *Apricot Blossoms and Swallows* inkstone 杏花春燕硯

 Date: not known; only that Lin Ji had died (ca. 1725)

 Patron: Lin Fuyun

 Place: Suzhou ("The old neighborhood of Zhuanzhu")

 Stone: Duan, Middle Cave

 Encomium (carved on the side):

 "A flower petal between beaks; an excess of feelings."

 只銜花片與多情

 Back: Carved painting of apricot blossoms and spring swallows

 Other Information: Lin Fuyun's note in *Yanshi*

 "The three generations of Gus in Suzhou are renowned for carving inkstones;
 those made by Dagu are particularly archaistic, elegant, and coherent [in
 design and execution]. My deceased father had written a poem for her which
 reads [in part]: 'The Weaving Maid bestows a piece of celestial stone, / In the
 earthy realm, an immortal holding a jade axe.' This spring, having netted a
 Middle Cave stone I visited Gu at the old neighborhood of Zhuanzhu. She
 took out a piece of stationery paper and begged me to write the lines down,
 and in return she proceeded to carve a picture of apricot blossoms and spring
 swallows on the back of the stone for me. The exquisite and tender views are
 incomparable. When [my father spoke of] an 'immortal holding a jade axe,'
 wasn't he referring to this? (Lunchuan; E; Regular script. Two seals: Dequ
 [Obtaining pleasure]; Luanfeng lai yanzi [With the warm breeze come the
 swallows].)"

 吳門顧氏三世以斲硯名, 大家所製尤古雅渾成, 先君子舊有分來天上支機石,
 占取人間玉斧仙贈句. 今春偶得中洞石, 訪顧於專諸舊里, 因出片箋, 乞余
 書之, 隨於硯背製杏花春燕圖酬余, 細膩風光, 得未曾有, 所謂玉斧仙, 不其
 然乎 (輪川, 峩, 楷書, 印二: 得趣, 暖風來燕子)

 Reference: *Yanshi* C6.5b, cf. B6.5a

DATES NOT KNOWN

9. *Phoenix* inkstone 鳳硯

 Stone: Duan

 Encomium by Lin Zhaoxian:

 "Replete with grace from Mt. Cinnabar Grotto, / The phoenix turns and soars. /
 Made by Gu Dagu, / Scooped from the Lingyang [Duan] quarry. / The purple
 clouds swirl; / The sun savors the vibration of its flapping wings. / The moun-
 tain reflects the cinnabar feathers, / Body and hair on the phoenix pond [ink-
 stone]. / My desire is to magnify my ancestors, / Tung flowers in late spring,
 ten thousand miles, strong in roots and bones."

具丹穴姿, 回翔超越, 製自顧大家, 探從鸜羊窟. 紫雲入袖, 日含毫翻, 羽丹山
鑑, 身髮鳳池, 吾欲揚先芬, 萬里桐花有根骨
Reference: *Yanshi* C6.7b

10. *Moon on Water Flowers in Mirror* inkstone 水月鏡花硯
 Encomium by Yu Dian, but not known if it was his stone
 Encomium: "Shadows of the moon on water; / flower in the mirror. / Appreciating
 a fine stone, / Unblemished in every way. / Tracing the elegant style [alt. mark]:
 / Gu Dagu. (Encomium by Dian; regular script)"
 水中月, 鏡中花, 品美石, 不爭差, 徵雅款, 顧大家 (甸銘楷書)
 References: *Yanshi* C1.6b, A2.7a, cf. Yu Dian, *Yu Jingzhao ji*, 19b

11. *Blue Spots* inkstone 青花硯
 Patron: Huang Ren
 Date: Not known ("this spring" in Huang's narrative, latest by 1733)
 Place: Suzhou
 Encomium (back):
 "One inch of Ganjiang [sharp blade], cutting into purple clay, / The sun begins to
 set on Zhuanzhu Lane. / How has it come to pass that the hands that make the
 loom sing 'ya-ya,' / Have cut through all ten miles [of quarries] along the river
 in Duanzhou?"
 一寸干將切紫泥, 專諸門巷日初西, 如何軋軋鳴机手, 割遍端州十里溪
 Other Information: Huang Ren's note in *Yanshi*
 "I have been carrying this stone in my sleeves for almost ten years. This spring I
 took it to Wu [Suzhou]. Gu Erniang of Suzhou saw it and took a liking to it;
 she then made me this inkstone. Delighted by the refinement of her artistry
 and touched by the sincerity of her intent, I wrote a poem for her and had it
 engraved on the back of the inkstone so that the people who handled this ink-
 stone after me would know its story. The Gu shop is in the old ward of Zhuan-
 zhu. Xintian."
 余此石懷袖將十年, 今春攜入吳, 吳門顧二娘見而悅之, 為製斯硯, 余喜其藝
 之精而感其意之篤, 為詩以贈, 並勒於硯陰, 俾後之傳者, 有所考焉。
 顧家在專諸舊里。莘田。
 References: *Yanshi* C2.3a, A3.2b

12. Wu Zhen's *Oak Forest Buddhist Hut* inkstone 吳鎮 橡林精舍硯 [吳仲奎硯 A7.2a]
 Patron: Huang Ren
 Date: Not known
 Stone: Duan, over 1 *chi* wide, 2 *cun* thick, with blue spots and mynah's eye mark-
 ings

Encomium: By Wu Zhen (twentieth day, fifth month, 1350) in cursive script

守吾墨而無喪其真, 利吾用而無染其塵, 從容乎法度, 下筆如有神, 是可為知
者道, 而不可以語之俗人 (至正庚寅夏五月廿日, 宿雨初霽, 清和可人, 有
風動竹瀟灑檀欒之聲, 欣然? 寐 [亡味 A7.2a], 梅道人雨窓戲墨於橡林精舍,
草書)

Other Information: Note by Xie Gumei

"This inkstone was remade by Gu Dagu of Suzhou, which took two months.
Shaped as a majestic phoenix, it is the supreme treasure in [Huang Ren's] Ten
Inkstones collection. When [the Han poet Jia Yi] wrote [of the phoenix], 'Soar-
ing high in the sky, [descending] only when it recognizes a sagacious master,'
could he have meant this? (Gumei)"

經吳門顧大家重製, 両月始成, 形如威鳳, 此十研至寶也. 所謂 [翔] 千仞而覽
德輝, 其在斯乎 (古梅)

Reference: *Yanshi* C7.3a (Gumei note not in A; same omissions of individual words
in B)

Appendix 2

INKSTONES BEARING SIGNATURE MARKS OF
GU ERNIANG IN MAJOR MUSEUM COLLECTIONS

1. Phoenix Trope

LOCATION AND SOURCE	STONE	SIZE (IN CM)	NAME (AS-SIGNED BY THE MUSEUM)	DESIGN	SIGNATURE MARK	OTHER INSCRIPTIONS
Palace Museum, Beijing (Zhang, *Wenfang sibao*, 94–95)	Duan	L 21.5 W 18.1 H 2.6	1a. *Phoenix* inkstone (fig. 4.9)	Face: head and upper body of phoenix Back: lower body and tail	Side: Wumen Gu Erniang zao (seal script)	Back: Lin Ji, encomium and seal; "One-inch Ganjiang" poem and note, Huang Ren seals; Shiyanxuan tushu
Metropolitan Museum, New York (Thorp and Vinograd, *Chinese Art*, fig. 9.25; Hay, *Sensuous Surfaces*, 54–55)	Limestone		1b. *Phoenix* inkstone (fig. 3.7B)		Back: Wumen Gu Erniang zhi (seal script)	Nil
Compare: Former collection of Zhu Yi'an (Zhu Chuanrong, *Xiaoshan Zhushi*, 99–100)	Not known	L 15.8 W 10.2	1c. *Phoenix* inkstone (fig. 3.7A)	Face: head and wings of phoenix and clouds Back: tail of phoenix and clouds	Back: Wumen Gu Dagu zhi (mixed clerical and regular scripts)	Back: rectangular seal under signature mark: Renjian yufu xian (An immortal wielding a jade axe on earth)

213

2. Apricot Blossoms and Swallows Trope

LOCATION AND SOURCE	STONE	SIZE (IN CM)	NAME	DESIGN	SIGNATURE MARK	OTHER MARKS
Tianjin Museum (Tianjin Bowuguan, *Tianjin Bowuguan cangyan*, 96)	Duan	L 18 W 12 H 3	2a. *Paired Swallows* inkstone (fig. 3.7C)	Face: swirling cloud edges Back: paired swallows	Back: Wumen Gu Erniang zhi (standard script)	Back: Zhihan huapian yu duoqing (A flower petal between beaks, an excess of feelings) Seal: Dequ (Getting the pleasure) Side: "One-inch Ganjiang" poem
National Palace Museum, Taipei (Guoli Gugong, *Lanqian*, 160–62)	Duan	L 6.7 W 7.2 H 2.1	2b. *Paired Swallows* inkstone (figs. 3.7D, 4.2)	Face: irregular Back: paired swallows	Back: Wumen Gu Erniang zhi (seal script)	Back: Xinlin chunyan (Apricot forest and spring swallows)

3. Banana Leaf Trope

LOCATION AND SOURCE	STONE	SIZE (IN CM)	NAME	DESIGN	SIGNATURE MARK	OTHER MARKS
National Palace Museum (Guoli Gugong, *Lanqian*, 164–66)	Duan	L 18.4 W 12.9 H 2.2	3a. *Banana Leaf* inkstone	Face: banana leaf Back: banana sheath	Face: Gu Erniang zhi (seal script)	Back: Yutian (name; perhaps a corruption of Huang Ren's Xintian)
National Palace Museum (Guoli Gugong, *Lanqian*, 112–14)	Duan	L 4.5 W 9.6 H 2	3b. *Banana and Moon* inkstone (figs. 3.7E, 3.7F)	Face: banana leaf with moon-shaped water pool Back: portrait of Bodhidharma	Back: Wumen Gu Erniang zhi (regular script, slightly running)	Back: Bodhidharma poem, signed Xintian Huang Ren; seal: Huangshi zhencang (Collection of Mr. Huang)
Compare: National Palace Museum (Guoli Gugong, *Lanqian*, 106)	Duan	L 16.7 W 11.7 H 1.9	*Banana and Moon* inkstone	Face: banana leaf with moon-shaped water pool	None	Back: encomium by Huang Ren; Seal: Xintian

4. *Kui*-Dragon Pool Trope

LOCATION AND SOURCE	STONE	SIZE (IN CM)	NAME	DESIGN	SIGNATURE MARK	OTHER MARKS
Palace Museum (Zhang, *Wenfang sibao*, 92)	Duan	L 23.5 W 20.2 H 3.6	4a. *Grotto and Sky as One* inkstone (fig. I.4)	Face: *kui*-dragon bordered water pool	Side: Wumen Gu Erniang zao (seal script)	Face: encomium by [Huang] Ren; seal, 1719 Back: encomiums by [Yu] Dian and Luyuan [Lin Ji]
Compare: Palace Museum (Zhang, *Wenfang sibao*, 90–91)	Duan	L 17.9 W 13.7 H 3	4b. *Irregular-shape* inkstone	Face: *kui*-dragon bordered water pool Back: encomium by Yu Dian	No Gu mark, but associated with her by way of Yu Dian's encomium	Back: encomium by Yu Dian, 1732

5. Clouds and Moon Trope

LOCATION AND SOURCE	STONE	SIZE (IN CM)	NAME	DESIGN	SIGNATURE MARK	OTHER MARKS
Tianjin Museum (Tianjin Bowuguan, *Tianjin Bowuguan cangyan*, 97)	Duan	L 18.8 W 12.3 H 2.5	5a. *Jielin* inkstone (fig. 3.8E)	Face: swirling clouds revealing round moon (water pool) Back: encomium	Left side: Gu Erniang zao (clerical script)	Face: Jielin Back: encomium by Xu Liangchen; seal: Shiquan
Guangdong Folk Arts Museum	Duan	L 12.8 W 11 H 1.9	5b. Inkstone made by Gu Erniang with encomium by Huang Ren	Face: Swirling clouds revealing round moon Back: Landscape scene of boat in water; craggy rock and twisted pine on river bank	Back: Wumen Gu Erniang zhi (regular script, slightly running)	Left side: Square seal: Shiyan Laoren (Old Man with Ten Inkstones) Square seal: Huang Ren Zhencang (Collection of Huang Ren) Right side: Deshao jiaqu (Getting the rare pleasure); Huangjuan youfu (Supremely fine lyrics)
Compare: Shanghai Museum (Shanghai Bowuguan, *Weiyan zuotian*, 92–93)	Duan	L 18.2 W 14.7 H 3.2	5c. *Scene of Red Cliff* inkstone	Face: Swirling clouds revealing round moon Back: Scene of Su Shi at Red Cliff	Signature mark on right side "Ruqi zuo" (Made by Ruqi) No Gu mark but associated with her by way of Xie Ruqi and Huang Ren	Left side: square seal Huancui Lou (Pavilion Surrounded by Greens; name of Huang Ren's study in Jiyan, near his ancestral home in Yongtai)

6. Mushroom Trope

LOCATION AND SOURCE	STONE	SIZE (IN CM)	NAME	DESIGN	SIGNATURE MARK	OTHER MARKS
Palace Museum (Zhang, *Wenfang sibao*, 93)	Duan	L 15 W 8 H 1.9	6a. *Mushroom* inkstone (fig. 4.15)	Face: crescent-shaped water pool with gills Back: mushroom cap and stem	Face: Wumen Gu Erniang zhi (seal script)	None
Compare: Former collection of Zhu Yi'an (Zhu Chuanrong, *Xiaoshan Zhushi*, 101–2)	Duan, pebble stone (*zishi*)	L 10.8 W 7.4	6b. *Mushroom* inkstone	Face: crescent-shaped water pool with gills Back: mushroom caps with stem	Face: Wumen Gu Erniang zao (seal script)	None

7. Lotus Leaf Trope

LOCATION AND SOURCE	STONE	SIZE (IN CM)	NAME	DESIGN	SIGNATURE MARK	OTHER MARKS
Nanjing Museum (Zhongguo wenfang sibao, 131)	Duan	L 14 W 8.1 H 1.9	7a. *Gu Erniang* inkstone	Face: rolled lotus leaf borders Back: the rest of the leaf, with the cut stem near the center	Back: Erniang (seal script)	None

Appendix 3

MEMBERS OF THE FUZHOU CIRCLE

1. Core Members

NAME	BRIEF BIOGRAPHY	FAMILY RELATIONS WITH OTHER COLLECTORS	NON-KIN RELATIONS WITH OTHER COLLECTORS	RELATIONSHIP WITH ARTISANS	NO. OF INKSTONES IN *YANSHI* C
Chen Dequan (1683–1755)	1713 Metropolitan graduate Hanlin bachelor; appointed junior compiler; censor Metropolitan governor of Fengtian (*Yanshi* A8.12b–14b)	Maternal nephew of Lin Ji	Close friend of Lin Zhengqing Resident of Guanglu Lane Colleague of He Zhuo in Wuying Dian for three years	Patron/client of Gu Erniang	1
Huang Ren (1683–1768)	1702 Provincial graduate 1720 Finished Ten Inkstones Studio 1724–27 Magistrate of Sihui, Guangdong 1726 Jurisdiction expanded to include Gaoyao 1731 Returned to Fuzhou 1738–40 in Guangdong	Maternal cousin of Xu Jun	Calligraphy student of Lin Ji Resident of Guanglu Lane	Patron/client of Gu Erniang Patron of Yang Dongyi in Guangdong Hired female carvers in Yellow Hill villages	38
Lin Ji (1660– ca. 1725)	1699 Provincial graduate 1706 Drafter in Wuying Dian 1712 Metropolitan graduate; secretary in Grand Secretariat 1723 imprisoned; released and retired	Father of Lin Zhengqing, Fuyun, and Jingyun Maternal uncle of Xie Gumei	Close friend of Yu Dian Resident of Guanglu Lane	Patron/client of Gu Erniang	25

(*continued*)

217

1. Core Members (*continued*)

NAME	BRIEF BIOGRAPHY	FAMILY RELATIONS WITH OTHER COLLECTORS	NON-KIN RELATIONS WITH OTHER COLLECTORS	RELATIONSHIP WITH ARTISANS	NO. OF INSKTONES IN *YANSHI* C
Lin Fuyun (ca. 1690–1752)	1717–24 in Beijing 1739–43 in Beijing 1745–52 in Suzhou	Third son of Lin Ji 3 sons: Zhaoxian; Wan; Chang		Patron/client of Gu Erniang	27
Lin Jingyun		Fourth son of Lin Ji			0
Lin Weiyun (d. 1736)	Imperial student	Son of Lin Ji's brother Tong First cousin of Jingyun, Fuyun, and Zhengqing	Colleague of Xie Gumei in the gazetteer bureau		1
Lin Zhengqing (1680–1756)	1706 Lecturer at Aofeng Academy, Fuzhou Apprentice at the Ministry of Justice 1724 Visited Huang Ren in Guangdong Assistant department magistrate (rank 7b), Lianghuai Salt Administration 1732 Retired and returned to Fuzhou	Eldest son of Lin Ji Two sons: Sheng; Jing Grandson: Cong	Close friend of Chen Dequan, Xie Gumei, and You Shao'an		27
Xie Gumei (1691–1741)	1719 Viewed Han and Tang rubbings with Huang Ren 1721 Metropolitan graduate 1728–37 Compiler-in-chief of *Gazetteer of Fujian* (Fujian tongzhi) 1738 Promoted to academician of the Grand Secretariat (rank 2b) and vice minister of Ministry of Rites (*Yanshi* A1.6a, 3.2a, 5.4a, 8.10b, 8.28a; *Sanfang qixiang zhi*, 350)	Maternal nephew of Lin Ji (mother is Ji's elder sister)	Close friend of Lin Zhengqing Took exam with You Shao'an and Zhou Shaolong Colleague of Xu Jun in Beijing for 3 years ca. 1726 Resident of Guanglu Lane		1
Xu Jun (1687–1730)	1718 Metropolitan graduate Hanlin Academy Director (rank 5b), Bureau of Sacrifices, Ministry of Rites (*Yanshi* A4.1b–3a, 4.2b, 4.3a–b)	Son of Xu Yu Maternal cousin of Huang Ren	Colleague of Xie Gumei in Beijing for three years ca. 1726 Resident of Guanglu Lane	1719 went on outing in Beijing with Yang Dongyi (also present were You Shao'an and Lin Fuyun)	6

(*continued*)

1. Core Members (*continued*)

NAME	BRIEF BIOGRAPHY	FAMILY RELATIONS WITH OTHER COLLECTORS	NON-KIN RELATIONS WITH OTHER COLLECTORS	RELATIONSHIP WITH ARTISANS	NO. OF INKSTONES IN *YANSHI* C
You Shao'an (1682–still alive 1756)	1723 Metropolitan graduate 1725 Visited Huang Ren in Duanzhou Prefect of Nan'an	Brother-in-law of Xu Jun (first wife is daughter of Xu Yu; sister of Xu Jun)	Close friend of Lin Zhengqing Took exam with Xie Gumei and Zhou Shaolong Resident of Guanglu Lane	Close friend of Yang Dongyi	2
Yu Dian (d. 1733)	1706 Metropolitan graduate Magistrate of Jiangjin, Sichuan Ministry of Personnel Surveillance commissioner (rank 3a), Shandong Governor of Shuntian Prefecture		Friend of Lin Ji; friend of Huang Ren	Patron/client of Gu Erniang Commissioned a friend, Xue Ruohui, to "open the ink pool" and "polish the face" of an inkstone made of Liuchuan stone (*Yanshi* A2.13a–b)	82
Zhou Shaolong (still alive 1734)	1723 Metropolitan graduate 1727 Commissioner of Sichuan Provincial governor of Shanxi (rank 2b) Died in post, governor of Shuntian Prefecture (*Yanshi* A1.4b, 5.1a–3a, 8.27a)		Took exam with Xie Gumei and You Shao'an Resident of Guanglu Lane		9

2. Second-Tier Members

NAME	BIOGRAPHY	RELATIONS WITH OTHER COLLECTORS	RELATIONSHIP WITH ARTISANS
Chen Zhaolun (1700–1771)	1730 Metropolitan graduate 1731–34 Magistrate, Gazetteer Bureau, Fujian 1735 Secretary in the Council of State (rank 3a) 1736 *Boxue hongci* special exam, appointed examining editor of the Hanlin Academy (rank 7b) 1754 Governor of Shuntian Prefecture 1756 Chief minister, Court of Imperial Sacrifices (rank 3a) 1767 Chief minister, Court of Imperial Stud (rank 3b)	1731–34, colleague of Xie Gumei in Fuzhou Friend of Huang Ren, Lin Fuyun	1731–34, befriended Dong Cangmen in Fuzhou
Li Fu (1666–1749)	1684 Provincial graduate 1722 Provincial governor of Zhejiang 1724 Dismissed 1724–25 Imprisoned	Native of Fuzhou Neighbor of Lin and Huang (Juye Tang on Huang Lane)	1724 Inscribed painting *Xingle tu* by Dong Cangmen Frequent patron of Gu Erniang according to Chen Zhaolun
Li Yunlong (1710–1761)	1754 Prefect of Pingyuan, Guizhou	Friend of Huang Ren Eldest daughter married Lin Fuyun's third son Saw Chen Zhaolun in Beijing ca. 1754	
Weng Luoxuan (1647–1728)	1688 Metropolitan graduate Provincial education commissioner of Guangdong	Friend of Lin Ji, Xu Yu, Huang Ren	
Zhao Guolin (1673–1751)	1709 Metropolitan graduate 1727–29 Administration commissioner of Fujian (rank 2b) 1730–34 Provincial governor of Fujian (rank 2b) 1734–38 Provincial governor of Anhui 1738 Minister of Justice; Minister of Rites and Chancellor of the National University (rank 1b) 1739 Grand secretary of Wenyuan Ge (rank 1a) 1742 Dismissed 1743 Returned to hometown Tai'an 1750 Rehabilitated	Patron of Xie Gumei, Lin Fuyun Edited Yu Dian's collected works	
Zhu Jingying	1753 Arrived in Fujian; met Huang Ren	Friend of Fuyun's son Wan	

3. Fringe Members (Only those names in bold are included the glossary)

3A. Friends whose encomiums are included in *Yanshi* C: **Chen Yixi**; A-Jin; Lan Lian; Qi Chaonan; **Yan Zhaowei**; **Liu Ci**; **Xu Liangchen**; Shen Tingfang; Chen Chaochu; **Yu Wenyi**; and others.

3B. Friends whose responses to Huang Ren's eighteen congratulatory poems are included in *Yanshi* C: Zhou Zhangfa; Lin Xingsi; Zhou Tiandu; Zhou Zhengsi; He Chong; Lu Tianxi; Ling Hao; **Zhang Hechai** (along with core and second-tier members)

3C. Acquaintances whose congratulatory poems are included in *Yanshi* C: Zhao Rongmu; Li Guo; Chen Shiguan; **Fu Wanglu**; **Qian Chenqun**; **Xu Baoguang**; **Yu Zhen**; Li Xu; Hu Baolin; Li Xiangyi; Song Nan; Zhuang Yougong; Fang Hang; Li Chonghua; Liu Tongxun; Tian Zhiqin; **Zhang Pengge**; Lu Guishen; Li Shiqian; Tong Dashen; Wu Yingmei; Chen Huo; Cha Kai; Kong Xinghui; Cha Xiang; Zhang Wei; Yao Peigen; Zhou Jing; **Yuan Mei**; Zhang Zhengtao; **Shen Dacheng**; Ye Guanguo; **Qian Daxin**; Qian Zai; and others.

3D. Acquaintances whose congratulatory messages are included in *Yanshi* C: **Fang Bao**; Lei Hong; Zhuang Hengyang; Zhou Jingzhu; **Jin Nong**; **Gao Fenghan**; Shao Tai; Liu Hongzhang, **Shen Deqian**; Wang Xiaoyong; and others.

Appendix 4

TEXTUAL HISTORY OF LIN FUYUN'S
INKSTONE CHRONICLE (YANSHI)

1. AUTHORS AND COMPILERS

The bulk of *Inkstone Chronicle* consists of inkstone encomiums written by Lin Ji, Yu Dian, Huang Ren, and other core members of the Fuzhou circle. Ji's third son, Fuyun, compiled them into a volume, consulting extensively with his eldest brother, Zhengqing, and youngest brother, Jingyun, in the process. Fuyun's sons Zhaoxian, Wan, and Chang helped with the tasks of collating and copying (*Yanshi* C *fanli*.2a). Lin Wan is likely to be the one who incorporated new prefaces and congratulatory poems after Fuyun's death. Curiously, Ji's second son, Xiangyun, was scantly involved.

2. TEXTUAL HISTORY

The textual history of *Inkstone Chronicle* is convoluted and murky at times because of its unstable nature: during the editing process if Fuyun (and his sons) found a new encomium or received a new endorsement they would insert them in the text. These endorsements are recursive, often taking the form of a response to an earlier one. The book was apparently never printed during the Qing; different copies, or portions thereof, circulated in multiple regions simultaneously.[1] Both the format and organization of the book changed drastically as Lin Fuyun responded to feedback from contemporary readers.

Although Lin Fuyun had long collected inkstone encomiums, compilation of the book began in earnest only after the death of his father Lin Ji (ca. 1725). Fuyun also began to carve the encomiums his father composed on the intended inkstones. Around then, Yu Dian retired to Fuzhou, and in 1731, Huang Ren returned from Guangdong. The three often gathered to view the Duan stones in their respective collections, whereupon Yu would compose encomiums and Lin would eventually carve them onto the stones. Fuyun

explained the circumstances that led to the compilation of his work: "We thus set off a trend [in Fuzhou]; people would judge whether one is elegant or vulgar by the presence or absence of a [good] inkstone on his desk. Further, they would not consider a stone worthwhile unless they managed to procure an encomium from the Governor [Yu Dian]." He continued, "I therefore decided to gather up the inkstones from the various families, make rubbings of their encomiums, and compile this volume of *Yanshi*."[2]

Having copied and/or carved the encomiums and made rubbings, Lin Fuyun codified the first-known rendition of the book in the autumn of 1733 and gave it the unremarkable title, "Inkstone Encomiums from Taofang [the studio housing Ji's library]" (Taofang Yanming). The compilation, bounded in eight slim volumes, consists of about one hundred encomiums and at least the congratulatory poems (two sets of eighteen) by Huang Ren and a set of responses by Yu Dian. (This was the likely version he showed Chen Zhaolun in 1734.) He sent a copy to his younger brother, Lin Jingyun, in the capital. Jingyun renamed it *Yanshi* and wrote a response to Huang's set of eighteen poems. Fuyun's elder brother, Zhengqing, who was also in Beijing at the time, contributed a preface and a set of poems of his own. From then on, copies of the manuscript began to circulate in Beijing. That winter, when Zhengqing left for Huai'an to take up his new post at the Salt Administration, he took a copy with him.

In 1735, Lin Jingyun returned to Fuzhou and found that Fuyun had doubled the coverage to two hundred encomiums and the book was now bound in four volumes. Four years later, Fuyun traveled to Beijing and, by sheer coincidence, ran into his elder brother at the docks in Linqing on the twenty-second day of sixth month, after an absence of twelve years. They viewed a copy of *Yanshi* together, but it is not known who was carrying it (A8.17a). The longer version of the book circulated in the capital under at least two different titles—*Taofang Yanming* (C9.21a) and *Taofang Yanshi* (C10.1a)—in the early 1740s as a four-volume set. The circle widened as Fuyun systematically called on famous people and former associates of his elders asking for endorsements. "This book assumed its present form in 1746," Fuyun noted (C *fanli*.2a).

Scattered evidence suggests that in its early incarnation(s), the manuscript was illustrated, perhaps comprised of the actual rubbings from the inkstones.[3] But none of the extant copies include images.

3. EXTANT COPIES

Text A

I have not found the 1733 version. The earliest extant version of the manuscript is housed in the Capital Library in Beijing; a facsimile copy is in the C.V. Starr East Asian Library of Columbia University. Identified as "*Yanshi* A" in the present book, it is comprised of ten fascicles. The latest date mentioned in it is 1746. A singleton Qianlong-era copy, it has

not been scrutinized until now. Several copyediting marks integral to the text suggest that it was a working copy in the hands of Lin Fuyun and/or his sons. A collector's seal, "Yi'an jiacang," identifies its former owner as Republican-era inkstone aficionado Zhu Yi'an (1882–1937). Zhu's handwritten eyebrow comment (7.3a) suggests that he had in his possession an "original copy" of *Yanshi*. The whereabouts of the latter is unknown.[4]

There is no pagination in the original manuscript. The page numbers referred to in the present book are added by the present author.

Text B (named after Baoshan Lou)

A Republican era handcopied manuscript in the Shanghai Library (call no. *Xianpu* 579635–36); formerly in the collection of Panshi Baoshan Lou in Suzhou, dated 1935. Although different in size and format, it is a verbatim copy of Text C with minor divergences.

Text C (named after Changlin Shanzhuang)

A Qianlong-era handwritten manuscript in the Shanghai Library (call no. *Xianpu* T798129–32); a facsimile copy is in the C.V. Starr East Asian Library of Columbia University. This version is identified as "*Yanshi* C" in the present book. A seal, "Mountain Retreat in the Deep Forest" (Changlin Shanzhuang), affixed on two of the pages (C1.1a, C7.1a) identifies this copy with the Lin family. It was the name of Lin Ji's dream house near the Lin ancestral graves in the northern hills in the suburb of Fuzhou but never built. Another seal, "Pure fragrance from our bygone elders" (*xianren qingfen*), is on the lower corner of the table of contents.

Text C appears to be a working copy that contains editorial marks for changes to be made in a later version. Examples are a reverse sign on 8.6b, and a crossed-out name on 7.4a (cf. A7.3b). It is a handwritten manuscript, but the paper, with the title "Yanshi" on the centerfold, appears to be preprinted.

Also in ten fascicles, it is a later version than Text A, with an added preface dated 1775. By then Fuyun had died, and this edition is likely to be the handiwork of his son Lin Wan, who showed the manuscript to his patron, Examiner Yu Wenyi, and asked for a preface. Wan also inserted the biography of his father, noting that Fuyun died in Suzhou in 1752 (C6.6b–7a). His editorial hand is also evident in the new congratulatory poems and endorsements in C that are not in A (C9.21a–22a; 9.25a–29b; 10.6a–7b). At least one of these people, Zhu Delin, is identified as his friend and peer (C9.27b).

This version is more widely circulated than Text A, as all of the twentieth-century copies extant today are verbatim copies of it.

There is no pagination in the original manuscript. The page numbers referred to in the present book are added by the present author.

Text D

This is a Republican-era handcopied manuscript in the Fujian Provincial Library (call no. 852.9); a verbatim copy of Text C or some derivative thereof.

Other copies I did not examine

A 1942 copy (call no. *Xianpuchang* 414911) in the Shanghai Library, which I was not allowed to see in 2009, and which was reported lost in 2012; a modern typeset version (based upon Text C) in *Shuoyan*, a PRC volume used by most scholars in China today.

4. ORGANIZATION OF TEXT A

Preface by Lin Zhengqing, 1733
Biographies of Lin Ji, Yu Dian, Xu Jun, Zhou Shaolong, Xie Gumei, Huang Ren (all by You Shao'an), dated 1742
Table of Contents
Fascicle 1: [Inkstone encomiums by] Lin Lixuan [Sun]; Lin Ji
Fascicle 2: [Inkstone encomiums by] Yu Dian
Fascicle 3: [Inkstone encomiums by] Huang Ren
Fascicle 4: [Inkstone encomiums by] Xu Jun; Lin Weiyun
Fascicle 5: [Inkstone encomiums by] Zhou Shaolong; Xie Gumei; appended: Chen Dequan; You Shao'an
Fascicle 6: [Inkstone encomiums by] Lin Zhengqing; Lin Fuyun
Fascicle 7: Encomiums by Song, Yuan, Ming, and Qing people
Fascicle 8: Congratulatory Poems (sets of eighteen poems, each four lines with seven characters, initiated by Huang Ren, Yu Dian, and responses by others)
Fascicle 9: Congratulatory Poems (other formats)
Fascicle 10: Rhymed prose; song lyrics, essays; afterword

The bracketing of fascicles 2 through 5 by the works of the Lin forefathers (fascicle 1) and the Lin sons (fascicle 6) suggests that the book is Lin family–centered. This is changed in the subsequent version.

5. ORGANIZATION OF TEXT C

Preface by Yu Wenyi, 1775 (Examiner/patron of Lin Fuyun's son Wan)
Preface by Huang Zhijun, 1746 (friend of Lin Zhengqing)
Preface (Xiaoyin) by Lin Zhengqing, 1733 (shorter than the version in A)
Preface by Lin Fuyun, 1733 (edited from the version in A)

Editorial Principles (Fanli) (not in A)

Table of Contents

Fascicle 1: Inkstone Encomiums: Experts from the Neighborhood—Yu Dian

Fascicle 2: Inkstone Encomiums: Experts from the Neighborhood—Huang Ren

Fascicle 3: Inkstone Encomiums: Experts from the Neighborhood—Chen Dequan; Xu Jun; Xie Gumei; Zhou Shaolong; You Shao'an

Fascicle 4: Inkstone Encomiums: Collected in the Family—Lin Lixuan; Lin Ji

Fascicle 5: Inkstone Encomiums: Collected in the Family—Lin Weiyun; Lin Zhengqing (son appended)

Fascicle 6: Inkstone Encomiums: Collected in the Family—Lin Fuyun (three sons appended)

Fascicle 7: Inkstone Encomiums: From Ancient Inkstones and Other Notables— Song, Yuan, Ming, and Qing

Fascicle 8: Congratulatory Poems (sets of eighteen poems, each four lines with seven characters, initiated by Huang Ren, Yu Dian, and responses by others)

Fascicle 9: Congratulatory Poems (other formats)

Fascicle 10: Afterword

The new order, opening with Yu Dian and terminating in the Lin fathers and sons (fascicles 4–6), suggests that the book is Fuzhou focused.

Appendix 5

CHINESE TEXTS

INTRODUCTION

"Valorizing the *dao*" (page 5):
重道輕器
形而上者為之道，形而下者為之器

"Those who labor with their brains" (page 5):
勞心者治人, 勞力者治於人

CHAPTER 1

Tang Ying, *Words from A Potter's Mind* (pages 17–18):
客有不得其解而問者曰：陶為勞力之事。 陶人， 勞力之人。 其事其人槩可想
見。 又何所取於其心， 更及於之所語哉？ 予曰： 然。 客亦知夫人各有心，
心各有語乎。 ...陶人有陶人之天地， 有陶人之歲序， 有陶人之悲歡離合眼界
心情。 即一飲一食， 衣冠寢興， 與夫俛仰登眺交遊之際， 無一不以陶人之心
應之。 即無一不以陶人之心發之於語以寫之也.

CHAPTER 2

Auspicious couplet, "hacking through rocks. . ." (page 56):
伍丁鑿開山成路， 硯田長留子孫耕

CHAPTER 3

Li Fu's poem for Gu (page 251, n30):
伊誰奪得天工巧， 纖手專諸顧二娘

Dong Cangmen's encomium (page 107):
切之琢之， 溫而且栗。 篤實輝光， 君子之德。 滄門禹銘.

Yu Dian's tributes to Yang-Dong (pages 108–9):
楊董曾如顧氏工、 步趨名款細磨礱、 由來邱叡胸中有、 得手真同鬼斧攻。
最是文人運斧工、 董楊雅製善磨礱、 開池深淺憑心曲、 錯認吳趨女手攻。

Xie Ruqi's tribute to Gu (page 110):
同董滄門過鱄諸巷訪女士顧二娘觀硯：
勇夫寶劍文人硯， 一樣雄奇性所同。 雅慕蘇門游俠女， 割雲琢玉奪天工。
硯史由來讓董園， 鱄諸古巷更思存。 顧家繡法人爭羨， 曾識清芳解討論。
竹裏簾櫳暎碧紗， 斜泉磨洗舊青花。 出藍宋款應無敵， 井字縱橫風字斜。
專門家數大方家， 花底香浮顧渚茶。 更羨銘文鐫寫妙， 黃金無滓玉無瑕。
香窟兼具石言真， 龍尾羚巖脫手新。 他日輶軒應入傳， 特書定比魏夫人。

Gu on her artistry (page 113):
硯係一石琢成， 必圓活而肥潤， 方見鐫琢之妙， 若呆板瘦硬， 乃石之本來面目， 琢磨何為？

CHAPTER 5

Madame Zhang's (or Lin Weiyun's) encomium (page 165):
琢歙溪之精英，伴君子之幽貞。童孫書聲、午夜白髮、相對寒檠。
覯子髫齡之穎妙，感我歲月之嶒嶸。

Madame Zhuang's poem (page 166):
萬里寒更三逐客，七年除夕五離家。

NOTES

INTRODUCTION

1 I'm drawing an analogy between "ruling by the writing brush" and Bruno Latour's Salk Institute, where he observed that whereas the input into the elaborate apparatus is tangible materials, the output—lab reports and conference papers—consists of reams of texts (*Laboratory Life*). This transmutation from material to text captures the workings of Chinese imperial-bureaucratic governance.

2 Richard Sennett thus describes the early Greek craftsman: "More than a technician, the civilizing craftsman has used these tools [knives, the wheel, the loom] for a collective good . . ." and in so doing, "brought people out of the isolation" to form communities (*The Craftsman*, 21–22). For the meanings of "artisan" (*gong* and *jiang*) in Chinese, see Barbieri-Low, *Artisans in Early Imperial China*, 24–45.

3 The expression is a modern summary of a line in the *Book of Changes*. In Lynn's translation: "Therefore what is prior to physical form pertains to the Dao, and what is subsequent to physical form pertains to concrete objects [the phenomenal world]" ("Xici" A.12; Lynn, *Classic of Changes*, 67). The dichotomy became salient when the seminal work of literary criticism *Literary Mind and the Carving of Dragons* (Wenxin diaolong) by Liu Xie (465–522) expounded on it.

4 *Mencius* 3A.4. Translation by Derk Bodde, cited in Barbieri-Low, *Artisans*, 38–39.

5 I use "skills" instead of "technology" (which hardly appears in this book) because the latter term is subject to contradictory interpretations. See, for example, its divergent use in the hands of Tim Ingold (*Perceptions of the Environment*) and Francesca Bray ("Toward a Critical History of Non-Western Technology"). "Skills," at once embodied by the craftsman and socially distributed, is a less ambiguous category of historical analysis. See Sigaut, "Technology"; Eyferth, *Eating Rice*; Roberts et al., *Mindful Hand*.

6 Not to be confused with Han Chinese, Hanjun is a special status assigned to the descendants of those Chinese who came under Manchu rule in Manchuria before the conquest of the Ming in 1644. Steeped in both Chinese and Manchu ways, they were instrumental to the consolidation of dynastic power in the early Qing. For the early history of the Hanjun-banner, see Crossley, *Translucent Mirror*, 89–128. Cf. chapter 1 for an explanation of the Eight Banners system of which it is a part.

7 Kopytoff, "Cultural Biography of Things," in Appardurai, *Social Life of Things*.

8 Xue Feng [Dagmar Schäfer], "Zuiqiu jiyi," in Gugong Bowuyuan and Bolin Mapu, *Gongting yu difang*, 11–30. Previous scholars have focused on Manchu mastery of the Chinese bureaucratic procedures and writing systems. The importance of the research of Schäfer and her colleagues is to extend

the analysis to technical, artistic, and material production. Far from being copycats of Chinese culture, the Manchus thus appear to be innovators in the institutional and material realms.

9 Xue Feng, "Zuiqiu jiyi," *Gongting yu difang*, 17.

10 As such my use of "technocrat" is different than William Henry Smyth's (1855–1940), who is often seen as the modern inventor of the word when he published "Technocracy—Ways and Means to Gain Industrial Democracy" in 1919. Smyth, an engineer, is concerned with the involvement of workers in the decision-making of industrial factories.

CHAPTER 1. THE PALACE WORKSHOPS

1 In Qing bureaucratic parlance, *xingzou* means serving concurrently in two posts but in the Zaobanchu, it often means "to work" or "to make things" in one of the workshops. See, for example, ZBC1.678. The early location of the workshops was in Yangxindian; in 1691 all but the Mounting Works and Archery Works were moved to the former site of the larder in Cining Palace north of Wuyingdian, occupying a block of 151 rooms. A hundred more rooms from the back buildings of Baihudian were later added. Even after the move, Yangxindian remained the shorthand for the Imperial Workshops (Peng Zeyi, *Zhongguo jindai shougongyeshi*, 147–48). See a map in Ji Ruoxin, "Qianlong shiqi de Ruyiguan," 151.

2 "Qianyan," 2, ZBC. The number of works was about forty-two by 1758 (Peng, *Zhongguo jindai*, 148). Manufacturing also extended to sites in Beijing but outside the palace, notably Jingshan and Yuanmingyuan, in the Qianlong and Jiaqing reigns. There is much fluidity in the names and jurisdiction of these works. For the convoluted early history of the Imperial Workshops in the Kangxi reign and the contradictory accounts of the different

works in the Qianlong reign, see Ji Ruoxin, "Qing qianqi Zaobanchu," 3–4. The Qing imperial workshop system built on those of its predecessors, but also departed from them significantly in financial and personnel management. For state manufactures of the Mongol-Yuan and the Ming, see Schäfer, *Crafting*, 94–108.

3 Ji, "Qing qianqi Zaobanchu," 2–3, 6–7, 18. Cf. Chang, "Kangxi zhizuo," 9. Gu Gongwang, the nephew of Suzhou female inkstone maker Gu Erniang, was said to be one of these recruits, but there is no mention of him in the palace workshop archives.

4 Chang, "Kangxi zhizuo," 7–9. I am indebted to Chang who established the dating of the "discovery" of Songhua stone.

5 Kangxi, "Zhiyan suo," in *Shengzu Renhuangdi yuzhi wenji, di erji*, 30.17a–b. The essays in this volume were written between 1683 and 1697. Cf. Ji, "Pinlie Duan She," 13–15, in Guoli Gugong Bowuyuan, *Pinlie Duan She*; Chang, "Kangxi zhizuo," 7–8.

6 Kangxi, *Shengzu Renhuangdi, di erji*, 30.17b.

7 Chang, "Kangxi zhizuo," 10–18. Kangxi had so many Songhua inkstones made that his successors Yongzheng and Qianlong were left with a surplus supply (13). Chang finds textual mentioning of over 200 Songhua inkstones, which Kangxi bestowed as gifts (20).

8 Qi, *Qingdai Neiwufu*; Torbert, *Ch'ing Imperial Household*; Rawski, *Last Emperors*. For the Manchu's intricate system of subordinating eunuchs to bondservants, see Qi, 42–51; Torbert, 1–12, 173–79. The term "personal bureaucracy" is from Silas Wu, *Communication and Imperial Control*, vii.

9 Qi, *Qingdai Neiwufu*, 134–45. The revenue figure is from Lai, "Neiwufu dangpu" 133; profit figure from Lai, "Shuiguan yu huangshi caizheng," 53. See also her *Qianlong huangdi* and "Qianlongchao Neiwufu de pihuo maimai."

10 Torbert, *Ch'ing Imperial Household Department*, 29. In 1796, the number of officials was 1,623, staffing about fifty-six subde-

partments (28–29). For a history of the key subdepartments, including the Privy Purse, see 32–39. For the titles and ranking of the officials, see Qi, *Qingdai Neiwufu*, 84–88. The overall positions in the department numbered over 3,000, ten times the size of the Ministry of Revenues, the largest agency in the regular bureaucracy (Du, *Baqi yu Qingchao*, 474–75).

11 Mukerji, *Impossible Engineering*, 216–23. A less powerful but just as omnipresent group of technocrats are Chinese itinerant assistants called *muyou* (friends of the tent), who thrived in the eighteenth and nineteenth centuries. They were outside the official bureaucracy but managed technical projects for the officials. See Folsom, *Friends, Guests, and Colleagues*.

12 For the formation of the Eight Banner system, see Elliott, *Manchu Way*, 39–88. The political and legal status of the bondservant is higher than that of household slaves (*qixia jianu*). Du Jiaji has argued that the latter is a "mean" (*jian*) category whereas the former is analogous to that of "free" (*liang*) people in society (Du, "Qingdai baqi nupuzhi," cf. Du, *Baqi yu Qingchao*, 445–55, 466; Elliott, *Manchu Way*, 81–84). The number of *booi* households in 1909 is estimated to be about 13,847, or about 11.7% of the overall banner population. The number was higher in the early Qing (Du, *Baqi*, 440–41).

13 In 1601, Nurhaci formally organized the *niru* into units of 300 members (Qi, *Qingdai Neiwufu*, 3–7, 29–32). Besides capture or punishment, some of the *booi* were adopted or married into their lord's families (17). *Booi* also served as soldiers before the formal establishment of the banner system in 1616 (18).

14 Qi, *Qingdai Neiwufu*, 36–41. According to Du Jiaji, the designations Three Superior Banners and Five Lesser Banners (that belonged to the princes) appeared only in 1651, after the death of Dorgon. The colors of the Three Superior Banners were Plain Yellow, Bordered Yellow and Plain White

(Du, *Baqi yu Qingchao zhengzhi*, 187–88, 203, 226–29, 264). See also 152–59 for the chronology of the evolving ranking of banner colors.

15 Kangxi established the first of six bondservant schools, School on Prospect Hill, in 1685. The initial enrollment of 360 was increased to 388 ten years later. Graduates became clerks or storehouse keepers. The schools held their own exams every three years. Besides schools that catered only to them, some bondservants also enrolled in schools for the rank-and-file bannermen (Torbert, *Ch'ing Imperial Household Department*, 37–39; Du, *Baqi yu Qingchao zhengzhi*, 373–86; Qi, *Qingdai Neiwufu*, 82–83).

16 Some even managed to have their status commuted to that of the rank-and-file bannerman (Du, *Baqi yu Qingchao zhengzhi*, 325–26).

17 Bondservants from the princely households (the Five Lesser Banners) also found employment in both the private and formal bureaucracies, but they were not eligible to be managers in the Imperial Household Department.

18 For two chief-managers of the Imperial Workshop who managed the European priests on behalf of the emperor Kangxi, see Chen Guodong, "Yangxindian zongjianzao Zhao Chang" and "Wuyingdian zongjianzao Heshiheng."

19 Kaijun Chen, "Rise of Technocratic Culture."

20 *Tang Ying quanji*, 1:7. I am indebted to Kaijun Chen who introduced this remarkable passage to me. My translation is adapted from his. See also discussion in Chen, "Rise of Technocratic Culture," 60. Tang entered in his notebook the name of at least one inkstone craftsman, probably with the intention of recruiting him to the palace workshop (*Tang Ying quanji*, 2.363). Tang noted his name as "Wang Yingxuan, an inkstone craftsman," his native place of Gaoyao, Zhaoqing, Guangdong, and his

juren credentials. I thank Kaijun Chen for this information. It is not known if Wang ended up serving; there is no record of his name in the Zaobanchu archives.

21 Shen ended his career as a hydraulic engineering and financial expert in the lucrative post of director-general of the Grand Canal. His role in the Fujian granary case is described in Liu Donghai and Wang Zhiming, "Yongzheng ruhe qianghua zhongyang jiquan." For the technical demands of the Director General of the Grand Canal, see Zheng Minde, "Qingdai Zhili hedao zongdu."

22 Xie, *Chuncaotang shichao, tizeng*, 1a.

23 The dedicatory poem for the inkstone, made of a fine Duan stone from an old quarry, is in Xie, *Chuncaotang shichao*, 2.9b; Xie's response to Shen's gift of the name Ruqi in the same rhymes is in 2.4b–5a.

24 Shen's tutelage in the hands of Xie can be gleaned in a minor incident. Xie acquired a She stone which Shen "marveled at" and proceeded to name *Virtue of Jade; Sound of Gold*, after a poem by Su Shi. Xie's poem commemorating this exchange reads in part like a lesson: "Of the many inkstones in this world, / The Duan and the She are both admirable. / Everyone values the Duan, / Ranking it before the She. / In truth She is especially fine, / In sound, color, and stone nature" (Xie, *Chuncaotang shicao*, 2.8b).

25 There is no direct evidence that the book was indeed submitted to Kangxi, but my guess is that it was for two reasons. First, self-recommendations to the throne by submitting one's artwork was common during the late Kangxi reign. Lin Ji, a calligrapher from Fuzhou, waited by the roadside in Miyun for Kangxi's entourage to return from a hunting expedition in 1706 to submit two volumes of Kangxi's poetry written in Lin's hand and in rhymed prose. Lin garnered a position as a copyist in Wuyingdian (Lin, "Xianfu shimo," 1a–5a, in *Puxuezhai wenji*). Second, three extant copies of Liu's *Lingyange* are found in the National Library

in Beijing (included in its collections are books from the Grand Secretariat and the Guozijian), along with an incomplete copy in Beijing University (Burkus-Chasson, *Through a Forest of Chancellors*, 309n9), suggesting that multiple copies reached the capital.

26 Besides the twenty-four chancellors, the set includes three portraits of the Bodhisattva Guanyin and three of Guandi, the god of war. This work is analyzed by Burkus-Chasson and reproduced in her book, *Through a Forest of Chancellors*. Liu Yuan's early career is gleaned from his "Zixu" (My own narration) to the illustrated book (Burkus-Chasson, 270–72). See also her reconstruction of Liu's life and relationship with Tong (172–83). Burkus-Chasson sees Liu as a conflicted Han Chinese subject who had to assimilate to Manchu rule. The *Qingshigao* mentions that Liu was a Hanjun, and Burkus-Chasson interprets the status as a reward (176) after his service in the Kangxi court. This is highly unlikely, for Hanjun is an inherited status granted only to those Chinese who submitted to Manchu rule before 1644. My interpretation of Liu's psychic life thus differs from hers. For studies on Liu as a designer of porcelain, see Cao Ganyuan, Tong Shuye, Lin Yeqiang, and Song Boyin.

27 Tong's preface to *Lingyange*, in Burkus-Chasson, 260–63. Translation adapted from Burkus-Chasson.

28 Liu Tingji, *Zaiyuan zazhi*, 1.15a. Although originality (*qi*) was valued in art and calligraphy, Liu Tingji's choice of adjectives, *guaipi*, is less than flattering. Tingji did transmit one (mediocre) poem by Yuan, but stated that Yuan "seldom wrote poetry, nor did he save any drafts." Liu Yuan's biography in the *Qingshi gao* is drawn largely from Tingji's account. Burkus-Chasson (174–76) has analyzed Liu's ambivalent self-presentation as a scholar in staging his portrait, executed by painter Zhang Yuan.

29 For models (*yang*), see Gugong Bowuyuan,

Gongting yu difang; Chen, "Rise of Techno-cratic Culture," 48–49.

30 Liu Tingji, *Zaiyuan zazhi*, 1.15a–b. The "hu" which Tingji mentioned as an example bearing Yuan's minuscule engraving can refer to either a tablet or an ink-cake; "hu," which means tablet, is also the counter for ink-cakes. Among the curios in Liu Yuan's collection, Tingji mentioned a mountain-shaped rock and a pillow he carved out of Canaan fragrant wood that cures bed-wetting (1.16.a). Among the objects he authenticated was a jade cup (1.15b-16a); he also offered opinion on the best materials for toggles of folding fans (4.29b).

31 Collector Zhou Shaoliang mentioned that after 1949, curators of the Palace Museum found ten of these identical boxes of *nanmu* wood, with fourteen ink-cakes in each (*Xumo xiaoyan*, 17). Lin Yeqiang, in turn, suggests that Qianlong had them boxed in eight mother-of-pearl inlaid lacquered boxes, each wrapped in yellow silk with woven *kesi* dragons (18).

32 His encomium on the ink-cake reads in part: "Your humble servant Yuan has been afforded extraordinary opportunities, having frequently served [your Majesty] by the stove and smoke [or soot, a euphemism for ink-cake]. And whenever I rendered my service with the painting brush, You showered gifts upon me." Since the ink was dated the third lunar month of 1678, Liu's service must have occurred before then. He might have painted murals; the *Qingshigao* mentions Liu's service as a painter of bamboos on palace walls.

33 In line with the multiplicity of the Qing persuasion, two other ink-cakes are in Buddhist imageries: pagoda and sutra on pattra leafs.

34 Quote from Liu Tingji, *Zaiyuan zazhi*, 1.15a–b. For efforts to identify his porcelain designs, see Lin Yeqiang, "Cangu yunxin", 16–22; Hay, *Sensuous Surfaces*, 155, 157. Among his characteristic traits are figures suspended in a blank ground and circular

swirls of waves. Lin also identifies sets of vessels made in the Imperial Porcelain Manufactory as Liu's design based on their dating to the 1680s. In their refined shapes and elegant silhouettes they bridge the "clumsy and heavy-handed" designs of the late Ming and the "elegant and refined" designs of the Yongzheng period (20). See also Cao Ganyuan (13) for his suggestion that a number of blue-and-white and red overglazed brush pots bearing calligraphy in regular script, which began to appear after 1681, as likely to be based on Liu's designs. For Liu's drawings of dragons, see a leaf from his *Forest of Chancellors*, Burkus-Chasson, 298. For dragons in early Chinese art, see John Hay, "Persistent Dragon."

35 Liu, *Zaiyuan zazhi*, 1.15b.

36 Referring to its design motifs, curators from the time of *Xiqing yanpu* on have called this inkstone "Paired Dragons" or "Paired Dragons Playing with a Pearl." Liu intended its name to be "Luminous Dragons" (Long Guang), as inscribed on a square seal in the box cover. Liu's mark on the inkstone is engraved in a flat clerical script and inlaid with gold, a ceramic technique. I viewed this inkstone on Nov. 5, 2012. In Qianlong's time it was placed in Yanchunge, a four-story tower in the Jianfugong garden built by Qianlong in 1742, according to the compilers of *Xiqing yanpu* (15.30a). For Yanchunge, see Berliner, *The Emperor's Private Paradise*, 76.

37 Yu et al., *Xiqing yanpu*, 15.30a–31b. This catalogue requires separate analysis as it lies outside the chronological scope of the present book.

38 The use of hydraulic engineering principles in inkstone-making in the Kangxi court is evident in a genre of "heated inkstones" (*nuanyan*), outfitted with some heating device to keep the ink from freezing in the frigid winter. Heated inkstones had been made in previous centuries, but the ones made in the early Qing court are especially

elaborate; see one made of green Songhua stone fitted on a cloisonné brass brazier, in *Zhongguo wenfang sibao quanji: Yan*, no. 190 (figures, 179; captions, 95); Zhang Shufen, *Wenfang sibao: Zhiyan*, 111.

39 Seal on box: "Servant Yuan" (Chen Yuan). Traditionally, the box is made after the inkstone is completed. Curiously, the date Liu Yuan inscribed on the box, the seventh month of 1678, is ten months earlier than the date on the inkstone. For "demonic craft," see chapter 3. Ji Ruoxin gave a succinct explanation of how the nested layers of the ivory ball are fabricated from the inside out in *Shuangxi wenwu suibi*, 62–63.

40 Liu, *Zaiyuan zazhi*, 1.15b. This is not entirely true, for Qianlong ordered Liu Yuan's inkcakes copied.

41 Domestically produced glaze was successfully manufactured the latest by 1728. Yu Peijin, "Tang Ying"; Ji Ruoxin, "Ji yijian Kangxi chao"; Xu Xiaodong's chapter in Gugong Bowuyuan, *Gongting yu difang*, 277–335; Chen, "Rise of Technocratic Culture," chap. 6.

42 Jonathan Hay has spoken of three systems of tastes that influenced one another: the highly controlled court, urban spectacle, and literati understatement (*Sensuous Surfaces*, 27–40). See also his revised chronology of the development of Ming-Qing material cultures in "Diachronics."

43 The nineteenth-century Hanlin academician Wu Zhenyu (1792–1870), deducing from boxes of Songhua inkstones stored in Duanningdian, suggested that Kangxi, Yongzheng, and Qianlong all used Songhua inkstones (Wu Zhenyu, *Yangjizhai conglu*, 26.5b). Ji Ruoxin (*Shuangxi*, 133) thinks that they are gift inkstones. For an organic clam-shaped Songhua inkstone from the Kangxi reign, see Ji, *Shuangxi wenwu*, 145, cf. 130–31. Kangxi's gourd-shape inkstones appear more mimetic (fig. 1.1a–c; cf. Luo Yang, "Xiqing," 20), whereas Yongzheng's are more abstract. A particularly graceful example of the latter is one used by Yong-

zheng himself, in Feng, *Yongzheng*, 184 (no. II-14). See another in Zhang,*Wenfang sibao*, 118 (no. 78).

44 For some of the finest examples of Songhua inkstones made in the Kangxi court, see Zhang Shufen, *Wenfang sibao*, 108–11 (nos. 68–71); Guoli Gugong, *Xiqing yanpu guyan tezhan*, 357–64 (nos. 77–78). The majority of Songhua stones are in various shades of green, some solid in color and some in stripes. There are also stones purple in color. Kangxi discovered the fish fossil and ordered his artisans to polish and encrust them on the lid of inkstone boxes. He specified that they were to be fitted with Songhua inkstones. *Kangxi jixia gewubian*, 10b–11a, in *Shengzu Renhuangdi, di siji*. See image of one such boxed set in Hay, *Sensuous Surfaces*, 259 (fig. 155). According to Ji Ruoxin, the glass-encrusted cases were made only during the Kangxi reign, as were inkstones with mother-of-pearl encrusted in the water pool (Ji, "Yongzheng huangdi yuci," 45). This is not entirely true. Yongzheng ordered his artisans to remove the carved immortals on the cover of an inkstone box made of purple stone and fit them on a *zitan* wood incense table. In their place on the cover, he ordered a replacement of plate glass (zbc 2.687 [1727.09.26]).

45 Yongzheng ascended the throne on the twentieth day of the eleventh month, 1722. The first entry of the archive appeared on the first day of the first month, 1723. Over 5,000 bound volumes of the Zaobanchu archives are extant, covering the years 1723–1911. Housed in the First Historical Archives in Beijing, the records of the Huoji Fang exist in two formats: the original log (*zhiyi titou didang*, or *didang*; aka *liushui dang*), recorded by the day of the arrival of the imperial order, and the edited copy (*gezuo chengzuo huoji qingdang*, or *tengqing dang*; *qing dang*), made by copyists later and organized by date and categories of things to be submitted for the emperor's approval and the auditing office. The fact that both

have *Yongzheng xx nian gezuo chengzuo huoji qingdang* written on their covers has led to confusion among scholars. Both sets have been available in print since 2005 (cited in the present book as ZBC). Besides logs of orders and artifacts, the archives also include records of the working schedules of artisans, logs of incoming tribute items, and over 70,000 pieces of edicts, communiqués, inventory lists, and so on in loose-leaf form. "Qianyan," ZBC vol. 1; Wu Zhaoqing, "Qing Neiwufu Huojidang"; Wu, "Qingdai Zaobanchu"; Ji Ruoxin, "Qianlong shiqi de Ruyi guan," 128–30. The *Suandang fang* was renamed *Chahe fang* in 1748.

46 Prince Yi (1686–1730), Kangxi's thirteenth son, was a highly capable technocrat. Besides the imperial workshops, he was also in charge of the Three Vaults (of Silver, Piece Goods, and Miscellany) of the Ministry of Revenue and hydraulic works near the capital. For an inkstone purportedly used by him and bearing his "portrait" holding an ink-slab in his hand on its back, see Cai, *Zhonghua guyan*, 48–51. The old man dressed in Chinese scholar garb does not at all resemble a semi-official portrait of the prince at the Arthur M. Sackler Gallery (reproduced in Hay, *Sensuous Surfaces*, 38, fig. 17).

47 On the basis of Yongzheng's reform, the mature form of the administrative structure of the Zaobanchu in the Qianlong years was: Director of Section—Vice-Director of Section—Secretary (Deputy Secretary)—Storehouse Keeper (Deputy Storehouse Keeper)—Clerk. Qi, *Qingdai Neiwufu*, 82. The storehouse keeper and clerk titles were unique to the Imperial Household Department. For the use of terms connoting parity in official communiqués, see Zhu, "Foreword," 2, in *Yangxindian Zaobanchu* (hereafter YXD). For the addition of new offices whose duties were to supervise the craftsmen, see Ji Ruoxin, "Cong Huojidang kan," 72.

48 This system was initiated by Shunzhi (r. 1644–1661), who in 1645 abolished the system of hereditary craftsmen in operation since the Mongol Yuan (1271–1368) period (Gugong Bowuyuan, *Gongting yu difang*, 177–78, 233–34). See also Zhu Jiajin, "Foreword," 1–6, in YXD. The trainees ("learning hands") are called by different names: *xueshou yiren* (YXD 86), *xueshou jiangren* (52), *xueshou yujiang* (177). For the recruitment and remuneration of the "craftsmen from the south" (*nanjiang*) during the Qianlong reign, see Ji Ruoxin, "Qianlong chao Neiwufu Zaobanchu nanjiang."

49 The term "agora" is Schäfer's, in *Cultures of Knowledge*, 157–59. See chapter by Luo Wenhua (127–46) for the contributions of foreign craftsmen in the Qing court. For a selection of innovative ware (notably porcelain in Song glazes but novel shapes, thin-body agate bowls, painted enamel vases, and a cloisonné *dou* vessel) made in the Yongzheng-era Imperial Workshops, see Feng, *Yongzheng*.

50 YXD 2, 3, 10, 25, 48, 69, 86, 187, 234. Yongzheng also commanded his lacquer craftsmen to imitate a lacquer box so that the decorative motifs can "sink deep to the bones," 235. Ji Ruoxin has suggested that "cultured" (*wenya*) encapsulates Yongzheng's taste and that the refined taste of the Jiangnan workshops, especially Suzhou, is evident in his imperial style (Ji, "Qing shizong de yishu pinwei," 400, in Feng, *Yongzheng*). See also her summary tables listing the adjectives and remarks Yongzheng used or made (408–10). Zhang Liduan discerns that Yongzheng had more of a definite style in mind when he issued orders whereas Qianlong used the models to communicate with artisans in the interest of soliciting the latter's response (Zhang Liduan, "Cong Huojidang kan," 53).

51 YXD 120 (1728.05.04).

52 YXD 17. Yongzheng's interest in alchemy is evident in the Zaobanchu archives. For example, he asked Haiwang, "What is the composition of the crucible for heating gold amalgam sent by Nian Xiyao?" (YXD 269).

See other examples in Yang Qiqiao, "Huo-jidang baolu Qinggong mishi."

53 He wanted several coral belts made from the model of a carved peach-shaped coral box with Song dragons: "If no one in the palace workshops is up to the task, when someone is going to Guangdong, have him ask the artisans there to make it according to the model" (YXD 122). He sometimes asked specific artisans to take on a task, e.g., after complaining about the "vulgar" Falang ware and the shoddy materials, he commanded in the remakes, "have He Jinqun paint them" (YXD 123).

54 Yongzheng also paid meticulous attention to calligraphic styles and the carving of inscriptions. For example, he mandated the brush strokes of encomiums on inkstones to be less formal and more cursive. YXD 25 (1724.09.04).

55 YXD 53. See also similar warning regarding a drum set (YXD 144).

56 In the Zaobanchu archives the words "inside" and "outside" were routinely used, fostering a sense of exclusivity of the inside. But they are relative categories. A memorial from Haiwang seeking permission to commandeer some vases from the warehouse to use as models (YXD 195), "inside" refers to the store room manned by the head eunuch, and "outside" is anywhere outside of it, including the halls and workshops in the palace compound.

57 In a 2006 study of the Porcelain Manufactory, Yu Peijin cites this passage as proof that there was a preexisting imperial style ("Tang Ying yu Yong-Qian zhiji," 12–13). Her interpretations changed; in a 2009 essay she writes that in mandating the making of models, "The emperor is concerned not only with the exterior styles of an object, perhaps he also intends to emphasize the procedure of 'seeking prior approval of models' in the process of making things" (Yu, "Jiangzuo zhi wai," 416, in Feng, *Yongzheng*).

58 The mechanism of quarrying awaits further research. In 1730, Yongzheng anticipated that the supply of green Songhua stone in his warehouse was near depletion and sent an edict to his "Ula general" stationed in Ningguta to send in a supply. Seven months later, fifty-one stones arrived. YXD 188–89 (1730.12.29; 1731.07.17). This appears to have been a routine procedure. For the locations of some of these quarries and their revival after 1949, see Ji Ruoxin, *Shuangxi*, 127; Xia, "Pin lie Duan She."

59 Inkstone-making was dispersed in the Qing palace workshops. In the Yongzheng era, inkstones were made not only in the Inkstone Works, but also in the Ivory Works, Jade Works, and Miscellany Works. Although evidence is scant for the Yongzheng reign, in early Qianlong the Inkstone Works used mostly Songhua stone. Later, in mid-Qianlong period, the Inkstone Works was absorbed into the Gold and Jade Works. In late-Qianlong, the Ruyiguan, the primary workshop for painting, took on such new tasks as making inkstone boxes (Ji Ruoxin, "Qing qianqi Zaobanchu," 4n15, 18; "Qianlong shiqi de Ruyiguan," 140–41).

60 We know the names of three "inkstone craftsmen" from the Yongzheng era (Huang Shengyuan, Wang Tianque, Tang Chugang) only because Vice-Director Haiwang singled them out for bonuses (YXD 212 [1731.05.19]).

61 Ji Ruoxin discovers Shi Tianzhang's background as a Jiading bamboo carver in "Cong Huojidang kan" (63), her informative study of artisans who acted as "artistic consultants" in the Yongzheng and Qianlong courts. Shi Tianzhang's place of abode is named in a commendation by Haiwang, YXD 211 (1731.05.19). He remained in court in the early years of Qianlong's reign (YXD 177).

62 For Yuan's authentication of the fake eye, see ZBC 1.367; YXD 24 (1724.02.04). He was specifically asked to "authenticate and rank" six boxes of ink-cakes. ZBC 2.241 (1726.04.12). Cf. Ji, "Cong Huojidang kan," 58–62. Yuan is likely to have entered the

court during Kangxi's reign, but disappeared from the records after 1727 according to Ji.

63 ZBC 1.367; YXD 24 (1724.02.04). One can imagine this scenario: Gu, not daring to ruffle imperial feathers, deliberated on the technicalities involved in his judgment. Prince Yi, knowing that the emperor would defer to the experts, did not transmit the explanations, hence the logbook records only the verdict. It is unclear if this Gu Jichen 顧吉臣 is the same person as the earlier-named Gu Jichen 顧繼臣. The sleuthing of Ji Ruoxin yields inconclusive results. See her "Cong Huojidang kan," 62–63, 92, 94; "Qianlong shiqi de Ruyiguan," 143n91.

64 The green "Duan" (lü Duanshi) in Qing court records is not a Duan stone from Guangdong (which does produce a green stone called "green Duan"), but a Songhua stone. The entry "The green 'Duan' stones for inkstone-making in the Imperial Workshops are tributes from the Ula General" (1730.12.29) made this clear. Cf. Ji Ruoxin, Shuangxi, 126–27.

65 ZBC2.501; YXD 87 (1727.07.27).

66 ZBC1.418; ZBC1.552 (1725.06.04); YXD 42 (1725.08.21). The lacquered boxes originally contained snuff bottles. Jonathan Hay describes the making of "composite objects" by boxing them, along with putting them in frames and on stands, as part of a strategy of "distribution" that multiplies the viewer's pleasure. Sensuous Surfaces, 251–55.

67 ZBC5.292; ZBC5.584 (1732.08.15). Zhu Jiajin (YXD 220) mistook the date to be 1732.08.23. Nian sent in a lot of thirty-six boxes sixteen months later, ZBC6.311–12 (1734.01.07).

68 ZBC3.275; YXD 86 (1727.03.24). Bondservant Tang Ying, then a vice-director in the palace workshops, decided on the number of replicas (four) upon consultation with his colleague Shen Yu. Black lacquered boxes were made in multiples in 1734 (YXD 137, 273). Yongzheng once paired "cultured" with "plain" (sujing) when he complained

of a badly made lotus inkstone. Adding carvings onto the naturally occurring stone "eyes" is an affront to the "cultured and plain" look (YXD 120 [1728.05.04]).

69 YXD 239 (1727.09.26). I deduce the color of "West Hill stone" by comparing the verbal description of the bamboo box with the actual object in the National Palace Museum.

70 In the Yongzheng workshops, some models for inkstones were drawn before work was authorized. An example is a model for an ink-slab called Ever Growing Ever Lasting, with coordinated water dropper and vase, drawn by artisans in the Miscellany Works (ZBC2.762; YXD 101 [1727.03.10]). Other models were actual objects. For another order of copying an earlier inkstone made in the imperial workshops, see YXD 239 (1732.02.01). Yongzheng was so set on leaving models for his artisans to copy that he sent Haiwang to retrieve a gift inkstone he had bestowed upon Prince Guo earlier so that a model could be made. He also stipulated that workshop trainees practice their craft by making several replicas of it (ZBC2.455; YXD 86 [1727.run3.03]). Once Yongzheng ordered a "small model" (xiaoyang) to be made of a brocaded inkstone box (YXD 185 [1729.01.11]).

71 Some of these stones are named after their origins, e.g., Wuding stone, Guandong (ZBC3.275–76) or Hu-Guang (ZBC3.275). Others are named after their features, e.g., Yellow Wax (YXD 83) or Five Fortunes (ZBC3.276; YXD 86/126). They are likely to be tributes from local officials. An inventory list of the storehouse at the end of 1735 shows a huge cache of these and other stones, including 725 pieces of raw Guandong inkstones, ninety-seven Five Fortunes stone beads, forty-eight Wuding stones, and eight strips of Duan stone (6.792–93). There was no Songhua stone in stock.

72 Yongzheng wanted the box to be fitted with a green "Duan" stone. Zhu Jiajin mistook Wuding stone as Dingwu (YXD 171 [1729.02.08]).

73 ZBC3.792; YXD 172 (1729.04.30). When completed, the former was fitted with a *zitan* wood stand inlaid with gold-plated copper wire. It is not clear whose decision it was. The agate box was fitted with an Ula inkstone on Yongzheng's order.

74 ZBC5.7; YXD 206 (1731.09.23). Although Yongzheng had ordered stone boxes fitted with glass plates on top, these appear to be entirely made of glass. The boxes were made in one month and submitted on the 28th day of the tenth month.

75 ZBC 1.370 (1724.11.29). It must have been a sizable box, for the knickknacks included two ink-cakes, folded ruler, an opener, a brush stand, a pocketknife, and a pencil. When done (1724.12.05), Yongzheng asked to have the ink-cakes, brush stand, pocketknife, and pencil removed and a set of compass and square added. The order was completed 1725.04.12.

76 ZBC 3.791–92; YXD 172 (1729.04.18). I have not been able to locate this item in the extant court collections.

77 ZBC3.792; YXD 172 (1729.04.30). The red stone is a "Bug-Hole stone" (Zhu misread "bug" as "snake"). For potted sceneries, see for example ZBC1.551 (1725.02.29). They are meant to be fitted under domed covers of glass or gauze, as evidenced by frequent orders to the Glass Works, although extant samples are not shown with them. For "architectural envelope," see Hay, *Sensuous Surfaces*. See also two images of potted sceneries made in the Qianlong court, 316–17 (figs. 181–82). For depictions of illusionistic architectural space in the Qing court, see Kleutghen, *Imperial Illusions*, 245–52.

78 Since the early empire, a tribute system ensured that the best products from each locale were conveyed to the center annually as material embodiment of local imminence. As described in the *Tribute of Yu* in the classic *Book of Documents*, these tribute goods have economic and symbolic values.

79 Dong, "Qing Qianlong chao wanggong dachen." Cf. Hay, *Sensuous Surfaces*, 50–51.

80 For the Ryūkyū gift, see ZBC3.799 (1729.10.23); for the Xisha tribute of Tuoji stone, see ZBC3.799; YXD 174 (1729.11.01). Yongzheng ordered the six polished into inkstones, a task completed on the 28th day of the twelfth month and at which point they were fitted with "Butter stone" boxes. The Tuoji is a greenish-black stone that resembles She stone; they were also found on the islands off the shore of Shandong (Kitabatake, *Chūgoku kenzai*, 43–45; cf. Guoli Gugong, *Lanqian shanguan*, 364).

81 For tribute inkstones from Zhaoqing in the Song and Ming dynasties, which includes raw and carved stones, see Wu Lanxiu, *Duanxi yanshi*, 41; Chen Yu, *Duanyan minsu*, 40–41. Although the Qing court valued Songhua stones, tribute stones from Zhaoqing did not abet. For the memoirs of an officer tasked with selecting and conveying Duan stones in Zhaoqing in 1777, see Zhu Yuzhen, *Duanxi yankeng zhi*.

82 My survey is limited only to Qing scholars who appear in the present book. Those who received Duan inkstones from Yongzheng include Chen Zhaolun in 1724 (*Zichu shanfang shiwenji, nianpu* 14a) and Yu Zhen in 1727 (*Yanshi* C2.4a). Shen Tingfang (Preface to Wu Shengnian, *Duanxi yanzhi*, 1a–b) received one from Qianlong in 1736. Li Fu and Zhou Shaolong (*Yanshi* C8.28a–b) were gifted Songhua inkstones by Yongzheng.

83 Wang Shizhen, *Xiangzu biji*, 132. His student, Li Zilai (1650–1728), served as a junior prefect in Fengtian (Shenyang). Wang did not say that the inkstone was an imperial gift, and it is possible that Li procured it from locals in Manchuria. See also Wang's well-placed friends who were the first to have received gift Songhua inkstones in 1702, *Xiangzu biji*, 17. One particularly inventive maki-e lacquer inkstone box is a composite object that also contains four pieces of ink-cakes. The connoisseur Ji Yun mistook a Songhua stone for a She and was corrected by an "old inkstone worker Student Ma" (*Yuewei caotang*, 10b).

84 Lin, *Yanshi* C8.28a–b. "Hewing to quietude in action, / Thus the years everlasting" is a favorite expression of Yongzheng. It was engraved on so many Yongzheng inkstones that it might as well be his trademark (fig. 1.11B), albeit it cannot be used for dating because Qianlong followed suit. It is hard to shake off the suspicion that the Chinese scholars did not like the color and touch of Songhua stones but could not voice their feelings. Silence was the only prudent response.

CHAPTER 2. YELLOW HILL VILLAGES

1 Administrative boundaries on the city and county levels shifted multiple times in the area, leading to a confusion of names. Duanzhou was renamed Zhaoqing in 1118 during the reign of Song emperor Huizong. The city of Zhaoqing today encompasses an area of 14,822 sq km, much larger than the early modern walled city. I use the shorthand "Duan area" (after the ancient name Duanzhou) to refer to the general area of Zhaoqing walled city, the city of Gaoyao across the Xi River, the Yellow Hill (Huang Gang) villages on the eastern outskirts of the walled city, as well as the quarries in nearby Mount Lanke and Beiling. I call all stones mined from the area Duan stones. Today, Huang Gang is divided into an upper and a lower village; White Stone (Bai Shi; 4,100 residents) and Bin Ri, bastions of inkstone making, are part of the latter (Chen Yu, *Duanyan minsu kao*, 15–18).

2 Sixteenth and seventeenth-century writings give the iconic number of five hundred households employing female hands in Huang Gang (see the epilogue). There is some indication that in the Song, most inkstones exported from Duan to the central plains were finished products carved in Duanzhou (e.g., Su Yijian's description discussed later), although Mi Fu mentioned that some Duan natives sold uncarved raw stones (*Yanshi*, 8). By the Ming-Qing period, the trade had become bifurcated.

The Yellow Hill carvers made ordinary inkstones whereas the exquisite stones were carved in workshops in Suzhou and elsewhere from raw blocks exported from the Duan area. This crucial transition awaits further research.

3 Duan stones were mined as early as the Tang, but the discourse of their superiority (especially compared with the rival She stones from Longwei) did not emerge until the Song. The Southern Song writer Zhang Bangji (fl. 1131) was among the first to proffer this opinion. *Mozhuang manlu*, 209–10. The Qing writer Ji Nan cited Su Shi's saying that ink slabs made of Duan stones first appeared during the reign of emperor Gaozu of the Tang (r. 618–26) (*Shiyin yantan*, 1767). Cf. Liu Yanling, *Duanyan de jianbie*, 3.

4 Green and white Duan stones also exist, but are quite rare. White Duan stones, rich in mica, were formed 70 million years later than the purple and green ones. For geological formation and qualitative analysis, see Gao Meiqing, *Zishi ningying*, 137–49; Liu, *Duanyan de jianbie*, 17–19, 24–26; Duanyan daguan bianxiezu, *Duanyan daguan*, 1–32.

5 The expressions *famo* and *sunhao* originated with Su Shi, who compared the frustration of using a slow inkstone that does not activate ink with riding a dumb horse. Cited in *Duanyan daguan*, 104. The expression *famo er bu sunhao* is used by Qing connoisseur Chen Gongyun (1631–1700), in *Duanyan daguan*, 5.

6 This functionalist explanation, one proffered by Guangdong scholars today, tells only part of the story. In itself it does not explain the overwhelming preference among Chinese scholars of Duan over She or Songhua, equally fine stones in terms of use. The ability of Duan stoneworkers to maintain a steady supply through the centuries (whereas many of the She quarries became depleted in the Ming), not to mention the former's cunning in manipulating the connoisseur's discourse recounted later

in this chapter are important factors behind the domination of Duan stones.

7 Mi Fu, *Yanshi*, 2; Van Gulik, *Mi Fu on Inkstones*, 31–36. Most of the English translations from this work are my own; occasionally I adapt them from Van Gulik's. I cite Van Gulik's translation, which derives from his master's thesis and contains a considerable number of errors, for the benefit of readers who do not read Chinese. An ancient road over thirty meters long that traversed the Mei Ridge (Mei Ling), separating Guangdong from the rest of the empire, was opened in the eighth century, around the time Duan stones became valued in the central plains. Beyond the pass the Duan stones were conveyed by land and the Grand Canal system to the core of the empire in the north (Chen Yu, *Duanyan minsu*, 11, 148–49).

8 Another legend about the felicitous union between stone and writing features Provincial Graduate Liang from Duanzhou who traveled to the capital to sit for the exam in the late Tang. When the temperature dropped and his ink became frozen, Liang was saved by the stone, which remitted warmth when he breathed on it. He captured the highest honor (Liu, *Duanxi mingyan*, 33). For this and a variant featuring a poor student called Ah-Duan, see Chen, *Duanyan minsu*, 193–94. Transmitted by contemporary Zhaoqing-based scholars, this story circulates widely in the Duan area but is not found in the historical record. Taken together, this and the one told by He Wei suggest that such legends originated in the Duan area.

9 He Wei, *Chunzhu jiwen*, 9.2b–3a.

10 Some writers construed "child stone" in a magical mode, as one stone giving birth to another, whereas others took it to mean as the embedding of one round stone within another (e.g., Ouyang Xiu, *Yanpu*, in *Duanyan daguan*, 102). On child-stones, see Van Gulik, *Mi Fu on Inkstones*, 32–36; *Duanyan daguan*, 152–53. For a smattering

of lore about the affinities between the inkstone and water and its variant, between the inkstone and fishes in water, see Yu Huai, "Yanlin," 42.2b–23b.

11 Interviews with workers at the Zhongyi Duan Inkstone Factory, Nov. 25, 2007. Many of the quarries are located deep in the mountains and are only accessible by steep hiking paths. Stoneworkers sometimes camp out for a fortnight in caves or tents near the quarry. For such a prolonged operation, each brings forty to fifty chisels. Even for a one-day operation, they need about half the number (Chen, *Duanyan minsu*, 51).

12 Chen, *Duanyan minsu*, 48–50. My description of tool-making and other Duan rituals in this chapter is indebted to Chen Yu's interviews with stoneworkers in 2004–2009.

13 Chen, *Duanyan minsu*, 49–50.

14 Chen, *Duanyan minsu*, 50. Claims of family secrets should not be taken at face value. Similarly, Jacob Eyferth interprets the claims of secrecy of papermaking families in Jiajiang, Sichuan, not as an empirical statement, but as a statement of their control of market share against potential competitors. Other than the composition of the pulp, the skills involved in papermaking are socially distributed throughout the community and can be readily observed (*Eating Rice from Bamboo Roots*, 32, 39).

15 Several incidents of mining accidents are recorded in history, the most famous one being the collapsed tunnel of Little Pit in 1065, which buried the eunuch official in charge and scores of stoneworkers from Jiangxi. In 1781, mining at Old Pit was halted when a tiger appeared (Wu Lanxiu, *Duanxi yanshi*, 48, 51). For the various ceremonies the miners staged at the quarries to pray for safety and for their ghost stories, see Chen, *Duanyan minsu*, 86–92.

16 This version that circulates in the Duan area is slightly different from the one reconstructed by historian Steven Sage from several written accounts: *Shuwang benji*,

attributed to Yang Xiong (53 BCE–18 CE); "Mianshui," in *Shuijing zhu*; "Shu zhi," in *Huayang guozhi*. Archaeologists have shown that the road was built by boring holes in the cliff that supported beams on which wooden planks were laid (*Sichuan and the Unification of Ancient China*, 108–12).

17 This conjecture is based on the fact that these officials composed poetry when visiting scenic sites and had them carved on steles in situ. The earliest of these extant steles mentioning Wuding is dated Duanping 2 of the Southern Song (1235 CE), in the Seven Star Rocks (Qixing Yan) in Zhaoqing. Also extant are ones from the Yuan (1292 CE) and late Ming (1637 CE) (Chen, *Duanyan minsu*, 94–96). Since the scholars did not carve the stones themselves, they are likely to have hired local stonecutters.

18 Yuming He has suggested the useful notion of "book conversancy" instead of literacy (*Home and the World*, 7–8, 16, 248). For a discussion of gradations of literacy in the Qing, see Brokaw, *Commerce and Culture*, 470–75.

19 Chen Yu documents in some detail the business practices of the inkstone trade in Yellow Hill, especially of its two guilds (called *tang*)—mining and inkstone-carving—in the early twentieth century (*Duanyan minsu*, 132–46). The guilds ceased functioning in 1949. Some families in Bin Ri village held on to their legers (*changsheng bu*, *changsheng shoujin bu*, which reveal how the guilds operated loan associations. Although Chen alleges that the guilds dated to the Ming on the basis of the dating of two Wuding tablets (132), further support is necessary.

20 Chen Yu (96–99) found three extant Wuding tablets in the Yellow Hill villages. The two Ming tablets are in the ancestral hall of the Yang lineage in Bin Ri village, still active in inkstone-making today. I have not been able to examine these tablets in person. Judging from the published photographs, they could be from the second half of the

Ming, or sixteenth to seventeenth centuries. The third tablet (1946) is in White Stone village, another bastion of inkstone craft. For other details of the celebrations on Wuding's birthday, see Chen, *Duanyan minsu*, 182–88.

21 Chen, *Duanyan minsu*, 87–92. The date of this stone is not known. The entrance to the Old Pit has moved several times during history. Near the eighteenth-century entrance, a military officer consecrated another stone in 1689 that reads "Tutelary god" (89). For jargons in the stonework trade, see Chen, 101–6. Also relevant are the Cantonese songs of the stoneworkers (one was carved on stone near the Pockmark Pit in the 1930s), 203–10.

22 James Hayes' classic study of village literacy describes the preponderance of scribes and ritual specialists. This study is most relevant here, not least because his site of fieldwork is in the same southern region as Zhaoqing ("Specialists and Written Materials," 75–111).

23 Chen, *Duanyan minsu*, 182.

24 Examples abound. One of my favorites is the early Qing loyalist scholar Lu Liuliang's (1629–1683) *Ploughing Stone*, which is a veritable stele bearing two encomiums describing his uncompromising attitude: "[It suffices one to] plough a field of stone and to quell hunger with ink" (Guoli Gugong, *Lanqian shanguan mingyan mulu*, 74–75, item 18).

25 In his substantial study of stele-carvers from the Tang to the Republican periods, Cheng Zhangcan documents the lowly status of the carver, but shows that the profession became more respectable during the Ming as more educated carvers such as Zhang Jianfu and son Zhang Zao entered the trade in the Jiangnan area and established family businesses by socializing with the scholars (Cheng, *Shike kegong yanjiu*, 140–68).

26 In Dongyu village, the Liang lineage carved its regulations on a stele, dated 1731. For a complete text, see Chen, *Duanyan minsu*, 220–22.

27 In terms of the skills required, quarrying and inkstone-carving are separate trades. Although neither has any use for written manuals, inkstone makers in Yellow Hill are more likely to be literate, as evidenced by the signature and other inscriptions they left in the nineteenth century (e.g., Chen, *Duanyan minsu*, 246, 249, 317).

28 The manner of court supervision or appropriation differs from dynasty to dynasty. The Northern Song and Ming courts dispatched eunuchs to supervise the mining operation of the choicest quarries on site. The Qing lifted the ban, allowing private prospectors to mine all the quarries except the Underwater Lode, which required heavy financial investment and approval of the local prefect, who often chipped in a share. For Pockmark Pit, approval of the magistrate sufficed (Li Zhaoluo, "Duanxi yankeng ji," 85). Cf. Chen, *Duanyan minsu*, 40–41.

29 Some of the quarries are named after prospectors according to Duan-originated lore. The prestigious Shui Yan (Underwater Lode), some locals claim, is so named not because it is submerged under water according to scholarly discourse, but because it was discovered by a stoneworker Yang Ah-shui (Chen, *Duanyan minsu*, 48, cf. 8). The Pockmark Pit was discovered by Pockmark Chen, and so on (48, 321–24).

30 The Old Pit was mined only on demand of the court for tribute stones before the Qing. Since precise knowledge of the exact years of operation aids the connoisseur in dating and identifying stones, it receives much attention. For a summary discussion, see Liu Yanling, *Duanyan de jianbie*, 14–17.

31 Li Zhaoluo, *Duanxi yankeng ji*, in *Meishu congshu*, 1.85. For a biography of Li, see Ye Yanlan and Ye Gongzhuo, *Qingdai xuezhe xiangzhuan heji*, 321–22. For descriptions of the logistics of modern mining and labor practices, see Chen, *Duanyan minsu*, 54–68.

32 The term "skeleton" is from Li, *Duanxi yankeng ji*, 84. The implication is that if the skeleton is weakened, the shaft may collapse.

33 The "parts" are called "days" (*ri*), in the Qing (Li, *Duanxi yankeng ji*, 85).

34 The term is in Liu, *Duanyan de jianbei*, 42; Chen, *Duanyan minsu*, 45–6.

35 Su, *Wenfang sipu*, 3.2b. His preamble, "It has been said," suggests that the terminology of "patterned principles of the lode" was already in circulation in Su's time. Cf. Tang Xun, *Yanlu*, in *Duanyan daguan*, 101.

36 As Mircea Eliade observed, mining and metallurgy in many civilizations were sexualized and understood in terms of gynecology and obstetrics—the ores are embryos of the Earth Mother (*Forge and the Crucible*, 26–33). In this world of creation-as-procreation, the metalsmith's tools are sexualized and endowed with magical powers.

37 For the intellectual history of the rise of the scholar group in the Northern Song, see Bol, *"This Culture of Ours."* For an analysis of the gendered dimension of this process, see Bossler, *Courtesans, Concubines, and the Cult of Fidelity*, parts 1–2. The centrality of inkstones and writing implements in the lives of these men is outlined in Yanchiuan He, "Materiality of Style and Culture of Calligraphy."

38 A pioneer of antiquarian collecting, especially of rubbings from ancient vessels (*jinshi*, or metal and stone), is Ouyang Xiu (1007–1072). See Egan, "Ou-yang Hsiu and Su Shih on Calligraphy." On "characterology," see McNair, *Upright Brush*. On antiquarianism, see Miller and Louis, *Antiquarianism and Intellectual Life*, and Hung Wu, *Reinventing the Past*.

39 Yanchiuan He, "Materiality of Style," 89, 103. In *Yanshi*, Mi Fu mentioned that he made a jade inkstone and another using a purple stone in a Jin style. He also tried to improve carved inkstones by recarving them (1, 7–8); Van Gulik, *Mi Fu on Inkstones*, 28, 47–50.

40 According to Yanchiuan He, the actual name "four treasures" first appeared in the works of Mei Yaochen (1002–1060). About a century later, another literatus Li Demao used "four friends." "Materiality," 56–57.

Han Yu's essay is "Miaoying zhuan" (Biography of fur point).

41 Su, *Wenfang sipu*, 3.3b.

42 Clunas, *Empire of Great Brightness*, 132. Thus turning Aristotelian analytic logic, the foundation of modern science, on its head, Clunas has provided an alternative yardstick for judging the validity of the traditional Chinese approach to connoisseurship in particular and knowledge-making in general.

43 The former quote is from Sturman, *Mi Fu*, 90; the latter is from Ledderose, *Mi Fu and the Classical Tradition*, 5.

44 Mi Fu did not stipulate that his list of the twenty-six inkstones is ranked, but his comments make it clear that the first stone mentioned, a jade inkstone he made himself, is his favorite. Second comes the Immortal Ge rock in Fangcheng and third, the stone from the Huayan Nunnery in Wenzhou. None of Mi's contemporaries mentioned these stones, but Mi deemed them superior to Duan stones (fourth in place) and She stones (fifth) then in vogue because they produce ink faster without generating heat (Mi, *Yanshi*, 1–3; Van Gulik, *Mi Fu*, 28–47).

45 Mi, *Yanshi*, 1–2; Van Gulik, *Mi Fu*, 30, 32. Van Gulik praised Mi Fu's insistence on personal observation, independent investigation and eschewing supernatural phenomena associated with mining as "scientific" (58, 62). I have discussed my disagreement with van Gulik's assessment in "R. H. Van Gulik, Mi Fu, and Connoisseurship."

46 Mi, *Yanshi*, 7; Van Gulik, *Mi Fu*, 47.

47 Mi Fu's ranked list is a rebuke of Tang Xun's (1005–1064) *Yanlu*, which lists Upper Rock first, followed by Lower Rock, Xi Keng (West Pit) and Houli. *Duanyan daguan*, 101. The rivalry of She and Duan stones was unsettled in the Song. With the decline of She mining in the Yuan and especially after the (re)opening of Duan Old Pit in the Ming, Duan stones became the unsurpassed leader unto the present day, to the chagrin

of She natives and collectors. For the major quarries in Ming-Qing China, especially She, see Hu, *Zhongguo shiyan gaikuang*, and Kitabatake, *Chūgoku kenzai shūsei*.

48 Mi, *Yanshi*, 2; Van Gulik, *Mi Fu*, 32. Scholars have debated for centuries if Mi Fu's Lower Rock (Xia Yan) is the same as what came to be known as Shui Yan. Liu Yanliang has made a persuasive argument in the affirmative by interpreting previous discourse in light of modern geological findings. "Guanyu Duanxi Xiayan yu Shuiyan de zenglun," in Liu, *Duanyan quanshu*, 125–34. See also Li Yuchun's amendment, "Chonglun 'Shuiyan' yu 'Xiayan,'" in Gao Meiqing, *Zishi ningying*, 151–55.

49 Tang Xun, *Yanlu*, in *Duanyan daguan*, 101. Ming and Qing connoisseurs distinguish between different kinds of birds' eyes, the mynah being merely one of many. In the interest of simplicity, all birds' eyes are called mynah's eyes in the present book.

50 Ouyang Xiu, *Yanpu*, in *Duanyan daguan*, 102. Northern Song collectors seem to have only cherished mynah's eyes and "gold streaks." Both are already mentioned in Su Yijian, in *Wenfang sipu*, 3.4a. The Southern Song treatise *Duanxi yanpu* also mentions "burned mark," "yellow dragon," and several other "defects" (5). By the Qing, collectors have identified over thirty mineral features or "natural stone markings" (*shipin*). For a partial list in Chinese and English, see Gao, *Zishi ningying*, 14, 150. For illustrated descriptions, see Liu, *Duanyan de jianbie*, 29–41; Chen, *Duanyan minsu*, 107–18. For the official designations of the eighteen recognized markings today, see Guangdongsheng, *Duan yan*, 5–18.

51 This argument was made explicit in the anonymous Southern Song treatise *Duanxi yanpu*, transmitted by Ye Yue: "When stones have eyes it is easy to rank them" (2). Following Webb Keane, sociologist Alison Leitch ("Materiality of Marble") calls the veining on Carrara marble "qualisigns": material markings open to diverse and

often conflicted interpretations. Markings on Duan stones are veritable "qualisigns."

52 Mi, *Yanshi*, 2–3; Van Gulik, *Mi Fu*, 34–35.

53 Mi, *Yanshi*, 2; Van Gulik, *Mi Fu*, 34.

54 Su, *Wenfang sipu*, 1.13b.

55 Mi, *Yanshi*, 1; Van Gulik, *Mi Fu*, 27–28.

56 The dilettanti are useful as foil to the establishment of standards defining who or what a connoisseur is. The editors of the *Siku quanshu* used a graphic term to describe them, *ershi* or "eat with their ears," which originated in Sima Qian's *Shiji*. See Clunas's discussion of this process in the Ming, in *Superfluous Things*, 86–87.

57 For a list of the salient titles in which Duan stones are mentioned, see Liu Yanliang, "Lidai Duanyan zhushu," in *Duanyan quanshu*, 159–63. For a description in English of some of the titles, see Van Gulik, *Mi Fu*, 14–21.

58 For the rise of philological scholarship and the decline of speculative moral philosophy, see Elman, *From Philosophy to Philology*. Translation of the slogan adopted from ii.

59 The hunt for ancient scripts on steles in the northern regions of the empire is analyzed by Qianshen Bai, *Fu Shan's World*, 177–84. See also Xue Longchun, *Zheng Fu yanjiu*, 28–50, for activities in the south and north. Instead of relying on local artisans, many scholars brought their own trusted artisans to make rubbings or even made rubbings themselves. For the enduring tradition of writing and carving words on cliffs that has been practiced since the classical era, see Harrist, *The Landscape of Words*.

60 Mi Fu, who evidently had never been to Shezhou, based his information on She stones on a diagram of inkstones (*yantu*), which is no longer extant. See brief discussion by Van Gulik, *Mi Fu*, 18. It is likely to be a drawing of the shapes of inkstones instead of a map (Mi, *Yanshi*, 8), perhaps the same one made by Tang Ji, author of *Shezhou yanpu* (6). Mi, *Yanshi*, 3; Van Gulik, *Mi Fu*, 36–38. Van Gulik appears to have mistranslated this sentence. I have

not found any mention of a map of Duan quarries until He Chuanyao's.

61 He Yuan et al, *Chongxiu Gaoyao xianzhi*, 4.6b–13a.

62 The shrine on the lower edge of the image is dedicated to the Heavenly Queen (Tian Hou), a patroness of seafaring in southern China who was incorporated into the official pantheon in the Song. The shrine in the center is "Shrine of the Inkstone Pit," which guards the entrance to the Underwater Lode.

63 The treatise by Qian Chaoding (1647 *jinshi*), which discusses stones from the Underwater Lode exclusively, was instrumental to the canonization of this valuation. Qian, a native of Changshu, Jiangsu, served as a commissioner in the Education Intendant Circuit of Guangdong. In his treatise Qian claimed to have learned of the supreme value of Shui Yan from the "natives" (*turen*), whose views he used to correct the old hierarchy of the "scholars from the central plains" (Qian, *Shuikeng shiji*, 2472).

64 The *tu* on the first inkstone is entitled "Map of [the caves] inside the Old Pit"; the second reads "Map of Duanxi." The Duanxi is a tributary of the Xi River on the banks of which is the entrance to the Underwater Lode. There is an ongoing debate as to whether the Laokeng and Shui Yan are synonyms or each signifies a different quarry. The carver of the title evidently holds the former view, which is the majority view and also that of He Chuanyao's (discussed below). A holder of the opposite view is Qian Chaoding who, citing "natives," opined that Lao Keng refers to another quarry in Mount Lanke that is inferior to Shui Yan (*Shuikeng shiji*, 2472) (Liu, *Duanyan de jianbie*, 14–15). For Bray's discussion, see her "Introduction: The Power of *Tu*," in *Graphics and Text*, ed. Bray et al. To make a *tu* means "to order" and "to position in space" (13).

65 Included in this group are three influential inkstone treatises: Cao Rong's (1613–1685),

who served as Guangdong provincial commissioner in 1673; Jing Rizhen's (*jinshi* 1691), magistrate of Gaoyao from 1697 to 1703; and Wu Shengnian's, prefect of Zhaoqing from 1752 to 1755. As the dates show, the trend of an out-of-province official dispensing knowledge about Duan inkstones predates the late eighteenth century but it becomes intensified with the rise of philology.

66 The copy of *Baoyantang yanbian* at the C.V. Starr Library, Columbia University, bears a collector's seal that identifies it with the famed Tianjin collector Xu Naichang. He Chuanyao completed the manuscript in 1827 but could not finance its publication until he found a patron, a visiting *muyou* (private assistant to officials) by the name of Gao Hong. Gao arrived in Zhaoqing in 1833 and made a handsome profit buying stones from a major quarrying operation in 1834 and hiring teams of local craftsmen to carve them into inkstones (Gao preface, 1a–2a). The book was printed locally by Feng Jiru Tang in Zhaoqing. It also bears a seal: "Distributed by Qunyu Lou, Dongmen Street, Zhaoqing." The printed lines "Newly carved in the year *dingyou* of Daoguang [1837]" and "Blocks kept at the present [Baoyantang] studio" suggests that there was an earlier printing. Wu Lanxiu mentioned that he wrote a preface for a published version of He Chuanyao's treatise (*Duanxi yanshi*, 8), but I have not located extant copies of this earlier printing.

67 The printed map is likely to be the model for the one carved on the back of the inkstone and not the other way around, because it is a scholar's god-seeing's view of the quarry. There may have been an earlier map of inside the Underwater Lode in Wu Shengnian, *Duanxi yanzhi*. He included an entry before the main text entitled, "Pictorial notes on the mining of Duanxi inkstone quarry," dated 1753. Despite the "pictorial" in the title, it is a written description of the Underwater shaft from the miner's perspective, which anticipates the nineteenth-cen-

tury maps. There was no map appended to the notes in the extant version of the work.

68 Mukerji, *Impossible Engineering*, 205, cf. 221, 223. In the case of the Underwater Lode, the concern with manpower was evident in previous treatises by the bureaucrats who had to supervise mining operations. See, for example, Gao Zhao, *Duanxi yanshi kao*, in *Meishu congshu*, 416–18. But He Chuanyao and Huang Peifang were the first to depict the information visually.

69 I added the numbering and the parameters of the four caves from He's text for clarity of presentation. Nineteen of He's "Misc. quarries" appear in Wu Lanxiu's map.

70 I have not been able to establish a direct connection between He Chuanyao and the burgeoning philological movement, but the link is tantalizing. The term I render "discerning inkstone" (*yanbian*) in the title of his treatise can also read "debates on inkstones" or "refuting other views on inkstones," which is common in the titles of philological treatises. Governor-General Ruan Yuan (1764–1849), a major figure in the movement, established the Xuehai Academy in Guangzhou in 1824 by merging four regional academies, including the Duanxi in Zhaoqing, into one. For Ruan Yuan's career as a collector, see Lefebvre, "The Conservation and Mounting of Chinese Paintings." For the Xuehai Academy, see Miles, *Sea of Learning*.

71 Wu Lanxiu incorporated the bulk of He Chuanyao's opinions verbatim in his treatise, with proper credit given to He. His maps are also based on He's. Wu included five maps, progressing from general to specific: (1) general view of the Duan area; (2) view of the Lingyang Gorge, the section of the Xi River where the quarries are concentrated; (3) Mount Lanke; (4) Mount Beiling; (5) inside the Underwater Lode. Numbers two through four are expanded from He's outside-view map; number five is an amendment of He's inside-view map. Wu indicates the locations of 38 quarries

in numbers three and four, including those He did not deign to mention. Wu claimed that his map of the Underwater Lode was the result of "actual surveying" during the 1833 mining operation (*Duanxi yanshi, tu*, 12). It is difficult to know what he meant by "survey"; most likely he interviewed the stonecutters who took part in the operation. It differs from He Chuanyao's in minor details, mostly numbers indicating the manpower needed.

72 Wu Chongyao, "Afterword," 1, in Wu Lanxiu, *Duanxi yanshi*. Cf. same comment made by Wu Lanxiu, 8. Wu organizes the quarries according to geographical locations.

73 He named explicitly Cao Rong's *Yanlu* (so popular that He did not need to mention its title, 16, 17, 26) and one *Lishi yanbian* (18, 26), which bear the blunt of He's refutations. Also mentioned are *Duanyan kao* (18) and *Guangdong xinyu* (26).

74 Some scholars complained about the deceitful practices of stoneworkers, but in general they are respectful of the knowledge their native informants possessed; none had mounted a frontal attack until He Chuanyao. Wu Shengnian, a prefect of Zhaoqing, complained that the miners hid the best stones and had to be subjected to surveillance (*Duanxi yanzhi*, 116). Li Zhaoluo accused the stonecutters of attaching faked eyes to stones and lamented that they refused to teach him how to mend broken inkstones seamlessly (*Duanxi yankeng ji*, 84–85). Zeng Xingren devoted an entire entry to "Fake Duan stones" in *Yankao*, 2.22b.

75 Complaint about the inconsistency of knowledge from one stoneworker to another is common among scholars. See, for example, Zhao, *Duanxi yanshi kao*, 417. The complaint about the stoneworkers' valuation of blue-green stone is from Lin Zhaotang, another visiting private assistant who befriended He Chuanyao and wrote a preface for *Discerning Inkstones* (Lin preface 2b).

76 These three subject positions have resonances outside China. Pamela Smith, for example, has analyzed the travelling cleric Albertus Magnus (1193?–1280) who formulated a theory of metals by interviewing stonemasons and miners, a move similar to that of the "out-of-province eyewitness" (Smith, "The Matter of Ideas in the Workings of Metal in Early Modern Europe," in *The Matter of Art*, ed. Christy Anderson et al.).

CHAPTER 3. SUZHOU

1 Barbieri-Low, *Artisans in Early Imperial China*, 116–52.

2 The transportation network of the empire was comprised of three main routes: (1) the north–south route via the Grand Canal; (2) the west–east route via the Yangzi River and its tributaries; (3) the coastal sea route from Manchuria in the northeast to Guangzhou at the southern tip. Suzhou provided easy access to all three.

3 Skinner, "Structure of Chinese History." For the shifting spatial dynamics between the eastern and western neighborhoods, see Wu Renshu, *Youyou fangxiang*, 153–61.

4 Qiu, "Shiba shiji Suzhou mianbuye," 249. Wu Chengming (*Zhongguo ziben zhuyi*, 217–65) estimates that merchants shipped 40 million bolts of cotton cloth from Jiangnan per year. In Suzhou, by the 1720s and '30s there emerged a vertically integrated silk manufacturer-exporter that a century later came to be called *zhangfang*. In the cotton industry, capital-intensive ventures, called *zihao*, appeared even earlier, in the late Ming (Qiu, "Shiba shiji," 246–47).

5 Being so crowded, the Chang Gate neighborhood was prone to fire. A description of one deadly disaster on the fifth day of the tenth month, 1713, is in Zhu Xiangxian, *Wenjian oulu*, 612. The Qing official is Nalan Chang'an, see his *Huanyou biji*, 950–51. He also wrote of the propensity to fire, but attributed it to the reckless management style of Suzhou merchants. Ya-chen Ma has

described the merchant culture that developed in the Chang Gate area in "Picturing Suzhou," 19–52.

6 The work, *Calligraphic Model from the Chunhua Pavilion*, refers to a Northern Song collection of 420 iconic works from Han to Tang made in 992. The original is a copy that was subsequently lost. The job of the authenticator, then, involves discerning older copies from more recent copies. For a long poem by scholar Shao Changheng (1637–1704) describing the art forgery industries near Chang Gate, see Clunas, *Superfluous Things*, 110–11. See also a later description (by Qian Yong, 1759–1844, *Lüyuan zaji*) of Qin Père et Fils who specialized in forging Song and Yuan paintings identified as *Qinjia kuan* in Zhang Changhong, *Pinjian yu jingying*, 63. For a guide for buyers, see Lu Shihua, *Shuhua shuoling* (1777, in Lu Fusheng, *Zhongguo shuhua quanshu*,12.553–8. For an English translation see Van Gulik, *Scrapbook*).

7 Yang Bin, *Dapiao oubi*, 348. Coincidentally, Yang was a friend of Lin Ji's brother Tong and Huang Zhongjian, as well as a teacher of Zhu Xiangxian.

8 Each of the four variants of "to carve" (*zhuo, diao, lou,* and *ke*) describes a medium-specific skill set that involves different tools and was recognized as specialized fields of knowledge in the seventeenth and eighteenth centuries. The Ming bamboo carvers and the Qing jade carvers have been best studied because they often left signature marks. For bamboo carvers, see Wang Shixiang, *Jinhui dui*, vol. 1; Ji Ruoxin, *Jiangxin yu xiangong (zhumu guohe bian)*. For jade carvers, see Guo Fuxiang, "Gongting yu Suzhou," in Gugong and Bolin Ma Pu, *Gongting yu difang*, 169–220. Zhu Xiangxian named three of the most famous Zhuanzhu Lane printing block carvers (for texts and pictures): Zhu Gui, Liu Yuan, Jin Guliang (*Wenjian*, 614).

9 For the design-build process of a Huizhou house, including the work of the master

carpenter, carvers, and stonemasons, see Berliner, *Yin Yu Tang*, 120–39.

10 The term "demonic craft" first appeared in Cao Zhao's *Gegu yaolun*, completed in 1388, to refer to carving improbably small or complicated objects. It appears as part of the compounds *guigong shi* (demonic craft gem) and *guigong qiu* (demonic craft balls). Cao explained that the former referred to a ring set with a piece of agate with the twelve astrological animals engraved on its surface in hair-thin lines, whereas the latter was an ivory ball with three latticed layers, the two inner layers movable (Cao and Wang, *Gegu yaolun*, 213). The skill is generally identified as the specialty of Guangdong ivory carvers. Another expert, Monk Qutan, named by Zhou Lianggong (1612–1672), was from Fujian (Ji, *Jiangxin yu xiangong [xiangya xijiao bian]*, 5, cf. 7, 173). In the early Qing, "demonic craft" also described the craft of Suzhou carver Du Shiyuan, who carved olive or walnut pits into boats complete with movable windows, oars, mast, and sails. Although another carver of miniature pits, Zhou Xinjian, was from Wuxi; the trade was associated with Suzhou (Ji, *Jiangxin yu xiangong [zhumu guohe bian]*, 137–38).

11 Nalan, *Huanyou biji*, 947–48. It is not known when he visited Suzhou, but the work was completed and published in 1746.

12 The Chinese expression which I rendered "more than ten years" is *shishunian* (literally, ten years plus some). Deliberately ambiguous, it can mean anything from twelve to nineteen. Since Huang took the raw stone to Gu in the autumn of 1712, he probably bought it sometime between the late 1700s and early 1712. This also suggests that Gu Gongwang was summoned to court in the 1700s, the very decade when Kangxi was expanding his inkstone workshop to produce a steady supply of Songhua inkstones as gifts (see chapter 1).

13 Huang Zhongjian, "Yanming bingxu," in *Xuzhai erji*, 10.16a-b/27–458. For the full

texts of the encomiums in Chinese and in translation, see no. 3 in appendix 1. For Xu Yunwen, see *Xuzhai ji, Xuzhai erji*, 27–247, 283, 284, 289, 300, 431–32. Huang was affluent enough to finance the printing of his collected works, including poetry, biography, and inscriptions on paintings, under the name of his studio, Dihua Tang. The blocks of the collection were carved 1709–11 and those of the sequel, 1714.

14 The book on palindromes, *Huiwen leiju xubian*, was published in 1708 and the one on seals, *Yindian*, contains an afterword dated 1722. These were probably commercial ventures. Zhu, whose highest degree was only that of imperial student (*jiansheng*), later made a living as a personal assistant (*mufu*) in Yunnan and Guizhou. His proven capabilities led to an appointment as county magistrate of Putian, Fujian, in 1741 and of Yushan, Jiangxi, 1748. Information compiled by He Limin, the modern annotator of *Yindian*. The anecdotes in *Wenjian oulu* were likely to have been compiled through the years; the dated observations cluster in the 1700s and 1720s. The latest year mentioned was Qianlong 16 (1751).

15 Zhu, *Wenjian oulu*, 628–29.

16 Huang called Gu Delin 德林, whereas Zhu used a different word for Lin, 麟. The *Jiangnan tongzhi* (170.11b–12a/2802), following *Gujin tushujicheng* (*Zhongguo lidai kaogong dian*, 8.82), used a third character, which also reads Lin: 鄰. This kind of discrepancy is rather common. That neither Huang nor Zhu were in themselves famous enough beyond Suzhou means that their years cannot be dated with certainty, limiting the utility of their writings for dating artisans. Since two crucial pieces of information about Delin are missing—his age when he died and when he turned to making inkstones—I do not feel confident to speculate on the span of his inkstone-making years.

17 The better-known biographies of the Zhu house of carvers in Jiading (also three

generations) suggests that socializing with scholars who wrote and published poetry was key to being known nationally (Wang Shixiang, *Jinhui dui*, vol. 1, 271–93).

18 Zhu, *Wenjian oulu*, 628. He is the only writer who identified Gu's natal family name.

19 Wu Ligu hypothesizes that Gu was born around 1664 and died around 1734. *Mingyanbian*, 266, 274–75. Using different criteria, we arrive at similar estimations for her year of death. The birth year suggested by Wu hinges on too many assumptions—that Gu Gongwang was at least thirty years old when he was summoned to court, and that Erniang was at least twenty years older than him—for my comfort.

20 This point may seem moot but is in fact significant. It may well be common for the daughter-in-law and wife of a male artisan to learn the craft so that she could help out in the workshop and to take over when needed. We do not know when Gongwang and the other son were adopted, but my guess is that they were also trained by Delin and Qiming, and not solely by Erniang as some have claimed.

21 There is no English equivalent of the construction "family name–*shi*." *Shi* 氏, meaning "lineage name," can refer to: (1) male and female members of the Gu family; (2) a male individual member of the family; (3) a female individual member of the family.

22 Those who referred to Gu by Gu Dagu include: Lin Ji (*Yanshi* C 4.6a/A1.5b, C4.6a/A1.5b–6a); Yu Dian (C1.3a/A2.3a, cf. C1.6b/A2.7a); Lin Fuyun (C6.5b); Lin Zhaoxian (C6.7b); Xie Gumei (*Wumen Gu Dagu*, C7.3a). Those who used Gushi: Lin Zhengqing (A1.5b); Chen Dequan (C3.1b/A5.4a); Yu Dian (A2.11a). Lin's use of Wumen Nüshi Gushi is in C4.4a. For the history of *dagu* and *nüshi* as terms of address for talented women writers, see Ko, *Teachers*, 54, 117, 126–27.

23 In their poetry, the term "female hand from Suzhou" (*Wuqu nüshou*) was sometimes

also used. For example, Chen Dequan's 18 poems, C8.14b.

24 It was the Suzhou writer Zhu Xiangxian who related that Gu was commonly called Gu Qinniang, The two writers who used the variant Gu Qingniang are Gao Fenghan (1683–1741) in his *Yanshi*, 264, and Ruan Kuisheng (1727–1789), *Chayu kehua*, 587. Ruan's notation book (completed in 1771) is evidence that Gu became famous "in court as in society" by the Qianlong era. Gao was Gu's contemporary, although there is no evidence that they had met. The reading of Qinniang in the Wu dialect is Wu Ligu's (*Mingyan bian*, 268).

25 Neither Huang Zhongjian nor Zhu Xiangxian referred to Gu Erniang. Huang Ren used it once (Lin, *Yanshi* C2.3a/A3.2b). It became a common signature mark. Wu Ligu (*Mingyan bian*, 268) speculates that the *er* (literally, two or second) in Erniang refers to the generational ranking of her husband Qiming, meaning that he was the second-born son among the same generation in his branch of the Gu lineage. This is reasonable, but there is no way to confirm it short of unearthing the Gu genealogy, which is unlikely to exist because there is no compelling reason for an artisan family to compile a genealogy.

26 A notable exception to the former is the *Entwined Gourds and Butterfly* in the Capital Museum (see chapter 4).

27 My criterion in judging reliability is simple: it would have to be written by someone who had personal experience with Gu and her work. The work of those who did not meet her, even if they were Gu's contemporaries, will be discussed in the next chapter. As discussed in chapter 5, *Yanshi* is a book manuscript that took shape only after Gu's death. Compiled to publicize the Lin family collection not of inkstones but of encomiums to be carved on inkstones, the book is only obliquely about Gu.

28 In the annotation for a set of poems honoring his Fuzhou friends, Chen Zhaolun

wrote, "Mr. Li Lushan (Fu) loves inkstones; many of the excellent ones kept in his house are from the hands of Gu Erniang of Suzhou" (*Zizhu shanfang shiwenji*, 1.14b). Chen was a reliable informant, having been Li's protégé when the latter was governor of Zhejiang in 1720 (Li, *Juyetang, nianpu.*5a–b). Li referred to the "slender hands of Zhuanzhu Gu Erniang" in a poem (*Yanshi* A8.24a; not in C). But there is no concrete evidence of Gu's hand in the sizable extant inkstones bearing Li's seals or in his *Juyetang shigao*.

29 It is possible that besides the commissioned work received from her known Suzhou and Fuzhou patrons, Gu also made more generic inkstones for sale in the curio stores. The itinerant poet and inkstone lover Tao Yuanzao (1716–1801) provides possible support for this hypothesis. Tao reported that he viewed "small inkstones made by Gu Erniang in various styles" at the studio of He Bangyan (Diting, d. ca. 1762), magistrate of Panyu county, Guangdong, around 1759–61. Tao subsequently wrote Huang Ren and visited the latter in Fuzhou shortly before Huang's death in 1768. They socialized in drinking parties, but Tao did not say if he viewed Huang's inkstones. In a mourning poem, he suggested that Huang had sold all of his "Ten Inkstones" (27.7a). Tao, *Bo'ou shanfang ji*, 23.16a, cf. 11.11a–b, 26.14b–15a, 27.5a, 27.11b.

30 Individual encomiums existed for as long as there were inkstones, but they were seldom compiled into a set intended for publication until the early Qing. Ji Nan (*Shiyin yantan*, 52) mentioned that an early sixteenth-century connoisseurship manual *Tiewang shanhu* contains a fascicle of ancient encomiums. Lin Fuyun's *Yanshi* is a significant milestone, singular in that it encompasses the encomiums of multiple modern authors. Other examples, notably Jin Nong's *Yanming ce* and Gao Fenghan's *Yanshi*, are collections by a single author. See discussion in the epilogue.

31 That Huang brought his famed collection

"Ten Inkstones" to Guangdong is from Lin Zhengqing, "Shiyanxuan ji," 4.9a. Lin described these inkstones as "always antiqued in style, encased in boxes of exotic woods encrusted in jade and precious stones, and bearing carved encomiums on their backs" (4.8b). On Huang taking his inkstone collection to Guangdong, see also Yu Dian's note to his set of poems in *Yanshi* C8.5a.

32 Li Yunfu, an opium addict, was dead by 1722. Li was also a friend of You Shao'an, who mentioned that he inscribed Li's posthumous portrait (*Hanyoutang shiwenji*, 386).

33 The account books of an artisanal workshop can reveal valuable information on the changing patterns of specialized skills, subcontracting, division of labor, taste, and others, as the magnificent study *Silver in London* by Helen Clifford has shown. Unfortunately, no comparable account books exist for Chinese workshops outside the palace from the eighteenth century. The only hint that Gu operated a workshop engaging multiple craftsmen instead of working on her own is given by Gao Fenghan, who in 1738 wrote in ink on the back of one of the inkstones in his collection, "inkstone made in the *jia* of Gu Qingniang" (fig. E.2). *Jia* (family, home, house) connotes "shop" or "workshop" here (Gao, *Yanshi*, 264).

34 Zeitlin, "Petrified Heart," and Hay, *Sensuous Surfaces*.

35 This seems to be a standard practice. You Shao'an's "Eryan ji" describes a similar process of consultation with Yang Dongyi in Guangdong (see chapter four).

36 The story first appeared in *Han Feizi*. The carved jade eventually became the emblem of imperial authority of the First Emperor of Qin.

37 Two inkstones in Yu Dian's collection lent further support for the importance of "opening the ink pool" in the hierarchy of skills of an inkstone carver. Yu once was gifted a brick made of Zichuan stone. Desiring to convert it into an inkstone, Yu

asked a friend, Xue Ruohui, to "open the ink pool and polish the surface" (A2.13b). The procedure is synonymous to making an inkstone. In another instance, Yu bought an "extraordinarily precious" inkstone and debated with himself if he should improve on it: "Opening [enlarging] the ink pool, but fearing detriment to the natural wonders [of the inkstone]; a jade toad gracing the side of the water pool" (C8.10a). A poorly executed opening could ruin an inkstone.

38 Wu Ligu has argued that this was a spurious inscription (*Mingyan bian*, 215–17). The practice of "remaking" an old inkstone was common among the Fuzhou collectors in the early Qing. Yu Dian, for example, was advised by a friend in Beijing to have a She inkstone from Mount Longwei "polished and washed," which "instantaneously improved it" (*Yanshi* A2.7b).

39 The National Palace Museum has an inkstone that belonged to He Zhuo; an encomium he composed and wrote was carved on its back. On the lid of the box the carver of words was identified as Qiusheng (Guoli Gugong, *Lanqian shanguan*, 148–49).

40 Lin Ji was also meticulous about entrusting the carving of words to artisans who specialized in it. His son Fuyun recalled: "My late father had bought scores [literally, several tens] of inkstones from markets in the capital and attached specially composed encomiums to each. But since there were no skilled hands he could not have them engraved onto the stones" ("Houxu," *Yanshi* A10.13b).

41 For encomiums intended for the Yang brothers, see A10.13b; more detailed discussion on the brothers follows in a later section. For Lin Fuyun carving his late father's encomiums, see *Yanshi* A10.13b–14a; C.4.4a.

42 In Yongzheng's palace workshops, a "shop for carving words" (*kezi chu*) appeared in the records for 1723, 1724, 1727, 1729 and 1730. Sometimes its work was listed separately, and sometimes appended to the Mounting Works. Several artisans are

known as "writers of seal scripts" (YXD 102, 119, cf. Ji, "Cong Huojidang kan," 90) or "writers of Song scripts" (YXD 82, 90). There is a separate group of artisans called "word carvers" (*kezi ren*) (YXD 6–7, 90, 189). Before 1725.02.20, there might not have been designated "word carvers," as evinced by this edict: "Those who are good in making things and not good in carving words should not carve words" (YXD 53). In the Qianlong period, the "word carving craftsmen" (*kezi jiang*) were often recruited from Jiangnan, especially Suzhou. Cf. Ji, "Qing qianqi Zaobanchu," 12–16.

43 Interview with Guan Honghui, Zhaoqing, Nov. 28, 2007.

44 The viewing party, in autumn 1700, was described in an encomium that Wang was said to have written, along with a note by one of the guests present, Chen Yixi, a friend of Yu Dian. Both are in Lin Fuyun, *Yanshi* C7.4b–5a. Only Wang's encomium appears in *Yanshi* A7.5a. Although the encomium may be spurious, it establishes that by 1733, the year *Yanshi* was completed, inkstones bearing Gu Erniang's mark have appeared on the market.

45 A Northern Song inkstone maker in southeastern Shanxi by the name of Old Man Lü left a trade-mark of "Lü" on the *chengni*-clay inkstone he made. Collectors believed that Lü was an alchemist who rendered clay harder than metal. At his death forgers flooded the market with fakes (He Wei, *Chunzhu jiwen*, 9.4a–5a). *Chengni*-clay inkstones, which are fired in a kiln from sieved clay, often bear trademarks like ceramics. I have not found examples of Song inkstones carved from stone bearing a trademark.

46 The Chinese use two terms to describe words carved or written on a vessel. *Mingwen*, usually translated "colophons" or "inscriptions," refers to such textual messages as poems and auspicious sayings on the body of the vessel. *Kuanshi* has a more specific meaning tied to the processes of making and circulation, including such

marks as reign mark, signature mark of the artisan, and sometimes (confusingly) the signature of the owner or user of the vessel (Xiao, *Qixing, wenshi yu wan-Ming*, 235, 263). Cf. Hay, *Sensuous Surfaces*, 56–59.

47 I owe this insight to Mr. You Guoqing, a specialist of antiquity and calligraphy at the National Palace Museum in Taipei.

48 My suspicion is rooted in the dearth of institutional venues for her work to spread beyond the Suzhou and Fuzhou circles in her lifetime other than the informal network of travelling bureaucrats mentioned earlier. *Yanshi*, the text that ultimately made her famous, did not circulate until after her death. Even with this and other texts, it would have been difficult for anyone outside the Fuzhou circle to have access to enough samples of her authentic works to study and compare, hence establishing a body of connoisseurship knowledge. For some reason, the Fuzhou collectors had the resources but not the desire to do so.

49 It is not clear if the books in the family were confined to the rudimentary exam curriculum. The existence of some books is deduced from one line in You's poem (*Hanyoutang shiwenji*, 390, cf. 364). Lin Fuyun disclosed that Zhongyi had a courtesy name, Wan; Dongyi's was Liang (A10.13a); Lin also called him Er (A8.18a).

50 One, the "Lanting xu," was completed in the sixth month, 1700. It was likely to be carved in stone for reproduction. The other is "Beiqian caoluji," which described the circumstances of Lin building a studio, Beiqian caolu, next to his ancestral graves on Mount Mayuan in the suburb of Fuzhou, in 1702. My guess is that the carved stone was erected as a stele at the site.

51 Further evidence for this distinction between scholarship and craft in Lin Fuyun's mind is his use of the word "craft skill" (*ji*) to refer to Yang in his lament, "How sad it is that the two Yang sons, being skilled in but one technique/craft skill, would still incur the envy of Heaven" (A10.13b).

52 Lin Ji first travelled to Beijing in 1698, re-turning to Fuzhou in 1700. He then went in 1705, returning in 1710 to bury his mother. The third trip was in 1711, returning in 1723. He brought Yang Zhongyi either on the second or third trip, more likely the third.

53 You, *Hanyoutang shiwenji*, 362–64.

54 You, *Hanyoutang shiwenji*, 390.

55 Huang, "Yanshi tihou," A8.2b.

56 There are two records of Yang's gifts. One, made from a fine Middle Pit (Zhong Keng) stone, was sent to Lin Fuyun, who praised it "as if it were naturally formed" (A8.18a). The other, to He Chong, bore an inscription, "waves as pillow". He praised Yang as a "sagely craftsman" (*zhe jianggong*), an unusual expression that captures what I mean by the new subject-position of artisan-scholar. He, a local scholar likely to be younger than Yang, called him Yang-*jun* Dongyi (A8.25b). The nuance of *jun* is conveyed by its modern Japanese reading *kun*, which is used when speaking to someone younger or socially inferior.

57 All other known male artisan-scholars both "opened" the ink pool and carved words. They include Yu Dian's friend Xue Ruohui (see Yu's entry in appendix 3), other Fuzhou natives Dong Cangmen and Xie Ruqi (discussed later in this chapter), as well as Jin Nong and Gao Fenghan (epilogue).

58 According to *Guochao yinshi* compiled by Feng Chenghui (1786–1840), Cangmen is his courtesy name whereas his given name is Hanyu (cited in *Fujian yinren zhuan*, 41). His itinerant life and pursuit of seal scripts is in a colophon written by Li Fu (1666–1749) in 1724 on one of Dong's paintings, *Xingle tu* (Li, *Juyetang shigao*, 149). His being a regular in scholar's gatherings is mentioned by Chen Zhaolun, who was in Fuzhou in 1731–34. At his writing (ca. 1740s), Dong had already died (A8.41b/ C8.20a). Information about his housing situation is from Lin Ji's set of four poems. Lin gifted Dong with some poetic lines on the occasion of Dong's moving from one rental to another; Dong sent as counter-gift a painting of himself moving house. Lin composed the four poems to inscribe on the painting (Lin, *Puxuezhai shigao*, 109). Dong composed an encomium for a well-field inkstone (A7.12a; not in C). Xie Ruqi inscribed on one of Dong's painting of chrysanthemums (Xie, *Chuncaitang shicao*, 3.7b).

59 All four examples are in Wu Ligu, *Mingyan bian*, 209–10; cf. Wu, *Wanxiang*, 143–44. Wu did not doubt the authenticity of the two inkstones attributed to Dong. Although I have not examined them myself, I am also inclined to believe that they are genuine because of two reasons. First, the given-name-only signature conforms to a pattern. Other early Qing male artisan-scholars such as Xie Ruqi and Wang Youjun/Xiujun also signed their inkstones without the family names. Second, Dong Cangmen was not popular enough to be forged.

60 Wu, *Mingyan bian*, 210.

61 For the rise of literati seal carving in the late-Ming Wanli era (1573–1619), with its center in Suzhou, see Qianshen Bai, *Fu Shan's World*, 50–57. Jonathan Hay identifies traces of literati education on not only seals but other crafts as well (*Sensuous Surfaces*, 32).

62 Gu Erniang's father-in-law, Delin, also gave up his studies to become an inkstone carver. The *Lidai kaogong dian* states that "he liked to compose poems; there is a cache of his poems at home" (8.82). But Gu Delin did not seem to have risen from the status of craftsman to be regarded as an artisan-scholar like Yang and Dong. Could it be that he did not carve seals?

63 Ko, *Teachers of Inner Chambers*, 61–62.

64 Yu Dian's high regard for Gu's craftsmanship is evidenced in an encomium he wrote for an unnamed inkstone made by Gu: "A fine stone bears appreciation, / An antique style invites emulation. / The layman shies away, / The expert itches to take the challenge" (Yu, "Ti Gushi yan," *Yu Jingzhao*

ji, 19b). This poem suggests that Gu copied old styles and insinuates that other experts copied or forged her. The clear line Yu drew between the layman and the expert carver is suggestive of the increasing expertization of inkstone carving in the early Qing.

65 Ursula Klein demonstrates the fruitfulness of reconstructing the artisan's workshop environment in her chapter "Apothecary Shops, Laboratories and Chemical Manufacture in Eighteenth-Century Germany," in *Mindful Hands*, ed. Roberts et al., 247–78.

66 Xie's biographic details are from Zhu Jingying, *Shejing tang wenji*, 193. See also Lin Qianliang, *Fujian yinren zhuan*, 47. For the Ruqi mark, see Wu, *Mingyan bian*, 207–8. Xie later served as a *mufu*-assistant but soon retired to Fuzhou, where he was a member of a poetry society, Minshan Yinshe (*Chuncaotang shichao*). His son, Xie Xi, was a calligrapher and a carver of seals and inkstones (Lin, *Fujian yinren zhuan*, 44). Xi also worked briefly as a personal assistant (Ni, "Guji xieyang dajia Lin Ji yu Xie Xi").

67 This pairing of the military man's sword and the scholar's inkstone is conventional; the implication is that both men need fine instruments to carry out their duties.

68 I interpret "clouds" to be short form for "purple clouds," a common euphemism for Duan stone.

69 I do not know what Dong Yuan (or Dong-Yuan; Dong and Yuan) refer to. The "inkstone annals" (*yanshi*) could not have referred specifically to Lin Fuyun's *Yanshi* because by the time the book took shape and acquired this title, Gu had died.

70 Guzhu tea is a legendary tea grown in the Guzhu Mountains in western Zhejiang. It was so excellent that it became a local tribute to the Tang court in 770 CE.

71 These may be Gu's parting gifts for Xie and Dong.

72 It is not clear if the envoy refers to Xie Ruqi or someone else.

73 Xie Shiji [Ruqi], *Chuncaotang shichao*, 6.3b–4a. This set of poems is one of eighteen in

a section "Wuyou cao" (Poems scribbled on a trip to Suzhou). Although the poems are undated, it is possible that the visit took place in spring, 1713. Xie's traveling companion Dong Cangmen mentioned on a dated inkstone encomium that he procured a Duan stone in Suzhou during a trip that year, returning to Fujian in 1715. The carved inkstone is extant (*Tianjin Bowuguan cangyan*, no. 18, 102).

74 Ko, "Pursuing Talent and Virtue," 24–25.

75 For Gu embroidery, see Huang I-fen, "Gender"; Shanghai Bowuguan, ed., *Guxiu*.

76 A third possible reading is that "Gujia xiufa" refers to actual samples of Gu embroidery that Erniang had collected in her studio; the visiting artisans viewed them while launching into a discussion. Although not implausible, the phrasing is even more awkward.

77 Zhu supplied his own interpretation of Gu's speech, that Gu took her inspiration from the casting of Xuande censers (*Wenjian oulu*, 628).

78 Interview with Wu Ligu, Nov. 14, 2012, Beijing. Wu elaborates on his understanding of Gu's saying: "The nature of stone is hard, the artisan has to transform it with a soft power. The material is square but the *qi* is round, [carving brings] yin and yang in perfect harmony" (*Mingyan bian*, 273).

CHAPTER 4. BEYOND SUZHOU

1 *Yanshi* C6.5b. The complete poem is in Lin Ji, *Puxuezhai shigao*, 9.26a/103. The last two lines read: "Passing on to he who awaits his imperial appointment by the golden horse [Lin Ji], / Will the mysterious markings alter the astral rankings?" The latter refer to the rankings on the exam roster.

2 This note is translated in full in appendix 1 (inkstone no. 8). In a later poem, Lin Fuyun recalled an undated visit to Gu's studio in Zhuanzhu Lane. The details seem to match, but the season differs. The first line established the season as summer instead

of spring: "Sailing by River Xu, awash in the fragrance of lotuses." An earlier version of the next three lines uses the same allusion of the "jade axe" and speaks of curtains fluttering by Gu's window and Gu's "fine bestowal" (*Yanshi* A8.19a). Fuyun changed them in a later version to read: "Keeping each other's company in Zhuanzhu Lane. / If you want the corners and edges to be roundly polished, / Ask none but Gu Erniang with her discerning eyes [*congming*]" (*Yanshi* C8.35a).

3 Guoli Gugong, *Lanqian shanguan*, 159–62. I viewed this inkstone on Dec. 19, 2005, and Nov. 29, 2012. The Lanqian Shanguan collection was amassed by philanthropist Lin Boshou (1895–1986), scion of the Lin family of Banqiao.

4 Tianjin Bowuguan, *Tianjin Bowuguan cangyan*, 96. I first viewed this inkstone on Nov. 6, 2008; the second viewing was on Nov. 5, 2012. Unlike the deep purple color characteristic of Duan, this stone has a yellowish hue.

5 The gourd-shaped seal reads *dequ* (obtaining pleasure), a common description of a connoisseur's tacit appreciation of an object.

6 I owe this insight to Jonathan Hay.

7 The modern term for this subtle operation is *yadi yinqi*, literally "suppressing the ground while making a faint relief."

8 The five scalloped lines in relief resemble the raised threads of gold crouching, a common stitching technique in embroidery that involves securing a strand of golden floss (a piece of thread wrapped in gold leaf) onto the ground fabric with darting stitches.

9 Interview with Zhang Lei, Apr. 11, 2003, Nantong, Jiangsu.

10 Ko, "Between the Boudoir and the Global Market."

11 I do not know of similar treatments of plumage in other carved media—bamboo, wood, or jade. It may be in part due to the common use of high relief and openwork in these media. For an early to mid-Qing example of a pair of Asian paradise flycatchers

(*shoudai niao*; *Terpsiphone paradisi*) nesting in plum branches in carved bamboo, see Ji Ruoxin, *Jiangxin yu xiangong (zhumu guohe pian)*, 77–78.

12 Intermedia crossings are common in the art and material culture of imperial China. Maggie Bickford has investigated the migration of the plum motif across a spectrum of media, from paintings to textiles, in the Song. See her *Bones of Jade, Soul of Ice*. She has also suggested that needlework might have influenced the stylization of Song Huizong's painting *Auspicious Cranes* ("Emperor Huizong," 82). More recently, scholars have explored "remediation" of the visual arts in the Qing in an AAS panel organized by Yuhang Li, "Art Production and Remediation in the Qianlong Court," San Diego, Mar. 24, 2013. My approach is different in that I am less interested in the migration of pictorial motifs across media, but rather the traveling of artisanal knowledge itself.

13 This inkstone is not without problems. The very presence of a signature mark is suspicious, as argued in the previous chapter. The "one inch of Ganjiang" poem by Huang Ren carved on the side is spurious. Huang did write such a poem, but it is undated. This one is dated 1719, and is commonly found on faked stones attributed to Gu (see discussion later in the chapter). The other candidate for Gu's authentic work is the *Entwined Gourd and Butterfly* inkstone in the Capital Museum in Beijing. Not having been able to view the actual stone, I withhold judgment. The identification with Gu in this case is not based on a signature mark—there is none—but a notation carved on the inkstone. While marveling at the craftsmanship, Wu Ligu has raised questions about the wording of the notation (*Mingyan bian*, 279). Zhang Zhongxing was the first to propose that the authenticity of Gu's work is ultimately unknowable ("Gu Erniang," in *Yuedanji*, 277–83).

14 In Lydia Liu's formulation, "'super-sign' refers not to a self-contained word-unit

but to a hetero-cultural signifying chain that cuts across the semantic fields of two or several languages" (Liu et al., *Birth of Chinese Feminism*, 12n12). A super-sign is "a linguistic monstrosity that thrives on the excess of its presumed meanings by virtue of being exposed to, or thrown together with, foreign etymologies and foreign languages" (Liu, *Clash of Empires*, 12–13). A super-brand can also be understood as an "assemblage." David Turnbull explains: "By virtue of the fact that knowledge is local, it is also located; it has a place, and an assemblage is made up of linked sites, people and activities" (Turnbull, "Travelling Knowledge," 275).

15 Nalan, *Huanyou biji*, 947–48. For a related saying, "Court design/model; Suzhou craftsmen" (*gongting yang, Suzhou jiang*), see Lai, "Guaren haohuo," 205–9. The term *Suzhou yang* was first used to describe the city's fashionable dress (Lin Liyue, "Daya jianghuan").

16 Chang'an's ranking of Su over Guang is only relative. In the last part of his passage (translated in chapter 3), he ultimately disdained Su-ware for being superficial, deceptive, and fragile. Chang'an was no fan of the decorative arts that have no practical function (Nalan, *Huanyou biji*, 947–48).

17 Two other inkstone makers famous in the early Qing, Gao Fenghan and Jin Nong, were primarily painters (see discussion of their inkstone works in the epilogue). Their brands were not super-brands in that they were tied less to a place and more to their personal aura. We know too little about Wang Youjun/Xiujun, another early-Qing inkstone maker who was identified as a native of Jiangnan, to analyze how his brand worked.

18 Lin Qianliang, *Fujian yinren zhuan*.

19 This inkstone is named "Jielin" (bonding with neighbors) by the museum because of the encomium incised on its face (*Tianjin Bowuguan cangyan*, 97). I viewed this inkstone on Nov. 5, 2012. Xie Ruqi's

Scene of Red Cliff inkstone in the Shanghai Museum features a flat profile face with a similar cloud-revealing-the-moon motif. It bears the mark "Ruqi zuo," which is almost identical to the two in Tianjin (fig. 4.6). Shanghai Bowuguan, *Weiyan zuotian*, 92–93.

20 The same combination of high relief and open work is even more dramatic in the *Cloud and Li-Dragon* inkstone in private collection. A color photograph shows an intricate water pool bisected by a bridge in the shape of a *li*-dragon, one of the mythical nine sons of the *long*-dragon (Wu, *Mingyan bian*, color plate no. 13, cf. rubbing on 208). Here, even the subject of the *li*-dragon is borrowed from Fujian seal-carving and not found on Suzhou inkstones. The open-work treatment of the water pool is similar to one in the Tianjin Museum bearing an encomium by Yu Dian dated 1732 (*Tianjian Bowuguan cangyan*, 78).

21 Huang Ren called Xie by the cordial address "Xie jun" and contributed four congratulatory poems to Xie's poetry collection. Xie is particularly close to Zhou Shaolong, another scholar from the Fuzhou circle (Zhu Jingying, *Shejingtang ji*, 7.9a).

22 Wu Ligu has gone as far as calling Dong, Yang, and Xie "private disciples of Gu" (*Mingyan bian*, 275), and that Gu thus was the founder of the "Fujian school" of inkstone making (213). I agree that Suzhou and Fuzhou inkstones are different in sensibilities and technique, but the nomenclature of "school" is anachronistic. I prefer the early Qing expressions of "Su-ware" and "Guang-ware."

23 This description was written in 1747 by Dong's friend You Shao'an, as part of his remembrance of the times the two shared in Guangdong in 1726. You did not give the source of his information; my guess is hearsay from Huang or other Fuzhou scholars who travelled to Guangdong after 1726 (*Hanyoutang shiwenji*, 556). You was dismissive of *Sihui kuan*, viewing it as a

knockoff if not forgery instead of an example of Cantonese artisanal inventiveness.

24 Nalan (*Huanyou biji*, 28.14a) wrote of a "stone monkey" from Mount Shimen in Leqing, Zhejiang, whose body is four to five inches long. When placed on the writer's desk, it grinds ink and serves as the bearer of brush and inkstone. The monkey holding an inkstone is an old visual trope, see for example the early thirteenth-century painting attributed to Zhang Sigong, *The Planet Deity Chenxing (Mercury) Attended by a Monkey*, Museum of Fine Arts, Boston.

25 Guoli, *Lanqian shanguan*, 124–26. Another difference between this and the Tianjin *Paired Swallows* is the addition of a pair of mandarin ducks carved in low relief at the transition between the ink pool and water pool. Having viewed this inkstone twice, in 2008 and 2012, I can attest to its cruder workmanship than the Tianjin one.

26 *Yanshi* C6.7b. For full text of the encomium, see no. 9 in appendix 1. The writer, Zhaoxian, is the eldest of Fuyun's three sons. He was too young to have commissioned an inkstone from Gu; it is more likely that he was adding an encomium to a stone already in the family collection. As discussed in chapter 3, the inkstone bearing Wu Zhen's encomium and remade by Gu was also in the form of a phoenix (*Yanshi* C7.3a).

27 The phoenix in the Metropolitan Museum (fig. 3.7B) is an exception. Without the raised rims, the inkstone appears dematerialized. The smaller size and thinness (L 12.9 cm; w 9.5 cm) adds to its ephemeral quality. See Thorp and Vinograd, *Chinese Art and Culture*, fig. 9–25; Hay, *Sensuous Surfaces*, 54–55.

28 For climbed-over dragons on jade cups, see one mid-Ming example in the form of a bamboo segment (420, no. 1125) and one bearing a Lu Zigang mark (425, no. 1138) in *Gugong Bowuyuan lidai yushuguan*. Dr. Rosemary Kerr (personal communications, Dec. 13, Dec. 19, 2013) told me about the V&A bowl (C.325–1916) and three similar

ones in the Hallwyl Museum in Stockholm (Gr.XLVIII:IX:B.a.a.1; Gr.XLVIII:XI.C.b.h.6; Gr.XIVII:XI:C.b.h.6), all made in Jingdezhen. Wang Guangyao (personal communications, July 15, 2015) confirmed that the "climbed-over" dragon treatment began to appear on ceramics in the late-Kangxi era and by and large disappeared by the mid-Qianlong era.

29 These are in the Palace Museum in Beijing, the Tianjin Museum, the MMA, and the Guangdong Museum (Xie Ruqi mark, seen on the exhibition floor), and a private collection, Juyan zhai, in Beijing. See nos. 1a–c, appendix 2. For four other examples of the phoenix trope, see Wu Ligu, *Mingyan bian*, 289–91.

30 The stem-like protrusion resembles a rhizome in that it is not straight, like the stem. But its having a base makes it more like a culm. The side branch, too, is ambiguous. A bamboo shoot is not branched.

31 The encomium reads: "According to the 'Record of growing bamboo' by Xiangshan [the Tang poet Bo Juyi, 772–846]: The steady bamboo plant anchors a man's virtues, the straight culm establishes morality, the hollow cavity teaches flexibility, the tough node reinforces one's will. Therefore a bamboo is called a gentleman; one should not live a day without it. Now, when a bamboo stem is carved into an inkstone, it becomes an item that [a scholar] cannot part with everyday. How sophisticated it is to fashion an object one cannot part with everyday [an inkstone] by making it into an image of something that one cannot live without [bamboo]." On the upper right corner on the face of the stone there are two words in seal script and carved in relief, *lingyun* ("soaring to the clouds"). Its relationship to Cao or the bamboo motif is not apparent (Tianjin Bowuguan, *Tianjin Bowuguan cangyan*, 40).

32 Because Cao was a Ming personage and his encomium was dated 1635, the researchers who prepared the catalogue of inkstones

in the Tianjin Museum placed the *Bamboo Stem* inkstone in the Ming section. The curator emerita Cai Hongru said that "the feeling is not right for a Ming stone" and opined that it should be reclassified as a Qing product (personal communications, Nov. 9, 2012). For a similar bamboo stem inkstone in a Japanese collection, see Aiura, *Tankeiken*, 38–39.

33 Judging from the inkstones extant today, Gu, Dong, Xie, and Wang are the only four early Qing inkstone artisans whose signature marks stand in for them. I exclude Jin Nong and Gao Fenghan who were primarily painters.

34 When I viewed this inkstone on Nov. 29, 2012, I was surprised by its tactility. Housed in a box shaped as a bamboo stem, it appears to be a collector's item. In the Anhui Museum there is a *Bamboo Stem* inkstone made of She stone that is similar in shape and conception. The museum dates it to the Ming (*Zhongguo wenfang sibao*, 75, plate no. 85, *tuban shuoming*, 43).

35 Following the practice of literati painting, Xiujun attached an encomium which forms a metaphoric continuum with the bamboo. In a private collection there is another inkstone shaped as a cut bamboo segment bearing the Xiujun signature (Wu, *Mingyanbian*, color plate no. 59, no page; cf. Wu, *Wanxiang*, 133). It is fashioned as a horizontal segment, cut against the grain of the stem and close to a node. The exposed diaphragm thus becomes the ink pool, and the node can be seen ringing the waist of the inkstone. This is another ingenious treatment of the three-dimensionality of a bamboo stem.

36 Ruan, *Chayu kehua*, 587. The compilation of this book was completed in 1771. Ruan, born in a scholar's family in Huai'an, Jiangsu, is no doubt a scholar—he held a *juren* degree (1752) and was picked from the rejected pool in the 1761 exam to be appointed a drafter in the Grand Secretariat. He rose to the posts of investigating censor

and vice minister of the Ministry of Justice. But perhaps his early career as a drafter (a secretary who drafted official documents) and his later career as a jurist nurtured a technocratic outlook that explains his interests in and respect for the crafts.

37 Ruan, *Chayu kehua*, 587. Ruan traveled widely as a student, but stayed largely in Beijing as an official from 1759 until his death thirty years later. Among his friends in the capital was the scholar and inkstone collector Ji Yun, who had one of Wang Xiujun's landscape inkstones. *Yuewei caotang yanpu*, 17b–18b. There is no sign that Ruan's network intersected with the Fuzhou circle. His mention of the renown of Gu Erniang and Wang Xiujun "in court as in society" is thus indicative of the spread of the fame of the two inkstone makers to the capital in the Qianlong era.

38 To add to the intrigue, there is an inkstone *Five Dragons Quelling the Flood* with the signature mark "Made by Wang Xiuyun" dated 1716 (*Tianjin Bowuguan cangyan*, 100). Yun is often mispronounced "Jun."

39 I viewed this inkstone on Nov. 5, 2012.

40 The landscape trope appears to be Wang Xiujun's crowning achievement. The scholar and inkstone collector Ji Yun remarked on Wang's individuality: "[The contributions of] Wang Xiujun to inkstone making is analogous to [the contributions of] Zhong Bojing to poetry writing. Although they do not follow the established way, their work is full of unexpected intrigues and delights." Zhong Bojing (Xing) is a late Ming poet known for his innovations. Ji's remark, dated 1795, is carved on the lid of the box holding an inkstone with landscape scenery carved on its face. The stone bears no Xiujun mark; Ji assumed that it was his from the landscape trope (Ji Yun, *Yuewei caotang yanpu*, 17b–18b). Beijing collector Yan Jiaxian has an inkstone in a landscape of a crane standing in tall grass in front of a body of wavy water, a rising sun on the horizon. On its side is the mark

"Wumen Gu Erniang zhi" (Yan, *Jiaxian cangyan, shang juan*, 102–3). I viewed this inkstone twice. Another landscape inkstone bearing Gu's mark ("Wumen Gu Erniang zhi" in regular script on the back) is in the Guangdong Folk Arts Museum (no. 5b in appendix 2). I thank Dr. Haiyan Huang for this information.

41 This gesture strikes me as defensive, for male painters did not shy away from signing with their family and given names. There are minor differences in the shape of the scripts of the Xiujun mark (figs. 4.13C, 4.14B, cf. Wu, *Wanxiang*, 133).

42 I viewed this inkstone on Nov. 5, 2012. For an apparently finer example of the mushroom trope, see the rubbings in Zhu Chuanrong, *Xiaoshan Zhushi*, 101–2; cf. Zhu Jiajin, *Gugong tuishilu*, 237. This latter stone, with the mark "Wumen Gu Erniang zao" in seal script in relief on the face, was in the collection of Zhu Yi'an but its whereabouts today is unknown.

43 One example of the woven colander with Gu's mark is in *Shuangqing cangyan*, 220–21. See another, without Gu's mark, in Zhu Chuanrong, *Xiaoshan Zhushi*, 142–43. Wu suggests that they are forged en masse by modern artisans in Shanghai and Suzhou (*Mingyan bian*, 290). Indeed, it is intriguing that the fine creations of modern Shanghai inkstone carver Chen Duanyou (1892–1959) include a magnificent mushroom (Shanghai Bowuguan, *Weiyan zuotian*, 238–40), a rolled lotus leaf (270–73), and a colander (274–76), all designs remade by lesser hands that often bear Gu's mark. Even the format of one of Chen's signature marks, a long vertical rectangular seal in relief (e.g., 214, 258), was similar to the one on Gu's *Phoenix* inkstone at the Metropolitan Museum of Art (fig. 3.7B).

44 For two other examples of the banana leaf trope and its variant, banana and moon, see Guoli Gugong, *Lanqian shanguan*, 105–9, 163–66. For another example of the *kui*-dragon trope in the Palace Museum, one

bearing an encomium by Yu Dian (no. 4b in appendix 2), see Zhang Shufen, *Wenfang sibao: Zhiyan*, 90–91. I viewed this inkstone in Nov. 2012.

45 There is, for example, the trope of the lotus and crab (Shanghai Daoming, Dec. 17, 2008, RMB 28,000). The Jiangxi Museum has an inkstone in the shape of overlapping jade disks bearing the mark "Wumen Gu Erniang zao" (*Jiangxisheng Bowuguan wenwu jinghua*, 238).

46 Shoudu Bowuguan, *Shoudu Bowuguan cang mingyan*, 24–25, cf. Wang Nianxiang and Zhang, *Zhongguo guyan pu*, 150–51, 314. This inkstone became famous after being featured in a CCTV documentary, part of the program "Guobao dang'an" (Archives of national treasures), first broadcast on Apr. 26, 2011. This inkstone is unusual among those attributed to Gu in that it is singular and not an example of a known trope.

47 "Qinghua yan," *Yanshi*, A3.2b, C2.3a.

48 This poem with the notation first appeared in *Yanshi*, A3.2b. It was published in Huang Ren's poetry collection, *Qiujiang ji* (prefaces 1754, 1756), without the notation (2.13b/743). It is retained in a later annotated edition, *Qiujiang jizhu* (2.20a–b). The poem is also included in a later compilation (preface 1814) of Huang's poetry, *Xiangcaozhai shizhu* (2.33b–34a). I have not found the earlier, unannotated version *Xiangcaozhai shi*, but it was selected and financed by Huang's friend Sang Tiaoyuan in 1758 according to the *Nianpu* appended to *Huang Ren ji*, 586. Ganjiang is the name of an ancient swordsmith. Its use here anticipates the ancient assassin Zhuan-zhu in the next line. Purple clay alludes to the characteristic dark purple colored Duan stone, which the skillful artisan cut through as if it were soft mud. The second line can be interpreted at various levels of specificity: the time of the day when Huang visited, the waning of Gu's workshop, perhaps because Gu Gongwang was working in Beijing at the time, or the

declining fortunes of workshops in the neighborhood. The first reading seems too specific for a tribute poem of this sort, and since Zhuanzhu Lane remained prosperous into the Qianlong era, the second reading seems the most likely. Zhou Nanquan misread the third line, taking the loom (*ji*) to mean jade-carving tools (Zhou, "Qingchu nüzhuoyan gaoshou," 17).

49 The fact that Gu was not named in the poem makes it an even more enticing identifying mark. The collector who chanced upon one such stone without a direct indexical mark is made to think that his expert knowledge allows him to identify the stone like no other. There are many more textual tropes, mostly pastiche of poems and encomiums written by the Fuzhou patrons, that serve as identifying marks of Gu. They sometimes appear on stones also bearing Gu's mark. For some examples, see Wu, *Mingyanbian*, 219–21.

50 Yuan, *Suiyuan shihua*, 642. Liu Ci is an acquaintance of the Fuzhou circle; his poem is included in *Yanshi* (C9.17a). He likely had nothing to do with the fake. I suspect that the forgers had access to *Yanshi*, perhaps fragments of a copy of a copy. This notation is in *Suiyuan shihua puyi*, which consists of entries that did not make it into the *Suiyuan shihua* proper. The latter was compiled from 1750–1790 and published in 1790. The *puyi* was brought together between 1790 and Yuan's death in 1797 and published in the Jiaqing era (1796–1820). It is impossible to trace when Yuan Mei's friend He Chunchao bought the inkstone.

51 Yuan, *Suiyuan shihua*, 642.

52 It has not always been so. I have argued that before the invention of high heels around the sixteenth century, footbinding was more a sign of gentility than eroticism (*Cinderella's Sisters*, 190–95). I also argued that the spread of the practice to the peripheral regions of the empire and to the lower classes in the eighteenth century was in part propelled by an unsuccessful Qing ban,

turning it into a symbol of Han ethnicity ("The Body as Attire").

53 See, for example, the entry on Gu in the section "Qiaoyi" (Skilled artistry) in Yi Zongkui (b. 1875), *Xinshishuo*, 562. The legend of testing stones with the shoe-tip is taken verbatim from Yuan Mei. The sources of Yi are mainly Zhu Xiangxian (whom he did not identify) and Yuan Mei (whom he did). A modern historian Huang Yunpeng tacked on the anecdote about Gu's feet at the end of his narrative, "Wumen zhuoyan mingjia." The professor and connoisseur Deng Zhicheng (1887–1960), in contrast, omitted it in his entry "Gu Erniang zhiyan," *Gudong suoji*, 561–62.

54 Xu Kang, *Qianchen mengyinglu*, 103. This work is prefaced 1885 and 1888. Both the stories of the butcher and the chef are from *Zhuangzi*. The butcher is from *Zibeiyou* (XXII.43–52); Cook Ding is from *Yangshengzhu* (III.2–12).

55 Xu's embellishment was cited by modern writer Zhou Nanquan, but misattributed to Huang Ren's *Xiangcaozhai shiji* (Zhou, "Qingchu nüzhuoyan gaoshou," 20, cf. 17).

56 Huang Zhijun, *Qianlong Jiangnan tongzhi*, 170.11b–12a/2802. The Kangxi edition does not mention artisans.

57 Kangxi's *Gujin tushu jicheng* project was under the editorship of Fuzhou scholar Chen Menglei (1650–ca. 1714). The section on artisans and technology ("Kaogong," which rearranged a host of technical writings according to the scheme of the *Kaogongji*) are reprinted as *Zhongguo lidai kaogongdian*. The first half of the Gu entry in the latter is identical to the one in *Qianlong Jiangnan tongzhi*: "Gu Shengzhi, courtesy name Delin, is a native of Wu county [Suzhou]. His father, Gu Daoren, was skilled in making inkstones, hence people called Delin 'the Lil' Daoren.' All of the inkstones he made are emulations of ancient styles; they are simple but refined and worthy of appreciation." But the second half, instead of mentioning his daughter-in-

law, continued with Delin's craft: "He once told others, 'When carving with a knife, it is easy to be skilled in places that are even, but it is difficult to sort out the places that are uneven.' He also liked to chant poetry, and have drafts of poems stashed away at home" (8.82). This latter statement marked him as having scholarly aspirations. The 1883 *Suzhou fuzhi* combined the *Qianlong Jiangnan tongzhi* entry with this one, omitting the information about Gu Delin's poetry.

58 The *Gujin tushu jicheng* does not mention Gu Erniang at all. The *Jiangnan tongzhi* recognized her by adding her into its narrative, albeit as an unnamed "daughter-in-law."

59 Chang Jianhua, a historian at Nankai University, did not adopt this genealogy in his succinct biographical entry on "Gu Erniang." Wu Ligu is the first to openly question its validity, in *Mingyan bian*, 267–68.

60 Lin, *Puxuezhai shiwenji*, 9.26a/103.

CHAPTER 5. FUZHOU

1 Chen Zhaolun, *Zizhu shanfang shiwenji*, nianpu.10a. Chen set off from Hangzhou in the tenth month, taking the faster but more treacherous Xianxia route, and arrived in Fujian in the twelfth month of Yongzheng 8 (1730–31). Huang Ren did not return to Fuzhou from Guangdong until the autumn of 1731, so the meeting took place in either autumn or winter of that year.

2 The neighborhood, called "Three Lanes and Seven Alleys" (Sanfang Qixiang), is a major tourist attraction. The name came into being only in the Jiaqing-Daoguang period and was not used in the early Qing (Fuzhoushi difangzhi bianzuan weiyuanhui, *Sanfang qixiang zhi*, 35). For two conflicting legends about the name Guanglu, see 5, 44–45. Huang's home is on Zaoti Alley off the northeastern side of Guanglu Lane. I have visited this compound twice, in Nov. 2011 and Dec. 2012, when it was under renovation, and I plan to analyze the physical site of Huang's inkstone studio in a separate article.

3 Chen, preface to Huang Ren, *Xiangcaozhai shizhu*, preface.4b.

4 Chen, preface to Huang Ren, *Xiangcaozhai shizhu*, preface.4b. After stints in the Hanlin Academy (examining editor, 7b; academician reader-in-waiting, 4b), as metropolitan governor of Shuntian prefecture and others, Chen would eventually retire as the chief minister of the Court of the Imperial Stud, ranked 3b.

5 Lin, *Yanshi* A8.41b. Among the inkstones lost, Chen singled out one bearing the mark "Kuizhang Ge tushu" (the seal of Kuizhang Pavilion), a gift from Lin Xingjing, a relative of the Lin brothers. Kuizhang Pavilion is where the Yuan court warehoused its collection of rare books and objects of art. Chen's early congratulatory poem is in *Yanshi* A9.9a–b. The dating of seventh month is from Chen, *Zizhu shanfang, nianpu*.11b.

6 We know that Xu Yu died on the thirteenth day of the eighth month, 1719, because You Shao'an recorded the news when he was en route from Beijing to Fujian (*Hanyoutang shiwenji*, 364). His year of birth is deduced from his age of seventy at death. His father is the calligrapher and aesthete Xu You (1615–1663). For a *Heart sutra* inkstone bearing encomiums by Xu Yu and Lin Fuyun, see Wu, *Wanxiang*, 137–38.

7 Lin Zhengqing, "Yanshi xiaoyin," *Yanshi* A xiaoyin.1a.

8 Lin Fuyun, "Houxu," *Yanshi* A10.13a. Fuyun described the rubbings as his father's collection, but it was Lin Tong who collected and studied them. For Lin Sun's biography, see *Yanshi* C4.1a–b. He was magistrate of Sanyuan in 1660–65 (ECCP, 506).

9 "Zongjiao" refers to a boy between about eight and fourteen. The term "fellowship in stone since our teenage years" appears in a poem You sent to the group and asked for responses in 1748 (*Hanyoutang shiwenji*, 340). You also used the term "fellowship in metal and stone" in his remembrance (*Yanshi* A xiaozhuan.5b). Lin Zhengqing formed another "fellowship of stone" with two men

in the local academy, the Aofeng Academy (*Yanshi* C1.4a).

10 Huang Ren, preface to Xie Gumei, *Xiaolan-gai shiji*, *xu*.1a–b. These poems can be found in all of their collected works.

11 Lin Ji served in the capital from 1707 to 1710, when he took a leave to bury his mother, and again from 1712 to 1722/23. He moved into his house (Jinglu Xuan) in Liangjia Yuan in 1712. Chinese scholars congregated in Xuannan because they were not allowed to reside in the inner city. For the development of the neighborhood into a nexus of intellectual and artistic ferment, see Yue et al., *Xuannan*.

12 For the fair and curio stores on the grounds of Ciren Temple (a.k.a. Baoguo Si), see Yue et al., *Xuannan*, 37, 71, 76, 202; Naquin, *Peking*, 425, 630–31; Nalan, *Huanyou*, 2.29a–30b.

13 Lin Fuyun, "Houxu," *Yanshi* A10.14a–b. Metropolitan governor is the unofficial title of the administrative head of Shuntian pre-fecture, the highest honorary rank Yu Dian attained.

14 Huang Hui (*jinshi* 1754) was the son of Ren's younger brother. He was raised by Ren after Ren's son Du died at age nineteen. Huang Hui's collected works are reprinted in *Huang Ren ji*, 398–454.

15 This editorial decision makes it difficult to accurately reconstruct the collection of each person. The earlier version of *Yanshi* does not follow this principle consistently. The encomiums are sometimes listed under the author and sometimes under the inkstone.

16 Ledderose, *Mi Fu*, 30, 39–44.

17 In the late Tang poems were written eulo-gizing the Duan inkstone, including one by the maverick Li He (790–816), entitled "Song of Scholar Yang's Purple Inkstone with Bluish Green Spots" (Liu, *Duanyan de jianbie*, 3).

18 Both stories turn on Mi's legendary clean-liness, albeit with contradictory implica-tions. Both are first recorded in Zhou Hui (b. 1126), *Qingbo zazhi* (*juan* 11, 5), cited in

Duanyan daguan, 131. Cf. Yu Huai, *Yanlin*, 42.4a. Yet another version construes Mi's friend as Su Shi, who spat on the inkstone (Yu Huai, *Yanlin*, 42.4a–b). Stories about Mi's inkstone collection abound. For his prized purple gold inkstone and moun-tain-shaped inkstone, see Sturman, *Mi Fu*, 194–97, 223.

19 A variant is Zhao Bian (1008–1084) who took only one inkstone (Yu Huai, *Yanlin*, 42.13b). Although set in the Song, stories of inkstone and official corruption circulated only since the Ming; I have not found them in Song texts. For the corrupt Du Wanshi and three clean ones including Bao Zheng, see Qu, *Guangdong xinyu*, 5.192. According to a legend still popular in Zhaoqing today, Bao threw his constituency's parting gift for him into the river; the inkstone turned into the sandbar Yanzhou (Inkstone Islet) on which the locals built a shrine in Bao's honor (Tan, *Qutan Duanyan*, 37–39; Liu Yanliang, *Duanxi mingyan*, 20–21; Chen Yu, *Duanyan minsu*, 199–200). Another tale about a greedy official is told from the point of view of a local stoneworker, Grandpa Phoenix (Chen Yu, *Duanyan minsu*, 195–98).

20 Sturman, *Mi Fu*, 223.

21 Reitlinger, *Economics of Taste: Picture Market* and *Economics of Taste: Objets d'Art*. Quote from *Objets d'Art*, 2. In Euro-Amer-ica, the gap between the market of genius and that of craftsmanship widened only in 1860 through 1890, with the rise of the Parisian studio art system and, later, the popularity of the Impressionist painters. In the eighteenth century, consumers were generally willing to pay more for a fashion-able commode than an old masters paint-ing. The concept of the two markets allows one to avoid the bifurcation of "fine art" and "applied arts," which is a recent phenome-non in terms of market prices, although the conceptual distinction has existed since the Roman times. The historical pattern of the markets differs in China, but the concept itself is useful.

22 For this reason, I refrain from using Ba-
drillard's bifurcated scheme of "functional
object" and "aesthetic object." The two are
inherent in an inkstone from the start. Mi
Fu's discourse of function represents his
efforts of aestheticizing it.

23 "On Inkstones," He, *Chunzhu jiwen*, *juan*
9. *Juan* 8 was devoted to the *qin*-zither
and inksticks and *juan* 10, cinnabar and
alchemy. The inkstone connoisseurship
circle assumes a spokes-like structure with
He Wei at its center. It is not known if all
the members knew one another. The two
sets of dates mentioned in the text are 1097
and 1102–1106 (9.2a, 9.9b). He also traveled
to Jiaxing and Hangzhou to acquire or view
inkstones (9.6b, 9.7a, 9.9b). For He Wei's
biography, see Wang, "Yinshi Hejun muzhi,"
Dongmou ji, 14.9a–13b. I thank Man Xu for
this reference.

24 According to Man Xu, a "powerful man"
(*guiren*) in Song notation books generally
refers to a powerful official in court, but
occasionally also to imperial relatives. Per-
sonal communications, July 23, 2013.

25 The *guiren*'s crown jewel is a thin bell-
shaped inkstone allegedly from the Jin
dynasty (9.7a). Xu Cai's is a round Duan
inkstone from the collection of official
and calligrapher Cai Xiang (1012–1067),
"thickness over one inch, the diameter
reaches one foot. Its color a true greenish
purple; on the edge there is an 'eye' as big as
[the diameter of] a chopstick." It was named
Auspicious Star Circling the Moon (9.8a).

26 Ebrey, *Accumulating Culture*.

27 For two other exchange transactions in He
Wei's circle, see *Chunzhu jiwen*, 9.7a (bell-
shaped Jin inkstone for copper/bronze cen-
sor); 9.7a–b (black copper/bronze inkstone
with handle for an unspecified object). Of
the four trades He Wei described, admit-
tedly a limited sample, an inkstone was
exchanged for paintings or other objects
of art, but not another inkstone. For other
exchanges mentioned, see 9.11b (cash for
stone), 9.12b (copper water dropper for

antique books). On his death bed, He Wei
instructed his wife to take his collection of
objects of art, several of his own paintings,
two inkstones, and some personal items
to a friend in exchange for money for his
funeral (Wang, *Dongmou ji*, 14.11b).

28 The common shapes and forms (*yang*) are
given proper names, a sign of the codifica-
tion of descriptions. He Wei used the fol-
lowing: antique ladle (9.1a, 7b, 8a, 10b), toad
(9.2a—twice—see also a toad-shaped water
dropper, 9.12a), the character "wind" (9.7a,
9b); jade hall (9.8a, 8b); round (9.8a, twice);
horseshoe (9.10b). He also described one
shaped as a curled lotus leaf (9.6b), but it
appears to be less a generic term and more
a concrete description. For a study of the
shapes of Tang and Song inkstones based
on textual and archaeological sources, see
Ji Ruoxin, "Tang Song shiqi jixingyan." For
the writing implements on a Song schol-
ar's desk, including inkstones and water
droppers, see Ji, "Songdai shu'an shang." For
the shapes of Song vernacular inkstones, see
Chen Yu, *Duanyan minsu*, 303–7.

29 The only exception is Liao Shuchou (b.
1684; still alive 1743), the wife of Xu Jun. The
daughter of Lin Tong, she was adopted to
the Liao family. A poet and painter, she is
said to have a poetry collection *Langqian ji*
by modern scholars (*Huang Ren ji*, 601) but
I have not been able to locate it. The reason
for the infrequent publication of Fujian
women's works might have been more
economic than cultural or moral. Even
Fujian men often did not have the funds to
publish their own collected works; Yu Dian
is an example. Huang Ren's two daughters
formed a poetry society with a group of Fu-
zhou women. See Guotong Li, "Imagining
History and the State," 330–36. The works of
the second daughter Shuwan are collected
into a volume entitled *Qichuang yushi* and
appended to Huang Ren's *Xiangcaojian*
(reprinted in *Huang Ren ji*, 352–87). It also
circulates under the title of *Xiangcaojian
waiji*. Those of the elder daughter Shutiao

(1705–1761), appeared in manuscript form as *Mo'anlou shicao* (reprinted in *Huang Ren ji*, 323–49).

30 Fuzhoushi, *Sanfang qixiang zhi*, 349. According to Lin Fuyun's biography by Chen Dequan, Fuyun also went to the capital in 1717 to assist in the project. *Yanshi* C6.2a–3a.

31 Lin Wan (b. 1720) was the second son of Lin Fuyun. He turned out to be the most capable of Fuyun's sons who inherited the mantle of writing inkstone encomiums. He also invited his teacher to contribute a preface for a later version of *Yanshi*. Lin Weiyun was the son of Lin Ji's brother Tong but was often called a brother by Ji's four birth sons. "Longwei yan," *Yanshi* A.6.9a–10a; cf. C.8b–9a.

32 Lin, *Yanshi* A.*Xiaoyin*.2b.

33 It is possible that Weiyun got it wrong in the earlier version and that Wan, the likely editor of the later version, corrected it. But my wager is that Zhang did write the encomium for two reasons. First, although I hedge my bet in my translation (hence "the grandson" instead of "my grandson"), it is more natural to read it in Zhang's first person. Second, the editors of the later version made deliberate efforts to tone down the impression that *Yanshi* was the account of the Lin family tradition, an effort that resulted in a reshuffling of the chapters. The line in Lin Zhengqing's preface had to be deleted because it no longer describes the organization and priorities of the later version. See appendix 4.

34 Zhuang composed her poem in 1709 (Huang Ren, *Qiujiang ji*, 5.16b–17a). She commended a separate entry in a subsequent compilation on women poets in Fujian (Liang, *Minchuan guixiu shihua*, 1.14b). Its source is apparently Huang's mourning poem. The editor cited *Yongfu xianzhi* as the source, but I fail to find any mention of her in the 1749 edition. The other two lines of the poem are lost.

35 The compliment is not far-fetched. Yuan Mei praised Huang as Li Bo's only true

follower in the Qing. The poetry of both, according to Yuan, are unmediated expressions of their nature (*Suiyuan shihua*, 326).

36 Huang, *Qiujiang ji*, 5.16a; cf. *Yanshi* C2.9b. Huang stayed in Guangdong for three years after his dismissal before returning to Fujian. He was so broke that he had to appeal to a friend of his former teacher, someone he had never met before, for help to finance the trip (Ruan, *Chayu kehua*, 648).

37 Huang Ren's second daughter Shuwan used *mosuo* in a poem: "Missing my parent(s), failing to see anything, / But one inkstone, which I fondle often" (*Xiangcaojian waiji*, 33). The only two other mentions of inkstones are on 33, 40. In both, the inkstone on a writing desk evoked for Shuwan the gentility of her poet friend, Madame Fang Zizhai, and other ladies in her poetry circle who were her social superior (judged by the advanced degrees of their husbands). She thus positioned women as users of inkstones, not collectors.

38 In *Wumen shuhua*, Fa Shishan wrote that *Springtime Crimson* fell into the hands of Shen Dacheng, a member of the *Yanshi* fringe group (*Huang Ren ji*, 529). There are at least two extant inkstones by that name, both attributed to Huang. One is in the Taipei Historical Museum, the other in the National Palace Museum in Taipei (Wu, *Mingyanbian*, 260–61). The former is from the collection of Fuzhou journalist Lin Baishui (1872–1926) (Lin Wanli, *Shengchunhong ji*). For stories of Huang Ren's concubines, see Wu, *Mingyan bian*, 248–56. In the nineteenth century, stories of Huang asking his maids (or virgin nuns) to hug his inkstones in bed began to circulate. See, for example, Xie, *Baifan zalu* 4.9b. I have not found evidence of their existence in Huang's lifetime.

39 *Qianlong yuzhishi*, analyzed in Wu Ligu, *Mingyanbian*, 234–35. That Huang transferred the name of his studio to Guangdong is attested to by Lin Zhengqing, who wrote the sign ("Shiyanxuan ji").

40 Chen Dequan, who passed through Suzhou in 1752, reported that Lin invited him to his residence, "took out the inkstones he stored in drawers and placed them alongside those already on display on his desk and low tables." He saw that there were many "supreme stones from the Submerged Lode." Fuyun died shortly after and did not fulfill his wish of returning to Fuzhou with his collection (Lin, *Yanshi* C6.2a–3a).

41 For development of a consumer society, see Clunas, *Superfluous Things*; Brook, *Confusions of Pleasure*; Wu Renshu, *Pinwei shehua*; Wai-yee Li, "The Collector"; Li Huiyi, "Shibian yu wanwu." Li Rihua documented his collecting activities in his diary, *Weishuixuan riji*. For Xiang Yuanbian, see Shen, *Xiang Yuanbian shuhua*. For Anhui merchant collectors, see Zhang Changhong, *Pinjian yu jingying*.

42 The "handful of old inkstones" is from You Shao'an's biography of Huang, *Yanshi* A *xiaozhuan*.4b. In a later version (*Yanshi* C), the expression becomes "bequeathed by elders and purchased himself" (C2.1a). Xie Gumei wrote that Huang Ren's great-grandfather Wenhuan "wrote profusely and was rich in collections"; from context it is clear that he meant old books and rubbings (*Xiaolangai shiji*, 4.42a). One extant book bearing Huang Ren's collector seal that might have come from his family collection is a Wanli edition of Zhu Zaiyu's *Yuelu quanshu* (Worldcat, OCLC 122859315).

43 Yu Dian's student Wang Yannian, a native of Suzhou, listed the following old families who according to elders once had important inkstone collections: the Wangs of Mengjin, Liangs of Zhending, Songs of Shangqiu, Xus of Kunshan, and Qins of Wuxi. He also listed two individual collectors: Chen Yixi of Haining and Yang Dapiao [Bin] of Shanyin (*Yanshi* C10.4b–5a). Both Chen and Yang were known to Lin Ji and the Fuzhou group.

44 Lin Ji, *Puxuezhai xiaoji*, 1a. One of the renters who came after 1678 and lived in the quarters to the east of the western gardens until 1687 was a mysterious man in his seventies with a young daughter. He befriended the teenager Lin Ji but refused to divulge his name. The man, whom Lin called "The Old Man from Qingzhou," turned out to be an ex-bandit hiding from the law (*Puxuezhai xiaoji*, 26a–b).

45 *Yanshi* A *Xiaoyin*.1a. This line is not entirely accurate neither, as two of Lin Ji's inkstones are known to have been carved by Gu Erniang. Lin Fuyun's line about his forefathers (C [*Zixu*].1a) is not in A. In any case, the Lin collection seems to have grown quickly. In 1735, Fuyun's brother Jingyun boasted that "the inkstone collection in Taofang [Fuyun's studio] has grown ten times from before" (A 8.21b). Jingyun also remarked, with a hint of jealousy, that Huang and Xu outpaced the Lin family collection because they had a natural advantage of being from prominent families (A 8.21b).

46 Huang's wording is from *Qiujiang ji*, 6.29a–b. The phrase "derelict stores in obscure villages" is from Xie, *Xiaolangai shiji*, 4.42b. Xie mentioned that Huang has amassed four of the six extant versions of Ouyang Xun's stele, but he did not state if they were inherited or acquired. Xie Gumei was jealous that Lin gifted the *Langyewang bei* to Huang. Huang described his viewing pleasure in a long poem reprinted in *Fuzhou fuzhi yiwenzhi*, 174–75. Lin gifted the *Yuanyou dangren bei* to Xie, whose counter-gift was the *Yuzhen Lanting* attributed to Jia Qiuhe (*Xiaolangai shiji*, 4.41a). In another friendly exchange, Lin gave Xie a complete version of the *Jinglong guanzhong ming* by Tang Ruizong in return for Xie's truncated one (4.43a).

47 It is impossible to know if they are all rubbings or a mixture of rubbings, paintings, and calligraphy. Nor is it clear if these are from Huang's family, Xie's, or both. I lifted these details from Huang's poem. The poetic allusion "jade rods and gold scroll heads" (*yuxie jinti*) refers to precious scrolls

of paintings, calligraphy, or rubbings. The "Lu palace" of Han refers to singleton artworks that survived. The "six horse of Zhao mausoleum" can be either the rubbings made of the stele or a painting attributed to Jin artist Zhao Lin (fl. 1162–1189). Xie had his collection of ten rubbings from Tang calligraphers bound and described their titles in a poem (Xie, *Xiaolangai shiji*, 4.35b–36a).

48 The Wuxi site in Yongzhou, Hunan, features many important works, including Tang calligrapher Yan Zhenqing's *DaTang zhongxing song* and works by Song artists Huang Tingjian (dated 1104) and Mi Fu. For *moya* inscriptions, see Harrist, *Landscape of Words*.

49 Huang, *Qiujiang ji*, 6.29a–b. Ren's birthday was the sixteenth day of the twelfth month. Banxiang is the name Lin Ji concocted for a set of houses to be built near his ancestral grave. It later became the title of Lin Zhengqing's collected writings. I construe it as Zhengqing because Lin Ji was in Beijing in 1719.

50 Not much is known about the family inheritance of Yu Dian, whose father was a scholar, but apparently he was well off. He had a study in Taijiang, Fuzhou (Lin, *Yanshi* C6.8a), and had several properties outside Fuzhou, including the Wanjuan Lou in Hongtang (Lin, *Yanshi* A8.17b/C4.5b; cf. Huang, *Qiujiang ji* 2.45a) and the Xingzha Ting (A8.3a). It is not clear if they are the same as three others: Jiamei Caotang (*Xiangcaozhai shizhu* 4.11a); Zhuanli Caotang in Hongjiang (A8.7a); and a property in Tahu (A8.26b). His study in his house in Liangjia Yuan, Beijing, is named Bafen Shi (A8.12b, 8.15a).

51 For example, Lin Ji inherited an incomplete copy of the *Yuanying xiansheng ji*, a Ming edition of the collected works of the Yuan scholar Wu Lai (1292–1340). Lin stitched the work from three sources, copying the chapters with help from his friend Yu Zhongya (Dian's elder brother, d. 1696), and commit-

ted it to printing. He complained, "Such is the difficulty of locating books in Fujian!" (Lin, "Chongke Yuanying xiansheng ji," in *Puxuezhai xiaoji*, 14a [cf. 13b]).

52 Lin, *Puxuezhai shigao*, 1.34b. Lin mentioned that he paid for the two thousand volumes primarily with his wife's jewelry, supplemented by some antiques. For Xu Bo's years, I follow Chen Qingyuan, "Mingdai zuojia." The work of Xu that Lin Ji compiled, "Hongyulou tiba," was apparently never published. See Ma, "Hongyulou tiba" and Chen Qingyuan, "Xu Bo xuba buyi kaozheng." See also *Puxuezhai xiaoji* 11b, 12a–b, 14a–15b for other prefaces Lin Ji wrote for works he copied.

53 Lin Zhengqing, "Shiyan xuan ji," 4.8b.

54 Judith Zeitlin observes that collecting as *pi* ("an addiction") was part of the cult of *qing* since the late Ming ("The Petrified Heart"). Huang bought a jade tiger to keep his antique toad inkstone company (*Qiujiang ji* 6.26b). He described the colors and patination of Shoushan stone as well as the competitive market in a long poem (*Qiujiang ji* 6.24b–25a). He had poems inscribed on Shoushan stones; see *Xiangcaozhai shizhu* 5.42a, 6.21a, 6.41a. Huang's seal, "Shiyanxuan," (in two styles) is affixed on Gao Qipei's album of twelve leaves, "Flowers, Animals and Figures" in the Liaoning Provincial Museum. It bears a colophon by Gao dated 1682. See color illustrations in Ruitenbeek, *Discarding the Brush*, 96–97. Members of the Yongfu Huang lineage have compiled a list of ten seals commonly used by Huang Ren, but "Shiyanzhai" is not included. See *Linfeng Huangshi shuhua ji*, 51.

55 Lin, *Puxuezhai shigao*, 1.3b.

56 For *shou*, see *Yanshi* 6.2a insert. For *gou*, see *Yanshi* C2.7a, 4.8a. Besides *gou*, they also used "to procure" (*de*; C4.5a, 4.5b, 7.2a, 7.3a) and "to net" (*huo*; C4.3a, 5.3b). Of the ten cases of purchase I found scattered in *Yanshi*, five are from antique shops or dealers (C2.7a, 5.3b, 7.14a; see also C7.2a); two are from old families (C4.5a, 7.3a); others un-

specified. They gloated about the price only when it is ridiculously cheap. For example, Yu Dian bought a Duan inkstone with a cloud of bluish-green dots at an obscure market in Beijing for 240 cash. Lin Fuyun carved Yu's encomium (A2.7a/C1.6b). Curiously the same encomium was said to have been carved on a Duan stone gifted by Huang Ren (*Xiangcaozhai shizhu* 4.12b).

57 The Ming "manuals of taste" sought to establish categories of collectibles and the standards of judgment within each. They, along with the inkstone connoisseurship literature discussed in chapter 2, offer knowledge about the quarries and design of inkstones that would aid the collector. But even those that intend to be practical guides, such as the *Gegu yaolun* (which includes a section on "Ancient inkstones" in *juan* 7) compiled by Cao Zhao in 1388 and amended by Wang Zuo in 1459, is of scant use to collectors who needed to gain access to the market in the eighteenth century. None in the Fuzhou group mentioned these works.

58 Lin Zhengqing wrote that Huang "traveled to Wu [Suzhou], Yue [Guangdong], Yan [Beijing], and Liang [Shaanxi] in search of the precious collections of old families before 1724. I have only found anecdotal evidence of Huang's visit to Beijing and Suzhou (Lin, "Shiyanxuan ji," 4.8b).

59 Lin Ji first went to Beijing in 1698 while Huang first went in 1702, so I conjecture that it was Lin who became Huang's guide and not the other way around. Huang recounted the shopping experience with Lin in *Yanshi* A 8.1b. That the encomiums he wrote were still fresh but Lin had died brought tears to his eyes.

60 For Xu Yu's tenure in Changzhou, see *Huang Ren ji*, 568–69. Huang's documented visits to Suzhou include 1714, 1718, and 1719.

61 Lin, *Yanshi* A 8.1b. Xu Jun was nicknamed the "Poet of Dingmao" because he was born in the dingmao year (1687).

62 Yang Xiong, "Wuzi," *Fayan*, 2.21.

63 Lin, *Yanshi* C2.4a. The note about Li Yun-long asking Huang to authenticate his new purchase is on C2.7a. An encomium Weng Luoxuan wrote in 1706 for one of Xu Yu's inkstones is in C7.5b. He gifted an Old Pit inkstone to Lin Ji c. 1692 (A1.7a).

64 You Shao'an, "Eryan ji," in *Hanyoutang wenji*, 556. I do not know what You meant by "Li" as it is not a common shorthand for any of the Duan quarries. It could refer to the earliest Duan quarry opened in the Song, which became depleted by the Qingli reign (1041–1048). Or, it could refer to Houli, a Duan quarry generally of lesser quality. The generous owner, Yu Shide, gifted the stone to You, perhaps to curry favor with Huang Ren. You intended to keep the carved inkstone for himself, naming it after his own self-assigned name, Xinshui. It ended up in his second daughter's hands and was passed on to her son when she and her husband both died ("Eryan ji," 556 [cf. 391–92]).

65 Yang's remark suggests that in the early Qing there was a new fashion: inkstones without either the water pool or the ink pool. The latter would have been a decorative object, like many newly made Duan inkstones today. Yu Dian, writing about a precious inkstone he bought, voiced his concern: "Opening the water pool may visit harm on the natural interest," meaning some valuable markings on the stone. He thus opted to use a separate toad-shaped water container on the side (*Yanshi* C8.10a).

66 For another example, see Li Fu, who wrote of an inkstone a "guest" from Guangdong gave/sold him in 1710. First, he named the quarry, "said to be from the Old Pit," and then he described the perilous mining (maybe from imagination). He remarked that the stone was old, having been stored for several decades. Placing it on his desk, he noticed that its visage changed with the weather. He named the mineral features he discerned precisely: "mynah's eye," "charred mark," "banana leaf [white]," and "gold

streaks." He concluded: "How can a She stone measure up [to Duan]?" (Li, *Juyetang shigao*, 26).

67 For *xinbiao*, see Huang Ren's tribute to Lin Fuyun (A8.2a). Lin himself took pride in his ability to carve old and new styles: "The Jade Hall, the new styles, all within my reach" (A8.18b). "Jade Hall" is a Song style mentioned in He Wei's account (see n28, this chapter). For *xinqi*, see Li Fu's tribute to the group (A8.25a). For *xinxian*, see Jiang Yongnian's tribute (A9.2b). Yu Dian fell in love with an inkstone "cute as a small dish" because "this style and this way of making have never been done before" (A2.7a).

68 Lin Zhengqing suggested that Huang Ren preferred antique inkstone styles ("Shiyan xuan ji," 4.8b). Huang stated that his taste for Shoushan stones depends almost entirely on the age of the stone (*Qiujiang ji*, 6.25a).

69 Yu, *Yu Jingzhao ji*, 18a. This poem is not in *Yanshi* A. In C it appears under Lin Fuyun (*Yanshi* C6.2a). I suspect that it is due to a clerical error.

70 Lin, *Yanshi* C7.1a–4a. Lu You's inkstone is in Gao Fenghan, *Yanshi*, 42.

71 Cai Hongru, personal communications, Nov. 1, 2012.

72 A convenient collection of the Ming discourse of inkstones by such iconic writers as Gao Lian, Wen Zhenheng, and Chen Jiru is in *Duanyan daguan*, 138–45.

73 *Tianshui bingshanlu*, 186–87, 299. Also to be warehoused but listed separately are two small Duan inkstones. They appear thrice, probably due to clerical error (191, 193, 195). For a translation of the categories under the two lists, see Clunas, *Superfluous Things*, 46–48, cf. 81.

74 Li, *Weishuixuan riji*, 8.4b–5a. The entire list is translated in Clunas, *Superfluous Things*, 104–5. I agree with Clunas that it is a prescriptive list instead of a description of actual behavior (105). Li was often shown inkstones by dealers (1.22a, 1.55b, 2.7a, 2.13b, 2.25b, 3.24a, 4.13b, 4.79b, 4.57b, 4.86a–b, 6.7a, 7.17a, 7.64b), but he seldom

bought them (2.6a). He grinded ink with antiqued stones (1.10a, 2.42b), complaining that newly carved stones have too much "heat" (4.34b). Tellingly, he sought to study an inkstone made from a Tiaohe pebble by consulting Song and early Ming guide books, Zhao Xigu's *Bogu mingbian* and Cao's *Gegu yaolun*, instead of using his own judgment (3.17b–18a).

75 *Yanshi* C10.7b. Song Luo's family, the Songs of Shangqiu, was named by Wang Yannian as one of the old families with a significant inkstone collection (n43). Song Luo was a good friend of Lin Ji's teacher, Wang Shizhen. He Zhuo was a friend of Yu Dian. After Yu composed the encomium for his inkstone *Supreme Simplicity*, carved by Gu Erniang in 1709, he invited He to write the calligraphic model of the encomium and to recommend an expert carver of words (chap. 3, n39). For the collection history of multiple forged copies of the *Jade Belt*, see Wu Ligu, *Yingyankao*, 71–94.

76 Stewart, *On Longing*, 151–66. Quote from 155.

77 The collector of inkstones is gendered masculine because of the association of inkstones with the male-centered culture of *wen* and the exam system in the Confucian cultural world. But the art of collecting is not intrinsically masculine. Future research on women's relationship with sewing implements, garments, and jewelry may reveal a similar structure of desires.

78 Lin, *Yanshi* A8.29a; not in C. The son is Zhou Zhengsi.

79 Huang Ren was the most generous friend. While in Sihui he dispatched a Duan inkstone to Yu Dian (*Xiangcaozhai shizhu*, 4.12a), an inkstone with a hoe design to Xie Gumei (A8.11a), one with a pouch design to Lin Jingyun (A8.19b), and for his best friend, Xu Jun, one made from an antique stone quarried during the tenure of one Prefect Wu (Lin, *Yanshi* C2.9a). Upon return from Guangdong, Huang later gifted another quality inkstone from the

West Cave of Lower Rock to Li Lincun in 1739 (C2.7a), one of unspecified origins to Shen Tingfang in 1764 (C7.14b), and one to Chen Chaochu (C7.15a). Yu Dian gifted an inkstone to friend Chen Yixi (C1.3a).

80 Davis, *Gift in Sixteenth-Century France*, 9. Martha Howell makes a similar argument for the two preceding centuries in *Commerce before Capitalism*, 146. Similarly, I see no conflict between the so-called market economy and the gift mode. In the early Qing the two are so enmeshed that it is often difficult to make an analytical distinction. Although the word *yi* 貽 ("to gift"; e.g., C4.7a) is sometimes used, the verb the Fuzhou group used most often for gifting is *yi* 遺, which means "to bequeath."

81 "Xue ji," *Li Ji*, 18.10. The logic is that weaving a sieve from bamboo strips provides training for the more complicated task of bow making. Huang Ren added a new layer of meaning to the sieve, comparing its splayed shape with a wide mouth to slanderous words that flew freely and destroyed both his and Yu Dian's careers (*Xiangcaozhai shizhu*, 4.12b).

82 You, "Eryan ji," 556. The encomium he wrote is also in *Yanshi* C3.8a. Other Fuzhou collectors who gifted inkstones to sons include Huang Ren (C2.5a), Zhou Shaolong (C3.6b), and Lin Zhengqing (C5.3a).

83 *Yanshi* C3.4a. It is tempting to conjecture that the artisan might have been Gu Erniang, since the sealed or knotted pouch is a motif she executed for Huang Zhongjian, but there is no concrete evidence.

84 *Yanshi* C4.6b–7a; cf. C3.7b. It is not clear if Lin gifted the pouch-shaped inkstone to You or just the encomium. Perhaps as signs of their anxieties, both You and Xie Gumei were firm believers in dreams and premonitions before exams.

85 Huang's selection criterion, part of his encomium for the "Shiyan xuan yan," is in *Yanshi* C2.8a–b. Xie's remark on Wu Zhen's stone is in C7.3a. Lin Zhengqing ("Shiyan xuan ji") suggested that Huang brought the ten inkstones to Guangdong when he took up his post there in 1725.

86 Wu Ligu has reconstructed the probable candidates of another four (*Mingyanbian*, 232–34). He has also identified a late gift from Huang to the famous inkstone connoisseur Ji Yun, who served as education commissioner in Fujian in 1762–65 (*Mingyanbian*, 236–37). Ji also acquired a crown jewel of Zhou Shaolong, which he included in his *Yueweicaotang yanpu*, 16a–b. Huang Xiulang has offered his conjecture of the ten inkstones in his "Huang Ren zhuan," in *Linfeng Huangshi xianxian ji*, 14.

87 Huang Ren's fame grew in his lifetime, circulating in both local and extra-local circuits in a fitful manner. In the early 1760s, the itinerant poet Tao Yuanzao wrote Huang Ren out of the blue, hoping to view his inkstone collection, saying that "as soon as I crossed the Xianxia Ridge, I heard immediately that you are addicted to inkstones" (*Bo'ou shanfang ji*, 11.11a). The Beijing-based Mongol scholar Fa Shishan also wrote about Huang Ren and *Springtime Crimson* (*Huang Ren ji*, 529). But another Beijing-based official, Yan Zhaowei, had not heard of Huang until he read *Yanshi* (C9.3a). That artisans in Guangdong forged his encomiums in their "Sihui kuan" inkstones also testifies to his fame in Guangdong (You, "Eryan ji").

88 For Zhao's patronage of Xie and releasing Yu from jail, see Lin, *Yanshi* A xiaozhuan.2a–b, 4a–b (not in C). Yu Dian's gift inkstones are in A2.2b, 2.3a (cf. A2.1b). Zhao's role in compiling Yu's collected works is evidenced by the line, "Selected by Zhuo'an, the crippled Daoist adept" (both his self-assigned names) on the first page of *Yu Jingzhao ji*. Lin Fuyun brought an earlier version of *Yanshi* with him to Beijing in 1739, which began to circulate in the north. For examples of the encomiums he carved for Zhao, see Lin, *Yanshi* A7.6b–7a. For the gourd-shaped inkstone Lin gifted to Zhao in the latter's retirement, see A7.7b/C7.10a.

Could this be the one now in the Tianjin Museum, with Zhao's encomium on the back carved by Fuyun (*Tianjin Bowuguan cangyan*, 117)? For Zhao's regret, see *Yanshi* C6.1b.

89 *Yanshi* C8.2b. As stated in this poem, Huang suffered a second loss at the hands of another powerful official. Wu Ligu deduces that the inkstone is *Meiwudu* and the offending official is Zhou Xuejian (d. 1748), governor of Fujian (1743–1747) (*Mingyan bian*, 237–39, 246–47). Although there is no solid proof, Wu's conjecture is persuasive.

90 Zhao's encomium is in *Yanshi* C7.9a–b. Huang had written an encomium for the *Twelve Stars* in 1720 (*Yanshi* C2.6b) but the stone was gone before he could have it carved. He complained bitterly about the loss in a poem (*Yanshi* C8.2b). When Zhao was summoned to an imperial audience in 1738, he took this inkstone with him, perhaps intending it to be a gift to Qianlong. But he kept it. Wu Ligu suggests that the one making the introduction is likely to be Li Fuyun (*Mingyan bian*, 245–46).

91 Huang's encomium for the *Cloud and Moon* inkstone is in *Yanshi* C2.5b. It bears the seal of "Dongjing Shanfang," Huang's studio in his ancestral home in Yongfu which also housed an inkstone collection. His response to Zhao Guolin's rubbings is in *Xiang-caozhai shizhu*, 5.20b-21b.

92 For the theft of *Kuiyan*, see *Yanshi* C4.4a, 8.7a, 10.4a–b. After its recovery, Fuyun showed it to Yu Dian's student Wang Yannian (C10.4b) and another friend Zhuang Yougong, who described its appearance as: "Over one foot wide, more than that in length. There are big and small mynah's eyes aligned like the five stars of the sun and moon" (C9.8b). The description fits Yu Dian's encomium of an inkstone by a different name, *Natural Beauty* (Tianran miaozhi), which he deemed to be the Lin family's crown jewel (A2.12a). Lin Jingyun mentioned the theft of a *Phoenix* inkstone in the Lin collection (C8.35b). I do not know if he was confused or if there was a second theft.

93 Yu's disapproval of female fame is evidenced by his ambivalence about the fame of Gu Erniang, his regret that the painter Wen Shu's fame obscured her husband's achievements in calligraphic seal scripts, reduced as he was to inscribing her paintings as a form of trademark to foul the forgers (*Yu Jingzhao ji*, 11a–12a). For Yu's biographies of obscure scholars Qi Wangzi, Han Jinzhi, and Su Weng, see *Yu Jingzhao ji*, 12a–13b.

94 Compared to Huang Ren's inkstone collection, that of Lin Ji and his sons appears to be less formulated/codified/recognized as a set. One symptom is the lack of a recognized set of crown jewels. The *Ursa Major* became a crown jewel after having been recovered from theft (A8.29b; C8.37a). There are at least three other candidates: the *Sun, Moon, and Five Stars*; *Phoenix Pool*; and *Commemorating Victory* (*Yanshi* C4.2b–4a). These were placed at the front of the Lin Ji chapter, and Zhengqing expressed hopes that the *Sun, Moon, and Five Stars* and *Ursa Major* would be cherished by "sons and grandsons" (C4.3a, 4.4a). It is not clear if they are related to the *Natural Beauty* that Yu deemed the Lin crown jewel. The lack of agreement on even the names, let alone the list, is exactly the problem.

95 The Lin collection grew to about one hundred under Fuyun (cf. n45). Those who have more than a hundred had to constantly apologize for it. Huang Ren was chided by a critic: "How many pairs of clogs can a man wear in a lifetime? Do you have to have so many inkstones?" (*Yanshi* C2.8b). Lin Zhengqing put these words in Huang's mouth ("Shiyan xuan ji," 4.8b–9a). Even the insatiable Qianlong emperor sounded defensive about his inkstone collection, saying that if a mere man of letters Xu Cai (a Song collector friend of He Wei) had nearly a hundred, as an emperor who presided over peace for a century it is not unreasonable to have double that amount ("Yuzhi xu," Yu Minzhong et al., *Xiqing yanpu*, 2b).

96 I am indebted to Wu Ligu's research on the whereabouts of many of Huang's stones (*Mingyanbian*, 247–48).

97 Huang Hui, "Juanshou," *Linfeng Huangshi jiapu*. I am grateful to Mr. Huang Yizhu of Fuzhou, a descendant of Huang Ren, for showing me an original 1793 edition of this genealogy in his collection. Collector Zhu Jialian suggested that this inkstone might have been the same as Lin Ji's *Accruing Virtues* (Xude) inkstone mentioned in *Yanshi* (Zhu Chuanrong, *Xiaoshan Zhushi*, 175–76).

98 Lin, *Yanshi* C5.2a. This phenomenon seems common in Fuzhou. Xie Ruqi's son, Xie Xi, also provided the model (*yang*) for printing blocks. See Ni, "Guji xieyang dajia."

99 Lin Zhengqing, "Mohai yan," Lin, *Yanshi* C5.5a. The Yellow Emperor (honorary name Dihong shi), the cultural creator, was deemed the inventor of inkstones in the Song. His "Mohai" inkstone was mentioned in Su Yijian, *Wenfang sipu*. The "minor ocean" in Zhengqing's encomium alludes to his employment at the Salt Administration, also called "Field of Minor Ocean" (Xiaohai Chang). The *siwen* in the last line is from "Zi Han," *Analects* and usually rendered as "the cause" or "the truth." I follow Peter Bol's translation to highlight its centrality to the masculine identity of the literati group.

100 The basic format of the inkslab might not have changed, but the invention of the inkstick (between the Eastern Han and Six Dynasties) brought about a new way of grinding. It is true that a bit of stone dust became mixed in with the ink, but the quantity is so small that it does not affect the viscosity of the ink. The early Qing obsession with this fact is more a matter of faith.

EPILOGUE

1 Lin Fuyun, *Yanshi* C4.3b. "To inscribe an encomium is to make one's name known" is from "Jitong," *Liji*. In Legge's translation: "The tripods (at the sacrifices) had inscriptions on them. The maker of an inscription named himself, and took occasion to praise and set forth the excellent qualities of his ancestors, and clearly exhibit them to future generations." Xie deemphasized the original importance on self-glorification of one's family.

2 Qianshen Bai shows that seal-carving, taken up by Ming literati, was instrumental to the rise of epigraphic calligraphy in the seventeenth century (*Fu Shan's World*, 50–52). The Fuzhou group did to inkstone-carving what late-Ming seal-carvers such as Wen Peng and He Zhen did to seal-carving. Also relevant is Bai's argument that calligraphic or artistic "style" is a matter of ingrained physical habit of the body (130).

3 Qian, who acquired early fame as a poet, contributed four poems (*Yanshi* C9.27a). In the first poem, he expressed his mild disapproval of the collectors' obsession with things. In the third poem, he singled out the Fuzhou circle's practice of carving words on stones for comment.

4 Lin Ji studied with Wang for several months in 1688 and 1689. The story of Wang's poem is in "Puxuezhai xiaoji," *Puxuezhai ji*, 1a–1b. The full text of the poem is in Wang, *Yaofeng wenchao*, 3.4b. The plaque "Puxuezhai" hanging in Lin's (alleged) study in his ancestral home today is from the hand of late Qing official Chen Baochen (1848–1935). The Lin home was combined with its adjoining structure in the nineteenth century; the original Puxuezhai no longer exists.

5 Lin Fuyun, "Houxu," *Yanshi* A10.13a. For the rise of the epigraphic or stele school that challenged the hegemony of the model book school from the Tang to the seventeenth century, see Bai, *Fu Shan's World*.

6 Lin Fuyun, "Houxu," *Yanshi* A10.13a. I skipped the section where Lin recounted his father's mastery of all of the major scripts from antiquity.

7 I cannot identify any specific inkstones carved by Lin, who was likely to be too busy as a scribe. This aspect of Lin's craft was

put into practice by his son Fuyun and the latter's son, Wan.

8 Lin Ji's habit of recording the completion date at the end of each chapter allows me to make this rough calculation for Wang Wan's *Yaofeng wenchao* (1693), beginning in the twelfth month of 1690 and completed in the seventh month of 1692. I counted the number of lines instead of actual words. The bulk of the copying was completed in Jiaxing in Jiangnan and Fuzhou; Lin also made trips to Shangqiu, Henan, and Suzhou. The other three manuscripts are Wang Shizhen, *Yuyang shanren jinghualu* (1700); Chen Tingjing, *Wuting wenbian* (1708); and Wang Shizhen, *Gufuyuting zhalu*. The best editions for all four I have examined are in the library of the Chinese Academy of Science. In my estimation, the calligraphy of *Yaofeng wenchao* is less polished than *Yuyang shanren jinghualu*, which is Lin Ji at his best. The writing of *Wuting* and *Gufuyuting*, in turn, appears hurried.

9 For the names of block carvers who collaborated with Lin Ji, other examples of the trend, and connections to evidential scholarship, see Li Zhizhong, *Lidai keshu*, 342–46.

10 *Puxuezhai xiaoji*, 1a–6a. Knowledge about building and construction was more common among scholars than previously assumed: compare You Shao'an's boat-like retreat (*Hanyoutang*, 273–588). Nancy Berliner (*Yin Yu Tang*) has suggested that the Qing householder needed specialist knowledge to hire and oversee builders and stonemasons without being cheated.

11 Huang Ren, *Qiujiang ji*, 4.5a.

12 Huang's poem is from *Yanshi* C8.3b–4a. See also Huang Ren, *Xiangcaozhai shizhu* 4.11b–12a, with longer interlinear notes explaining the popularity of Yu Dian's encomiums in Fuzhou. Yu's tale of the broken inkstone is in *Yanshi* A2.7a. The details are omitted in C1.6a–b. For another mention of "borrowing to make a rubbing," see Yu's poem in C8.9a.

13 The stone drum script is a Qin big seal script carved on ten drum-shaped stones discovered in the Tang. There were originally 718 characters, but when the Northern Song scholar Ouyang Xiu copied them, only 465 were legible. The Ming Tianyige rubbing consists of 462 words. Huang Ren assembled two passages from the known words, totaling seventy-four words (fifty-seven without repeats) in 1725 while in Guangdong (*Yanshi* C2.8a). Yu Dian's encomium for the inkstone is in C1.12a, and Lin Ji's, C4.4b. The Tianjin Museum has a Stone Drum inkstone with 434 words copied and carved by Ming scholar Gu Congyi (1523–1588).

14 Zhang Hechai, a native of Baicheng (in modern Jilin), was advised by Prefect Li Jian to make exact copies of *Inkstone Chronicle* to study (*Yanshi* A8.35b). I have not been able to identify Zhang and Li.

15 *Yanshi* C10.3a–b. The essay appeared in *Yanshi* A under the title, "An Assortment of Goodness" (Leilei luoluo jie xianliang), that was deleted in the later version. The expression *leilei luoluo* is a pun, referring to both the rich array of stones and upright conduct of the Fuzhou collectors. This description is perhaps a veiled protest against the political persecutions suffered by Yu Dian and Lin Ji. Jin described how Lin Zhengqing, whom he had known for three years, called on him in Yangzhou with a copy of *Inkstone Chronicle* in 1737. The *Dongxinzhai yanming* is different in format from *Yanshi*. The version I viewed (anthologized in *Jinxiang xiaopin*, prefaced 1750) consists of ninety-five encomiums. Jin Nong has written another volume of inkstone encomiums, now in the Guangdong Museum, in running and regular scripts for a friend in 1730 (fig. E1). See Zhu Wanzhang, "Jin Nong shufa."

16 Gao's contribution was dated the ninth day of the eleventh month, 1736 (*Yanshi* C10.3b–4a). Gao did not mention the nature of his connection to the Fuzhou circle. Since he served in the salt administration

in Taizhou, he might have come to know Lin Zhengqing in that capacity. They had a mutual friend, Li Guo (1679–1751) of Suzhou, who wrote four poems for the Fuzhou *Chronicle* (C9.1a–b; see Li's encomium for one of Lin Ji's inkstones, C4.7b). Li, an untitled scholar, wrote a long preface for Gao's *Yanshi* (18–19). For Li's biography, see Gao, *Yanshi jianshi*, 23.

17 Gao's descendants sold the albums to collector Wang Xiang, who engaged calligrapher and inkstone maker Wang Ziruo (1788–1841) to reproduce the rubbings by carving them onto stones. He died having finished about half. The rest of the rubbings were reproduced by wood-block, a cruder method. Gao's *Yanshi* was originally produced as rubbings of inkstones (112 sheets; some have two to three stones on each sheet) using colored ink and then embellished with a brush. The seals are in red. There must have been very few copies made and only one copy was known to have existed (it was lost during WWII; sixteen leafs of the original and forty-five stones carved by Wang Ziruo are now in the Nanjing Museum). The multicolored original became black-and-white copies with a black ground in the present rendition. For an account of the reproduction process, see Tian Tuo, "Qianyan," in Gao, *Yanshi jianshi*, 7–8.

18 Gao, *Yanshi jianshi*, 5, 138, 140, 250; he also had an apprentice in carving words on stones (123).

19 Gao, *Yanshi jianshi*, 140, 233, 235. For a detailed description of the making of sieved-clay (*chengni*) stones, mixed and kiln-fired in a laborious process to an impervious stony consistency, see Guoli Gugong, *Xiqing yanpu guyan tezhan*, 27–29.

20 Gao compared defective stones to humans, vowing not to let them go to waste (*Yanshi jianshi*, 155, cf. 127, 191). For his reusing scraps, see 227, cf. 120, 126, 197, 204, 283. Like a good shopper, he delighted in recounting the source of all his stones: from collectors, old families, village markets, itinerant

vendors, and bookshops. He had an uncanny ability of prying them out of friends, just like Mi Fu the trickster (Gao, *Yanshi*, 54, 68). He took pleasure in relating that inkstones can be found everywhere (132, 274). He also related that some people bought Duan stones from the quarries or stoneworkers directly (48, 85). The insistence that usable stones can be found everywhere may be a reaction against the fad in pedigreed Duan stones. There is some evidence of a similar concern in Lin, *Yanshi* (C8.26a–b).

21 Liang Zhangju (*Langji congtan*, 21) used the term *tongren* to refer to three cultured salt merchants in the Kangxi and Yongzheng eras. See Yulian Wu's research on this term (275) and Wang Qishu in "Tasteful Consumption." For the accommodation between scholarship and commerce, see Yu Yingshi, "Zhongguo jinshi."

22 The subject position of physicians and their "Confucianization" in the Yuan is remarkably similar to the artisan-scholar (Hymes, "Not Quite Gentlemen?"; Furth, "Physician as Philosopher"). Dagmar Schäfer has discussed these "hybrid figures" who occupied ambivalent social positions in between scholars and artisans but self-identified as scholars in her *Crafting*, 12, 91–94.

23 Classic studies of the exam as entrance to officialdom include Ho, *Ladder of Success*.

24 Benjamin Elman views this circulation of social wealth as a necessary condition for the rise of academic communities whose members no longer depended on bureaucratic appointments that spearheaded evidential scholarship (*From Philosophy to Philology*). Fujian scholars encountered additional roadblocks to bureaucratic success in the early Qing because of the political sensitivity of the region: part of the province was the fiefdom of rebel Geng Jingzhong (1644–1682), quelled in 1676, while a Fuzhou scholar, Chen Menglei (1650–1741), was accused of treason and twice jailed. Chen, the editor of an imperial encyclopedia project, employed a number of Fuzhou scholars,

including Lin Ji, who was briefly jailed. Yu Dian incurred suspicion from a censor, which effectively ended his official life.

25 Smith, *Body of the Artisan*.

26 The Qing case is different in one important aspect: the most notable scientific experiments were conducted in the Imperial Workshops and under direct supervision of the emperor.

27 Eyferth, *Eating Rice*, 17, 41–43; Sigaut, "Technology."

28 "Difficult to manage" is my translation of a saying attributed to Confucius: "Women and the mean people are especially difficult to manage" (*Analects* 17.23).

29 Female artisans were active in private and state workshops in the early imperial period (Barbieri-Low, *Artisans*, 108–14). The home-based textile workshops throughout the Qing empire were the domain of women, whereas the commercial and imperial textile manufactories employed only men. Female artisans were employed as painters in commercial workshops such as those making New Year prints in Taohuawu, Suzhou, and the porcelain manufactories in Jingdezhen, not to mention as embroiderers in the embroidery workshops in Jiangnan. Publishers also hired women to carve woodblocks for book printing.

30 Huang Ren was said to have hired "female hands of Huanggang" to carve inkstones for him while in Sihui (*Yanshi* C8.4b, C8.32a). One *Yanshi* poet describes their skills in "sand polishing" (*shamo*, A8.49a), which Chen Yu describes as the last step in inkstone making. It involves rubbing the carved stone with a local talc rock and muddy sand from the banks of the Xi River to smooth out the knife marks (*Duanyan minsu*, 76, cf. Qu, *Guangdong xinyu*, 191).

APPENDIX 1

1 Gu might have made another inkstone for Xu Jun. In a poem, Lin Fuyun wrote of a

jade-colored She stone in Xu's collection: "A champion in the hall of literature since young, /A Longwei [She] in his family trove, carved by Dagu./ A bright blue sky lit by 'gold stars', / Rivaling the 'banana white patch' [on a Duan stone]."
早歲文壇薊標家, 藏 [家 A]藏龍尾大家雕, 蔚藍天際金星點 [金星點點碧如玉 A], 爭 勝東流 [精華 A]白葉蕉 (雪邨有歙研 [石 A], 如碧玉色). *Yanshi* C8.34a, cf. A8.18a-b.

APPENDIX 4

1 Yu Wenyi's preface to the 1746 version (i.e., *Yanshi* C) implies that it was soon to be printed, but there is no evidence of this.

2 Lin Fuyun, "Houxu," *Yanshi* A10.14a–b.

3 One poem by Zhou Xuejian, dated 1736, is particularly explicit: "Seeing this [book], there is no need to fondle [the stones], / Viewing the encomium rubbings [*mingta*], I marvel at their novelty" (A8.33b; cf. C8.16a). Zhou Changfa's reference to the decisiveness of the strokes of the "iron brush" (*tiebi*) also implied that he was able to appreciate the artistry of carving from the book (A8.44a; not in C). See also Li Xu's expression of "over two hundred rubbings" (A9.5a; C9.4b) and Fang Zaigu's reference to Fuyun's having "carved the encomiums, made rubbings of them by hand, and compiled them into bound volumes, entitled *Yanshi*" (A10.1a; not in C). That these references tended to be omitted in Text C suggests that the later versions that circulated no longer contain the rubbings.

4 Zhu made two eyebrow or interlinear comments on Apr. 24, 1934. In the first, he noted that Huang Ren's *Hewing to Silence* inkstone (Shoumo yan) "has now become mine" (A3.4b). In the second, he related that another inkstone, the *Xuande Lower Rock* (Xuande xiayan yan), "is now in my humble studio." He then noted four words inscribed on the stone that are missing in *Yanshi* Text A due to a clerical error and added: "Mr.

Lin's original copy does not [make this mistake]" (A7.3a). Zhu purchased a batch of inkstones from the descendants of Lin Ji in Houguan (Fuzhou) in 1934 and is most likely to have bought *Yanshi* Text A (and the "original copy" if there is one) at the same time. The *Xuande* inkstone was donated by Yi'an's sons to the Bishu Shanzhuang Museum in Chengde, along with eight others (Zhu Chuanrong, *Xiaoshan Zhushi*, 5, 183–84). See 68–70 for ink rubbings of the *Hewing to Silence* inkstone and 71–73 for the *Xuande* inkstone.

GLOSSARY OF CHINESE CHARACTERS

Bafen Shi 八分室
baiitangga 柏唐阿
banchang 半腸
Banxiang 瓣香
Bao Zheng 包拯
bianzuo 扁鑿
bigeng 筆耕
Bin Ri village 賓日村
bishi 筆勢
bōsokuu 撥什庫

Cangmen zuo 滄門作
Cao Sugong 曹素功
Cao Xuequan 曹學佺
chabei du 茶杯篤
Chahe fang 查覈房
Changlin Shanzhuang 長林山莊
changsheng bu 長生簿
changsheng shoujin bu 長生壽金簿
chaoshou 抄手
Chen Chunzhong 陳純仲
Chen Dequan 陳德泉 (Yishu 以樹, Zhizi 治滋)
Chen Yixi 陳奕禧 (Xiangquan 香泉)
chen Yuan 臣源
Chen Zhaolun 陳兆崙 (Xinzhai 星齋,
 Goushan 句山)
chiyin jiang 食銀匠
cong hui qian qiao 聰慧纖巧
congming 聰明
chun 蠢
chunqing 純青

Da Ming zuo 大明作
Dang fang 檔房

daofa 刀法
dazuo 大鑿
dequ 得趣
deshao jiaqu 得少佳趣
diao 雕
diaochong 雕蟲
Dishi 砥石
Dong Cangmen 董滄門 (Hanyu 漢禹)
Dongxinzhai yanming 冬心齋硯銘
Du Wanshi 杜萬石
Duanxi 端溪
Ducui Fang 督催房

ershi 耳食

Fa Shishan 法式善
famo er busunhao 發墨而不損毫
Fang Bao 方苞
Feng Jiru tang 馮積儒堂
Five Fortunes stone 五福石
Fu Wanglu 傅王露

Gao Hong 高鴻
Gezuo chengzuo huoji qingdang 各作成做活計
 清檔 (*Tengqing dang* 謄清檔, *Qing dang* 清
 檔)
gong 工
gong yiqi 攻一器
gong zhi jing 功之精
gongting yang, Suzhou jiang 宮廷樣、蘇州匠
Gu Delin 顧德林 (in Huang Zhongjian's text)
Gu Erniang 顧二娘 (Qinniang 親娘; Qingniang
 青孃); née Zou 鄒; Gu Dagu 顧大家
Gu Erniang zao 顧二娘造

277

Gu Gongwang 顧公望 (Zhonglü 仲呂)
Gu Jichen 顧繼臣 (imperial workshop artisan;
 Suzhou native)
Gu Jichen 顧吉臣 (imperial workshop artisan;
 refused Yongzheng's order)
Gu Qiming 顧啟明
Gu Qingniang 顧青娘
Gu Xiaozu 顧小足
guaipi 怪僻
Guan Honghui 關紅惠
Guandong stone 關東石
Guangdong jiang, Suzhou yang 廣東匠、蘇州
 樣
Guangzuo 廣作
guigong 鬼工
guiren 貴人
Gujia xiufa 顧家繡法
Guo 郭 (Yellow Hill family)
guoqiang 過牆
guoyu gongqiao 過於工巧
gupu 古樸
guya 古雅
guya huncheng 古雅渾成

He Bangyan 何邦彥 (Diting 迪亭)
He bi 和璧
He Chong 何崇
He Chuanyao 何傳瑤 (Shiqing 石卿)
He Chunchao 何春巢
He Jinqun 賀金昆 (imperial workshop artisan)
He pu 和璞
He Wei 何薳
He Zhuo 何焯 (Qizhan 屺瞻)
Hongjiang 洪江
hu 笏
Hu-Guang stone 湖廣石
huamei 華美
Huang Du 黃度
Huang Gang (Yellow Hill) villages 黃崗村
Huang Hui 黃惠 (Chengdi 成迪, Xin'an 心庵)
Huang Peifang 黃培芳
Huang Ren 黃任 (Yuxin 于莘, Xintian 莘田,
 Huang Shiyan 黃十研, Shiyan xiansheng 十
 研先生, Shiyan weng 十研翁, Shiyan gong
 十硯公)
Huang Shengyuan 黃聲遠 (imperial workshop
 artisan)

Huang Wenhuan 黃文煥
Huang Zhongjian 黃中堅
huangbai hua 黃白花
huangjuan youfu 黃娟幼婦
Huangshi zhencang 黃氏珍藏
Hui Dong 惠棟
Hui Zhouti 惠周惕
Huizhong Fang 匯總房
Huoji Fang 活計房

ji 技 (skill)
ji 機 (loom)
jiacang 家藏
jiajiang 家匠
Jiamei Caotang 葭湄草堂
jian 堅 (strong)
jian 鑑 (to authenticate)
jianding 鑑定
jianei jiangyi 家內匠役
jiang 匠
Jielin yan 結鄰硯
Jinglong guanzhong ming by Tang Ruizong 唐睿
 宗景龍觀鐘銘
Jinglu Xuan 警露軒
Jingting 敬亭
jingxi 精細
jinshi xue 金石學
jiyi mingjia 技藝名家
jun 君

kaichi 開池
kan chuan shi 看穿石
ke 刻
Kengzai 坑仔
Kezi chu 刻字處
kezi jiang 刻字匠
kezi ren 刻字人
kuanshi 款識
Kuizhangge tushu 奎章閣圖書

Laiyan 賚硯
Langqian ji 琅玕集
Langyewang bei 琅琊王碑
Laokeng 老坑
Laoyan 老巖
leilei luoluo jie xianliang 磊磊落落皆賢良
Li 歷

Li Fu 李馥 (Rujia 汝嘉, Lushan 鹿山)
Li Guo 李果
Li Yunlong 李雲龍 (Lincun 霖邨, Yuhe 玉和)
Li Zhaoluo 李兆洛
Li Zilai 李子來 (Xianfu 先復)
lianlong 簾櫳
liao 料
Liao Shuchou 廖淑籌 (Madame Shouzu 壽竹夫人)
Lin Boshou 林柏壽
Lin Chang 暢 (Chengxiu 承修)
Lin Cong 林琮
Lin Fuyun 林涪雲 (Lunchuan 輪川, Zai'e 在峩)
Lin Ji 林佶 (Jiren 吉人, Luyuan 鹿原)
Lin Jing 林暻
Lin Jingyun 林涇雲 (Yuheng 玉衡)
Lin Sheng 林甡
Lin Shouzhu 林壽竹
Lin Sun 林遜 (Minzi 敏子, Lixuan 立軒)
Lin Tong 林佟 (Laizhai 來齋)
Lin Wan 林皖 (Xinxiang 心香, Chengkui 承奎, Jingtian 擎天, Moucai 茂才)
Lin Weiyun 林渭雲 (Zaihua 在華, Beilong duonong 北隴惰農)
Lin Xiangyun 林湘雲 (Zaiheng 在衡)
Lin Zhaotang 林召棠
Lin Zhaoxian 林兆顯 (Chengmo 承謨)
Lin Zhengqing 林正青 (Zhuyun 洙雲, Cangyan jushi 蒼巖居士)
lingcui 領催
Liu Ci 劉慈
Liu Tingji 劉廷璣
Liu Yuan 劉源
Liuchuan stone 溜川石
longde 龍德
Longguang 龍光
lou 鏤
lü Duanshi 綠端石
Luo 羅 (Yellow hill family)
luqi 鹵氣

Madame Fang Zizhai 方紫齋夫人
Madame Zhuang 莊孺人
Mazi keng 麻子坑
mingta 銘搨
mingwen 銘文
Mo'anlou shicao 墨庵樓試草

mosuo bu qushou 摩挲不去手
Mount Beiling 北嶺
Mount Lanke 欄柯山 (a.k.a. Mount Fuke 斧柯山)
Mu Dazhan 穆大展
muji 目擊

nanjiang 南匠 (southern craftsmen; imperial workshop term)
nanzun nübei 男尊女卑
nanzuo 摘鑿
Neiting gongzao shiyang 內廷恭造式樣
Neiwufu 內務府
nuanyan 暖硯
nüshi 女史

Old Man Lü 呂老
Ouyang Xiu 歐陽修

Panshi Baoshan Lou 潘氏寶山樓
paoshu 拋書
penjing 盆景
pin 品
pinding 品定
Pockmark Chen 陳麻子
Prince Yi 怡親王
Prince Zhuang 莊親王
pu 璞

qi 奇
Qian Chenqun 錢陳群
Qian Daxin 錢大昕
Qianliang Ku 錢糧庫
qiaomiao 巧妙
Qinjia kuan 欽家款
qixia jianu 旗下家奴
Qiusheng 秋生
Qunyu Lou 羣玉樓

ri 日
Ruqi zuo 汝奇作
rushang 儒商

Sang Tiaoyuan 桑調元
shamo 沙磨
Shao Changheng 邵長蘅
Shen Dacheng 沈大成

Shen Deqian 沈德潛
Shen Tingzheng 沈廷正
Shen Yu 沈喻 (imperial workshop manager; Tang Ying's colleague)
Sheng chunhong 生春紅
shi 石
shi shanshi zhi wenli 識山石之文理
Shi Tianzhang 施天章 (southern craftsman and ivory craftsman in imperial workshop)
shigu 石骨
shijiao 石交
shimai 石脈
shimo xiangnian 石墨相黏
shipin 石品
shirou 石肉
shishi qiushi 實事求是
shishunian 十數年
Shiyan xuan 十硯軒
Shiyan xuan tushu 十硯軒圖書
shizhen 施針 (shimao zhen 施毛針)
shizhi wenni 石質溫膩
Shoumo yan 守默硯
shuangdao 雙刀
Shui Yan 水岩
shuipan 水盤
Sihui kuan 四會款
Songfeng shuiyue 松風水月
su 俗
sujing 素淨
suqi 俗氣
Suzuo 蘇作

Tahu 塔湖
tang 堂
Tang Chugang 湯禇岡 (imperial workshop artisan)
Tang Xun 唐詢
Tang Ying 唐英
Tao Hongjing 陶泓景
Taofang Yanming 陶舫硯銘
Taofang Yanshi 陶舫硯史
Taohong jun 陶泓君
Tianfu yongcang 天府永藏
Tianran miaozhi 天然妙質
tiebi 鐵筆
Tong Pengnian 佟彭年
tongren 通人

tongxiao 通曉
tu 圖
Tuoji stone 駝磯石
turen 土人

waigu jiang 外雇匠
waizao zhiqi 外造之氣
wanchun guya 溫純古雅
Wanjuan Lou 萬卷樓
Wang Muzhai 汪木齋 (Nanqiao 南橋)
Wang Tianque 王天爵 (imperial workshop artisan)
Wang Wan 汪琬
Wang Xiang 王相
Wang Xiujun 王岫君
Wang Xiuyun 王秀筠
Wang Yingxuan 硯臺匠王應選 (inkstone craftsman)
Wang Youjun 王幼君
Wang Ziruo 王子若
Wei Shuo 衛鑠
Weng Luoxuan 翁蘿軒 (Songnian 嵩年, Kangyi 康詒)
wenli 文理
wenya 文雅
wenzhi 文治
Wu Lai 吳萊 (Yuanying 淵穎)
Wu Lanxiu 吳蘭修
Wuding stone 武定石
Wumen Gu Erniang zao 吳門顧二孃造
Wumen Gu Erniang zhi 吳門顧二娘製
Wuqu nüshou 吳趨女手
Wuxue 武穴

Xia Yan 下巖
xianglian 香奩
xianren qingfen 先人清芬
xiaoyang 小樣
Xie Gumei 謝古梅 (Daocheng 道承, Youshao 又紹)
Xie Ruqi zuo 謝汝奇作
Xie Shiji 謝士驥 (Ruqi 汝奇)
Xiezi 謝子
xin zhi ku 心之苦
xinbiao 新標
Xingzha Ting 星楂亭
xingzou 行走

xini zhuangya 細膩莊雅

xinqi 新奇

xinxian 新鮮

xiuqi 秀氣

xu 蓄

Xu Baoguang 徐葆光

Xu Bo 徐燉 (Weiqi 惟起, Xinggong 興公)

Xu Cai 許採 (Shizheng 師正)

Xu Jun 許均 (Shudiao 叔調, Xuecun 雪邨)

Xu Liangchen 許良臣 (Shiquan 石泉)

Xu You 許友

Xu Yu 許遇 (Buqi 不棄, Zhenyi 真意, Huanong 花農, Yuexi 月溪)

Xuande xiayan yan 宣德下巖研

Xude yan 蓄德硯

Xue Jinchen 薛晉臣

Xue Ruohui 薛若輝 (Yu Dian's friend who made an inkstone for him)

xueshou jiangren 學手匠人

xueshou xiaojiang 學手小匠

xueshou yiren 學手藝人

xueshou yujiang 學手玉匠

yadi yinqi 壓地隱起

yajiang 牙匠 (imperial workshop term)

Yan Zhaowei 顏肇維

yang 樣

Yang Ah-shui 楊阿水

Yang Bin 楊賓

Yang Dapiao 楊大瓢 (Bin 賓)

Yang Dongyi 楊洞一 (Liang 亮, Er 二)

Yang sheng 楊生

Yang Xiong 揚雄

Yang Zhongyi 楊中一 (Wan 浣)

yangong 硯工, 研工 (He Wei's term)

Yangshi zi 楊氏子

yanjiang 硯匠 (imperial workshop term)

yanpu 硯譜

yantian 硯田

yantu 硯圖

ye 業

Ye Dingxin 葉鼎新

Yellow Wax stone 黃蠟石

yi 藝 (artistry)

yi 貽 (to gift)

yi 遺 (to bequeath)

yi zhi du 意之篤

yi zhi jing 藝之精

yiyan weitian 以硯為田

yong 用

Yongzheng xx nian gezuo chengzuo huoji qing-dang 雍正 xx 年各作成做活計清檔

You Guoqing 游國慶

You Shao'an 游紹安 (Xinmen 性門, Xinshui 心水)

Yu Dian 余甸 (Zuxun 祖訓, Zhongmin 仲敏, Tiansheng 田生)

Yu Shide 余世德

Yu Wenyi 余文儀

Yu Zhen 于振

Yu Zhongya 余仲雅

Yuan Jingshao 袁景劭

Yuan Mei 袁枚

Yuanyou dangren bei 元佑黨人碑

Yubi 御筆

Yutian 于田

Yuxiang 御香

Yuzhen Lanting, attributed to Jia Qiuhe 賈秋壑 玉枕蘭亭

zai linglong xie 再玲瓏些

zakeng 雜坑

Zaoban huoji chu 造辦活計處

Zhang Hechai 章鶴儕

Zhang Jianfu 章簡甫 (Ming educated stone carver)

Zhang Lei 張蕾

Zhang Pengge 張鵬翮

Zhang Roujia 張柔嘉

Zhang Yuan 張遠

Zhang Yuxian 張玉賢

Zhang Zao 章藻 (son of Jianfu)

zhangfang 賬房

Zhao Bian 趙抃

Zhao Guolin 趙國麟 (Renfu 仁圃, Zhuo'an 拙庵, Bo daoren 跛道人, Tai'an gong 泰安公)

zhaomu jiang 召募匠

zhe jianggong 哲匠工

zhi 質

zhi yiye 治一業

zhishi 知事

Zhiyi titou didang 旨意題頭底檔 (*Didang* 底檔; *Liushui dang* 流水檔)

Zhongyi Duan Inkstone Factory 中藝端硯廠

Zhou Shaolong 周紹龍 (Yunqian 允乾, Ruifeng
 瑞峰)
Zhou Xuejian 周學健
Zhou Zhengsi 周正思
Zhu Delin 祝德麟
zhu gulao 諸故老
Zhu Jingying 朱景英
Zhu Yi'an 朱翼盦 (Wenjun 文鈞, Youping 幼平)
Zhuanli Caotang 篆隸草堂
zhuke 逐客
zhuo 琢
zi 子
zihao 字號
ziran guya 自然古雅
zixue 字學
zongjiao shijiao 總角石交
zuo 作

REFERENCES

Aiura Shizui 相浦紫瑞. *Tankeiken* 端溪硯. Tokyo: Mokujisha, 1965.

Anderson, Christy, Anne Dunlop, and Pamela H. Smith, eds. *The Matter of Art: Materials, Practices, Cultural Logics, c. 1250–1750.* Manchester: Manchester University Press, 2014.

Appardurai, Arjun, ed. *The Social Life of Things: Commodities in Cultural Perspective.* New York: Cambridge University Press, 1988.

Bai, Qianshen. *Fu Shan's World: The Transformation of Chinese Calligraphy in the Seventeenth Century.* Cambridge, MA: Harvard University Asia Center, 2003.

Bai Lifan 白黎璠. "Zhu Yizun jiqi yanming kaolue" 朱彝尊及其硯銘考略. In *Tianjin Bowuguan luncong, 2011* 天津博物館論叢, 200–205. Tianjin: Tianjin renmin, 2012.

Barbieri-Low, Anthony J. *Artisans in Early Imperial China.* Seattle: University of Washington Press, 2007.

Beijing tushuguan 北京圖書館, ed. *Linfeng Huangshi jiapu* 鱗峰黃氏家譜. In *Beijing tushuguancang jiapu congkan: MinYue (Qiaoxiang) juan* 北京圖書館藏家譜叢刊: 閩粵（僑鄉）卷, vol. 4. Beijing: Beijing tushuguan, 2000.

Berliner, Nancy. *Yin Yu Tang: The Architecture and Daily Life of a Chinese House.* North Clarendon, VT: Tuttle, 2003.

Bickford, Maggie. *Bones of Jade, Soul of Ice: The Flowering Plum in Chinese Art.* New Haven: Yale University Art Gallery, 1985.

———. "Emperor Huizong and the Aesthetic of Agency." *Archives of Asian Art* 53 (2002–2003): 71–104.

Bol, Peter K. *"This Culture of Ours": Intellectual Transition in Tang and Song China.* Stanford: Stanford University Press, 1992.

Bossler, Beverly. *Courtesans, Concubines, and the Cult of Female Fidelity: Gender and Social Change in China, 1000–1400.* Cambridge, MA: Harvard University Asia Center and Harvard University Press, 2012.

Bray, Francesca. "Toward a Critical History of Non-Western Technology." In *China and Historical Capitalism: Genealogies of Sinological Knowledge*, edited by Timothy Brook and Gregory Blue, 158–209. Cambridge: Cambridge University Press, 1999.

Brokaw, Cynthia J. *Commerce and Culture: The Sibao Book Trade in the Qing and Republican Periods.* Cambridge, MA: Harvard University Asia Center, 2007.

Brook, Timothy. *The Confusions of Pleasure: Commerce and Culture in Ming China.* Berkeley: University of California Press, 1998.

Burkus-Chasson, Anne. *Through a Forest of Chancellors: Fugitive Histories in Liu Yuan's Lingyan ge, an Illustrated Book from Seventeenth-Century Suzhou.* Cambridge, MA: Harvard University Asia Center, 2010.

Cai Hongru 蔡鴻茹. *Zhonghua guyan yibaijiang* 中華古硯一百講. Tianjin: Baihua wenyi, 2007.

Cao Ganyuan 曹淦源. "'Zangyao' ciyang shejizhe Liu Yuan sanlun" 「臧窯」瓷樣設計者劉

源散論. *Jingdezhen taoci* 景德鎮陶瓷 2, no. 2 (1992): 31–33.

Cao Rong 曹溶. *Yanlu* 硯錄. In *Congshu jicheng chubian* 叢書集成初編, vol. 1498. Beijing: Zhonghua, 1991.

Cao Zhao 曹昭 and Wang Zuo 王佐. *Gegu yaolun* 格古要論. Beijing: Jincheng, 2012.

Chang Jianhua 常建華. "Gu Erniang." In *Biographical Dictionary of Chinese Women: The Qing Period, 1644–1911*, edited by Lily Xiao Hong Lee, A. D. Stefanowska, and Clara Wing-chung Ho, 47–48. Armonk: M. E. Sharpe, 1998.

——. "Kangxi zhizuo, shangci Songhua shiyan kao" 康熙製作, 賞賜松花石硯考. *Gugong Bowuyuan yuankan* 故宮博物院院刊 160 (Mar. 2012): 6–20.

Chen, Kaijun. "The Rise of Technocratic Culture in High-Qing China: A Case Study of Bond-servant (Booi) Tang Ying (1682–1756)." PhD diss., Columbia University, 2014.

Chen Guodong 陳國棟. "Kangxi xiaochen Yangxindian zongjianzao Zhao Chang shengping xiaokao" 康熙小臣養心殿總監造趙昌生平小考. In *Sheng Qing shehui yu Yangzhou yanjiu* 盛清社會與揚州研究, edited by Feng Mingzhu 馮明珠, 269–310. Taipei: Yuanliu, 2011.

——. "Wuyingdian zongjianzao Heshiheng: Wei Kangxi huangdi zhaogu xiyangren de Neiwufu chengyuan zhier" 武英殿總監造赫世亨: 為康熙皇帝照顧西洋人的內務府成員之二. *Gugong wenwu yuekan* 故宮文物月刊 334 (Nov. 2011): 50–57.

Chen Qingyuan 陳慶元. "Mingdai zuojia Xu Bo shengzu nian xiangkao" 明代作家徐㶿生卒年詳考. *Wenxue yichan* 文學遺產, no. 2 (2011): 108–116.

——. "Xu Bo xuba buyi kaozheng" 徐㶿序跋補遺考證. *Wenxian* 文獻, no. 3 (July 2009): 79–84.

Chen Yu 陳羽. *Duanyan minsu kao* 端硯民俗考. Beijing: Wenwu, 2010.

Chen Zhaolun 陳兆崙. *Zizhu shanfang shiwenji* 紫竹山房詩文集. N.p., n.d. [between 1783–1795]. Copy in the C.V. Starr Library, Columbia University.

Cheng Zhangcan 程章燦. *Shike kegong yanjiu* 石刻刻工研究. Shanghai: Shanghai guji, 2008.

Clifford, Helen. *Silver in London: The Parker and Wakelin Partnership, 1760–1776*. New Haven: Yale University Press, 2004.

Clunas, Craig. *Empire of Great Brightness: Visual and Material Cultures of Ming China*. London: Reaktion, 2007.

——. *Superfluous Things: Material Culture and Social Status in Early Modern China*. Cambridge: Polity, 1991.

Crossley, Pamela Kyle. *Translucent Mirror: History and Identity in Qing Imperial Ideology*. Berkeley: University of California Press, 1999.

Davis, Natalie Zemon. *The Gift in Sixteenth-Century France*. Madison: University of Wisconsin Press, 2000.

Deng Zhicheng 鄧之誠. *Gudong suoji quanbian* 骨董瑣記全編. Beijing: Beijing, 1996.

Dong Jianzhong 董建中. "Qing Qianlongchao wanggong dachen jingong wenti chutan" 清乾隆朝王公大臣進貢問題初探. *Qingshi yanjiu* 清史研究 2 (1996): 40–50, 66.

Du Jiaji 杜家驥. *Baqi yu Qingchao zhengzhi lungao* 八旗與清朝政治論稿. Beijing: Renmin, 2008.

——. "Qingdai baqi nupuzhi kaoxi" 清代八旗奴僕制考析. *Nankai shixue* 南開史學, no. 1 (1991): 134–48.

Duanyan daguan bianxiezu 端硯大觀編寫組. *Duanyan daguan* 端硯大觀. Beijing: Hongqi, 2005.

Ebrey, Patricia Buckley. *Accumulating Culture: The Collections of Emperor Huizong*. Seattle: University of Washington Press, 2008.

Egan, Ronald. "Ou-yang Hsiu and Su Shih on Calligraphy." *Harvard Journal of Asiatic Studies* 49, no. 2 (Dec. 1989): 365–419.

Eliade, Mircea. *The Forge and the Crucible*. Translated by Stephen Corrin. London: Rider & Company, 1962.

Elman, Benjamin A. *From Philosophy to Philology: Intellectual and Social Aspects of Change in Late Imperial China*. Cambridge, MA: Council on East Asian Studies, Harvard University, 1990.

Elliott, Mark C. *The Manchu Way: The Eight Banners and Ethnic Identity in Late Imperial China*. Stanford: Stanford University Press, 2001.

Eyferth, Jacob. *Eating Rice from Bamboo Roots: A Social History of a Community of Handicraft Papermakers in Rural Sichuan, 1920–2000*. Cambridge, MA: Harvard University Press, 2009.

Feng Mingzhu 馮明珠, ed. *Yongzheng: Qing shizong wenwu dazhan* 雍正：清世宗文物大展. Taipei: National Palace Museum, 2009.

Folsom, Kenneth E. *Friends, Guests, and Colleagues: The Mu-fu System in the Late Ch'ing Period*. Berkeley: University of California Press, 1968.

Furth, Charlotte. "Physician as Philosopher of the Way: Zhu Zhenheng (1282–1358)." *Harvard Journal of Asiatic Studies* 66, no. 2 (Dec. 2006): 423–59.

Fuzhoushi difangzhi bianzuan weiyuanhui 福州市地方志編纂委員會, ed. *Sanfang qixiang zhi* 三坊七巷志. Fuzhou: Haichao sheying yishu, 2009.

Gao Fenghan 高鳳翰. *Yanshi* 硯史. Ink rubbings in the collection of Wang Xiang of Xiushui 秀水王相收藏勒石拓本. 1852. Harvard-Yenching Library.

———. *Yanshi jianshi* 硯史箋釋. Copied and recarved by Wang Xiang 王相重摹. Annotated by Tian Tao 田濤 and Cui Shichi 崔士篪. Beijing: Sanlian, 2011.

Gao Meiqing [Kao Meiching] 高美慶, ed. *Zishi ningying: Lidai Duanyan yishu* 紫石凝英：歷代端硯藝術. Hong Kong: Art Gallery, Chinese University of Hong Kong, 1991.

Gao Zhao 高兆. *Duanxi yanshi kao* 端溪硯石考. In *Meishu congshu*, edited by Huang Binhong and Deng Shi, 1:416–18. Nanjing: Jiangsu guji, 1997.

Guangdongsheng zhiliang jishu jianduju 廣東省質量技術監督局. *Guangdongsheng difang biaozhun: Duan yan* 廣東省地方標準: 端硯. DB44/T 306–2006. N.p., n.d. [2006].

Guangling shushe 廣陵書社, ed. *Zhongguo lidai kaogong dian* 中國歷代考工典, 4 vols. Nanjing: Jiangsu guji, 2003.

Gugong Bowuyuan 故宮博物院 and Bolin Mapu xuehui kexueshi suo 柏林馬普學會科學史所, eds. *Gongting yu difang: Shiqi zhi shiba shiji de jishu jiaoliu* 宮廷與地方：十七至十八世紀的技術交流. Beijing: Zijincheng, 2010.

Gugong Bowuyuan lidai yishuguan 故宮博物院歷代藝術館, ed. *Gugong Bowuyuan lidai yishuguan chenliepin tumu* 故宮博物院歷代藝術館陳列品圖目. Beijing: Wenwu, 1991.

Guoli Gugong Bowuyuan bianji weiyuanhui 國立故宮博物院編輯委員會, ed. *Xiqing yanpu guyan tezhan* 西清硯譜古硯特展. Taipei: National Palace Museum, 1997.

———. *Pinlie Duan She: Songhua shiyan tezhan* 品埒端歙：松花石硯特展. Taipei: National Palace Museum, 1993.

———. *Lanqian shanguan mingyan mulu* 蘭千山館名硯目錄. Taipei: National Palace Museum, 1987.

Han Yu 韓愈. "Maoying zhuan" 毛穎傳. In *Changli xiansheng ji* 昌黎先生集, 36.1b–5a. Suzhou: Jiangsu shuju, 1869–70.

Harrist, Robert E., Jr. *The Landscape of Words: Stone Inscriptions from Early and Medieval China*. Seattle: University of Washington Press, 2008.

Hay, John. "The Persistent Dragon (Lung)." In *The Power of Culture: Studies in Chinese Cultural History*, edited by Willard J. Peterson, Andrew Plaks, and Ying-shih Yu, 119–49. Hong Kong: Chinese University Press, 1994.

Hay, Jonathan. "The Diachronics of Early Qing Visual and Material Culture." In *The Qing Formation in World-Historical Time*, edited by Lynn Struve, 303–34. Cambridge, MA: Harvard University Press, 2004.

———. *Sensuous Surfaces: The Decorative Object in Early Modern China*. London: Reaktion, 2009.

Hayes, James. "Specialists and Written Materials in the Village World." In *Popular Culture in Late Imperial China*, edited by David Johnson, Andrew J. Nathan, and Evelyn Rawski, 75–111. Berkeley: University of California Press, 1985.

He, Yanchiuan. "The Materiality of Style and Culture of Calligraphy in the Northern Song

Dynasty (960–1127)." PhD diss., Boston University, 2013.

He Chuanyao 何傳瑤. *Baoyantang yanbian* 寶硯堂硯辨. Zhaoqing: Baoyantang, 1837 [new blocks]. Collection of the C.V. Starr Library, Columbia University.

He Wei 何薳. *Chunzhu jiwen* 春渚記聞. In *Xuejin taoyuan* 學津討源, 15 *ji*. Shanghai: Hanfen Lou, 1922.

He Yuan 何元 et al. *Chongxiu Gaoyao xianzhi* 重修高要縣志. N.p., 1826.

Ho, Ping-ti. *The Ladder of Success in Imperial China: Aspects of Social Mobility, 1368–1911*. New York: Columbia University Press, 1962.

Howell, Martha C. *Commerce before Capitalism in Europe, 1300–1600*. Cambridge: Cambridge University Press, 2010.

Hu Zhongtai 胡中泰. *Longwei yan* 龍尾硯. Nanchang: Jiangxi jiaoyu, 2001.

———. *Zhongguo shiyan gaikuang* 中國石硯概況. Wuhan: Hubei meishu, 2005.

Huang, I-fen. "Gender, Technical Innovation, and Gu Family Embroidery in Late-Ming Shanghai." *East Asian Science, Technology and Medicine* 36 (2012): 77–129.

Huang Hui 黃惠, comp. *Linfeng Huangshi jiapu* 鱗峰黃氏家譜. N.p., 1793.

Huang Ren 黃任. *Huang Ren ji, wai sizhong* 黃任集 外四種. Annotated by Chen Mingshi 陳名實 and Zheng Xi 鄭曦. Beijing: Fangzhi, 2011.

———. *Qiujiang ji* 秋江集. In *Siku quanshu cunmu congshu* 四庫全書存目叢書, *jibu* 子部vol. 262. Taipei: Zhuangyan wenhua shiye youxian gongsi, 1997. Facsimile of a Qianlong edition [1756] in the Jilin University Library.

———. *Qiujiang jizhu* 秋江集注. Annotated by Wang Yuanlin 王元麟. N.p.: Dongshan jiashu keben 東山家塾刻本, 1843. Copy in the Library of Congress.

———. *Xiangcaozhai shizhu* 香草齋詩注. Annotated by Chen Yingkui 陳應魁. Yongyang: Gongwo cangban 贛窩藏版, 1814. Copy in the Fujian Provincial Library.

Huang Shutiao 黃淑窕. *Mo'anlou shicao* 墨庵樓試草. In *Huang Ren ji*, 324–49. Beijing: Fangzhi, 2011.

Huang Shuwan 黃淑畹. *Qichuang yushi* 綺窗餘事. In *Huang Ren ji*, 351–87. Beijing: Fangzhi, 2011.

———. *Xiangcaojian waiji* 香草箋外集. Xiamen: Xinmin shushe, 1930.

Huang Xintian xiansheng guyan tu 黃莘田先生古硯圖. N.p., n.d. Collection of the Harvard-Yenching Library.

Huang Yunpeng 黃雲鵬. "Wumen zhuoyan mingjia Gu Erniang" 吳門琢硯名家顧二娘. *Suzhou wenshi zhiliao xuanji* 蘇州文史資料選輯 28 (2003): 101–3.

Huang Zhongjian 黃中堅. *Xuzhai erji* 蓄齋二集. N.p., 1765. Reprint, in *Siku weishoushu jikan* 四庫未收書輯刊, edited by Siku weishoushu jikan bianzuan weiyuanhui 四庫未收書輯刊編纂委員會, series 8, 27:317–458. Beijing: Beijing, 2000.

Huang Zhijun 黃之雋, Zhao Hong'en 趙弘恩 et al. *Qianlong Jiangnan tongzhi* 乾隆江南通志. 1737. Reprint, Yangzhou: Guangling shushe, 2010.

Hymes, Robert. "Not Quite Gentlemen? Doctors in Sung and Yuan." *Chinese Science* 8 (1987): 9–76.

Ingold, Tim. *Perceptions of the Environment: Essays on Livelihood, Dwelling and Skill*. London: Routledge, 2011.

Ji Nan 計楠. *Shiyin yantan* 石隱硯談. In *Meishu congshu*, edited by Huang Binhong and Deng Shi, 2:1767–70. Nanjing: Jiangsu guji, 1997.

Ji Ruoxin [Chi Jo-hsin] 嵇若昕. "Cong Huo-jidang kan Yong-Qian liangchao de neiting yishu guwen" 從活計檔看雍乾兩朝的內廷器物藝術顧問. *Dongwu lishi xuebao* 東吳歷史學報 16 (Dec. 2006): 53–105.

———. "Ji yijian Kangxi chao boliqi de zuigao chengjiu" 記一件康熙朝玻璃器的最高成就. In *ShengQing shehui yu Yangzhou yanjiu* 盛清社會與揚州研究, edited by Feng Mingzhu 馮明珠, 421–38. Taipei: Yuanliu, 2011.

———, ed. *Jiangxin yu xiangong: Ming-Qing diaoke zhan (xiangya xijiao pian)* 匠心與仙工：明清雕刻展(象牙犀角篇). Taipei: National Palace Museum, 2009.

———, ed. *Jiangxin yu xiangong: Ming-Qing diaoke zhan (zhumu guohe pian)* 匠心與仙工：

明清雕刻展(竹木果核篇). Taipei: National Palace Museum, 2009.

———. "Qianlong chao Neiwufu Zaobanchu nanjiang zhixin jiqi xiangguan wenti yanjiu" 乾隆朝內務府造辦處南匠資薪及其相關問題研究. In *Qingshi lunji, shang* 清史論集（上）, edited by Chen Jiexian 陳捷先, Cheng Chongde 成崇德, and Li Jixiang 李紀祥, 519–75. Beijing: Renmin, 2006.

———. "Qianlong shiqi de Ruyiguan" 乾隆時期的如意館. *Gugong xueshu jikan* 故宮學術季刊 23, no. 3 (Spring 2006): 127–50.

———. "Qing qianqi Zaobanchu de Jiangnan gongjiang" 清前期造辦處的江南工匠. Paper presented at the international conference on Efflorescence: Life and Culture in Ming-Qing Jiangnan 過眼繁華：明清江南的生活與文化, Academia Sinica, Taipei, Taiwan, Dec. 18–20, 2003.

———. *Shuangxi wenwu suibi* 雙溪文物隨筆. Taipei: National Palace Museum, 2011.

———. "Songdai shu'an shang de wenfang yongju" 宋代書案上的文房用具. *Gugong xueshu jikan* 故宮學術季刊 29, no. 1 (Autumn 2011): 49–80.

———. "Tang Song shiqi jixingyan, fengziyan, chaoshouyan jiqi xiangguan wenti zhi yanjiu" 唐宋時期箕形硯、風字硯、抄手硯及其相關問題之研究. *Gugong xueshu jikan* 故宮學術季刊 18, no. 4 (2001): 17–61.

———. "Yongzheng huangdi yuci Songhua shiyan" 雍正皇帝御賜松花石硯. *Gugong wenwu yuekan* 故宮文物月刊, no. 318 (Sept. 2009): 42–51.

Ji Yun 紀昀. *Yuewei caotang yanpu* 閱微草堂硯譜. Yangzhou: Guangling shushe, 1999. Facsimile of Minguo (1912–1949) edition.

Jiangxisheng Bowuguan 江西省博物館, comp. *Jiangxisheng Bowuguan wenwu jinghua* 江西省博物館文物精華. Beijing: Wenwu, 2006.

Jin Nong 金農. *Dongxinzhai yanming* 冬心齋硯銘. In *Jinxiang xiaopin* 巾箱小品, Jin Nong et al. Huayun xuan 華韻軒. n.d. [prefaced 1750]. Chinese Academy of Sciences Library.

Jing Rizhen 景日眕. *Yankeng shu* 硯坑述. N.p., n.d.

Kangxi 康熙. *Shengzu Renhuangdi yuzhi wenji* 聖祖仁皇帝御製文集. SKQS.

Kitabatake Sōji 北畠雙耳 and Kitabatake Gotei 北畠古鼎. *Chūgoku kenzai shūsei* 中國硯材集成. Tokyo: Akiyama shoten, 1981.

Kleutghen, Kristina. *Imperial Illusions: Crossing Pictorial Boundaries in the Qing Palaces.* Seattle: University of Washington Press, 2015.

Ko, Dorothy. "Between the Boudoir and the Global Market: Shen Shou, Embroidery and Modernity at the Turn of the Twentieth Century." In *Looking Modern: East Asian Visual Culture from the Treaty Ports to World War II*, edited by Jennifer Purtle and Hans Thomsen. Chicago: Center for the Arts of East Asia, University of Chicago and Art Media Resources, 2009.

———. "The Body as Attire: The Shifting Meanings of Footbinding in Seventeenth-Century China." *Journal of Women's History* 8, no. 4 (Winter 1997): 8–27.

———. *Cinderella's Sisters: A Revisionist History of Footbinding.* Berkeley: University of California Press, 2005.

———. "Pursuing Talent and Virtue: Education and Women's Culture in Seventeenth- and Eighteenth-Century China." *Late Imperial China* 13, no. 1 (June 1992): 9–39.

———. "R. H. Van Gulik, Mi Fu, and Connoisseurship of Chinese Art." *Hanxue yanjiu* 30, no. 2 (June 2012): 265–96.

———. *Teachers of the Inner Chambers: Women and Culture in Seventeenth-Century China.* Stanford: Stanford University Press, 1994.

Lai Hui-min 賴惠敏. "Guaren haohuo: Qianlong di yu Suzhou fanhua 寡人好貨：乾隆帝與蘇州繁華." *Zhongyan yanjiuyuan Jindaishi yanjiusuo jikan* 中央研究院近代史研究所集刊, 50 (Dec. 2005): 185–233.

———. *Qianlong huangdi de hebao* 乾隆皇帝的荷包. Taipei: Institute of Modern History, Academia Sinica, 2014.

———. "Qianlongchao Neiwufu de dangpu yu fashang shengxi" 乾隆朝內務府的當舖與發商生息. *Zhongyang yanjiuyuan Jindaishi yanjiusuo jikan* 中央研究院近代史研究所集刊 28 (Dec. 1997): 133–75.

———. "Qianlongchao Neiwufu de pihuo mai-

mai yu jingcheng shishang" 乾隆朝內務府的皮貨買賣與京城時尚. *Gugong xueshu jikan* 故宮學術季刊 21, no. 1 (Autumn 2003): 101–34.

———. "Qing Qianlongchao de shuiguan yu huangshi caizheng" 清乾隆朝的稅關與皇室財政. *Zhongyang yanjiuyuan Jindaishi yanjiusuo jikan* 中央研究院近代史研究所集刊 46 (Dec. 2004): 53–103.

Latour, Bruno. *Laboratory Life: The Construction of Scientific Facts*. Princeton: Princeton University Press, 1986.

Ledderose, Lothar. *Mi Fu and the Classical Tradition of Chinese Calligraphy*. Princeton: Princeton University Press, 1979.

Lefebvre, Eric. "The Conservation and Mounting of Chinese Paintings Viewed by the Connoisseur in the Age of Evidential Scholarship: The Case of Ruan Yuan (1764–1849)." Paper presented at the conference on the Making of Chinese Paintings: 700 to the Present, Victoria and Albert Museum, London, Dec. 5–6, 2013.

Leitch, Alison. "Materiality of Marble: Explorations in the Artistic Life of Stone." *Thesis Eleven* 103, no. 1 (2010): 65–77.

Li, Guotong. "Imagining History and the State: Fujian *Guixiu* (Genteel Ladies) at Home and on the Road." In *Inner Quarters and Beyond*: *Women Writers from Ming through Qing*, edited by Grace S. Fong and Ellen Widmer, 313–38. Leiden: Brill, 2010.

Li, Wai-yee. "The Collector, the Connoisseur, and Late-Ming Sensitivity." *T'oung Pao*, second series, 81, nos. 4/5 (1995): 269–302.

Li Fu 李馥. *Juyetang shigao, xu* 居業堂詩稿, 續. Facsimile reprint of unpublished manuscript in *Qingdai shiwenji huibian*, vol. 219. Shanghai: Shanghai guji, n.d.

Li Huiyi [Li Wai-yee] 李惠儀. "Shibian yu wanwu: luelun Qingchu wenren de shenmei fengshang" 世變與玩物：略論清初文人的審美風尚. *Zhongguo wenzhe yanjiu jikan* 中國文哲研究集刊 33 (Sept. 2008): 35–76.

Li Mingwan 李銘皖, Feng Guifen 馮桂芬 et al. *Suzhou fuzhi* 蘇州府志. 1883. Reprint, Taipei: Chengwen chubanshe, 1970.

Li Rihua 李日華. *Weishuixuan riji* 味水軒日記. Liushi Jiayetang, n.d.

Li Zhaoluo 李兆洛. *Duanxi yankeng ji* 端溪硯坑記. In *Meishu congshu*, edited by Huang Binhong and Deng Shi, 1:82–85. Nanjing: Jiangsu guji, 1997.

Li Zhizhong 李致忠. *Lidai keshu kaolue* 歷代刻書考略. Chengdu: Bashu shushe, 1989.

Liang Zhangju 梁章距. *Langji congtan* 浪跡叢談. Beijing: Zhonghua, 1981.

———, ed. *Minchuan guixiu shihua* 閩川閨秀詩話. N.p., 1849.

Lin, Yeqiang [Peter Y. K. Lam] 林業強. "Cangu yunxin: Liu Yuan sheji ciyang kao" 參古運新：劉源設計瓷樣考. In *Gugong Bowuyuan bashi huadan gutaoci xueshu yanjiuhui lunwenji* 故宮博物院八十華誕古陶瓷學術研究會論文集, 11–24. Beijing: Zijincheng, 2007.

Lin Fuyun 林涪雲, comp. *Yanshi* 硯史. Manuscript in the Capital Library, Beijing [*Yanshi* A].

———. *Yanshi* 硯史. Formerly in the collection of Panshi Baoshan Lou, 1935 [*Yanshi* B].

———. *Yanshi* 硯史. Manuscript in the Shanghai Library [*Yanshi* C].

Lin Ji 林佶. *Puxuezhai shigao* 樸學齋詩稿. *Siku quanshu cunmu congshu* 四庫全書存目叢書, *jibu* 集部, vol. 262. Tainan: Zhuangyan wenhua shiye youxian gongsi, 1997.

———. *Puxuezhai xiaoji* 樸學齋小記. N.p., n.d. Manuscript in the Fujian Provincial Library.

———. *Puxuezhai wenji* 樸學齋文集. Fujian: Lishuizhuang, 1825 reprint of 1744 edition.

Lin Liyue 林麗月. "Daya jianghuan: Cong 'Su-yang' fushi kan wan-Ming de xiaofei wenhua" 大雅將還：從「蘇樣」服飾看晚明的消費文化. In *Ming-Qing yilai Jiangnan shehui yu wenhua lunji* 明清以來江南社會與文化論集, edited by Xiong Yuezhi 熊月之and Xiong Bingzhen 熊秉真, 213–24. Shanghai: Shanghai shehui kexue, 2004.

Lin Qianliang 林乾良. *Fujian yinren zhuan* 福建印人傳. Fuzhou: Fujian meishu, 2006.

Lin Wanli 林萬里. *Shengchunhong shi jinshi shuji* 生春紅室金石述記. Taipei: Xuehai, 1977.

Lin Zhengqing 林正青. "Shiyanxuan ji" 十硯軒

記. In Xie Zhangting 謝章鋌, *Baifan zalu*稗販雜錄, in *Duqishanzhuang ji* 賭棋山莊集.

Linfeng Huangshi shuhua ji 麟峰黃氏書畫集. *Linfeng Huangshi yiwen* 麟峰黃氏藝文, vol. 2. Fujian: Linfeng shuyuan, n.d. [preface 2010].

Linfeng Huangshi xianxian ji 麟峰黃氏先賢集. *Linfeng Huangshi yiwen* 麟峰黃氏藝文, vol. 1. Fujian: Linfeng shuyuan, n.d. [preface 2010].

Liu, Lydia H. *Clash of Empires: The Invention of China in Modern World Making*. Cambridge, MA: Harvard University Press, 2004.

Liu, Lydia H., Rebecca Karl, and Dorothy Ko, eds. *The Birth of Chinese Feminism: Essential Texts in Transnational Theory*. New York: Columbia University Press, 2013.

Liu Donghai 劉東海 and Wang Zhiming 王志明. "Yongzheng ruhe qianghua zhongyang jiquan: yi Yongzheng chao Fujian de liangcang zhili yu lizhi wei li" 雍正如何強化中央集權：以雍正朝福建糧倉治理與吏治為例. *Tansuo yu zhengming* 探索與爭鳴, no. 9 (2008): 77–80.

Liu Tingji 劉廷璣. *Zaiyuan zazhi* 在園雜志. Shanghai: Shenbaoguan, n.d.

Liu Wen 劉文, ed. *Zhongguo gongyi meishu dashi: Li Keng* 中國工藝美術大師：黎鏗. Nanjing: Jiangsu meishu, 2011.

Liu Yanling 劉演良. *Duanxi mingyan* 端溪名硯. Guangzhou: Guangdong renmin, 1979.

———. *Duanyan de jianbie he xinshang* 端硯的鑒別和欣賞. Wuhan: Hubei meishu, 2002.

———. *Duanyan quanshu* 端硯全書. Hong Kong: Eight Dragons Publishing, 1994.

Lu Fusheng 盧輔聖, ed. *Zhongguo shuhua quanshu* 中國書畫全書. Shanghai: Shanghai shuhua, 2009.

Luo Yang 羅揚. "Xiqing yanpu yu Songhua shiyan" 西清硯譜與松花石硯. *Shoucangjia* 收藏家 12 (2006): 19–22.

Lynn, Richard John. *The Classic of Changes: A New Translation of the* I Ching *as Interpreted by Wang Bi*. New York: Columbia University Press, 1994.

Ma, Ya-chen. "Picturing Suzhou: Visual Politics in the Making of Cityscapes in Eigh-teenth-Century China." PhD diss., Stanford University, 2007.

Ma Tai-loi 馬泰來. "Hongyu lou tiba shize" 紅雨樓題跋十則. *Wenxian* 文獻, no. 3 (July 2005): 29–38.

McNair, Amy. *The Upright Brush: Yan Zhenqing's Calligraphy and Song Literati Politics*. Honolulu: University of Hawai'i Press, 1998.

Mi Fu 米芾. *Yanshi* 硯史. In *Congshu jicheng chubian*, vol. 1497. Beijing: Zhonghua shuju, 1985.

Miles, Steven B. *The Sea of Learning: Mobility and Identity in Nineteenth-Century Guangzhou*. Cambridge, MA: Harvard University Asia Center and Harvard University Press, 2006.

Miller, Peter N., and Francois Louis, eds. *Antiquarianism and Intellectual Life in Europe and China, 1500–1800*. Ann Arbor: University of Michigan Press, 2012.

Mukerji, Chandra. *Impossible Engineering: Technology and Territoriality on the Canal du Midi*. Princeton: Princeton University Press, 2009.

Nalan Chang'an 納蘭長安. *Huanyou biji* 宦遊筆記. Taipei: Guangwen shuju reprint, n.d.

Naquin, Susan. *Peking: Temples and City Life, 1400–1900*. Berkeley: University of California Press, 2001.

Ni Qinghua 倪清華. "Guji xieyang dajia Lin Ji yu Xie Xi" 古籍寫樣大家林佶與謝曦. *Dongfang shoucang* 東方收藏, no. 9 (2012): 80–81.

Peng Zeyi 彭澤益. *Zhongguo jindai shougongye-shi ziliao (1840–1949)* 中國近代手工業史資料. Beijing: Sanlian, 1957.

Qi Meiqin 祁美琴. *Qingdai Neiwufu* 清代內務府. Shenyang: Liaoning minzu, 2009.

Qian Chaoding 錢朝鼎. *Shuikeng shiji* 水坑石記. In *Meishu congshu*, edited by Huang Binhong and Deng Shi, 3:2472. Nanjing: Jiangsu guji, 1997.

Qiu Pengsheng [Chiu Peng-sheng] 邱澎生. "Shiba shiji Suzhou mianbuye de gongzi jiufen yu gongzuo guize" 十八世紀蘇州棉布業的工資糾紛與工作規則. In *Jiangnan shehui lishi pinglun* 江南社會歷史評論, edited by Tang Lixing, 3:239–70. Beijing: Shangwu, 2011.

Qu Dajun 屈大均. *Guangdong xinyu* 廣東新語. Hong Kong: Zhonghua, 1974.

Rawski, Evelyn S. *The Last Emperors: A Social History of Qing Institutions*. Berkeley: University of California Press, 2001.

Reitlinger, Gerald. *The Economics of Taste: The Rise and Fall of the Objet d'Art Market Since 1750*. New York: Holt, Rinehart and Winston, 1963.

———. *The Economics of Taste: The Rise and Fall of the Picture Market, 1760–1960*. New York: Holt, Rinehart and Winston, 1963.

Roberts, Lissa, Simon Schaffer, and Peter Dear, eds. *The Mindful Hand: Inquiry and Invention from the Late Renaissance to Early Industrialisation*. Amsterdam: Koninklijke Nederlandse Akademie van Weterschappen, 2007.

Ruan Kuisheng 阮葵生. *Chayu kehua* 茶餘客話. Taipei: Shijie shuju, 1963.

Ruitenbeek, Klaus. *Discarding the Brush, Gao Qipei and the Art of Chinese Finger Painting*. Chicago: Art Media Resources, 1992.

Sage, Steven F. *Ancient Sichuan and the Unification of China*. Albany: State University of New York Press, 1992.

Schäfer, Dagmar. *The Crafting of the 10,000 Things: Knowledge and Technology in Seventeenth-Century China*. Chicago: University of Chicago Press, 2011.

———, ed. *Cultures of Knowledge: Technology in Chinese History*. Leiden: Brill, 2012.

Sennett, Richard. *The Craftsman*. New Haven: Yale University Press, 2009.

Shanghai Bowuguan, ed. *Haishang jinxiu: Guxiu zhenpin teji* 海上錦繡： 顧繡珍品特集. Shanghai: Shanghai guji, 2007.

———. *Guxiu guoji xueshu yantaohui lunwenji* 顧繡國際學術研討會論文集. Shanghai: Shanghai shuhua, 2010.

———. *Weiyan zuotian: Shanghai Bowuguan cangyan jingcui* 唯硯作田： 上海博物館藏硯精粹. Shanghai: Shanghai shuhua, 2015.

Shen Hongmei 沈紅梅. *Xiang Yuanbian shuhua dianji shoucang yanjiu* 項元汴書畫典籍收藏研究. Beijing: Guojia tushuguan, 2012.

Shoudu Bowuguan 首都博物館, ed. *Shoudu Bowuguan cang mingyan* 首都博物館藏名硯. Beijing: Gongyi meishu, 1997.

Shuangqing cangyan 雙清藏硯 (The Fine Chinese Inkstones: Collection of Steven Hung and Lindy Chern). Taipei: Guoli Lishi Bowuguan, 2001.

Sigaut, Francois. "Technology." In *Companion Encyclopedia of Anthropology*, edited by Tim Ingold, 420–59. Oxford: Taylor & Francis, 1994.

Skinner, G. William. "The Structure of Chinese History." *Journal of Asian Studies* 44, no. 2 (Feb. 1985): 271–92.

SKQS. *Siku quanshu*.

Smith, Pamela H. *The Body of the Artisan: Art and Experience in the Scientific Revolution*. Chicago: University of Chicago Press, 2004.

Song Boyin 宋伯胤. "Cong Liu Yuan dao Tang Ying: Qingdai Kang, Yong, Qian guanyao ciqi zongshu" 從劉源到唐英—清代康、雍、 乾官窯瓷器綜述. In *Qingci cuizhen* 清瓷萃珍, edited by Peter Y. K. Lam, 9–42. Nanjing and Hong Kong: Nanjing Museum and the Art Gallery, Chinese University of Hong Kong, 1995.

Stewart, Susan. *On Longing: Narratives of the Miniature, the Gigantic, the Souvenir, the Collection*. Durham: Duke University Press, 1993.

Sturman, Peter Charles. *Mi Fu: Style and the Art of Calligraphy in Northern Song China*. New Haven: Yale University Press, 1999.

Su Yijian 蘇易簡. *Wenfang sipu* 文房四譜. SKQS.

Tan Wosen 譚沃森. *Qutan Duanyan* 趣談端硯. Tianjin: Baihua wenyi, 2007.

Tang Ji 唐積. *Shezhou yanpu* 歙州硯譜. In *Congshu jicheng chubian*, vol. 1497. Beijing: Zhonghua shuju, 1985 [colophon 1066].

Tang Ying 唐英. *Tang Ying quanji* 唐英全集. Beijing: Xueyuan, 2008.

Tao Futing 陶覺亭 (Yuanzao 元藻). *Bo'ou shanfang ji* 泊鷗山房集. N.p.: Henghe Caotang cangban 衡河草堂藏版, n.d. [ca. 1753].

Thorp, Robert L., and Richard Ellis Vinograd. *Chinese Art and Culture*. Upper Saddle River, NJ: Pearson Prentice Hill, 2006.

Tianjin Bowuguan 天津博物館, ed. *Tianjin Bowuguan cangyan* 天津博物館藏硯. Beijing: Wenwu, 2012.

Tianjinshi Yishu Bowuguan 天津市藝術博物館, ed. *Tianjinshi Yishu Bowuguan cangyan* 天津市藝術博物館藏硯. Beijing: Wenwu, 1979.

Tianshui bingshanlu 天水冰山錄. In *Congshu jicheng chubian* 叢書集成初編, edited by Wang Yunwu 王雲五, vols.1502–1504. Shanghai: Shangwu, 1937.

Torbert, Preston M. *The Ch'ing Imperial Household Department: A Study of Its Organization and Principle Functions, 1662–1796.* Cambridge, MA: Council of East Asian Studies, Harvard University, 1977.

Turnbull, David. "Travelling Knowledge: Narratives, Assemblage, and Encounters." In *Instruments, Travel and Science: Itineraries of Precision from the Seventeenth to the Twentieth Centuries*, edited by Marie-Noëlle Bourguet, Christian Licoppe, and H. Otto Sibum. London: Routledge, 2002.

Van Gulik, R. H. *Mi Fu on Inkstones.* Translated with an introduction and notes by R. H. van Gulik. Beijing: Henri Vetch, 1938.

———. *Scrapbook for Chinese Collectors, Shu-Hua-Shuo-Ling.* Translated with an introduction and notes by R. H. Van Gulik. Beirut: Imprimerie Catholique, 1958.

Wang Nianxiang 王念祥 and Zhang Shanwen 張善文. *Zhongguo guyan pu* 中國古硯譜. Beijing: Beijing Gongyi meishu, 2005.

Wang Shixiang 王世襄. *Jinhui dui* 錦灰堆, vols. 1–3. Beijing: Sanlian, 1999.

———. "Qingdai Wang Muzhai shidiao" 清代汪木齋石雕. *Meishujia* 美術家 22 (1981): 56–59.

Wang Shizhen 王士禎. *Xiangzu biji* 香祖筆記. Shanghai: Shanghai guji, 1982.

Wang Wan 汪琬. *Yaofeng wenchao* 堯峰文鈔. Edited and copied by Lin Ji; blocks carved by Cheng Jisheng 程際生. N.p., 1693. Reprint, *Sibu congkan chubian suben* 四部叢刊初編縮本, vols. 355–56. Taipei: Shangwu, 1965.

Wang Yang 王洋. "Yinshi Hejun muzhi" 隱士何君墓誌. *Dongmou ji* 東牟集, 14.9a–13b. SKQS.

Wu, Hung, ed. *Reinventing the Past: Archaism and Antiquarianism in Chinese Art and Visual Culture.* Chicago: Center for the Art of East Asia, University of Chicago and Art Media Resources, 2010.

Wu, Silas H. L. *Communication and Imperial Control in China: Evolution of the Palace Memorial System, 1693–1735.* Cambridge: Harvard University Press, 1970.

Wu, Yulian. "Tasteful Consumption: Huizhou Salt Merchants and Material Culture in Eighteenth-Century China." PhD diss., University of California, Davis, 2012.

Wu Chengming 吳承明. *Zhongguo ziben zhuyi yu guonei shichang* 中國資本主義與國內市場. Beijing: Zhongguo shehui kexue, 1985.

Wu Lanxiu 吳蘭修. *Duanxi yanshi* 端溪硯史. In *Congshu jicheng chubian.* Beijing: Zhonghua, 1991.

Wu Ligu 吳笠谷. *Mingyan bian* 名硯辨. Beijing: Wenwu, 2012.

———. *Wanxiang yihong: Wu Ligu zhiyan, cangyan, ji shuhua yishu* 萬相一泓：吳笠谷製硯、藏硯及書畫藝術. Gwacheon-si: Chusa Museum, 2015.

———. *Yingyankao* 贗硯考. Beijing: Wenwu, 2010.

Wu Renshu [Wu Jen-shu] 巫仁恕. *Pinwei shehua: Wan Ming de xiaofei shehui yu shidafu* 品味奢華：晚明的消費社會與士大夫. Taipei: Academia Sinica and Lianjing, 2007.

———. *Youyou fangxiang: Ming-Qing Jiangnan chenshi de xiuxian xiaofei yu kongjian bianqian* 優遊坊廂：明清江南城市的休閒消費與空間變遷. Taipei: Institute of Modern History, Academia Sinica, 2013.

Wu Shengnian 吳繩年. *Duanxi yanzhi* 端溪硯志. N.p., n.d. [1757].

Wu Zhaoqing 吳兆清. "Qing Neiwufu Huojidang" 清內務府活計檔. *Wenwu* 文物 3 (1991): 89–96, 55.

———. "Qingdai Zaobanchu de jigou he jiangyi" 清代造辦處的機構和匠役. *Lishi dang'an* 歷史檔案 4 (1991): 79–86, 89.

Wu Zhenyu 吳振棫. *Yangjizhai conglu* 養吉齋叢錄. N.p., n.d. [preface 1896].

Xia Dezheng 夏德政. "Pin lie Duan She Songhua shi" 品埒端歙松花石. *Diqiu* 地球 3 (2002): 19.

Xiao Feng 蕭豐. *Qixing, wenshi yu wan-Ming shehui shenghuo* 器型，紋飾與晚明社會生活. Wuhan: Huazhong shifan daxue, 2010.

Xie Daocheng 謝道承 [Gumei 古梅]. *Xiaolangai shiji* 小蘭陔詩集. N.p., Qianlong 38 (1773).

Xie Shiji 謝士驥 [Ruqi 汝奇]. *Chuncaotang shichao* 春草堂詩鈔. N.p., Qianlong 42 (1777). Copy in the rare book room, Fujian Normal University Library.

Xu, Yinong. *The Chinese City in Space and Time: The Development of Urban Form in Suzhou.* Honolulu: University of Hawaiʻi Press, 2000.

Xu Kang 徐康. *Qianchen mengyinglu* 前塵夢影錄. In *Meishu congshu* 美術叢書, edited by Huang Binhong 黃賓虹 and Deng Shi 鄧實, 1:96–123. Nanjing: Jiangsu guji, 1997.

Xue Longchun 薛龍春. *Zheng Fu yanjiu* 鄭簠研究. Beijing: Yongbao zhai, 2007.

Yan Jiaxian 閻家憲. *Jiaxian cangyan* 家憲藏硯, *shang juan*. Beijing: Shijie zhishi, 2009.

———. *Jiaxian cangyan* 家憲藏硯, *xia juan*. Beijing: Shijie zhishi, 2010.

Yang Bin 楊賓. *Dapiao oubi* 大瓢偶筆. In *Zhongguo shuhua quanshu* 中國書畫全書, edited by Lu Fusheng 盧輔聖, 12:317–70. Shanghai: Shanghai shuhua, 2009 [prefaced 1708].

Yang Qiqiao 楊啟樵. "Huojidang baolu Qinggong mishi" 活計檔暴露清宮秘史. *Qingshi yanjiu* 清史研究 3 (1997): 26–35.

Ye Yanlan 葉衍蘭 and Ye Gongzhuo 葉恭綽. *Qingdai xuezhe xiangzhuan heji* 清代學者像傳. Shanghai: Shangwu, 1930.

Yi Picong 伊丕聰. *Wang Yuyang xiansheng nianpu* 王漁洋先生年譜. Jinan: Shandong daxue, 1989.

Yi Zongkui 易宗夔. *Xinshishuo* 新世說. Taipei: Mingwen, 1985.

Yin Runsheng 尹潤生. "Qingdai Neiwufu cang Liu Yuan mo" 清代內務府藏劉源墨. *Zijincheng* 紫禁城 2 (2010): 86–87.

You Shaoʼan 游紹安. *Hanyoutang shiwenji* 涵有堂詩文集. In *Siku quanshu cunmu congshu* 四庫全書存目叢書, edited by Siku quanshu cunmu congshu bianzuan weiyuanhui 四庫全書存目叢書編纂委員會, *jibu* 集部, 273:324–606. Jinan: Qilu shushe, 1997.

Yu Dian 余甸. *Yu Jingzhao ji* 余京兆集. Manuscript in the Fujian Provincial Library.

Yu Huai 余懷. *Yanlin* 硯林. In *Zhaodai congshu* 昭代叢書, edited by Zhang Chao 張潮, *jia* 42.1a–19a. N.p., n.d. [Qianlong era].

Yu Minzhong 于敏中 et al., eds. *Xiqing yanpu* 西清硯譜. [Preface 1778], SKQS.

Yu Peijin [Yü Pʼei-chin] 余佩瑾. "Tang Ying yu Yong-Qian zhiji guanyao de guanxi: Yi Qinggong falang caici huizhi yu shaozao weili" 唐英與雍乾之際官窯的關係：以清宮琺瑯彩瓷的繪製與燒造為例. *Gugong xueshu yuekan* 故宮學術月刊 24, no. 1 (Autumn 2006): 1–44.

Yu Yingshi 余英時. "Zhongguo jinshi zongjiao lunli yu shangren jingshen" 中國近世宗教倫理與商人精神. In *Shi yu Zhongguo wenhua* 士與中國文化, 441–579. Shanghai: Shanghai Renwen, 1987.

Yuan Mei 袁枚. *Suiyuan shihua* 隨園詩話. Beijing: Renmin wenxue, 1960.

Yue Shengyang 岳升陽, Huang Zonghan 黃宗漢, and Wei Quan 魏泉. *Xuannan: Qingdai jingshi shiren jujuqu yanjiu* 宣南：清代京師士人聚居區研究. Beijing: Beijing yanshan, 2012.

YXD. Zhu Jiajin 朱家溍, comp. *Yangxindian Zaobanchu shiliao jilan, diyiji: Yongzheng chao* 養心殿造辦處史料輯覽，第一輯，雍正朝. Beijing: Zijincheng, 2003.

ZBC. Zhongguo diyi lishi dangʼanguan 中國第一歷史檔案館 and Xianggang Zhongwen daxue wenwuguan 香港中文大學文物館, eds. *Qinggong Neiwufu Zaobanchu dangʼan zonghui* 清宮內務府造辦處檔案總匯. Beijing: Renmin, 2005.

Zeitlin, Judith. "The Petrified Heart: Obsession in Chinese Literature, Art and Medicine." *Late Imperial China* 12, no. 1 (June 1991): 1–26.

Zeng Xingren 曾興仁. *Leshantang Yankao* 樂山堂硯考. Banxiang shuwu 瓣香書屋, 1837.

Zhang Bangji 張邦基. *Mozhuang manlu* 墨莊漫錄. Beijing: Zhonghua, 2002.

Zhang Changhong 張長虹. *Pinjian yu jingying: Mingmo Qingchu Huishang yishu zanzhu yanjiu* 品鑑與經營：明末清初徽商藝術贊助研究. Beijing: Beijing daxue, 2010.

Zhang Liduan [Chang Li-tuan] 張麗端. "Cong Huojidang kan Qing Gaozong zhijiekong-guan yuzhiqiyong de liangge jizhi" 從活計檔看清高宗直接控管御製器用的兩個機制. *Gugong xueshu jikan* 故宮學術季刊 24, no. 1 (Autumn 2006): 45–70.

Zhang Shufen 張淑芬, ed. *Wenfang sibao: Zhiyan* 文房四寶：紙硯. *Gugong bowuyuan cang wenwu zhenpin daxi* 故宮博物院藏文物珍品大系. Shanghai: Shiji and Hong Kong: Shangwu, 2005.

Zhang Zhongxing 張中行. "Gu Erniang." In *Yuedanji* 月旦集, 277–83. Beijing: Jinji guanli, 1995.

Zheng Minde 鄭民德. "Qingdai Zhili hedao zongdu jianzhi kaolun" 清代直隸河道總督建置考論. *Beijing huagong daxue xuebao shehui kexue ban* 北京化工大學學報社會科學版, no. 3 (2011): 76–80.

Zhongguo wenfang sibao quanji bianji weiyuanhui 中國文房四寶全集編輯委員會, ed. *Zhongguo wenfang sibao quanji* 中國文房四寶全集, vol. 2, *Yan* 硯. Beijing: Beijing, 2007.

Zhou Hui 周輝. *Qingbo zaji* 清波雜記. Beijing: Zhonghua, 1985.

Zhou Nanquan 周南泉. "Qingchu nüzhuoyan gaoshou: Gu Erniang jiqi zhi Duanshi fang-chi yan" 清初女琢硯高手：顧二娘及其製端石方池硯. *Gugong wenwu yuekan* 故宮文物月刊, no. 109 (Apr. 1992): 16–21.

Zhou Shaoliang 周紹良. *Xumo xiaoyan* 蓄墨小言. Beijing: Beijing yanshan, 2007.

Zhu Chuanrong 朱傳榮. *Xiaoshan Zhushi cang-yan xuan* 蕭山朱氏藏硯選. Beijing: Sanlian, 2012.

Zhu Jiajin 朱家溍. *Gugong tuishilu* 故宮退食錄. Beijing: Beijing, 2000.

Zhu Jingying 朱景英. *Shejing tang wenji* 畬經堂文集. In *Siku weishoushu jikan* 四庫未收書輯刊, edited by Siku weishoushu jikan bianzuan weiyuanhui 四庫未收書輯刊編纂委員會. Series 10, vol. 18. Beijing: Beijing, 2000.

Zhu Wanzhang 朱萬章. "Jin Nong shufa yishu ji *Xingkaishu yanmingce* qiantan" 金農書法藝術及《行楷書硯銘冊》淺談. *Shoucangjie* 收藏界, no. 135 (2013.3): 99–101.

Zhu Yuzhen 朱玉振. *Duanxi yankeng zhi* 端溪硯坑志. N.p., 1799.

INDEX

Drawing of Antique Inkstones Held by Mister Huang Xingtian, 177*fig.*

Du Dashou, *Appreciating Inkstones*, 161*fig.*

Du Fu, "Dreaming of Li Bo," 166

Du Jiaji, 16, 233n14

Du Shiyuan, 249n10

Duan quarries (Zhaoqing): access to, 242n11; aerial photograph of, 59*fig.*; annotated map of Underwater Lode, 72, 73*fig.*, 247–48n71; Banbian Rock, 64, 67; connoisseurs' knowledge of, 173–74, 268n64; Houli Rock, 64, 67, 245n47; imperial control over, 58, 244n28; Little Pit, 58, 65*fig.*, 69, 74; locations of, 50*map*; Lower Rock, 64, 67, 245nn47,48; Major West Cave, 74; manpower for, 72, 73*fig.*, 247n68; maps of, 68–71, 69*fig.*, 71*fig.*, 72, 73*fig.*, 246nn60,64, 247nn67,71; Middle Cave, 115, 209; mining accidents and snakes, 54, 242n15; miscellaneous quarries, 74, 247n69; mix of stone and water in, 60; names of, 244n29; opening of, 160; Plum Blossom Pit, 65*fig.*; Pockmark Pit, 58, 59*fig.*, 65*fig.*, 69, 74, 243n21, 244n29; ranking of, 66, 76; Shrine of the Inkstone Pit, 246n62; Song Pit, 96; as source of livelihood, 49; tunnels of, 69–70, 71, 72; Upper Rock, 64, 67, 245n47; West Pit, 245n47. *See also* Duan stone; Old Pit (Underwater Lode); stoneworkers

Duan region, xiii*map*, 56, 241n1, 247n71; travelers to, 51, 64, 67, 68, 71. *See also* Duan quarries; Yellow Hill; White Stone village

Duan stone: colors of, 45, 49, 75, 76, 164, 173–74, 241n4, 248n75, 256n4, 260n48; compared with She stone, 64, 67, 241n3, 245n47; compared with Songhua stone, 14, 31; and competing knowledge systems, 77–78; connoisseurship of, 46, 76, 77, 172, 173–74, 241n3, 241–42n6; considered a fad, 65, 274n20; conveyance of, 242n7; "eyes" of, 39, 61, 64–67, 65*fig.*, 93*fig.*, 96, 163, 245nn49,50, 245–46n51, 248n74, 264n25; expertise regarding, 72–78; fakes, 39, 76, 248n74; geological characteristics, 49, 241n4; gold streaks in, 245n50; hierarchy of, 64–67, 70, 74–75, 76–77, 245n47; inkstones gifted by Yongzheng, 240n82; markings of, 66, 76, 93, 93*fig.*, 143, 206, 245n50, 268n66; mentioned

in poems, 234n24, 263n17; Mi Fu on, 64–67, 245n44; Ouyang Xiu's low opinion of, 65–66; as "purple clouds," 255n68; in storehouse inventory, 239n71; tales of, 51, 242n8; term used for Songhua stone by Yongzheng, 39–40, 239n64; used for inkstones, 25, 27*fig.*, 92, 140–41, 166, 234n23. *See also* Duan quarries; mineral features; mynah's eyes

Duanningdian, 236n43

Duanxi (tributary of Xi River), 49, 63, 246n64

Duanxi yanpu (Ye Yue), 161*fig.*, 245n51

Duanyang tribute, 22

Duanzhou (Guangdong), 241nn1,2. *See also* Duan region; Yellow Hill; White Stone village; Zhaoqing

Ducui Fang (Office of Overseers), 34

dustpan shape, 112*fig.*, 135

E

Eight Banners, 16, 233n14. *See also* Hanjunbanner

Eliade, Mircea, 244n36

Elman, Benjamin, 68, 190, 274n24

embroidery, 120–22, 132, 135, 256n8; *Guxiu*, 110, 113, 121*fig.*, 122, 137, 255n76; "hairy stitch," 121*fig.*, 122; workshops, 275n29

encomiums: with appended notes, 91, 97; attributing inkstones to Gu Erniang, 90–91; carved onto inkstones, 8*fig.*; compiled for publication, 91, 97, 194, 251n30, 274n17; format and style of, 189, 272n1; of the Fuzhou inkstone circle, 90–91, 156, 175; history of, 189; of Jin Nong and Gao Fenghan, 193–198, 194*fig.*; as required embellishment for inkstones, 192; rubbings of, 8*fig.*, 192, 194, 274n17; Yongzheng's choice of, 40–41*fig.*, 238n54. See also carving of words; Huang Ren: encomiums of; *Inkstone Chronicle* (Lin Fuyun); Gao Fenghan: *Inkstone Chronicle* of; Lin Fuyun: encomiums of; Lin Ji: encomiums of; Yu Dian: encomiums of

epigraphy, 104, 125, 169, 171, 173, 189, 191, 192, 272n2. *See also* evidential learning; Han Learning; Plain Learning; philological movement

ershi (eat with their ears), 246n56

gift-giving: to Chinese scholars by emperor, 15, 232n7, 240n82, 249n12; corrupt culture of, 51; by the emperor, 236n43, 239n70; among friends, 3; by the Fuzhou circle, 105, 164, 179–83; to one's son, 3, 179, 180–81, 185, 270n82; and theft, 182–83, 184; tribute gifts, 45

gilding, 28–29

Glass Works (Imperial Workshops), 240n77

God of the Entrance of the Cave, 55, 56*fig.*

Gold and Jade Works (Imperial Workshops), 238n59

Golden Cattle Road, 54, 242–43n16

gongbi painting, 120

gourd shape, 12–13*fig.*, 33, 88*fig.*, 182, 236n43, 270–71n88

Grandpa Phoenix, 263n19

Gu Congyi, 273n13

Gu Dagu. *See* Gu Erniang

Gu Daoren, 147–48, 261n57

Gu Delin, 85–87, 147, 111, 112, 250nn16,20, 261–62n57, 354n61

Gu Erniang: adopted sons of, 87; authenticity of inkstones attributed to, 88, 122–23, 144, 253n48, 256n13; biography of, 9, 87–89, 250n19; and the carving of words, 97, 111; contrasted with male inkstone carvers, 107; descriptions of, 87, 111–13; and embroidery, 113, 122, 132, 255n76; eroticization of, 146–47, 261n53; exceptional skill of, 97, 103, 108; fame of, 137, 259n37, 271n93; forgeries of, 103, 108, 109, 123, 129, 141, 142, 144–46, 149, 253n48, 255n64, 256n13, 260n43, 261nn49,50; Gao Fenghan's attribution to, 196*fig.*; gender of, 97, 108, 203; generic inkstones by, 251n29; as guide to the world of inkstones, 5; inkstones for Lin Fuyun, 96, 115–16, 118; landscape inkstones bearing the mark of, 259–60n40; list of inkstones bearing her signature mark, 90–91, 213–16; list of inkstones made for her patrons, 90, 205–11; lore of, 94; names and terms of address for, 88, 89–90, 111, 250n22, 251n24, 251n25; patrons of, 8, 8*fig.*, 90–94, 99, 103, 111, 129, 150, 164, 217–20, 251n29, 261n49; philosophy of inkstone making, 110–13, 115, 230, 255nn1,73,76,77, 255n78; poems dedicated to, 88, 93, 115, 144, 260n48; popularity in Fujian, 91–92; possible attributions to,

270n83; recarving of antique inkstones, 95, 176, 205–6; relations with other carvers, 127–28, 257n22; remake of Wu Zhen's inkstone, 96–97, 176, 182, 258n26; selection of designs, 85; signature mark of, 90–91, 99–103, 100*fig.*, 102*fig.*, 116, 116*fig.*, 130*fig.*, 132, 141, 143*fig.*, 213–16, 251n25, 253n44, 256n13; as super-brand, 123, 128, 129, 135, 142, 143, 146, 150; and three-dimensionality, 149; visit by Xie Ruqi and Dong Cangmen, 110–13, 255nn73,76; visual tropes of, 129–32, 142, 149, 213–16, 260n45; workshop of, 81, 85, 88, 111, 141, 147–49, 210, 252n33, 260–61n48. *See also* Gu Erniang, inkstones associated with

Gu Erniang, inkstones associated with: *Apricot Blossoms and Swallows,* 97, 115, 209; *Banana and Moon,* 100–101*fig.*, 102*fig.*, 214; *Banana Leaf,* 214; *Banana White* (a.k.a. *Supreme Simplicity*), 98, 206, 269n75; *Blue Spot,* 143–44, 210; *Dugu's* inkstone, 205–6; *Entwined Gourds and Butterfly,* 143–44, 145*fig.*, 251n26, 256n13, 260n46; *Grace of Moon,* 208; *Grotto and Sky as One,* 8*fig.*, 102*fig.*, 215; *Gu Erniang* inkstone, 216; *Irregular-shape,* 215; *Jielin,* 102*fig.*, 215, 257n19; *Knot,* 206–7; *Moon on Water Flowers in Mirror,* 210; *Mushroom,* 143*fig.*, 216; *Oak Forest Buddhist Hut,* 210–11; *Paired Swallows* (National Palace Museum, Taipei), 100–101*fig.*, 116–18, 116*fig.*, 214; *Paired Swallows* (Tianjin Museum), 100–101*fig.*, 102, 102*fig.*, 117–20, 118–19*fig.*, 122, 123, 126, 129, 140, 214, 256n4, 256n13, 258n25; *Phoenix* (encomium by Lin Zhaoxian), 209; *Phoenix* (former collection of Zhu Yi'an), 99, 100*fig.*, 213; *Phoenix* (Metropolitan Museum), 100*fig.*, 102, 102*fig.*, 213, 260n43; *Phoenix* (Palace Museum, Beijing), 130, 130*fig.*, 213; *Scene of Red Cliff,* 215, 257n19; *Song Cave,* 208; *Supreme Simplicity* (a.k.a. *Banana White*), 98, 206, 269n75; *Ursa Major,* 92, 99, 165, 183, 185, 207, 271nn92,94; *Water Lode,* 208; *Well Field,* 207; *Zhao Songxue's [Mengfu]* inkstone, 94–95, 176, 205–6

Gu Gongwang: adopted son of Gu Erniang, 87, 88, 111, 250n20; recruitment of, 85, 232n3, 249n12, 250n19, 260n48; signature mark Zhonglü, 87, 88*fig.*; training of, 250n20

Gu Jichen (imperial workshop artisan; Suzhou native), 39

Gu Jichen (imperial workshop artisan; refused Yongzheng's order), 39, 239n63

Gu Qiming, 85, 88, 89, 250n20, 251n25

Gu Qinniang. *See* Gu Erniang

Gu workshop, genealogy of, 147–49. *See also* Gu Erniang: workshop of

Gu Zhuting, 146

Guan Honghui, 99

Guandi statue, 37, 39

Guandong stone, 239n71

Guang-ware, 124, 257n22

Guangdong craftsmen, 49, 99, 124, 128, 257n16, 257–58n23, 270n87. *See also* Dong Cangmen

Guanglu Lane (Fuzhou), 152*fig.*, 153, 155, 156, 168, 262n2; residents of, 217, 218, 219

guigong (demonic craft), 30, 84, 108–9, 123, 249n10

Gujin tushu jicheng (Complete collection of illustrations and writings from ancient to modern times), 148, 261n57, 262n58

Guo, Prince, 239n70

Guo family (White Stone village), 57*fig.*

"Guobao dang'an" (Archives of national treasures; TV program), 260n46

guoqiang ("climbing over the wall"), 28*fig.*, 29, 130–32, 142, 149, 258n28

Guxiu (Gu Embroidery), 110, 113, 121*fig.*, 122, 137, 255n76

Guzhu tea, 110, 113, 255n70

H

Haiwang, Vice-Director, 237n52, 238nn56,60,61, 239n70

Hall of Mental Cultivation (Yangxindian), 14, 15, 232n1

hammers, 53, 53*fig.*, 54

Han Feizi, 252n36

Han Learning, 68, 190. *See also* epigraphy; philological movement

Han Yu, 62, 245n40

Hancui lou, 168

Hanjun-banner, 9, 16, 19–20, 231n6, 234n26

Hanlin academicians, 15

Hay, Jonathan, 236n42, 354n61

Hayes, James, 243n22

He Bangyan (Diting), 251n29

He Chong, 221, 254n56

He Chuanyao: annotated map of interior of Underwater Lode, 72, 73*fig.*, 247–48n71; collection of, 72; criticism of stoneworkers' knowledge, 76–77, 248n74; *Discerning Inkstones* (Baoyantang yanbian), 72–76, 77, 247nn66,70, 248n75; Four Caves of the Underwater Lode, 72–75, 76–77; incorporated verbatim by Wu Lanxiu, 75–76, 247n71; maps of Duan quarries, 69*fig.*, 246n60, 247–48n71; ranking of quarries, 74–75; revised structure of inkstone knowledge, 75–76, 77–78; viewed Old Pit and Underwater Lode as synonyms, 246n64

He Chunchao, 261n50

He Jinqun, 238n53

He Wei: and the codification of inkstone descriptions, 163–64, 174, 264n28; exchanges of inkstones, 163, 171, 264n27; inkstone connoisseurship circle of, 162–64, 264nn23,27; mentioned, 271n95; tale of magical stone, 51, 242n8

He, Yanchiuan, 244n40

He, Yuming, "book conversancy," 243n18

He Zhen, 272n2

He Zhuo: calligraphy for *Supreme Simplicity* inkstone, 98, 206, 269n75; *Imperial Gift* inkstone, 178; ink stone of, at National Palace Museum, 252n39; mentioned, 193, 217

heated inkstones (*nuanyan*), 235–36n38

Heavenly Queen (Tian Hou), shrine to, 246n62

Hermitage of One Thousand Orchids (Lanqian Shanguan) collection (National Palace Museum), 116, 256n3

hierarchy of head over hands, 5, 18, 201, 229

household slaves (*qixia jianu*), 16, 233n12

Howell, Martha, 270n80

Hua Yan, *Banquet in the Apricot and Plum Garden on a Spring Evening*, 157*fig.*

Huang Gang. *See* Yellow Hill

Huang Hui, 263n14

Huang Peifang, maps of Duan quarries, 72, 73*fig.*

Huang Ren: acquaintance with Chen Zhaolun, 153–55, 262n1; ancestral home of, 168, 169*fig.*; biography of, 217, 226; birthday celebration of 1719, 169–70, 267n49; *Blue Spot* inkstone of,

Ingold, Tim, 231n5

ink: and absorbency of the inkstone, 50, 241n5; stone dust in, 187, 272n100; viscosity of, 3, 201, 272n100

ink-cakes: designed by Liu Yuan, 22–24, 24*fig.*, 28, 28–29*fig.*, 235n31; eliminated need for grinder with pestle, 4*fig.*, 272n100; encomiums on, 22–23, 235n32; formulas for, 62; grinding of, 49–50; found at Palace Museum after 1949, 235n31; *Pine Moon* ink-cake, 22–23, 23*fig.*, 235n32; *Song Inkstone* ink-cake, 24, 24*fig.*, 28; *Virtuous Power of Dragon* ink-cake, 28–29*fig.*, 29, 131

ink grinder (*yan*), Western Han dynasty, 4*fig.*

ink pellets, 4*fig.*

ink pool: design decisions regarding, 174, 268n65; in illustration of parts of inkstone, 2*fig.*; importance of, 96; between nodes of bamboo on *Bamboo Stem* inkstone, 132; opening of, 6*fig.*, 95, 96, 99, 105, 109, 205–6, 252n37, 254n57; use of, 3

ink-slab encased in a box convention, 12–13*fig.*, 34, 40–41, 42

ink-slabs. *See* inkstones

inkstone boxes: black lacquer, 41, 239n68; composite, 42; etched glass, 42, 240n74; with fish-fossil lid, 236n44; housing knickknacks besides the ink-slab, 42, 240n75; ink-slab encased in a box convention, 12–13*fig.*, 34, 40–41, 42; made in Ruyiguan, 238n59; materials used for, 34, 236n44; with stand, 43, 240n73; stone, 33, 42, 239n71; West Hill–stone bamboo-shaped, 40–41*fig.*; Yongzheng's taste in, 40–42; *zitan* wood, 30, 31, 43, 128

inkstone carvers: attitudes toward, 85–86; carving of words, 97–99, 172–173, 252n40, 269n75; embroidery and, 113, 120–22, 132; Fujian, 103, 107, 124, 134, 135; Gao Fenghan as, 195–97; Guangdong, 99, 124; Huang Shengyuan as, 238n60; in the imperial workshops, 14, 38–39, 233–34n20, 238n60; itinerant employment, 104; modern, 66, 260n43; payments to, 92–93; and seal-carving technique, 124, 127, 132, 257n20; skills of, 6–7*fig.*; specialization of, 141; Suzhou, 84, 124, 260n43; Tang Chuang as, 238n60; task of "opening the ink pool," 6*fig.*, 95, 96, 99, 105, 109, 205–6,

252n37, 254n57; tools of, 96*fig.*; Wang Tianque as, 238n60; Wang Yingxuan as, 233n20; women as, 203; Yellow Hill, 49, 241n2. *See also* Dong Cangmen; Gu Delin; Gu Erniang; Gu Gongwang; Gu Qiming; Lin Fuyun; Liu Yuan; stone carvers; Xie Ruqi; Yang Dongyi; Yang Zhongyi; Wang Xiujun; Wu Ligu

inkstone catalogues: codification of descriptions in, 163–64, 174, 185, 264n28; imperial, 25–27, 46; museum, 258–59n32. *See also* Gao Fenghan, *Inkstone Chronicle* of; *Inkstone Chronicle* (Lin Fuyun); Mi Fu, *An Account of Inkstones*

Inkstone Chronicle (Yanshi; Lin Fuyun): afterword for, 191; authors and compilers, 223; as calligraphic model book, 193; circulated in the north, 270n88; collectors as characters in, 159–60; compared with the *Chronicle* of Gao Fenghan, 195–97; as a compilation of encomiums, 129, 156, 159, 184, 221, 251nn27,30; congratulatory poems and messages in, 221, 226, 227; endorsements of, 143, 156, 190, 223, 224, 225; extant copies of, 224–27; illustration of, 224, 275n3; inkstones from the Song, Yuan, and Ming, 176; number of inkstones of Fuzhou circle members in, 217–19; organization of, 159, 263n15, 265n33; origins of, 165, 265n33; poems in, 260n48, 261n50; preface by Lin Zhengqing, 165, 265n33; as source of information on Gu Erniang's works, 8, 89, 91, 253nn44,48; story of Zhang Roujia and her grandson, 165; taste for novelty described in, 174–75; textual history, 223–24. *See also* Fuzhou inkstone circle; Lin Fuyun

inkstone collecting: in the early Qing, 160, 167–71; fakes and forgeries, 103, 123; important collections, 266n43; market for inkstones in Qianlong era, 150; in the Northern Song, 160–64; and remaking of old inkstones, 91, 95–96, 252n38; and shared ownership, 179, 184; stories about, 146, 160–62, 263n18, 263n19; valuation, 92, 163; by women, 201–2. *See also* collections; Fuzhou inkstone circle; inkstone connoisseurship; inkstone market

inkstone connoisseurship: as addiction, 171, 267n54; antique and modern inkstones, 178; *Appreciating Inkstones* by Du Dashou, 161*fig.*; and choice of stone, 7, 46, 172, 173–74,

mining: accidents, 54, 242n15; manpower for, 247n68; procedures, 58–60; prospectors, 58, 61, 63, 77, 244n38; role of the assessor, 60–61; terminology of, 61, 244n36; tools for, 61. *See also* Duan quarries; stoneworkers

Ministry of Punishment, 21

Ministry of Revenue, 233n10, 237n46

Ministry of Rites, 25

Minshan Yinshe poetry society, 255n66

Miscellany Works (Imperial Workshops), 238n59, 239n70

model (*yang*), 24–25. See also *disegno*; inkstone models

monkey motif, 258n24

Mount Beiling (Guangdong), 50, 50*map,* 241n1

Mount Lanke (Guangdong), 50, 50*map,* 59*fig.,* 69, 241n1

Mount Longwei (Shezhou), 42, 66*fig.*

Mu Dazhan, 137

Mukerji, Chandra, 16

mushroom trope, 141–42, 143*fig.,* 149, 216, 260nn42,43

muyou (friends of the tent; private assistants), 233n11, 247n66, 248n75

mynah's eyes, 39, 64–67, 65*fig.,* 93*fig.,* 96, 116, 163, 245nn49,50, 245–46n51, 248n74, 264n25

N

Nalan Chang'an: on "demonic craft," 84, 123; on Guangdong and Suzhou craftsmen, 124, 257n16; on Zhuanzhu Lane, 83–84, 109, 248n5, 249n11

nanjiang (southern craftsmen), 38–39

National Palace Museum exhibition (Taipei, 1993), 46

native informants (*turen*), 67, 71, 75, 76, 77, 246n63

Neiwufu (Bureau of Inner Affairs). *See* Imperial Household Department

New Year prints, 275n29

Ni Zan, 176

Nian Xiyao, 17, 40, 237n52, 239n67

Ningguta, 238n58

niru (arrows), 16, 233n13

nuanyan (heated inkstones), 235–36n38

Nurhaci, 233n13

O

Office of Accounting (Dang Fang), 34

Office of Auditing (Suandang Fang), 34

Office of Overseers (Ducui Fang), 34

Old Man Lü, signature mark of, 253n45

Old Pit (Lao Keng; Duan quarries): appearance of tiger, 242n15; entrance to, 55, 56*fig.,* 59*fig.;* map of, on the back of an inkstone, 69*fig.;* mentioned, 14; oldest and most desirable, 58; raw stones from, 93*fig.;* reopening of, in Ming, 245n47; rocks and caves of, 172, 173; synonymy with Underwater Lode (Shui Yan), 58, 246n64; as Underwater Lode, 70–71, 71*fig.,* 72–74, 173, 244nn28–29, 246nn62–64, 247nn67,68, 266n40; years of operation, 58, 244n30. *See also* Duan quarries

Old Su stones, 76

olive pit carving, 84, 249n10

"opening the ink pool," 6*fig.,* 95, 96, 99, 105, 109, 205–6, 252n37, 254n57

Ortai, 42

Ouyang Xiu, 65–66, 244n38, 266n46, 273n13

ownership of inkstones, 179, 184–86. *See also* gift-giving

P

painted enamel, 31, 236n41

paintings: artisan and literati, 199; bamboo, 259n35; as collectibles, 160; landscape iconography, 139, 140; signing of, 260n41

paired swallows, 129, 142. *See also* apricot blossoms and swallows motif; inkstones by name: *Apricot Blossoms and Swallows, Paired Swallows*

Pan Shupo, 146

papermaking families, 242n14

patronage networks, 18, 71, 179, 183, 191

pestle, 4*fig.*

philological movement, 68, 71, 75, 190, 195, 246n59, 247nn65,70

phoenix trope, 129–32, 135, 142, 211, 213, 258nn26,27. *See also under* inkstones by name

physicians, 274n22

Plain Learning, 190. See also epigraphy; evidential learning; Han Learning; philological movement

plum motif, 256n12

"poetics of the list" (Clunas), 63, 68

potted sceneries (*penjing*) matched with boxed inkstone, 43, 240n77

potters, 17–18

pouch-shaped inkstones, 181

printing blocks: carvers of, 249n8, 275n29; for *Inkstone Chronicle*, 8; prepared by Lin family, 185, 185*fig.*, 191–92, 273n8

Project Management Office (Huoji Fang), 34

prospectors, 58, 61, 63, 77, 244n38. *See also* mining; stoneworkers

Q

Qi Chaonan, 221

Qian Chaoding, *Shuikeng shiji*, 246nn63,64

Qian Chenqun, 221

Qian Daxin, 190, 195, 221, 272n3

Qian Zai, 221

Qianliang Ku (Warehouse), 34

Qianlong emperor: boasted he had obtained Huang Ren's inkstones, 167; gifts of inkstones to Qing scholars, 240n82; imperial style, 237n50; and the ink-cakes of Liu Yuan, 22, 235n31, 236n40; inkstone collection of, 184, 271n95; inkstones used by, 236n43; material culture under, 43; *Stone Field* inkstone in the collection of, 180*fig.*, 184–85

Qin Père et Fils, 249n6

qing, cult of, 171, 267n54

Qing dynasty: and civil rule, 3–4, 45, 231n1, 231n8; civil service quotas, 9; as material empire, 15, 45, 149; technocratic culture, 11, 16, 35, 45, 47, 149. *See also* Imperial Workshops; Kangxi emperor; Qianlong emperor; Qing imperial style; Yongzheng emperor

Qing imperial style: developed by Liu Yuan, 20–21, 24; Kangxi and, 34, 45; and literati preferences, 45–46; Qianlong and, 237n50; Yongzheng and, 36–38, 41–43, 45, 237n50

Qiu Ying, *Along the River during Qingming Festival* (Qingming shanghe tu), 80*fig.*

"qualisigns," 245–46n51

Qutan, Monk, 249n10

R

Reitlinger, Gerald, 162, 263n21

recarving of inkstones, 91, 95–97, 176, 182, 205–6, 252n38, 258n26

Ruan Kuisheng: biography of, 259n36; notation book of, 136–38, 259n36; notation "Experts famed for their skills and artistry," 136; as official in Beijing, 259n37; references to Gu Erniang, 251n24

Ruan Yuan, Governor-General, 247n70

rubbings: from ancient vessels, 62, 244n38; collections of, 168–70, 189–90, 266n46, 266–67n47; of inkstones as models, 57*fig.*; from steles, 8, 189, 246n59; of "stone drum" script, 273n13. *See also* inkstone rubbings

Ruyiguan, 238n59

Ryūkyū king, inkstone gifted to, 45

S

Sage, Steven, 242–43n16

Salk Institute, 231n1

salt administration, 15, 272n99, 273n16

sand polishing, 275n30

Sanfang Qixiang (Three Lanes and Seven Alleys, Fuzhou), 262n2. *See also* Guanglu Lane

Schäfer, Dagmar, 190, 231–32n8, 274n22

scholar-artisans, contrasted with artisan-scholars, 9, 197, 198–200

scholar-connoisseurs, 67, 68, 71–72, 75, 77–78. *See also* inkstone connoisseurship

scholar-officials, 200

scholars: "denaturalization" of, 10; as elite identity, 61–62; imperial gifts to, 15, 232n7, 249n12; inkstone connoisseurship, 46, 62; Kangxi's appeal to, 14–15; masculinity and, 201–3; overlap with craftsmen, 9, 10, 201; in Tang and Northern Song, 62; varieties of, 10. *See also* calligraphy; inkstone connoisseurship; literati culture; scholar-artisans; scholar connoisseurs

School on Prospect Hill, 233n15

science, 11, 71, 149, 245n42; deductive method, 63, 66–67, 70, 75, 77; first-hand observation, 68, 72; objective perspective, 64, 76, 77; scientific experiments, 275n26; scientific revolution, 200–201; specialized knowledge, 60, 62, 141, 174. *See also* epigraphy

stone-water affinity, 52, 58, 242n10

stoneworkers: criticism of, 76–77, 248n74, 248n75; as custodians of useful knowledge, 52; expert knowledge of, 60, 61, 77, 78; literacy of, 55, 56–57, 243n18; lives of, 49, 51; in Mi Fu's account, 67; oral traditions of, 52, 76; rituals of, 54–55, 69; songs of, 243n21; story of the stoneworker and the heron, 51–52, 58; subject position of, 77–78; in tale of magic Duan stone, 51; tools of the stonecutter, 52–54, 53*fig.*, 242n11. *See also* prospectors

Su Shi: calligraphy of, 163; on Duan ink-slabs, 241n3; encomium on inkstone box, 163; eulogy of a She inkstone, 166; on the frustration of a slow inkstone, 241n5; inkstone stories featuring, 162, 263n18; involved in improved ink-cake formula, 62; painting of, 163; scene of, at Red cliff, 215; travel to Duan, 51

Su-ware, 84, 124, 135, 257nn16,22

Su Yijian: anecdotalist approach of, 68; compared with Mi Fu, 64–65, 67; *Four Treatises from a Scholar's Studio* (Wenfang sipu), 62–63, 67; mentioned, 241n2

Suandang Fang (Office of Auditing), 34

Sungari River, 14

super-brands, 123–24, 128, 256n14, 257n17

super-signs, 123, 256n14

Suzhou: art market of, 172; canals of, 81, 82*map;* carvers of, 84, 249n8, 249n10; Chang Gate neighborhood, 80*fig.*, 81–83, 82*fig.*, 94, 197, 205, 248n5; as commercial and political hub, 81–82, 248n2; inkstone workshops, 241n2; merchants of, 81, 248nn4,5; school of seal carving, 124; in the seventeenth century, 82*map;* "style," 86; as super-brand, 124; Taohuawu, 82*map*, 94, 275n29; Zhuanzhu Lane, 82–84, 82*map*, 86, 88, 108, 124, 261n48. *See also* Gu Erniang

Suzhou fuzhi, 262n57

Suzhou yang (Suzhou design), 124, 257n15

T

tablet-style inkstone, 2*fig.*

Tang Chugang, 238n60

Tang inkstones, 135, 176, 178, 180, 264n28

Tang Ji, *Shezhou yanpu*, 246n60

Tang Ruizong, 266n46

Tang Taizong, mausoleum of, 157, 170, 267n47

Tang Xun, *Record of Inkstones* (Yanlu), 65, 245n47

Tang Ying: decided on number of replicas, 239n68; named inkstone craftsman in notebook, 233–34n20; as poet, painter, and playwright, 17; prose and verse of, 19; self-identity as a craftsman, 17–18, 199; statue of, 18*fig.*; as supervisor of Imperial Porcelain Manufactory, 17; *Words from a Potters Mind* (Taoren xinyu), 17–18, 229

Tao Hongjing, *Imperial Gift* inkstone, 178

Tao Yuanzao, 251n29, 270n87

Taohuawu. *See* Suzhou

techniques: as basis of analysis, 135; of stone carving, 119–20, 139–40, 256nn7,8. *See also* carving of words; gilding; printing blocks; seal carvers; *shuangdao; shuipan;* tools

technocrats, 18–20, 104, 200, 233n11, 237n46, 259n36; and knowledge culture of early Qing, 11, 16, 35, 45, 47, 149; logistical power of, 16, 72, 247n68; use of the term, 232n10. *See also* bondservants; *muyou;* Shen Tingzheng; Tang Ying

technology, 11, 231n5, 261n57; of writing, 49, 62

textiles, 15, 81, 248n4, 275n29

textual tropes, 143–44, 261n49

theft, 182–83, 184, 271n94

Three Feudatories rebellion, 14. *See also* Geng Jingzhong.

Three Superior Banners, 16, 35, 233n14

Three Vaults, 237n46

three-dimensionality, 132–35, 149, 150; of bamboo stem, 136, 259n35; of landscapes, 138–39, 140; and mushroom inkstones, 141–42

Tiewang shanhu, 251n30

Tong, Mr., curio shop of, 94

Tong Pengnian, 20–21

tongren (knowledgeable man), 198, 274n21

tools, 62, 96*fig.*, 120; forging, 52, 53–54; rituals related to, 54, 55. *See also* hammers

transport routes, 248n2

tribute inkstones, 45, 240n81

tribute system, 43–45, 240n78. *See also* gift-giving

tu (maps), 70, 246n64

woven colander trope, 142, 260n43

Wu Chengming, 248n4

Wu Gang, 115

Wu Lai, 267n51

Wu Lanxiu, 75, 247nn66,69,71; *Chronicle of
Duanxi Inkstones* (Duanxi yanshi), 75–76;
maps of, 247–48n71

Wu Ligu: on Gu Erniang, 113, 250n19, 251n25,
252n38, 256n13, 257n22, 262n59; on Huang
Ren, 270n86, 271n89; *Tang Yin's Peach Blos-
soms Hut* inkstone, 66*fig.*

Wu Shengnian, *Duanxi yanzhi*, 247n65, 247n67,
248n74

Wu Zhen, 96, 176, 182, 258n26; *Oak Forest Bud-
dhist Hut* inkstone, 210–11

Wu Zhenyu, 96, 236n43

Wuding cult, 55–56, 243nn17,19,20

Wuding (five strongmen) hammer, 54. *See also*
Five Strongmen tale

Wuding stone, 42, 239n71

Wuxi cliffs (Hunan), 170, 267n48

Wuyingdian, 232n1, 234n25

X

Xi River, 49, 50*map*, 58, 241n1, 275n30

Xiang Yuanbian, 94, 168, 176, 205

xianweijing (magnifying lens), 84

Xie Gumei: acquaintance with Chen Zhaolun,
153, 154; biography of, 218, 226; calligraphic
scroll dedicated to Lin Weiyun, 158*fig.*;
colleagues and family of, 218; encomiums of,
226, 227; on the format and style of inkstone
encomiums, 189, 272n1; and the Fuzhou
inkstone circle, 156, 158, 217, 218, 219, 220; and
Huang Ren, 96, 182, 266n42, 269n79; men-
tioned, 270n84; notes on inkstones, 208, 211;
posthumous poetry collection *Xiaolangai*,
170*fig.*; posts of, 182; referred to Gu Erniang
as Gu Dagu, 250n22; rubbings collection of,
169, 170, 189–90, 266n46, 266–67n47

Xie Ruqi (Xie Shiji): as artisan-scholar and poet,
9, 109–10, 199, 254n57, 255n66; *Cloud and
Li-Dragon* inkstone, 125*fig.; Clouds and Moon*
inkstone, 125–26, 125*fig.*, 126*fig.*; exchange of
inkstones and poems with Shen Tingzheng,
19, 234n24; familiarity with Gu Erniang's ink-
stones, 127–28; friendships with Huang Ren
and Zhou Shaolong, 257n21; influenced by
seal-carving, 124–25; inscribed chrysanthe-
mum painting by Dong Cangmen, 254n58;
name Ruqi bestowed on, 19; *Paired Phoenix*
inkstone, 125*fig.*, 132; *Rising Sun over Waves*
inkstone, 125–27, 125*fig.*, 127*fig.; Scene of
Red Cliff* inkstone, 215, 257n19; set of poems
"Dong Cangmen and I passed by Zhuanzhu
Lane," 110–13, 115, 122, 230, 255n73; signature
marks of, 125, 125*fig.*, 132, 141, 254n59, 257n19

Xie Xi, 255n66, 272n98

xingzou (to work in the Imperial Workshops),
13, 232n1

Xiqing yanpu (Catalogue of Inkstones from the
Chamber of Western Purity), 25–27, 46,
180*fig.*, 235nn36–37

Xu Baoguang, 221

Xu Bo, 171, 267n52

Xu Cai, inkstone collection of, 163, 264n25,
271n95

Xu Jun: biography of, 226; death of, 159, 172;
encomiums of, 173, 208, 226, 227; family
of, 218, 264n29; and the Fuzhou inkstone
circle, 156, 158, 218; and Huang Ren, 172, 173,
217, 269n79; passed metropolitan exam, 181;
patron of Gu Erniang, 91, 275n1 (appendix 1);
as the "Poet of Dingmao," 172, 268n61; sealed
pouch inkstone of, 181

Xu Kang, 146–47, 261n55

Xu Liangchen, 215, 221

Xu Naichang, 247n66

Xu You, 164, 262n6

Xu Yu, 156, 172, 181, 218, 220, 262n6

Xu Yunwen, 85

Xuannan district (Beijing), 158, 263n11

Xue Jinchen, 137

Xue Ruohui, 219, 252n37, 254n56

Xuehai (Sea of Learning) Academy (Guang-
zhou), 75, 247n70

Y

yadi yinqi (supressing the ground while making
a faint relief), 119, 256n7

yan (ink grinder), Western Han dynasty, 4*fig.*

yan (inkstone). *See* inkstones; inkstones by name

modern inkstones, 175–76, 178; and Zhao Guolin, 182, 270n88

Yu Peijin, 238n57

Yu Shide, 268n64

Yu Wenyi, 221, 225, 226, 275n1 (appendix 4)

Yu Zhen, 221, 240n82

Yu Zhongya, 267n51

Yuan Jingshao, 39, 238n62

Yuan Mei, 146, 221, 261n53, 265n35; *Suiyuan on Poetry* (Suiyuan shihua), 144–47, 261n50

Yuanmingyuan, workshops at, 39, 232n2

Z

Zaoban Huoji Chu. *See* Imperial Workshops

Zaoti Alley (Fuzhou), 152*fig.*, 262n2

Zeitlin, Judith, 267n54

Zeng Xingren, 248n74

Zhang Bangji, 241n3

Zhang Hechai, 221

Zhang Jianfu, 243n25

Zhang Liduan, 237n50

Zhang Pengge, 221

Zhang Roujia, 165, 265n33

Zhang Sigong, *The Planet Deity Chenxing Attended by Monkey*, 258n24

Zhang Wei, 221

Zhang Yuan, *Portrait of Liu Yuan*, 20*fig.*, 234n28

Zhang Yuxian, 137–38

Zhang Zao, 243n25

Zhang Zhengtao, 221

Zhang Zhongxing, 256n13

zhangfang (silk manufacturer-exporter), 248n4

Zhao Bian, 166, 263n19

Zhao Guolin, 182–83, 184, 220, 270–71n88, 271n90

Zhao Lin, 267n47

Zhao mausoleum (of Tang Taizong), 157, 170, 267n47

Zhao Mengfu, 94–95, 176, 205

Zhao Xigu, *Bogu mingbian*, 269n74

Zhaoqing (Guangdong), 45, 240n81, 241nn1,2. *See also* Duan quarries; White Stone village; Yellow Hill

zhi (nature, materiality), 75

Zhong Bojing (Xing), 259n40

Zhou Changfa, 275n3

Zhou Lianggong, 249n10

Zhou Nanquan, 261n55

Zhou Shaoliang, 235n31

Zhou Shaolong: biography of, 219, 226; encomiums of, 226, 227; friendship with Xie Ruqi, 257n21; and the Fuzhou inkstone circle, 158, 179, 218, 219; gifted inkstone to his son, 270n82; given Songhua inkstone by Yongzheng, 46, 240n82; inkstones of, 270n86

Zhou Xinjian, 249n10

Zhou Xuejian, 271n89, 275n3

Zhou Zhengsi, 221

Zhu carvers of Jiading, 250n17

Zhu Delin, 225

Zhu Gui, 249n8

Zhu Jiajin, 239n72

Zhu Jialian, 272n97

Zhu Jingying, 220

Zhu Xi, 175*fig.*

Zhu Xiangxian: alternate genealogy of Gu workshop, 148; biographical information, 250n14; on Gu Erniang, 87, 89, 113, 250n16, 251nn24,25, 255n77; *Huiwen leiju xubian*, 250n14; mentioned, 249nn7,8, 261n53; *Wenjian oulu*, 86, 250n14

Zhu Yi'an: collection of, 99, 213, 216, 260n42, 275–76n4; owned a copy of *Inkstone Chronicle*, 225, 275–76n4

Zhu Yizun, 178

Zhuang, Madame (wife of Huang Ren), 165–67, 265n34

Zhuang, Prince, 34

Zhuang Yougong, 221

Zhuangzi, 261n54

Zhuanzhu (ancient assassin), 111

Zhuanzhu Lane. *See* Suzhou

Zichuan stone, 252n37

zihao (cotton industry ventures), 248n4

zitan wood, 30, 31, 43, 128, 236n44, 240n73

Zou family, 87, 88, 89